Praise for

Raphael, Painter in Rome

"As the plot thickens, intrigue and political machinations simmer, and the result is a rich and delicious portrayal of art and its creators and the forces that drive and often work against them. More than 25 years of research in Italian Renaissance art deepens the story and renders it full of fascinating detail about people and process, while Storey's painterly prose is also **sure to delight art lovers and fans of historical fiction.**"
 —*Booklist*

"**Stephanie Storey paints a warm, witty, mesmerizing portrait of the Renaissance's most famous painters: the charming Raphael and the irascible Michelangelo, dueling for the title of greatest artist in Rome.** Only one will win the ultimate commission of the Sistine Chapel, and Raphael is determined the ceiling will be his—but at what cost? *Raphael, Painter in Rome* **is a feast for the senses, every brush-stroke a delight.**"
 —Kate Quinn, author of *The Huntress,*
 The Alice Network, The Empress of Rome
 Saga, and The Borgia Chronicles

"**Stephanie Storey takes one of the most towering figures of the Renaissance and seats him across a tavern table from the reader. Raphael's voice is as vibrant and colorful as one of his paintings,** and he positively leaps off the page and to life. Impeccably researched, this is an engaging

and timely novel about the ways in which politics and art are and always have been intertwined."

"A breathtaking portrait of a self-portrait. In it, the artist and his vision, drive, eccentricity, earthly loves and rivalries all come to life in brilliant color. **Storey captures the way art can be a tangled creature, born both deliberately and subconsciously from a slice of the artist's life, and the swirl of history, politics, and magical moments.**"

"**A sumptuous, dazzling dive into the world of Italian Renaissance art through the eyes of one of its most celebrated artists.** *Raphael, Painter in Rome* unfolds in unforgettable detail, with all the color and richness of the era: popes and princes, courtesans and cardinals, mystery and murder, ardor and art. **The world of Raphael is one I wanted to linger in forever.**"

"Stephanie Storey conjures the masters of the Italian Renaissance back to life in full vivid detail. This entertaining tale will steep readers in the scheming, the romance, and brilliant talents behind the creation of the Sistine Chapel.

Prepare to be charmed! Your Art History 101 class was never this suspenseful and fun."

—Elise Hooper, author of *The Other Alcott*, *Learning to See*, and *Fast Girls*

"Stephanie Storey's gorgeous, unputdownable book *Raphael, Painter in Rome* illuminates the Renaissance and its storied artists in brilliant, page-turning prose. This novel will have readers laughing out loud and cheering for quirky, sweet, playful, unassuming Raphael in his efforts to fulfill his boyhood promise at his father's deathbed to be the greatest painter in history and, later, to win the pope's favor over the brooding, talented artist Michelangelo. Storey's is a novel of forbidden love, loss, faith, determination, carnage, beauty, and ultimately the ties that bind us all in the human condition. Raphael's commitment to paint pictures that "bend the world toward beauty" even in the ugliest of days will leave readers with a keen interest in Renaissance art and the 16th century Vatican, and a love for this charming, endearing man, Raphael. Five stars!"

—Michel Stone, author of *The Iguana Tree* and *Border Child*

"Along with Michelangelo and Leonardo da Vinci, Raphael Sanzio forms part of an unofficial 'holy trinity' of Italian Renaissance artists. In Stephanie Storey's new historical novel, *Raphael, Painter in Rome*, however, we experience Raphael not as a towering giant but rather as a lively, engaging friend. Storey deftly weaves together

extensive historical research on artistic, political, and religious events without it feeling heavy or didactic. Raphael's first-person narrative and his interactions with the other characters—most of whom are important historical figures of Renaissance Italy—pulls the reader seamlessly through the story to a satisfying conclusion. You'll want to have your internet connection ready so that you can look up each and every one of the beautiful works of art described in this engaging tale of ambition, rivalry, and ultimately, the power of art to transcend it all."

—Laura Morelli, PhD, art historian and author of *The Painter's Apprentice* and *The Gondola Maker*

"**Storey makes the world of Renaissance Rome come alive** and draws the reader into its constant intrigues... Above all, she has excellent insight into the Renaissance art world and the genius of these two great artists, Raphael and Michelangelo, who were opposites in many ways—painting vs. sculpture, idealism vs. realism—and who disliked each other but also supported each other at crucial moments."

—*Historical Novels Review*, Editor's Choice

Raphael, Painter in Rome

Also by Stephanie Storey:

Oil and Marble: A Novel of Leonardo and Michelangelo

Raphael, Painter in Rome

A Novel

Stephanie Storey

Arcade Publishing • New York

Arcade Publishing books may be purchased in bulk at special discounts for sales promotion, corporate gifts, fund-raising, or educational purposes. Special editions can also be created to specifications. For details, contact the Special Sales Department, Arcade Publishing, 307 West 36th Street, 11th Floor, New York, NY 10018 or arcade@skyhorsepublishing.com.

Arcade Publishing® is a registered trademark of Skyhorse Publishing, Inc.®, a Delaware corporation.

Visit our website at www.arcadepub.com.

10 9 8 7 6 5 4 3 2 1

Library of Congress Cataloging-in-Publication Data is available on file.

Cover design by Erin Seaward-Hiatt
Cover photo credit: *The Triumph of Galatea*, courtesy of Accademia Nazionale dei Lincei/Villa Farnesina in Rome

ISBN: 978-1-950994-06-9
Ebook ISBN: 978-1-950691-31-9

Printed in the United States of America

Dedicated to
my parents, Steve and Kathy Storey,
for always holding the kite strings

*

A Note from the Author

Although this book is fiction, the story is based on decades of
research into the art of the Italian Renaissance and the real life
of Raphael Santi of Urbino, painter for popes and Michelangelo's
fiercest rival during the Sistine ceiling years.

The experience of this book is greatly enhanced with visuals,
so I have created a section on my website with images of the
artwork mentioned in this novel, organized by chapter. Go to
https://stephaniestorey.com/blog/images-for-readers-of-raphael
to follow along with the art as it appears in the story. For your
immediate reference, the cover of this novel is Raphael's fresco
"The Triumph of Galatea," painted in Agostino Chigi's palace,
today known as the Villa Farnesina.

Prologue
Rome. March 1520

Why does Michelangelo always get to be the hero? *A struggling sculptor, not trained in the art of fresco—forced by a temperamental pope to abandon his precious marble and paint a wretched ceiling—overcomes agony and obstacles to create a divine masterpiece ... Si certo*, you're moved by the story. I'm moved by it.

But you don't honestly believe that he painted that ceiling while lying on his back, do you? How would he crawl in and out—his body only an arm length from the ceiling—without smearing the paint all the time? And how would he have moved? Wriggled about on his shoulder blades and hindquarters? Perhaps once or twice, when he was up against a particularly steep curve of a spandrel, he had no choice but to lie on his back for few moments, but let's bury the myth right now: Michelangelo painted—like the rest of us—standing up. Don't believe me? Look at his own drawings. He sketched himself painting that ceiling: head tilted back, arm stretching overhead, *standing* on his *feet*. So, no, Michelangelo was not some subjugated hero forced to lie on his back by an intransigent pope.

I'm not angry with him for the story. I only wish I'd thought of it.

And tell me, *per favore*, that you don't believe that he hates to paint. Yes, he repeats the lie often as the Nicene Creed, but that doesn't make it true. During the four years when he was painting the Sistine—not carving any marble at all—he still insisted on signing his letters *"Michelangelo, sculptor in Rome,"* as though he hates to paint so much that he's incapable of calling himself a painter. But have you ever walked into the Sistine on a quiet Tuesday morning and looked up at those colors? *Santa Madonna*, those colors. Were you moved to tears, too? Now, tell me that he could've painted such a thing while hating it. Is that what you tell your children? Find something you hate, force yourself to do it, and *Ecco!* A masterpiece!

I know what people say about me. They say that Raphael Santi of Urbino is the ideal courtier: polite, generous, humble. They say I was born with such happy countenance that nothing ruffles me. They say my good looks reflect the beauty on the inside. They say my talent comes easily; they say everything comes easily. But don't strip me of my humanity because I'm good at playing a part. You do it, too, I'll wager, put on a smile sometimes even when you're feeling foul, so don't deny me those same basic human talents. In real life, no one could be as generous and loyal and charming as I pretend to be. No one.

You imagine me—if you imagine me at all—the way he describes me, don't you? Standing in the background, easy to forget, an easy rival to vanquish. When I look back on those years, I picture the events the way he tells them, too: him in the center, me in the corner . . .

Maria Vergine, that's what I do, isn't it? All he does is make himself the hero of his own story—can I blame him for that?—but why do I insist on making him the hero of mine? How can I expect anyone else to say I'm the greatest painter in history, if I can't say so myself? Is there a version where I get to be the hero? Or does he end the victor every time?

Chapter I
February 7, 1497
Florence

The first time I saw Michelangelo, I don't remember seeing him, but he swears that we saw each other, and we've been 'round and 'round about this so many times that I don't want to argue about it anymore. So, if you'll do me a kindness, somewhere during this next part, insert his face and, if you get the chance, tell him that's how I remember it because the only face that I recall clearly from that night is the face of that woman in that portrait landing in that fire.

She was painted in profile with wavy umber hair tied up in blue ribbons. Her dress was the color of opals—lime white softened with hints of indigo and red ocher. She was young, alluring, and so graceful . . . "Is that a Botticelli?" I asked.

"*Andiamo*," Perugino said, voice so thick with fear that I would've painted it flat black.

"Why are they burning it?"

"Now. We have to go, now."

"I'm going to save it." I pulled my arm free and slipped through the crowd. I was only fourteen but already knew

that there was no way to bring a thing back once it was destroyed.

It was crowded in Florence's Piazza della Signoria that night. As I approached the fire, I had to strain to see the top of the flames—yellow with sparks of cinnabar—casting a devilish halo across the night sky. A line of men and women approached the bonfire, holding armfuls of . . . what? It was too smoky to see well, but once they stepped up to the flames, I could see a man tossing a lute into the fire, a boy throwing in a deck of playing cards, and a woman adding a pile of embroidered wool dresses; what would keep her warm come winter? After sacrificing, they dropped to their knees, raised their arms, and wailed as though they could— somehow—throw their voices into the fire, too.

"Burn your mirrors, your dresses, your paintings, your books," a grim voice called over the crowd. "If you don't repent, this city shall be no more than a well of blood, a den of thieves, a house of poverty." Standing atop a platform next to the bonfire was—did you guess?—Fra Girolamo Savonarola. (*Mi dispiace*, that name makes a lot of people uneasy. If you don't like it, I won't repeat it again. I promise.) Did you ever visit Florence during that madman friar's rule? Ah, you missed quite a spectacle. That night, he was wearing dark robes with a heavy hood pulled low over his forehead, shadowing deep-set eyes, long nose, angular cheeks. He waved his arms like a conductor and spoke in a melodious rhythm. "If we do not cleanse ourselves of sin, the sword of the Lord will come down upon us all, quickly and soon!"

I pressed my hands over my ears to keep from being entranced and pushed toward the flames. Where was that Botticelli? *There.* The wood panel looked thick and hard like oak. That was good, but flames were clawing at the wood,

digging ragged caves of orange cinder around the edges. I reached for the portrait. Flames tickled my fingers. I yanked back. Burned arm hair smells a lot like dead ermine.

"The line for atonement is there, son," a woman said, face smudged with ash.

"I'm not here to . . ." thankfully, I swallowed the word "atone" and instead said, "I don't have anything to give." I turned back to the Botticelli. A crack filled with bubbling orange cinder was splitting the portrait in two.

"But your pictures . . ." The woman grabbed the strap of my traveling bag.

"These are nothing," I said, making my voice calm as creamy white brushed flat on treated wood. "Only crude drawings."

"Sinner." I swear that woman's tongue flicked out, purple and forked, like a snake. (All right, perhaps that was only my imagination, but that's how I remember it, so that's the way I tell it.) In that moment, oh, how I regretted coming to Florence.

I'd lived most of my life in Urbino. Have you been? Yes, it's remote—a walled city on the eastern edge of the Apennines, takes several days to get there—but worth the trip. Terraced hills, cypress trees, Roman ruins. After a winter snow, the sky turns lavender with a little extra blue—ultramarine, not azurite—and the buildings glow in shades of copper, rust, and ale. When you visit, don't miss the Ducal Palace. With its bell tower and dome prominently positioned high upon the hill, it looks more like a church than a palace, which is appropriate because in many ways our court *is* our religion. When you think of the peninsula's great courts, you think of Milan, Venice, and Ferrara, don't you? *Va bene*, but don't forget Urbino. Our court was and still is a paragon of

poetry, fashion, and jousting of swords and words alike. It's also the court where my father served.

Giovanni Santi spent his days making pretty pictures for the duke and his nights teaching me to make pretty pictures of my own. Before I could walk, I used to sit atop his feet as he swayed back and forth while painting. I learned the rhythm of the paint through those feet.

What I remember most about my father's death was his paintbrush. It wasn't a family heirloom. The duke hadn't bestowed it during some special ceremony. My father hadn't made it; he never made his own brushes. He'd probably picked it up at some market or another. It had a long, wooden handle splattered with dried specks of indigo and lead-tin yellow. The bristles were extralong horsehair and caked with malachite green. The apothecary tried to take that brush from his hand, but my father wouldn't let go.

A nun nudged me into the room. It smelled of poppies, earwax, and blood—the scents of men trying to cure things that can't be cured. The windows were covered with red velvet curtains—red like ochre, not orange like vermillion. I wondered, why shut out the sun if you're only going to light so many candles? The room was crowded, not only with doctors and nuns, but furniture. My mother had crammed too many tables, chairs, and chests into the house, and my father hadn't removed a single piece, not even after she died.

Three years before, when my mother and sister got sick, I hadn't known what the word "deathbed" meant, but by age eleven, I was old enough to understand.

"You weren't born on Good Friday for nothing," my father said, taking my fingers in the same hand as the paintbrush. The wooden handle dug into my flesh. "God wouldn't

have blessed you with such charm and talent unless you were destined to rise."

I looked at my shoes. They were worn leather, splattered with blue paint. There was a hole over my left toe. I regretted not putting on a fresh pair.

My father whispered. "*Promettimi...*"

My mother had said the same. "Promise me you'll take care of your father."

I replied to him the same way I'd replied to her. "Anything."

"Promise me you'll never give up the paint."

"But I want to go with you." I resented that my voice cracked like a boy's.

"You must stay, Rafa, stay and become the greatest painter in the world. The greatest painter in history."

"Giovanni," Evangelista da Pian di Meleto—my father's most trusted assistant, tall and stout as a bell tower—said from the opposite side of the bed. "The boy doesn't need that now."

"Anything less, my son, will be a disappointment to God. And to me."

"Your father's delirious," a priest whispered.

"Time for childhood is over." My father's eyes fluttered. "*Promettimi.*"

I'd failed my mother's promise: I hadn't taken good enough care of my father. I wouldn't fail this one. I replied, "I promise."

"See," he said to Evangelista. "I told you this wouldn't destroy him." He turned back to me. "So, my son, you have plenty of work to do. For I've given you a job, so you must do it. There will be no time for grief. You will have to work hard, but never with sadness or anger. God has given you

life, so you must embrace it. Beauty springs from joy. If you remember that, you'll keep your promise to me. And keep your promise you must."

I wish death were like an altarpiece, contained in a single scene, don't you? Instead, it's panel after panel after panel . . . If I could repaint the moment of death, here's what I'd choose: a father limp in bed, hand open and empty, nuns raising arms in prayer, and a boy—off to the side—crouching at the foot of an old cabinet to pick up off the floor a long-handled, long-bristled paintbrush. That's how death *should* come. Shouldn't it?

The night my father finally slipped into the great sea, I returned to his studio—*my* studio. His assistants had packed up their things and left. The *maestro* was dead, they had families to support, and a boy of eleven couldn't help. They'd taken everything: jars of paint, stacks of panels, ropes, tarps, two studio chickens, all gone. The little they'd left was a mess. Empty bottles toppled over, bristleless paintbrushes strewn across the floor, a three-legged chair leaning against an old wooden table. I looked for a bucket of water, but those were gone, too. Kneeling in the doorway, I took my father's long-handled paintbrush out of my pocket (in real life, I'd pried that brush out of my father's rigid fingers as a priest tried to drag me away while I wept, not an ideal scene at all). I dipped that brush into a puddle of muddy rainwater and scrubbed the bristles. I scrubbed and scrubbed but still couldn't make the green tint disappear.

At the funeral (a gracious affair for which I would still owe the duke and duchess a great debt, if they were still alive to accept it), I thanked the Duke of Urbino, Guidobaldo da Montefeltro, for gifting me with one of my father's best

paintings—a Virgin and Child, beautifully framed. The next morning, the duke sent me to apprentice for the greatest painter in our region, Pietro Perugino. My father had used mainly tempera paints for his panel pictures, but Perugino taught me to stop mixing pigments with egg and start mixing them with linseed oil instead. Perugino helped me master oil paints—the medium of the future, of the great Northerners, of Leonardo da Vinci. Tempera is thin; oils are rich. Tempera dries fast; oils slow. Tempera relies on flat blocks of color, while oils live in shadow. I went to bed late, rose early, and mixed so many colors that my mortar and pestle began to wear thin.

When I was fourteen, Perugino agreed to take me to Florence to study the masters. I thought I was so important, crossing those mountains on that slow six-day ride. I'd heard the rumors that Florence had fallen on dark times. The Medici family had been the de facto rulers of Florence for—what? Over a hundred years? After they were exiled, someone had to fill the power vacancy, so in strode that madman friar. Whereas the Medici had preached the gospel of greed, that friar parabled poverty and the wrath of God. But I didn't take the warnings seriously. No preacher, no matter how good, could preach a city like Florence out of its love of art.

I was wrong, *sì certo.*

Proof was that woman trying to wrench my sketchbook from my hands, as flames wrapped around that Botticelli portrait. I was running out of time to save it, so I looked up at the woman and offered my best smile—the crooked one where only one of my dimples shows—and said, "These are devotional images, my lady. Madonnas, mainly."

"Madonnas?" Several men crowded around. I felt like

I was standing in the bottom of a well with walls made of strange followers of that madman friar.

"What else would a boy draw?" I pulled out my sketchbook and riffled through the pages. I was telling the truth—sort of. It *was* a book of Madonnas—mostly. I stopped where I knew there were several pretty Madonnas in a row. "Nothing but drawings of the most perfect woman in the world."

"And nudes!" that woman cried, pulling a page out of the back.

The drawing was a study of the pagan Greek goddess Aphrodite, not exactly proper subject matter for such a religious gathering. "That's how you draw a Madonna," I said, backing into a thick man blocking my escape. "You draw the natural body first and add clothes later."

"One way or another, those drawings are going in." The woman grabbed my neck and pushed me toward the fire.

If she made me burn my sketchbook, could I re-create the drawings inside? No. A drawing doesn't only capture a scene, but a particular moment in an artist's career, and that moment is always changing. As Leonardo said, it's like stepping into a river as the water rushes by; it's never the same river twice. (All right, yes, Leonardo was paraphrasing Heraclitus, but so what if I prefer to credit the master from Vinci over a notoriously malcontent Greek?)

I glanced toward the Botticelli—*where is it?* There. A glimmer of her pale face. I could still save it, but how many people were ahead of me in that line, waiting to throw their belongings into the flames? Fifteen, twenty? Why was the line moving so slowly? And why was the fire burning so hot? Smoke seeped into my nose and mouth. My eyes started to sting.

At the sight of tears on a boy's cheek, the woman softened. "Where are your parents?"

I turned my large, round eyes up—I knew that they

would reflect the fire quite dramatically—and sighed. "Both gone into the great sea, *signora*."

"Why . . ." Her eyes filled with tears. "You don't have anyone to show you better."

I shook my head.

She took my face in her hands and said, "Give your sinful things to God. Only then will He will save you—save us all—in a sea of miracles." Her face shone bright with faith. Those tears in her eyes were tears of hope. I felt sorry for her.

The first time I saw that lump bulging in my father's stomach, I thought God had granted a miracle and turned my father into the first man to grow a baby. My father would birth that baby, which would, no doubt, be a girl and grow up to be a mother with daughters of her own. My house would once again be filled with mothers and sisters. But that was before I discovered that God doesn't grant miracles and a lump growing in a *man's* stomach is never a sign of life, but only a sign of sick.

So, I felt sorry for that lady—that follower of that madman friar—because she hadn't yet learned the truth that God doesn't grant miracles, and it's a painful thing to learn, isn't it?

"Yes, yes!" I cried, throwing one arm in the air and rolling my eyes back into my head just like that boy cured of demons in the Gospels. "I feel the Lord!" As the woman fell to her knees to thank God for leading me to salvation, she released my face. I stumbled backward and dropped to the ground among the forest of feet and legs.

"Boy!" the woman cried. "Help that boy, he's fainted!"

I darted through the undergrowth of legs and weeds of shadows, my sketchbook held tight to my chest. I pushed my way to the edge of the fire. Where was the painting? A mirror, a stack of books, the lid of a harpsichord . . . *There!*

Almost gone, but her face still intact. With my left hand—I could still paint without a left hand—I reached toward the flames, but the bonfire crinkled, and one side collapsed. Ash blanketed me. I coughed and looked over at the Botticelli—or, rather, where it had once been. Now, it was nothing but cinder.

It didn't take long to find Perugino waiting at the edge of the piazza. "Where's the Botticelli?" he asked.

I shook my head.

He put his arm around my shoulders and hurried us out of the square. I knew I wasn't supposed to—Lot's wife, Sodom, salt and all—but I did look back. How many pieces of art were going up in flames that night?

After my mother died, I'd found my father in his studio, adding gold leaf to a picture of the Holy Family. The rest of court was mourning up at the palace, so I asked, "What are you doing down here?"

And he replied, "Painting the world as it should be, instead of as it is."

Looking back at the bonfire that night, I decided that's what I would do, too. I wouldn't paint scenes of angst or wretchedness or violence; the world had enough of those. No. I would paint picture after picture of beauty, so much beauty that no fire could ever consume it all. And maybe, just maybe, if I painted enough, then the world would bend toward my pictures and become as perfect as it should be. And if I could paint so well that I bent the world—even if only a little—toward beauty, then I would keep my promise to my father, for I, Raphael Santi, would indeed be the greatest painter in all of history.

Chapter II

Summer 1504

Città di Castello

R aphael?"
I heard her, yes, but pretended as if I didn't. I tugged both sleeves away from my hands, rolled my right wrist four times—*uno, due, tre, quattro*—dipped my brush into the paint, wiped the bristles twice on each side against the rim of the clay pot, and leaned in to add another touch of raw umber to my panel of the *Three Graces*.

"Raphael."

I waved my hand as if shooing away a fly. My painting of the three nude female Graces from Greek mythology dancing in a circle was my most *graceful* painting yet: soft lines, glowing skin, curving bodies, but . . .

When I was six years old or so, while my mother and sister were up at the house readying the noontime meal, I was down in the studio, like always, with my father when he told me, "We're part of a competition, Rafa. A competition to reach perfection." I was sitting on his paint-splattered stool as he leaned in talking in an excited whisper. I leaned in, too, as he delivered the secrets of his trade. *My* trade. "All painters—*maestro* to apprentice—know that it's possible to

create a perfect painting. But guess what." His voice sounded so urgent that it made my heart tap the speed of vermillion. "No one has done it yet. And do you know what that means? It means, we might be the ones to get there first. Now let's see if we've done it." He took me off the stool and led me toward his latest picture of the Holy Family: Joseph looking down on Mary cradling baby Jesus. It was beautiful, all of my father's paintings were beautiful, but . . .

"Not perfect," my father sighed. "Not yet."

Fifteen years later, there I was, sitting in front of yet another painting—this time *my* painting—silently repeating, *Not perfect. Not yet.*

"Rafa."

Are you the sort of person who can do eight things at once—painting, eating, squashing a bug with your heel, all while carrying on a conversation? Have you ever seen Leonardo da Vinci paint with one hand, play a lute with the other, all while dancing and telling a joke? I'm no juggler. If I'm focused on something, I focus only on it. The rest of the world fades away. I used to think that everyone was the same as me, but now I know better. Sometimes, I wish we all functioned the same, so we didn't have to explain ourselves to one another. If we all acted the same, thought the same, *were* the same, then life would be simpler. Life as it should be . . . *Right?*

"Rafa!"

I turned to face Tessa, standing in the doorway, looking annoyed. She was a servant from the duke's quarters in Urbino who'd come with me to keep my house in the Castello. I said, "You'll have poetry this evening, *mia cara*, but right now . . ." I turned back to my painting, tugged up both sleeves, rolled my wrist—*uno, due, tre* . . .

"You said you were taking me to church today," her voice went up like a question.

I stared blankly. Then, *oh!* I knocked over my tray. "*Persephone!*" How was I supposed to become the greatest painter, if I couldn't even keep a tray steady? I scrambled to pick up my brushes and began reordering them from shortest to longest.

"Rafa, *per favore, amore,* I know you're nervous . . ."

"I'm not nervous."

Sì certo, I was nervous. I was twenty-one years old, and after years of painting Madonna after Madonna after Madonna, I'd finally unveiled a work that had captured attention. And today, my former teacher, Perugino, was coming to view that work. Today, I would find out: would he finally call me *maestro*? Or not. I placed the brushes back on the tray in a neat row. I straightened the first brush, then another and another.

Tessa sighed. "Rafa, today's more important than . . ."

"I know how important today is," I said, straightening the last two brushes and crossing to the mirror. I tucked my hair behind both ears, ran my fingers across my eyebrows, and checked my nose and mouth for dregs. Yes, people call me handsome (high forehead, oval eyes, strong jaw, the whole *traditional* look), but—as my mother always said—handsomeness without cleanliness is wasted.

The town of Città di Castello had the same hills, same climate, same accents, same colors as Urbino. Living in a place that reminded me of home usually gave me comfort, but that day, I couldn't quell my apprehension. As Tessa and I crossed town, I counted every step—*uno, due, tre, quattro, uno, due, tre, quattro*—but when we arrived at the church of San Francesco, my foot landed on the top stair on a count of

three. There wasn't enough room to squeeze in another step. Not even a small one. On a day as important as that, would *you* have entered on an ill-fated count of three? "Wait," I said and turned to walk away from the door.

Tessa exhaled, "Rafa . . ."

"Sevens are luckier than fours." I walked back toward the entrance. *"Uno, due, tre, quattro, cinque, sei, sette."* With the last step, I landed beside Tessa again. I took her hand. *"Andiamo."*

Inside the old church of San Francesco, the morning light was warm and bright. Up ahead to the right, a group of men gathered around an ornate chapel. My heart thumped in the side of my neck. *Was my teacher Perugino among them?*

As I started to hurry up the nave, Tessa admonished, "Rafa, for holy's sake."

Dutifully, I backed up, dipped my finger into the font of holy water, crossed myself, genuflected, and then stood to hurry down the aisle.

"Slow down." She took a ceremoniously long time blessing herself.

"Per favore." The longing in my voice finally moved her. She took my hand and let me lead her into the church.

As we approached the group of men gathered around the altar, Tessa giggled. I shushed her. She said, "Rafa, let me be excited," but I wasn't listening.

I was scanning faces. *Was he there? There? No, no, where . . . ?* Finally, a man turned. He had the ruddy cheeks, ropy brown hair, and determined frown of a face I knew well: Pietro Perugino. He'd come. I'd grown taller and into my shoulders since I'd seen him last, but still felt like a child when he said, "Raffaello Santi of Urbino."

"*Maestro* Perugino." I released Tessa's hand and bowed. "Whatever successes I have, the credit goes to you." I breathed slowly. Would he praise me or dismiss me? Would he call me master? Would he hand me the keys to his studio, like Christ giving the keys to St. Peter?

Before Perugino could offer his verdict, two ladies stepped up. I'd already met—all right, more than *met*—the one with eyes the color of a frozen lake. She curtseyed and said, "Signor Raphael Santi, may I present my sister . . ."

The other shoved a piece of paper at me. "*Per favore,* may I have a drawing?"

I shrugged apologetically at Perugino, although I wasn't altogether upset that he had to witness such a request. I took a piece of chalk from my pocket and said to the lady holding the paper, "Behold, a deity stronger than I, who shall rule over me." (A Dante quote is always appropriate in any situation, don't you find?) Keeping my eyes on the lady's face—I haven't needed to look at my hand to draw since I was, what? Ten?—I sketched her quickly. "The corner of your eye turns quite nicely here," I said, using my bit of chalk to point to her face. "Look closely at my next Madonna, and you may find a touch of yourself in her features."

"Oh . . ." The young woman blushed the color of an oleander bloom. She took the drawing, and they both scampered back to their friends.

With a smile, I turned back to Perugino, whose bulbous nose was flaring. That's when he spit out a single word: "Thief."

The other men in his entourage muttered.

Tessa gasped.

I replied, "*Scusi?*"

Perugino was shorter than I, but his large, round head overshadowed mine. He said, "You stole my painting."

I willed the hot flush on my neck to cool and descend back down my chest. (Knowing how to defend against a blush is an invaluable skill for any courtier. Thank my mother for teaching me how to breathe properly to maintain a creamy complexion.) "*Maestro,* my work is—as always—a tribute to you, your talent, your influence, your . . ."

Perugino wagged his finger. "That altarpiece is nothing more than a copy of mine."

Have you seen my *Marriage of the Virgin*? That's all right, it's all the way up in Città di Castello, so it's not as if you'd run across it on a daily jaunt. But you've seen copies? Then you'll know I couldn't deny his charge. Not exactly. Both paintings—his hanging in Perugia's cathedral—depict Mary's marriage to Joseph, a common enough subject, but I also employed the same composition, same setting, and— yes—many of the same figures as Perugino's earlier version, but . . . *Ma per carità!* Perugino's figures are so static there's no rhythm, and the figures in the foreground are pressed against the picture plane, and the temple in the background is so heavy it weighs down the composition, and his colors are such thin blues and pinks. What was I supposed to do, allow a painting to remain inferior when I could see, so clearly, how to improve upon it? I didn't say any of that out loud, of course. Courtiers never speak their own minds, but only the minds of others. "Petrarch said that the way artists emulate each other is like bees extracting pollen from flowers to make honey and wax. It's not a matter of copying. It's a matter of taking what's come before and making it better."

"Better? *Better?!*" Perugino's face turned the color of cherry sauce on Easter. "I feel sorry for you, Raphael. All you want is to be the greatest, but the greatest will never be

a lousy copyist." Perugino marched out of the church. The other men followed.

Tessa took my hands and muttered how sorry she was. "And for you to bring me here, to your altarpiece of Joseph taking the hand of Mary to join for eternity. It's so romantic."

I turned to Tessa. Her brown eyes were wide and glistening. "*Che?*"

She blushed. "You're not going to make *me* say it, are you?"

"Say what?"

"Rafa." She sounded stern as a nun on Holy Thursday. "You don't have to be coy. I don't have a father. Nor brother or uncle. No family at all. You don't need to ask anyone else." She tugged plaintively on my fingers. "You're the one who brought me here."

"I brought you here to meet my *maestro*. To see if he liked my painting."

Her fingers turned cold. "But you said today would change our lives. You said we were going to create perfection. Then, you asked me to accompany you here, to San Francesco. I told you this was where I wanted to get married."

"Married?!" I dropped her hands.

"Or engaged."

"Tessa, whatever gave you the impression I was going to marry you?"

Pink crept up her chest. She crossed her arms and glared.

Uffa, I couldn't exactly argue with my own *actions* in my studio, in the woods, behind the blacksmith's shop . . . "I-I-I . . ." I began picking at a speck of green paint off my thumbnail. "I think you're lovely."

I braced for screams, but her voice was unnervingly calm

when she said, "It's time to stop hiding me behind locked doors and painters' tarps, Raphael Santi."

"*Mia cara*, I'm a painter, not made for marriages and family."

"Other painters marry. They keep workshops, assistants, wives, children."

"I'm not other painters." I reached into my pocket, took out my father's old long-handled paintbrush, and started twirling it between my fingers.

"Men need children to carry on their legacy." She grabbed my hand to stop my twirling.

"Children die," I said.

This time it was her turn to reply, "*Che?*"

"And even if children live . . ." I started twirling the brush again. "Do you know the names of Giotto's parents? Donatello's? Botticelli's? Even if I do great things, will my father's name trip off the tongues of future generations? Maybe if I make enough of a mark his name will be written down in a book somewhere, but I can't bring him back." My fingers missed a beat, and my paintbrush clattered to the floor. "People die. Marriage can't save you, children can't save you, love can't save you. Nothing can save you."

She smoothed out her skirt. "Your teacher upset you. We'll talk about this tomorrow."

"You think Perugino upset me?"

"He called you a thief."

"That was the greatest thing I've ever heard. I was hoping he'd tell me I did a good job or call me *maestro*, but never did I imagine him admitting that I'd surpassed him."

"That's not what happened."

"That's exactly what happened. His jealousy is proof that

my altarpiece is better than his. And he knows it." I bent down, picked up the brush, and pocketed it.

Tessa stared with—what was that? Distress? Horror? Disgust? "Rafa, to people on the outside you look so perfect, but . . ." She suddenly looked unmistakably sad. "How are you ever going to create perfection when you're so far from it?" She turned and walked toward the exit, her skirts swishing against the stone floors.

I hate it when people are angry with me. I hadn't meant to break her heart; I *never* mean to break their hearts, but I didn't follow after her. Instead, I sat down, pulled out my sketchbook, and began to copy my own altarpiece. There were so many details that still needed perfecting: the Madonna's head was too small, the priest's feet were awkward, and—*uffa*—although the boy in red tights breaking a stick over his knee was good (he was inspired by a figure in Luca Signorelli's panel of the same subject), his weight shifted so far back over his hips that, if he'd been a real boy, he would've toppled over. My painting might have been good enough to beat Perugino, but it wasn't perfect. *Not yet.* It was time for me to chase after the painters who were even better than Perugino—the Botticellis, Ghirlandaios, Leonardos of the world. It was time for me to find those painters, study them, copy them—copy, copy, copy, copy them—until I could take what they did and best it, too. Until there was no painter above me—except me.

Chapter III
September 1504
Florence

*T*hank the Blessed Mary that sculptor is not a painter.
That's what I thought the first time I saw that
giant. Have you seen it? Not copies of it, but the actual
thing standing guard outside of city hall. He's overwhelming,
isn't he? Is it his size? His glare? All that gleaming polished
whiteness? I approached quickly, hoping it would shrink
upon closer inspection, but it only grew taller. Staring up at
him that first time, I felt how the shepherd boy must've felt
when facing down his own giant: fearful, anxious, doubtful,
and yet flush with faith that I could—somehow—find a way
to defeat that undefeatable foe. It's ironic that I felt that way
not while staring up at a statue of Goliath, but of *David*.

I hadn't been back to Florence in seven years—*seven
years!* Even after the Florentines burned that madman
friar at the stake, same as he'd burned their Botticellis—an
irony that still gives me no end of joy—and fashioned their
city into a modern republic, I'd been too afraid to return.

But then, I heard a rumor about a new statue unveiled in Florence that, according to travelers along the pilgrimage route, "would change art forever." One young woman—ears so pointed she could've been a fairy—told me that it had been made by the same sculptor who'd carved his name into his Roman *Pietà*. No matter what he says now, no one knew his name back then, even though we'd all heard of his *Pietà*: a marble masterpiece of the Virgin Mary cradling the crucified Christ. I hadn't been to Rome, so I hadn't seen it yet, but that sculptor was already my hero. According to rumors, he'd carved his name into the strap crossing the Madonna's chest: *Such and such from Florence carved this.* Who had ever heard of such arrogance, such boasting, such . . . brilliance? *Che grande!* Yes, even at the time, I recognized the irony that although we'd heard about the *act* of signing his work, we couldn't remember his name, but still, I'd followed his lead and painted my own name onto my *Marriage of the Virgin* altarpiece, too. (On the cornice of the temple in the background: "Raphael Urbinas 1503.")

Where am I in the story, again? Ah yes . . . Not even the ghosts of Florence could keep me from seeing that sculptor's new statue.

As I neared the city, the cathedral's terra-cotta dome crested over the horizon first. It was late in the day, so the sky was turning warm golden pink. (If you want to make such a color, grind up the dried bodies of female Chermes insects, add a bit of white lead and a touch of yellow—ochre over orpiment—and a thin layer gold leaf over the top.) The Arno River reflected the pink-orange sky and distant violet mountains. No wonder art had grown back so quickly after that madman friar's execution: the city looked perfect as any painting I could imagine.

When I entered Piazza della Signoria—the same square where that bonfire had once burned—I once again faced a towering foe. I counted my steps as I approached. At least this time the foe was only a *statue*. Marble carving and painting are different, aren't they? Whereas statues naturally have weight—they're physical, in-the-round things—paintings must rely on tricks of the eye to achieve such weight and realism. Painters and sculptors don't practice the same art. No. Let him be the greatest marble carver in history; I could still be the greatest *painter*. And thank Madonna because as I walked around that statue, I wondered how could anyone make even a back feel so alive.

When I was young, I used to have to sit for hours at interminable court dinners. The duke would wave out course after course of rich food that made me sleepy, and Jester Dominic would tell a story or there would be dancing—I was too young to join in—and I would have to sit next to my mother and wait for my father to wheel out his paintings and read his poetry. I adored—*adore*—my father, but his poems were long. My mother would grab my twitching fingers and hold them still with a scolding look. Whatever I felt was to be sealed in a jar and not even used in my paintings.

I had no idea whether that sculptor had ever been taught to cloak his emotions in courtly manners, but I did know that he had put all of his energy, his passion, his . . . his . . . whatever it was, into that stone. And that's the moment when I decided to settle in Florence, so I, too, could learn to bend the world, not in the sculptor's direction, but in mine. But as I sat there copying that statue, I couldn't help but silently repeat: *Thank the Blessed Virgin Mary that sculptor is not a painter.*

Chapter IV

Autumn 1504

H ow dare they commission a *lowly stonecut-ter* for such an important painting," bellowed Davide Ghirlandaio as he barged into the tavern. Ghirlandaio was the most foul-tempered painter in all of Florence. (Don't blame him. How nice would you be if—after your brother had been dead for ten years—you were still considered the inferior painter of the two?)

Andrea del Sarto (three years younger than I with cheeks so angular and nose so long that his face looks like a masquerade mask) and I grabbed three more chairs and cups of ale for Ghirlandaio and the other two artists quick on his heels: Andrea della Robbia (I admire Andrea's blue-and-white terra-cottas almost as much as I admire his style; that day he was wearing a purple feathered hat that only Andrea could pull off without provoking laughter) and Leonardo da Vinci. Leonardo was one of the first artists I befriended upon entering Florence; he has a soft spot for handsome young men, so he invited me to his studio to copy whenever I wanted. I'm sorry you never met him. Like his paintings, he's hard to picture without seeing in person. Back then, he

was over fifty with a graying beard (I predicted correctly that he'd have a full head of silver before another year was out). He was taller than you'd think, and his golden eyes always pranced around, making you feel like you were missing out on half-a-thousand things happening right in front of you. Dropping into the chair next to me, he said, "If I'm not upset about the damned fresco, Davide, you have no right to be."

I tucked my hair behind both ears and asked, "What's going on?"

No one spoke as we waited for Leonardo to take a long, slow drink—no one ever spoke when waiting on the *maestro*. He ran his tongue along his teeth and finally responded, "The city has hired someone else to paint the wall opposite mine inside the Hall of the Great Council." For about a year, Leonardo had been working on his large-scale fresco, *The Battle of Anghiari*—a depiction of a Florentine military victory over the Milanese. Even in a city home to many of the greatest works of art in history, people hummed with the promise of such a masterpiece from such a master: *Imagine the pilgrims it will attract! Imagine the fame! Imagine the glory!* I'd never considered that the city would hire a different artist to compete with Leonardo on the opposite wall in the same room. And I'd certainly never considered what Leonardo said next: "To paint that wall, the city has hired Michelangelo."

I sat back hard in my chair. I'd learned the sculptor's name soon after settling in Florence; after the *David*, everyone was talking about him. Michelangelo Buonarroti was the son of a proud Florentine family that had fallen on hard times, and it was now up to Michelangelo to support his destitute father, stepmother, grandmother, uncle, aunt, and *four* gadabout brothers. If the city had offered him a lucrative painting commission, he no doubt would take it. The

sculptor was to become a painter, after all. I took out my father's old paintbrush and began to twirl.

Andrea della Robbia took off his hat and said, "His fresco is to be the same size as Leonardo's. In the same room."

"They're comparing that *lowly stonecutter* to Leonardo." Ghirlandaio banged his fist against the table, rattling cups. I adjusted mine so that the handle was once again aligned to the table's edge. "The only reason you're not upset about it, Leonardo, is that the city's touting it as a competition between the two greatest living artists."

Sarto, always one for theatrics, hopped up onto the table and exclaimed: "Leonardo on one wall! Michelangelo on the other! Who will prevail?"

"I don't mind *that* promotional campaign," quipped Leonardo.

Ghirlandaio shook his head. "I can't believe you're consenting to share your work space with that dirty, dusty . . ."

"Lowly stonecutter!" We called in unison and raised our cups to drink to that insult.

But Ghirlandaio held up a hand. "*Filthy* stonecutter."

We groaned and lowered our cups.

"You're only jealous because your brother gets all the credit for Michelangelo's success," said Sarto, sitting back down.

"Your brother?" I asked. "Who? Domenico?"

Ghirlandaio squeezed the bridge of his nose. "Michelangelo's *maestro* for a time."

I pressed my lips to avoid gaping. Was there a more skilled frescoist of his generation than Davide's older brother, Domenico Ghirlandaio? Michelangelo wasn't only trained as a sculptor, but as a *painter*?

Ghirlandaio flicked his fingers under his chin in an

obscene gesture. "The only thing my brother should get credit for is turning his famed student into a misanthropic recluse."

Sarto shook his head. "You make him sound a little coarse."

"In that case, allow me to make my meaning clear: he is *extraordinarily* coarse." As an aside to me, Ghirlandaio added, "He built a privacy shed so that no one could see his progress on his *David* until it was publicly unveiled. Once, when he caught me sneaking a peek at his work, he chased me out of his studio with a marble hammer. Then, he locked himself back inside with his precious stone like a deranged hermit. He's an aggressive sort of paranoid."

"He's impressive is what he is," said Sarto, looking at me with earnest eyes. "Michelangelo was trained in the Medici sculpture garden, taken in by Lorenzo de' Medici, *Il Magnifico* himself, light of Florence, greatest patron our city has ever seen, finest eye on the peninsula, most educated, most intelligent, most perceptive . . ."

"On with it, Sarto, we all know who *Il Magnifico* is," Ghirlandaio grumbled.

"The point is *Il Magnifico* himself recognized Michelangelo's talent and took him in to live in the Medici palace like one of his sons."

"All this according to Buonarroti," grumbled Ghirlandaio.

"It's not only according to Michelangelo," argued Sarto. "I heard one of *Il Magnifico*'s own sons, Cardinal Giovanni de' Medici himself, once call Michelangelo 'brother.'"

"When did *you* meet Cardinal de' Medici?" countered Andrea.

"I don't care about the Medici." Ghirlandaio got up to pace. "Stonecutters are nothing but craftsmen. They use heavy tools to beat into rock. They're nothing like painters.

Donatello, arguably the greatest sculptor in history, didn't also claim to be a *master* painter. Nanni di Banco, della Quercia, Nicola Pisano, none of them painted."

"What about Verrocchio?" I chimed in. "His *Baptism of Christ, Tobias and the Angel . . .*"

"Tell me you aren't suggesting that Michelangelo is another Verrocchio," he said, and I lowered my eyes to avoid an argument. "Not even Ghiberti," Ghirlandaio went on, "whose baptistery doors have so much grace that they themselves look like masterful paintings—painted anything worth quoting. That job should never go to a *lowly* stonecutter."

On those final two words, we clinked cups and drank, but none of us were laughing. Michelangelo was picking up our weapons and marching into our arena, and yet—the uncomfortable truth was—we had no idea how good of a painter he would be. Imagine if Michelangelo managed to keep another *David* secret; imagine if this time, the *David* was in paint. I put down my cup and asked, "So, who are Michelangelo's friends?"

The others exchanged looks. Andrea was the one who replied, "He doesn't have any."

"Then, how are we supposed to get into his studio to copy his work?"

"We don't," they all answered in unison.

"We have to find a way to see his designs." I straightened my cup. "Don't we?"

Ghirlandaio slumped back into his chair. "Raphael's right. We need to find out if Michelangelo has any chance of catching us."

And with his inscrutable half-smile, Leonardo added, "Or if we have any chance of catching him."

Chapter V

1505

For your lips, cinnabar. For your eyes, finely ground umber. And for your skin . . ." I paused to kiss her collarbone. "Gypsum, but with a hint of pinked carmine." The lady was my favorite model of late—what was her name, again? I don't remember. Let's call her Sofia. I liked a Sofia once. I'd been using *this* Sofia as the model for the Madonna in my newest altarpiece for the Ansidei family. She had a lovely long face and high forehead that made for a wonderfully believable Virgin. In paint, at least.

She touched a strand of my hair. "Do you use saffron or sulfur to lighten your locks?"

"Neither. It's all natural," I said and leaned in to kiss her again.

But she pushed her hand against my face. "Do you hear voices?"

"Only the voice of the poet Catullus imploring us to let live, let love, my Le . . ."

"Listen." She closed up her blouse.

Two voices echoed down the hallway. Footsteps approached. *Had I remembered to lock the door?* I'd locked it

yesterday. And last week. Two weeks ago, I'd forgotten, but
no one had come in. This time, let's see . . . I'd entered first
and held the door. When Sofia passed, she'd smelled of fresh
peaches. *Yes. Yes!* I'd definitely locked it; I'd cursed myself
for wasting time locking that door. *"Calmati,* the door is—"

A key slid into the lock.

"Andiamo." I yanked a tarp down over the scaffolding
and pulled her to the back wall. If we were discovered, my
reputation would survive, but Sofia's prospects for a good
marriage would drop faster than a jar of red lead off a high
shelf. I smoothed down my vest. It would be all right; as
long as whoever entered didn't want to look at the fresco, we
were well hidden. I winced. Why would anyone come into
that room unless they wanted to look at that fresco?

We were in the great *salone* of the Palazzo della Signoria,
where Leonardo's *Battle of Anghiari* fresco was going up on
one wall. Have ever you been inside Florence's Great Hall?
It's monumental: ceilings two stories tall with light coming
in through high windows. It feels like a cathedral, which
is appropriate considering the Florentines hold their civic
duties as dear as their spiritual ones. At the time, the most
prominent features of that great hall were Leonardo's spread
of scaffolding and his preparatory drawings rolled out across
the floor. His designs for that fresco were extraordinary: sol-
diers and horses swirling in the chaos of war. The Battle of
Anghiari had been a great victory for the Florentines, but
instead of depicting the glory, Leonardo captured the vio-
lence and fear. It was extraordinary, and every Florentine
was eager for a preview. So, yes, I gallantly gave my models
a private tour of the famous fresco whenever they asked.
Leonardo was always happy to take a walk in the hills during

such visitations. No wonder he finished so few projects: he was always looking for any excuse not to work.

On that day, two voices—neither belonging to Leonardo—entered the room.

"I'll pay whatever you want."

"It's not about the money. You're asking me to expose my soul."

Two men, both with Tuscan accents. I didn't recognize either.

"So? That's what artists do."

Artists? I signaled for Sofia to stay back while I peeked through a slit in the tarp. I could only see the back of one of their heads.

"I'm not asking to inspect it as a city official, but to see it as a friend, Michelangelo."

Michelangelo? I'd never been in the same room with the sculptor before. Ignoring the advice of Sarto and Ghirlandaio (the day I start listening to Sarto is the day I pick out my own sarcophagus), I'd stopped by Michelangelo's studio several times to try to cajole him into letting me study his designs, but he wasn't one to invite people in for soup. Once, I approached him in the market, waving a few drawings Leonardo had lent to me—"you can study the competition," I tempted—but Michelangelo glared and said he didn't want anything to do with "the *cavolo* who stole from Perugino." Although I found it encouraging that he'd heard of me, I'd made no progress toward seeing his designs.

I shifted behind the tarp to get a better look. The second man was wearing a blue cape with gold stars—the cape belonging to the head of Florence's Republican government, Gonfaloniere Piero Soderini. Have you met him? Bald, round eyes; picture a pigeon in a cape.

"You don't understand what you're asking." Michelangelo sounded like a wounded boy.

And Soderini replied, "I know you didn't bring that cartoon down here for nothing."

I clasped my hand over my mouth to keep from gasping out loud. His cartoon was *here*? I dropped down silently to the floor, lay on my stomach, and slid forward to peek under the tarp. There were Michelangelo's shoes: heavy brown work boots covered in mud and marble dust. And sure enough, down by his side was a long roll of paper. *Queen of Heaven* . . . His designs.

Soderini dropped his voice to a paternal tone. "Son, we're alone. You can trust me."

There was more back-and-forth, but Michelangelo's quarreling always gets a little tedious—doesn't it?—so let's skip to when he finally relented and started unrolling his designs. He handled his drawing as carefully as if it were thin gold leaf, and Soderini watched the cartoon unfold as intently as I.

Sofia whispered, "*Dai*, they aren't looking, *dai, dai.*"

I waved her off.

Soderini looked down at the unfurled drawing and murmured, "Miraculous."

From my position on the floor, I couldn't see even one line of that drawing, so I hopped up and quickly climbed the scaffolding. *Don't roll it up, don't roll it up, don't roll it up.* Sofia grabbed my foot, but I kicked off her hand. The wood creaked, but I kept going. The top of the scaffolding wasn't covered by a tarp, so I had to lie flat to look over the edge.

At first, I could only see one corner of the drawing, done in brown chalk and black ink: bulging calf, grasping hand, twisted knee. Was the figure naked? Was he pushing himself

up off the ground? Another naked man was bending over. A third lunged. What was going on?

I lifted up onto my elbows.

Che roba, that drawing.

The Battle of Cascina is esoteric Florentine history, so why would you know about it? It was a battle between the Florentines and the Pisans back in the fourteenth century—yes, the two cities have been at war forever. The Florentines won, but Michelangelo hadn't depicted the moment of victory. No. He'd chosen an obscure part of the story when the Pisans attacked the Florentine army by surprise as they bathed in the Arno. Michelangelo's drawing was as shocking as the attack: naked men sprang from the river as fully armored soldiers rushed in from the back, a torrent of twisting, straining figures. Today, we're accustomed to seeing such paintings, but fifteen years ago, no one had seen that kind of pulsing, irregular rhythm. There were over a dozen figures, each more astonishing than the last: a bare-backed man with ribs pressing through his skin; a bearded soldier reaching out with terror in his eyes; a disturbing set of hands springing out of the water, all tangled together in a panic . . . Any man who can draw like that can certainly paint, too. I felt as breathless as those soldiers.

I flipped open my sketchbook and began to copy. (Oh, how I wish I still had some of those drawings to show you. No, no, I never burn my sketches, but life intervenes; some are lost to floods, fires, an overzealous maid. Moving takes others—lost along the road or left behind. Assistants, too, swipe a drawing here or there; I like to think they're studying them, but sometimes I fear they're selling them. Whenever I discover one missing, I feel bad as a jar of spoilt ultramarine. I've probably lost more than I remember; the memories of

the unimportant drawings seem thrown out the window with the rest of the garbage. Or perhaps it's not that I forget the unimportant ones, but that the act of remembering and missing and regretting *makes* them important.) I was so focused on copying Michelangelo's cartoon that I didn't notice one of Leonardo's stray paintbrushes rolling toward the edge of the scaffolding. It's shocking how much noise a small brush can make when it drops a great height and cracks against a marble floor, isn't it?

The two men whirled around. Sofia cried out and—holding up her half-tied clothes—scampered across the room and out the door. Soderini chuckled. Michelangelo did not find the situation so funny. "*Cosa fai?*"

I stood up. "*Buongiorno, maestro.*" I immediately regretted not buckling my breeches.

"*Cosa fai?*" For someone so awkward, Michelangelo is surprisingly quick. Before I could react, he was climbing the scaffolding.

"Michelangelo," Soderini called. "That's young Raphael from Urbino. He's only a student, here to study, I'm sure, nothing to upset you . . ."

"Yes, *maestro*. I'm a great admirer," I said as I clumsily fixed my attire.

"Thief!" Michelangelo said, summiting the scaffolding. He's . . . what? Eight years older than I am, but substantially more of a presence, isn't he? That day, he was wearing a dirty gray tunic (it might've been blue at one time, but it looked gray) and clunky brown work boots appropriate for street cleaners who wade through when the sewage is calf-high. He had a mass of ratty black hair and coarse beard—had he offended the local barber?—but aside from his stench, the most striking thing about him was his powerful wave of . . . what is

it, exactly? Passion, anger, fear? Father Ficino had a name for it, didn't he? (Of course, you've heard of him. Humanist scholar from the Medici gardens? Yes, *that* Ficino.) The old priest used to call it, what? *Terribilità*? Whatever it is, it's always there, and it's always unbridled. I'd heard rumors of Michelangelo's temper, but I hadn't expected him to be quite so terrifying up close. Is it the way that vein throbs in his forehead or how his deformed nose (broken during a scuffle with a jealous studio apprentice, I've heard) turns red with rage or is it the way his muscles twitch or maybe it's his glare . . . ? What *is* so terrifying about him? That day, it was probably that heavy marble hammer cocked over his head, one strike of which could take off my nose.

"Um, Santi?" Soderini called from the floor. "Now might be the time to run."

The first blow of that marble hammer knocked my sketchbook out of my hands. Sheets went flying. I grabbed a few falling pages as another swipe breezed by my ear. I ducked another swing and scampered down the scaffolding. I took one fleeting look back toward that drawing, but Michelangelo was already down, too. Hammer raised, he charged again. I barely escaped with my head, but my heart was another matter entirely.

Whenever I copy a Leonardo, I have a sense of where the master began and where he's going. After copying his portrait of the silk merchant's wife, for example, I developed a feel for his delicacy of line, subtlety of shadows, and the way his strokes bring breath to his subject. I never would've said it back then—lest someone think I'd been turned by the moon—but the Master from Vinci was within my reach. Michelangelo's drawing, however, was unlike anything I'd ever seen. His figures were sculptural, exploding backward,

sideways, and forward with such force that it felt as if they were bursting through the picture plane. Leonardo always aimed toward beauty—something that I instinctively understand—but Michelangelo was aiming at . . . I don't know what. Something quite different.

And I had no idea how to best it.

Chapter VI

After escaping the reach of Michelangelo's marble hammer—Sofia was nowhere to be seen—I jogged across town to Santa Maria Novella, the Dominican church with the beautiful facade completed by Leon Battista Alberti. Usually, I sit down to draw the facade of that church—the balanced and harmonious geometric shapes of white, green, and black marble give me comfort—but on that day, I didn't even pause out front. I also didn't stop inside to take in the high nave, slender columns, or graceful black-and-white striped arches. No. I went directly to Masaccio's fresco, *Holy Trinity*. It's my favorite painting in all of Florence: Christ hanging on the cross, God the Father standing behind, white dove of the Holy Spirit fluttering between them, while Mary, John, and two patrons flank either side, all depicted in a painted chapel that looks so real you might think that Masaccio had cut an actual room into the wall of that church. The perspective is incredible, every element—down to the nails in Christ's hands—receding toward a single vanishing point. Before Masaccio—I love that nickname, "Messy Tom," don't you?—paintings had

been flat, lifeless things, but he showed us how to transform a flat picture surface into real depth.

That fresco isn't perfect. Far from it. But you know what it is, don't you? It's *our map* to perfection. It shows us what to aim for: perfect composition, perfect perspective, perfect color, perfect shadow, perfect light, perfect figures, perfect draperies, perfect balance, perfect harmony. Back then, it had already been eighty years since Masaccio painted that fresco and showed us the way to perfection, but not one painter had achieved it. *Not yet.* On the bottom of that fresco, Masaccio had painted a skeleton lying on top of a sarcophagus, inscribed with a warning about the brevity of life: *I once was what you are, and what I am you will be also.* Masaccio was young when he painted *Holy Trinity*—not much older than I was back then—and a few years later, at age 27, Messy Tom was dead.

I knelt in front of that painting and smoothed out a sketch of Michelangelo's cartoon that I'd managed to save: a quick copy of pulsating figures. Michelangelo was *not* aiming for perfection, but he had given me one of the keys to achieving it. Masaccio had tried—through shadow, curve, and perspective—to create realistic figures, but he'd fallen short. Michelangelo, on the other hand . . . His figures are too twisting, straining, and agonizing to be perfect, but they *are* sculptural and more real than anything I'd ever seen captured on a flat surface. In order to create a perfect painting, I was going to have to learn to paint figures as real and round as his.

Kneeling before Masaccio's *Holy Trinity*, I took out a piece of chalk, pulled up my sleeves, rolled my wrist, and began drawing Michelangelo's figures from memory, but as the last of the day's light started to fade, I got up. There

was one other thing inside that church I wanted to see: Domenico Ghirlandaio's frescoes—scenes from the lives of John the Baptist and Mary—in the main chapel. I'd copied those frescoes several times since arriving in Florence, but this time, I was looking for something I'd never thought to find before. The *Massacre of the Innocents* panel looked promising—it was a dramatic scene with twisting, lurching figures. Was that the part painted by Ghirlandaio's most famous apprentice? Were those the first bits of paint ever put up on a wall by Michelangelo?

Michelangelo was thirteen when he joined Ghirlandaio's studio and helped decorate that chapel—two years *older* than I when orphaned, but still young. His detractors could dismiss him as a *"lowly stonecutter,"* but he'd trained as a painter under one of the greatest frescoists Florence has ever known. Michelangelo knew how to paint.

As darkness fell, I jogged back across town to my studio. I opened the front door—wiping my feet twice before crossing the threshold—and slipped into the storefront of my workshop. I sidestepped buckets and rope and rags and jars and brushes; my men kept the space so cluttered. Have you ever heard Michelangelo moan about such a *bottega*? He makes it clear that he finds the idea of assistants working together to execute the designs of a single master abhorrent: "Churning out piece after piece, all based off designs by a single master, no imagination, no time to innovate, and for what? To *sell*? To whom? Merchants and clinging gentry?" *Beh*, when everyone can regularly secure lucrative commissions from cathedrals and city councils like him, then none of us will need our little *retail* shops. But until then . . . I ducked through a back door.

This was my private space, where I worked on designs

for the *bottega* and on commissions for those paying a high enough price for a painting by my own hand: the wealthy Doni family, my duke in Urbino, an emissary to the King of England (still Henry VII at the time, at least for another— what? Four or five years?). Back in this part of the studio, things *were* organized: brushes in impeccable rows arranged by bristle size; jars of pigment organized by tint, tone, and shade; stacks of treated panels grouped by wood type; and drawings cataloged in neat stacks by subject matter. And hanging on walls, leaning in chairs, and propped on stands were my paintings: Madonna after Madonna after Madonna.

I lit candles and sat down to practice making figures as sculptural as Michelangelo's. Over the next few weeks, I didn't stop at the tavern or dawdle by the baptistery doors drinking cherry red wine with the others. No. I stayed in my room, slept little as necessary, and worked on perfecting the details I could remember from Michelangelo's cartoon: lunging figures, twisting muscles, protruding bones ... I'd never seen abdomens, ankle joints, or knuckles captured with such precision. (Yes, I've heard the same rumors as you, about Michelangelo breaking into mortuaries to cut into the dead to study anatomy. Can you imagine all that blood and gore and stench? Every time I think about driving a chisel through a breastbone ... *uffa!* Instead of dissecting the dead, I think I'll stick to dissecting the work of others.) I practiced drawing the muscles of Michelangelo's figures bulging bigger, knees bending tighter, and torsos swiveling farther until I felt I'd come as close as I could to capturing his designs. Then, I drew hundreds of additional sketches, incrementally adjusting those figures to fit my own tastes: elongating muscles, smoothing curves, softening flesh,

idealizing faces, moving away from the rhythm of battle toward dance. But even after all of that, I wasn't sure I'd captured his energy, his passion, his . . . his . . . He was good. *Too* good.

One day, Sarto poked his head into my studio. "Michelangelo's leaving for Rome."

My fingers throbbed, but I didn't put down my chalk. *Not yet.* "Why?"

"To carve the pope's tomb."

My fingers loosened a little. "In marble?"

"Of course, marble. Rumor is, it's a three-story facade filled with forty marble statues. *Forty*. It'll take him a lifetime to carve. If he ever finishes it at all."

"And what about his city hall fresco?" I asked.

"Abandoned before it's even begun."

As Sarto ran off to continue spreading the news, I put down my chalk and stretched my cramping hands. Michelangelo was to return to marble. I exhaled. *Thank the Blessed Virgin Mary and Her Blessed Son and Her Blessed Blue Robe and Her Blessed Fingers and even Her Blessed Toes that sculptor is not to be a painter.*

Chapter VII
March 1505

I f you're trying to convince me to show you his drawing, he's sworn me to secrecy," Gonfaloniere Piero Soderini said as I walked alongside him through the cacophony of fishmongers and butchers lining the Ponte Vecchio.

"I'm not trying to steal his designs, Gonfaloniere." I bumped into a maid carrying a basket of mackerel on her hip. She huffed hair out of her eyes. She was pretty, so I gave a quick nod of apology before continuing after Soderini. "I'm offering my services to finish the fresco."

"Everyone loves you, Santi, but it's Michelangelo's commission." To a girl tending her father's booth, Soderini said, "A jug of garum, boy." The girl scooped a serving of fermented fish sauce into a pouch. She wore a cap tipped like a boy's, but one look at her features and you'd never doubt she was a girl. Sometimes it's amazing what people refuse to see, isn't it?

"You don't truly believe that Michelangelo is coming back to Florence, do you?" I asked, painting my tone thick with skepticism. "As Plato said, 'the worst deception is self-deception.'"

Soderini's brow furrowed. "You don't think Michelangelo

will return? Ever?" He was only holding a paltry *soldo*, so I slipped two more coins onto the young lady's table. She smiled and added an extra dab of garum.

I said, "From what I understand, that tomb will take a lifetime to carve."

Soderini put his pinkie in the fish guts and licked it. "But I've been counting on travelers seeking those frescoes to fill the city's coffers."

I winked at the fishmonger girl and pursed my lips sadly at Soderini. "*Mi dispiace*, Gonfaloniere, I'm afraid you're going to have to find another painter, unless you think a *drawing* will attract a crowd."

I swear I didn't mean for Soderini to take that comment as *advice*. I never thought he'd put that drawing on public display. But that's what he did, exhibiting both large-scale cartoons on opposite walls of the Great Hall—Leonardo's on the east, Michelangelo's on the west, where the frescoes would eventually live. (*If* they'd ever been finished, *sì certo*. Just the other day, I overheard a Florentine banker, visiting Rome on business, remark about what a tragedy it was that those "dueling frescoes" were never finished. Leonardo and Michelangelo would've pushed each other to "even greater greatness"—his clumsy words, not mine—if they'd only been *allowed* to compete side by side in the same room. He said it as if either of them would've chosen Florence over working for the pope or the King of France, if only they'd been *allowed*. He blathered on for quite some time about how those frescoes would've no doubt been the greatest in history if only . . . Until he spotted me, sitting between inarguably the two handsomest women in the place and grinning. That shut him up.)

Once those drawings went on display, thick crowds

streamed in and out of city hall to gape, as we artists sat and copied. Foreigners split their time between the two cartoons equally, but those of us from Florence focused on Michelangelo's—who knew when he might return and chase us all out? Andrea della Robbia always sat in the same place, just to the right of center. Sarto lay on his stomach, crumpling up page after page of his drawings. Davide Ghirlandaio paced. I—with my neat rows of chalk and sketch paper—was the first to arrive and the last to leave. Or at least that's what I thought, until . . .

About two weeks after the drawings went on display, I entered the Great Hall to find the bottom right-hand corner of Michelangelo's cartoon ripped away. The missing piece had been a brilliant bit of foreshortening of a naked soldier's legs stretched out behind him. As the other artists filed in, I asked: "Where did it go?"

No one answered.

I could've sat down with everyone else and continued drawing—there *was* a palpable new sense of urgency; copy while you can—but instead, I left to report the incident. The Gonfaloniere didn't take my meeting, but I left a note. For the next two nights, I camped out in the Great Hall, staying awake for nearly forty-eight hours straight—sketching, pacing, organizing Leonardo's boxes of unordered supplies—but after two days of no incidents, I went home to rest, change clothes, scrub chalk residue off my fingers . . . When I returned, another corner of that cartoon was gone; this soldier had been kneeling next to the Arno, pulling on a sock. "Who's stealing it?"

Andrea della Robbia moved to the left, but other than that, no one acknowledged the missing.

I considered writing to Michelangelo, but he was all the

way down in Rome, and why would he read a letter from me? I petitioned the city to post a guard, but while officials debated, the cartoon continued to disappear. When I was there, no one touched it; it was only when I left to sleep, eat, wash, or relieve myself that pieces of the cartoon vanished. Was it one person taking it piece by piece or different artists each pocketing a scrap? (I want you to repeat this next part to Michelangelo, word for word; write it down if you must. When I copy another artist, yes, I replicate the lines, but I do it with the intention of *improving* upon what they've done. Replicating someone else's work without the intention of adding your own touch is time burnt up as smoke. Only by using it to create something new does practice become *creative*. Sì, I combine elements from Perugino, Pinturicchio, Leonardo, and Michelangelo to create something closer to perfection, but it's still mine, so the constant accusation of theft is hurtful. I never would've stolen his cartoon. Copies, by me or anyone else, can't capture his pulsating lines, sinuous rhythms, his soul. No. Those are gone. Forever.)

One day, I entered the Great Hall to find Leonardo standing in front of where Michelangelo's cartoon once hung. There wasn't one scrap of jagged paper left. Leonardo said, "You should've taken a souvenir when you had the chance."

"Was it you?" I asked.

"I don't need his scraps. But the others . . ." Leonardo raised his palms to the sky. "Admiration does strange things to men."

"This world takes art as thoughtlessly as life," I muttered and sat down to draw again, this time only copying a memory.

I felt Leonardo watch me pull up both sleeves, roll my

wrist, and begin putting careful lines on my page. He crossed to get a closer look. "Try a bit more there . . .," he said.

"Like this?"

"Fish don't swim by softly caressing the water. They swim by pushing against it."

I adored that man, but sometimes his brain was three steps sideways. "*Cosa?*"

Leonardo took my hand and pressed my chalk firmly against the page. "Delicacy doesn't always come from a light touch." He guided my hand for a couple of strokes and then let go.

I imitated his pressure a few times, but . . . "I'm not close, am I?"

"Closer."

"But not perfect."

"Not yet." Leonardo sat down. "What are you still doing here, Young Sparrow? Florence is setting like the moon after a long night, and it's time for another to rise in its place. Perugino, Pinturicchio, Signorelli, Michelangelo, they're all working down in Rome . . ."

"I hope this isn't your way of telling me you're leaving, too, *maestro*. It feels as if Florence has been taken away piece by piece, and you're the last scrap of the cartoon. If you leave, there'll be nothing left to copy."

"This isn't about me. This is about getting your irresistible charms down to Rome."

I began picking a bit of pink paint out from under one of my fingernails. "*Beh,* I hear awful things about Rome. Dangerous, dirty, competitive, cardinals as likely to poison as bless you. I-I don't want to go."

"Ah . . ." Leonardo's voice lilted as if he'd discovered some

new kind of beetle. "So, that's why you're still here, eh? His Holiness hasn't invited you."

I rubbed hard at the pink paint, but it wouldn't come loose. "Not yet."

"Artistic preeminence will be won in Rome under this pontiff," said Leonardo. "It's up to you to make the pope bring you to Rome."

"But, *maestro*, he's pope. How can *I* make him do anything?"

"Oh, my Young Sparrow, I can't tell you that. After all, no bird can learn to fly for another."

Chapter VIII

Spring 1508
Urbino

Anytime I think about the death of Guidobaldo da Montefeltro, Duke of Urbino since before I was born, I feel guilty. He was a good man—patron to my father who taught me how to bow before a merchant, duke, or king—but did I mourn him properly? No. When I heard the news of his death, I smiled. You see, it was common knowledge that the duke's successor was a young man by the name of Francesco Maria della Rovere. That's right, I said *della Rovere*. My new duke was nephew to Giuliano della Rovere, Pope Julius II, head of the Church for nearly five years by then. If anyone could secure me an invitation to work in the Vatican, it was the pope's own nephew. By that point, Michelangelo had been working for the pope for about three years, while I, at age twenty-five, had been trying to create something good enough to attract papal attention: portraits, cabinet doors, devotionals, altarpieces, but although patrons claimed they adored me, my star had yet to shoot south across Rome. It was time to stop relying on paint and use my political connections to learn to fly.

The first thing I saw upon dismounting in Urbino was a servant carrying one of my father's paintings out of the palace as mindlessly as a bucket of bathwater. The staff hadn't even waited for the old duke's funeral before starting to clear his things out of the palace. Rugs, silver, chairs, all marched out in a line. I *know* those servants recognized me, so how could none of them offer my father's paintings to me? "Where are you going with that?" I asked.

"By orders of the duke," a servant said and kept walking.

Another servant carrying a garish gold mirror *into* the palace said, "He's looking for you."

"Where?"

"The workshop."

"*Grazie mille.*" I dusted off my tawny breeches (I'd changed into mourning browns before entering the city) and set off to present myself to the new duke.

I'd known Francesco Maria for years. When I was twenty (he must've been—what? Fourteen?), I was hired to paint his portrait in honor of him being named the duke's successor. At the time, I was proud of that commission, but now . . . ? The figure is flat and awkward, the composition static, and that fur-lined coat is so lackluster it makes me cringe. But do you know what annoys me most about that painting? That apple. Francesco Maria insisted on holding it, even though it had nothing to do with Urbino, his family, or any dukedom. I tried to get him to hold an acorn to represent the della Rovere family crest, but no. "I like apples!" I was in no position to argue with a future duke, so I smiled and dutifully added the nonsensical fruit. When Duke Guidobaldo asked me about it later, I made up some tale about how it represented his nephew growing into a fruitful leader. He liked the story, so it stuck, but after that I didn't much trust

Francesco Maria's judgment. Five years later, was he still the kind of man who illogically demanded apples?

I found Evangelista, who still ran my father's workshop—*scusa*, *my* workshop—in Urbino while I was away, pacing in the courtyard outside of the studio while a crowd of worried-looking, young assistants watched on. One glance at Evangelista told me something was wrong. I always know when he has a hard truth to tell; he'll look anywhere—floor, sky, black hair on his arms—to avoid looking at me. It's only when he's lying that he looks me in the eye. That day, he stared at his shuffling feet when he said, "He won't let me in. He has our tools, our paintings. Everything is in there. Everything."

The crowd of assistants looked to me.

Trying to sound unconcerned, I answered, "What's he going to do? Declare our paintings the property of the duchy and send us away?"

Evangelista rubbed his beard. He didn't have to respond. The duke was a duke; he could do anything he liked.

Oh, how I wanted to double back and count my steps to ensure that I landed on the threshold on a perfect count of seven, but I didn't want to alarm the crowd of assistants with superstitious behavior at a moment like this. Instead, I silently counted to four, took a deep breath, and opened the door. Inside my father's workshop—*my* workshop—work had ended in a rush: tempera settled in a cup, brushes soaked in buckets of water, rags lay in lumps on the floor, as the new Duke of Urbino flipped clumsily through a stack of panel pictures in a corner. Francesco Maria had grown broad since I'd seen him last. His hair was receding, but his beard was thick. He was only eighteen but already looked middle-aged. Why he was wearing full body armor, I didn't

ask. "I thought you were talented. Did you paint this?" The new duke held up a scene of the Crucifixion. The figures were awkward. The colors were bland. There was no style.

Picking a rag up off the floor and neatly folding it, I shook my head.

"It's horrendous." He dropped the wooden panel onto the floor and grabbed another. "And this?" A Holy Family. The perspective was poor. Joseph's hands were strange at best, and baby Jesus was . . . *Beh,* ugly.

"No, Your Excellency."

"I thought this was your workshop."

"I've been working abroad and have left my men . . ."

He interrupted, "I want to see something of yours."

"I'd be honored to escort you to see my new altarpiece in progress in Perugia."

"No one cares what happens in Perugia. I want to see something here. Now."

I would've suggested importing my newest altarpiece with a snap of my fingers, but he might've taken me at my word and expected me to deliver. Royals can be so unreasonable, can't they? Instead, I opened my sketchbook. "The worst of these drawings are better than anything being produced in Urbino."

He waved my drawings away. "The former duke was content to march in second place behind Florence." He tried to cross his arms, but his armor didn't bend enough, so he fumbled before settling his hands on his hips. "He thought Florence was too powerful to be beaten: 'Florence is like the fifth element,' he would say. 'Wherever one finds Earth, Water, Air, and Fire, one also finds Florentines.'" The duke kicked an easel, and it toppled over. "Unlike him, I'm not content with second place."

"I'm not, either." I picked up the easel and put it back on its feet.

"And yet here you are—my duchy's most *revered* painter—folding rags and picking up easels like a common servant. How am I supposed to send *you* to Rome?"

I stood up straight and smoothed out my jacket. "Rome, Your Excellency?" I painted my tone with a thick glaze of surprise.

"But I doubt you have the *talent* to succeed there."

Royals always appreciate humility—don't they?—so I responded, "Even a tiny spark of talent can burst into a mighty flame, Your Excellency."

"The problem is," the duke sneered, "I doubt you have even a spark."

I kept my features calm as I flipped through my sketchbook, searching for a drawing good enough to convince the duke of my ability to make a raging fire.

"Your portrait of me . . ." The duke's throat sounded tight.

I stopped flipping. *So that was the problem* . . .

"It's terrible!" he exclaimed.

I turned toward him with shoulders square. "I was only twenty, but unlike you, not so capable so early."

His eyes narrowed. "If you become famous, that wretched portrait will become famous."

I almost told him that no matter how famous I became no one would ever care about that *wretched* portrait, but, instead, I said, "That portrait will be famous regardless of me, Your Excellency, for you are its subject, and people will always care about you."

"That's true," he sniffed. "I could get over the no-talent thing . . ."

I smiled hard enough to show off both dimples.

"... *if* I thought you could represent me properly in my uncle's court."

Palm over my heart, I said, "Your reputation is safe. My contemporaries hold me up as the ideal courtier, perfect countenance, perfect politeness, perfect ..."

"I don't care about your *manners.*" He said the word as though speaking of something as trivial as girls rolling hoops in a garden. "I need to know if you're loyal to Urbino. To me."

"*Sì certo*, your Excellen—"

"If I send you to Rome, you must make me a promise." He took a clanging step forward. His armor gleamed; had he polished it that morning?

And I replied, "Anything."

He opened his armored fist to reveal a vial.

I picked it up and held it to the light. The powder inside was white. "Is it gypsum or ... ?"

"Arsenic."

I dropped the vial of poison to the floorboards.

"Pick it up." He clanged his fist on the top of his helmet, sitting on a stool, underscoring that he had an entire army of soldiers at his command, while I only had an army of brushes.

I did as ordered but dropped the vial onto the table and rubbed my shaking hand against my pants. *Was my leg burning? Could poison eat through pants?*

"I want you to finish the job Bramante couldn't," the duke said. "Michelangelo."

I may have taken a step backward or run my fingers through my hair, I don't remember, except that I felt very confused. "I don't understand, you want me to finish one of Michelangelo's sculpting jobs or ... ?"

Without warning, the duke hit me across the side of

my head with his armored hand so hard that I stumbled backward. I pressed my hands against my face—my cheek stung—and tripped over my own feet. I fell, my hip landing hard against the wooden floor. "Understand this, boy," the duke snarled. "I want you to rid Urbino of its competition. For good." When I only responded with a whimper, the duke made a motion as if to kick me. I balled up my legs to protect my stomach, but he didn't strike. *Not yet.* "Do you know why I want you in Rome?"

My head was pounding; my ears whirred.

"Because the pope is looking for a painter for the ceiling of . . . the Sistine."

I dropped my hands away from my face and looked up at the duke. "The Sistine Chapel?"

He nodded.

My heart thumped quick in my cheek—from the duke's blow, but also from excitement. *The Sistine?* One of the holiest chapels in all of Christendom, where the College of Cardinals gathers for conclave to elect popes? *Could this be true?* Pope Julius's uncle, Pope Sixtus IV, had built that chapel back in the 1470s and named it after himself—*Sistine,* as in "of *Sixtus"*—and hired the greatest masters of his day to decorate its walls. Hiring a new painter to decorate the ceiling of that great chapel *would be* a fitting way for this pope to honor his uncle. And since *my* duke happened to be nephew to the pope . . .

I stopped whimpering.

The duke bent down, grabbed my collar, and said, "Donato Bramante—citizen of Urbino like you—works for the pope, and he's considered the greatest architect on the peninsula. Don't *you* want to work for the pope and become the greatest *painter?"*

I tried to lick my lips, but my mouth was too dry. I whispered, "It's all I've ever wanted."

"Good." He stood up and marched toward the door. "I'll write to my uncle and recommend you for the Sistine."

"I . . . I . . ." I stood up.

"No need for flowery gratitude. You can thank me by keeping your promise."

The duke reached for the door and . . . *Beh*, what would *you* have done? I said, "I'm not going to do that."

"What?"

I don't know how the duke looked because I kept my eyes on my shoes—a pair of brown leather, with a drop of red paint on one toe. "I'm not poisoning anyone," I said.

"Michelangelo is your rival." He spit that last word like the devil.

"*Sì*."

"I can end your career."

Stomach coiling like rope on a pulley, I repeated, "*Sì*."

"I knew you were lacking in talent." And with that, the duke flung open the door. Outside, Evangelista and my assistants gaped at the duke, who sneered, "Too bad, now someone else will get the glory of the Sistine." As the duke clanged across the courtyard, my assistants buzzed: Was the studio closing? Were they out of work? Would the duke hire *them*?

Evangelista hustled inside and closed the door behind him. "What happened?"

"Nothing, he's . . . it's . . ." I straightened one chair at the table, then another and another. "He didn't like my portrait of him all those years ago, that's all. Not a fan of my work."

Evangelista grabbed my elbow. "So, what do we do?"

"You should stay here and keep the studio running as

long as he'll let you. Me? I'm going to do the only thing I can." I squeezed Evangelista's shoulder and said, "Paint." I wasn't going to be able to rely on politics to get myself to Rome, was I? No, I was going to have to be so good that I would get there in spite of them.

Chapter IX

I galloped back to Perugia, where I'd been working on my *Lamentation of Christ* altarpiece for nearly a year. If I were going to paint a masterpiece to impress a pope, then this was my best chance because it was already poised to have people talking because—you see—it had been commissioned by none other than the widow Baglioni.

Yes, that Baglioni, made famous during the Red Wedding back in 1500. You've heard of it, right? During a family wedding, the nonruling half of the Baglioni staged a coup, trying to murder the ruling half of the family while they slept after too much wedding wine. The rebelling half killed many, but a few of the ruling half escaped to thwart the plot. Did you attend that wedding? I was invited as a potential portrait painter of the happy couple, but I didn't leave my room during the massacre—only watched the horrors from my upstairs window in a local inn. A couple of years later, the widow Baglioni commissioned me to paint an altarpiece to honor her son, Grifonetto, killed during that infamous wedding. Was Grifonetto worthy of being honored? Depends on which side of the Baglioni family you're on, I suppose. He

was one of the rebelling half of the family, the one who cut out the groom's heart and took a bite out of it before dragging the groom's corpse through the streets. (I didn't see the biting portion of the evening—only heard about it—but I *did* witness the dragging-the-dead-body-through-the-streets part from my perch.) Grifonetto's surviving cousins eventually caught him and the other members of the rebelling family and flayed them all, too—right in that square beneath my window. After witnessing all of that gore, I had to wash my hands for an hour every day for the next month to feel like I'd cleaned off all the blood. When the widow Baglioni commissioned that altarpiece from me, she pressed her hands together in prayer and begged, *"Per favore*, Raphael, make me remember my son's goodness."

Make me remember him as he should've been instead of as he was.

I'll wager that you didn't realize that one of my earliest masterpieces was a tribute to an assassin, did you? And here you thought you knew me so well.

For the last year, I'd been working only on my preparatory drawings for that altarpiece, but after that exchange with my new duke, I decided it was finally time to start painting. (On which side of the great *disegno e colore* debate do you fall? I fall squarely on the side of *disegno*: a painting is not a painting without deep thought, detailed drawings, flawless preparation, so don't ridicule me for taking a year to prepare. A year is nothing.) I'd used as the foundation for my design an obscure engraving of an *Entombment* scene by Mantegna—a group of figures carrying a crucified Jesus to his tomb, Mary fainting, three crosses on a hill in the background. The Venetian master had died earlier that year, so using one of his paintings as inspiration seemed an

appropriate tribute. I also used my knowledge of Perugino to balance my composition, my studies of Leonardo to push my darks darker and my lights lighter, and my love of Botticelli to make my figures rise and fall in a rhythm more like a dance than a funeral march. And yes, I *borrowed* from Michelangelo, too: the female figure to the right, twisting to hold up a fainting Mary, was indeed influenced by the Madonna in his *Doni Tondo*. It's not as if I tried to disguise it. So yes, I openly built on previous works by other masters, but that doesn't mean that painting isn't my own.

The day of the unveiling was tragically overcast—what's worse than revealing a painting when there's no light? But as I pulled off the tarp to reveal it, I was pleased to see that my colors—scarlet, emerald, lapis, lemon—shone like stained glass on a sunny day. When the widow Baglioni saw Christ, she reached shaking fingers up to caress his face because— you see—I'd used the widow Baglioni's face for the Madonna, and for Christ, her son's.

That's when she looked up at me, her eyes shining with gratitude. "*Grazie,* for making my son beautiful again," she said, squeezing my fingers. "When I get home, I'm writing to the pope to tell him that he's missing out on the greatest painter on the peninsula."

I replied with proper courtly manners: "That's unnecessary, my lady, I only—"

"It's most certainly necessary. He's a fool to not hire you, and my pope is no fool."

A few weeks later, papal summons finally in hand, I snuck back into Urbino at night—careful not to alert the duke—to pick up a few supplies from my father's studio. Evangelista looked determinedly out the window, not anywhere near

me, as he spoke another hard truth: "You can't go to Rome. You're too nice for Rome."

I smiled and said, "*Ma dai*. Rome can't be as bad as they say. Can it?"

And then Evangelista looked this way and that and stared me *dead* in the eye when he replied, "No, Rafa. It's not so bad. I'm sure you'll be just fine in Rome."

Chapter X
Fall 1508
Rome

My meeting with the pope was to start in less than an hour, and yet, there I was, hiding up in the branches of a cypress tree *outside* the gates of Rome. Through the needles, I could make out seven—no, eight—swords, three maces, and five daggers ornamenting that pack of armored men camped at the bottom of that tree. The pine was making my nose itch. *Mia Madre*, one sneeze would give me away faster than Judas's kiss.

I'd been warned about the dangers of traveling down the pilgrimage route alone: wolves, wild boar, bears, thieves, and unemployed mercenaries on the hunt for any excuse to expend pent-up aggressions. So, whenever I heard something coming down the path, I did what any reasonable courtier would do: I climbed the nearest tree. Paintbrushes lose to daggers every time. Especially to this pack of men with a *certain* crest emblazoned upon their shields: red and white stripes with a red flower up top. (I expected more of a reaction from you. How could you *not* recognize that crest? The Orsini family. Yes, *that* Orsini family. One of the most notoriously dangerous Roman families in all of history. Red

and white diagonal stripes with a red flower on top—commit that crest to memory. It could save your life.) This was back before the *Pax Romana*, when those ancient Roman families—the Colonna, Savelli, Massimo, and, worst of them all, the Orsini—were still openly battling it out for control of Rome. Brutal days. Be glad you weren't here. But since that was my first time in town, I didn't yet know that those families posted sentries outside the gates to extract protection fees from travelers—ironic, since what we *most* needed protecting from were those offering protection.

From my perch, I could see the crumbling bell tower of St. Peter's Basilica on the horizon. I should've been in Rome the night before, washing off grime, getting a good night's sleep, organizing my sketchbook, but instead, there I was, still up a tree. Oh, how I regretted not sneaking out during the night, but those men had drunk so much wine that one or another was always up relieving himself.

The sun was already halfway up the morning sky. Roman thugs or not, it was time to go.

I scooted to the far side of the tree as quietly as able. Hugging my small travel bag close—Evangelista had promised to send most of my things down in trunks after I settled—I dangled my feet off a branch. *Uno, due, tre, quattro* . . .

I hit the ground hard, rolling head over feet through crisp leaves. "*Uffa!*"

The men scrambled for their weapons. Several yanked up their pants. Others hastily unsheathed swords. "Get him!" They charged.

As I stumbled away, the strap of my traveling bag caught on a branch. I yanked on the bag, but it wouldn't come free. My sketchbook was in that bag, and I had to have those

drawings for my meeting with the pope. A holy man may have faith in the unseeable spirit, but not even a pope would put faith in a painter unless he could see evidence of his talents. I fumbled with the latch and threw open the flap. Two Orsini men approached, swinging maces. I stuck my hand in—there were ducats, why didn't I think to grab five? And then, just as my fingers found my sketchbook, one of the men caught my arm. "Got you." His breath smelled of rotted meat.

Luckily, I was wearing a silk shirt, so his grip slipped. I wriggled my arm out of the sleeve, and the man's dirty fingers closed in around empty silk. I broke free, and the man roared as he waved my torn sleeve in the air like a battle flag.

I've never been the fastest courtier on the small ball field, but that day, sketchbook hugged close, I sidestepped stumps and sailed over roots. I was feeling wonderfully about myself—how strong, how fast, that I could outrun such men—but when I looked back, they weren't chasing me. They were gathered around my bag, counting my coins. They didn't want me; they wanted my money. But I had my sketchbook, and at the time, I thought that was all that mattered.

What year did you first arrive in Rome? *Va bene*, but back in the aughts, it was no marble metropolis shining atop seven splendid hills, but a neglected cemetery of crumbling buildings half-buried in dirt with weeds growing all around. One of the first things I saw upon entering the Eternal City was a dead body hanging by a noose in the streets. The corpse had been stripped naked, his skin was gypsum with a wash of indigo, and the whites of his eyes were the color of spoilt yolk. I assumed he was a criminal, since he'd been hanged and all, but I had no real way of knowing. Two

streets over, there was a whole row of dead bodies hanging there like sausages, and down by the river there was another and another . . . You'd think some polite Roman could've posted signs warning, "If you turn this corner, you'll come face-to-face with a dead man." All of those decaying bodies must've had something to do with the city's stench. It was a pungent mix of cow manure, urine, wet wood, fetid river water, and—for some reason—rotting oranges. Then, there were all those wolves, their howls echoing through ruins. It was strange, but then again, everything in Rome was strange, even the moss: bright yellowish-green and disturbingly thick, as if an animal were growing a heavy coat for winter. I'm serious, Rome's hot, wet air breeds peculiar moss. But the strangest part? All of the statues had been beheaded or at least defaced—noses missing, one eye or cheek removed, half a head of hair knocked off.

I was so distracted by the crumbling city that I didn't even think to count my steps. I don't know whether I arrived at the Vatican on a count of four, eight, or even an unlucky fifteen, but I marched right up to the entrance and demanded the guards take me to His Holiness at once, as confident as if I'd landed on a perfect number seven without having to try twice. (Oh, how I miss being young. With age comes *such* fear, doesn't it? I used to think that knowledge would make me more sure of myself, but instead, knowledge only feeds fears founded in truth: things can—and do—go wrong. Like the other day, I was overcome with fear that someone would steal my newest portrait. The rest of my day spiraled as I tried to figure out how to prevent the unpreventable. I painted my name on a band on the lady's arm, thinking that it would prevent the imaginary thieves from taking credit for my work, but that didn't make me feel better because, *beh*

... fires, floods, storms that blow wooden panels to splinters ... Solve one worry and there's always another waiting.) But back then, I was still young and didn't let the guards' suspicious looks deter me. No. I flashed my summons from the pope and told them—with a smile, *si certo*—that if they didn't take me to him, I would tell His Holiness that it was *they* who had ripped my shirt and roughed me up so. They escorted me inside—*that was easier than I'd thought; Rome isn't so scary*—and when the pope's steward told the guards that we would find His Holiness in the Sistine Chapel, I felt a thrill. The pope was waiting for me inside the *Sistine*. This went beyond the luck of Urbino; the Fates of Old must be guiding my step.

Do you remember the first time you entered the Sistine? Did you lose your breath, too? That long, slender, undivided chapel feels eternally large. And painted along the walls are those famous frescoes. They'd been painted, what? Forty years before? And yet, back then, they were still some of the most modern paintings on the peninsula. Which is your favorite? Wait, let me guess. You favor the grand architecture in Rosselli's *Last Supper*. No, I know, your soul can't turn away from the watery landscape in Domenico Ghirlandaio's mystic *Calling of the Apostles*. Don't tell me that you prefer Perugino's *Christ Giving the Keys to St. Peter*; I thought you'd be more provocative than that. My favorite is Botticelli's *Temptations of Christ*; have you ever seen a temptation with so few references to suffering and so much focus on beauty? Nor have I.

Something landed on my head. I touched my hair and came away with ... white powder? I rubbed it between my fingers and sniffed. *Plaster.* I looked up and was shocked to find scaffolding stretching under one half of the ceiling. Why

was I surprised to find scaffolding in the chapel? Because it wasn't normal scaffolding—no bulky wooden structure standing on the floor and rising all the way up to the ceiling. No. The floor was empty. (A typical scaffolding would've obstructed papal services, I suppose: *"Scusi, cardinal, sorry to interrupt Vespers, but I must get up there with this fresh batch of plaster!"*) I peered up through the boards; the scaffolding wasn't suspended from ropes hanging from the vault either, which would've left gaping holes in the ceiling. No. This scaffolding was an inventive array of connected footbridges, anchored into the wall above the old, famous frescoes, but beneath the new sections being prepped for paint. To reach the bottom rung of the scaffolding—a full story above the floor—you had to climb up via freestanding ladders that the artist could pull up or down depending upon the level of access he wanted to provide. That scaffolding was easy to use, wouldn't obstruct events on the floor, and didn't put any unnecessary holes in the walls. It was ingenious. (I didn't yet know who'd designed it, but please allow me to pause now and comment: Michelangelo still claims he's no architect, too, doesn't he?)

But that brilliant scaffolding design was not what held my imagination that first day in the Sistine. No. For up on that scaffolding, workers were chiseling something off of that long, barrel-vaulted ceiling: an expansive fresco of blue sky and gold stars. They were preparing the ceiling for *new paint*. My duke was right; the Sistine was soon to have a new master. (Can you name the artist who originally painted that patch of the heavens onto the Sistine ceiling? I'll give you a minute to think. No? Can't come up with anyone? It's all right. I only tracked down his name a few years ago when I realized that no one would have reason to remember it:

Piermatteo d'Amelia. Umbrian, student of Fra Filippo Lippi for a time. I'm grateful, for his sake, that he was dead before that fresco was ordered cut from that ceiling. Covering that massive vault with paint—even if only an amorphous field of color—would've been an arduous task that would've taken years, but now, that expanse of heaven was coming down with a few cracks of a chisel.)

I spotted my countryman, *maestro* Bramante, official papal architect, the man in charge of shepherding me through my first meeting with the pope. I hadn't seen him in years. He was, what? Sixty-five years old by then? His angular features had been considered handsome before time turned his skin to melted wax. He carried a bundle of scrolled architectural plans in a satchel crossing his back like a quiver of arrows. When he saw me, he looked annoyed. He said, "In Rome, on time is late."

I bowed. "*Grazie* for the advice, *maestro*. I'll keep it in mind henceforward."

He waved the guards away, and they obeyed. (Yes, I took note that Bramante had the power to command papal guards.) He scrunched his nose at my appearance. One of my sleeves was missing, my pink velvet vest was split down the side, and my hat was gone—not even a feather accidentally stuck in my hair. Mud caked my knees and boots, and it wasn't even a pretty reddish-brown clay, but a murky, gray ashen color. I also smelled like I'd been sleeping on the road for a week, which I had. "Are you trying to convince His Holiness that Urbino is, indeed, some backwater hamlet as rumored? At least brush back your hair," Bramante ordered as he adjusted his own immaculate green velvet jacket.

I ran my fingers through my hair, smoothed down my ripped vest, and brushed off my behind. I considered tearing

off the second sleeve of my shirt and proclaiming it a new fashion but thought better of it. "Perhaps I could borrow your jacket, *maestro?*"

"And present myself to the pope in shirtsleeves?" His nose flared incredulously. "You're lucky that His Holiness is still here."

When I was a child and would look proud after copying one of my father's devotionals, my mother would pinch my ear and make me kneel and pray for humility until my knees went numb. To this day, I know when I'm looking smug because my knees tingle. That day, striding across the Sistine to meet the pope, my knees, legs, and even feet pricked.

Pope Julius II was standing in the middle of the Sistine Chapel. Surrounded by a retinue of red-robed cardinals, he was dressed in his long, alabaster cassock, traditional white skullcap, and his famous red shoes. *And a great pillar of heavenly light shone down through a high window and cloaked him in a pearly glow!* I'm jesting, *sì certo,* there wasn't any such light. Despite what you may have heard, he was a man, aging like any other: tufts of gray hair poking out from under a white cap, crinkling wrinkles, cheeks drooping like wilted sunflowers. I'd heard he was once a famed Adonis; was this how I would look when *my* youth was gone? His legendary temper was, at least, intact, for he brought his long, gold-plated walking stick down on top of the head of . . .

Same unruly black hair, same anguished features, same clunky work boots . . .

Michelangelo.

The sculptor grabbed the pope's walking stick and growled, "Why are *you* abusing *me?* You're the one asking for the *blessed* impossible!" (He did *not* use the word *blessed* there.)

I don't handle arguments well—not even between *other* people—so as the pope was about to strike again, I almost stepped between them, but Bramante held me back, "Let him carve his own tomb for once."

Instead of me, a red-robed cardinal stepped in front of Michelangelo. "*Mi dispiace*, Your Holiness. Pay my brother no regard." He was a jowly man with soft skin that belied his advancing age; how do wealthy men always look young? I recognized him quickly from Rosselli's portrait: the Florentine Cardinal Giovanni de' Medici, son of *Il Magnifico*. According to the rumors, Michelangelo had grown up alongside this cardinal in the Medici palace like a brother, so it was no wonder that the cardinal now took a protective stance when he said, "He's been impossible since we were boys."

"Don't talk about our artist that way," the pope bellowed. "It's *you* who are the impossible wretch." He aimed his stick at the cardinal's head.

That's the moment when Bramante decided to introduce me to the pope. And here I'd always assumed the old architect had tact. "Your Holiness, allow me to present the young painter from Urbino about whom you've heard so much . . ." The pope's nose flared. The Medici cardinal's eyes narrowed. But apparently, Bramante didn't notice the awkwardness of his timing, for he barreled on. "He's young and wildly talented. May I present my countryman, son of painter and poet Giovanni Santi; student of Pietro Perugino; subject of your nephew, Francesco Maria, Duke of Urbino; and the celebrated painter of Madonnas: Raffaello Santi da Urbino."

As Bramante bounced on his toes obliviously, I wished I could disappear into one of the chapel's frescoes, perhaps become an onlooker in Signorelli's *Testament of Moses*. That

would be nice. Instead, I had to stand there as Pope Julius wrinkled his nose at my appearance and said, "Are artists today not taught to dress?"

I smiled bright as able and did what any good courtier would do: divert attention away from the social awkwardness and put the focus on something else. "Your Holiness, you must forgive my colleague"—I raised my chin toward Michelangelo—"his temper may offend, but it's that same spirit that gives his work such life."

Michelangelo exchanged an incredulous look with Cardinal de' Medici, and the pope lowered his walking stick and said, "Indeed. And how do you two know each other?"

"I . . . I . . .," the sculptor stammered, studying my face.

Please don't remember me, please don't remember me. Feigning deference, I tucked my head down, hoping to cloak my features in shadow. "The *maestro* has no reason to remember me, Your Holiness," I said. "By colleagues, I only mean that we were both artists in Florence at the same time. I was quite young, only managing my *bottega* then. He had no reason to notice me. I had yet to paint for the d'Este family, nor the Oddi or Colonna, the Baglioni or . . ."

Off that list of credits, the pope held out his bony hand, offering me his holy ring. I knelt, kissed it, and said, "I present myself as a humble servant in hopes that Your Holiness will bestow upon me some wood or wall so that I might make a slice of the world a little more beautiful." I stood again. "Your Holiness has shown superior taste in hiring the Florentine, so, if you'll allow the impertinence, I would like very much to show you how I can accomplish in paint what he can do in marble." I held out my sketchbook.

"We believe we should enjoy such an impertinence," the pope said.

I averted my eyes—don't you find that royals always prefer when you look away first?—but as I went to place my notebook into the pope's long, unfurled fingers, Michelangelo snatched my sketchbook out of the holy hand.

My eyes jerked up to meet the sculptor's gaze, and there I found one of the most terrifying things I'd ever seen: *recognition*. "Get out of my chapel."

The pope said, "We believe we would like to see the lad's trifles."

"Your Holiness, this man is a thief." A blue vein in Michelangelo's forehead throbbed.

The pope's eyes flicked to me.

I lowered my lashes. "Only a devoted student."

"I once had to chase him out of my private workspace with a marble hammer for spying on my designs," Michelangelo snapped.

His Holiness held his lips tight when he smiled. From the look of his hollow cheeks, he'd probably lost all his teeth and was trying not to flash his gums. "Indeed?"

To Michelangelo, I said, "I apologize for startling you that day, but *maestro* Leonardo"—my eyes darted to the pope—"*from Vinci*"—eyes back to the sculptor—"had given me permission to be in that room, where you were both working."

The sculptor's face turned crimson. "And does Leonardo give you *permission* to use his name for your attempts at social climbing?"

I turned my body fully toward the pope but kept my eyes humbly lowered. "I don't like to boast, and I never would've brought this up on my own, Your Holiness, but the *maestro* from Vinci has offered a letter of recommendation if it would be of benefit . . ."

"That *master*"—Michelangelo snarled when he said the word—"did not have the right to give you permission to copy *my* designs that day." He turned to the pope and said, "This young climber hasn't only stolen from me, Your Holiness, but from Perugino, his own teacher."

And I said, "He is a poor student who does not surpass his master."

Michelangelo huffed, "*Gesù*, now you're quoting Leonardo, too? Do you have one original thought in that head of yours?"

My lips parted, but I didn't have time to parry before the pope flicked his fingers and said, "We shall be the judge as to whether he steals or improves."

That's when Michelangelo shifted my sketchbook to behind his back. "I've seen his work, Your Holiness, and it's not good."

"You've seen my work?" I said, still young enough to be flattered by such a revelation.

"It's *not* good," Michelangelo repeated.

"We'll be the judge," said the pope.

"Michel, *per favore*," whispered Cardinal de' Medici. "Hand over the sketchbook."

The sculptor's eyes twitched this way and that—I'd never seen him calculate before—and then he clenched his jaw and said, "If he's working in the Vatican, then I won't be."

Pope Julius cocked his wild, gray eyebrows at me. I'd comported myself quite well already and speaking again would only feed the argument, so I made the courtly choice: I held a genial smile and waited for the fair deliverance of justice.

But the pope only shrugged—*shrugged!*—and said, "So be it." He flicked his fingers, and two papal guards marched toward me. *What had just happened?* As Bramante groaned,

the pope said to Michelangelo, "Since we're giving up *such* a prize for you, you owe us in return. We expect miracles on your ceiling, Buonarroti."

Michelangelo bowed; it was less clumsy than I'd imagined. "And you shall have them."

As the pope walked away, two guards stepped on either side of me, and I blurted at Michelangelo, "Why did he call this *your* ceiling? Are you putting the pope's tomb on the ceiling?"

"You're a fool," Bramante grumbled and trudged away.

Michelangelo called up, "How long before it's ready for paint?"

"Two, three days?" called down a voice.

"*Maria Vergine*," I said, my stomach dropping like Icarus, my own wax wings melting in the sun. "You're not putting marble on that ceiling. You're painting it."

As the guards hauled me away, Michelangelo said, "I am." Then he tucked my sketchbook into his satchel and fastened the flap over it.

"My sketchbook," I said, but the guards were already dragging me out. My heart ached, not only at being escorted out of the Vatican or the loss of my sketches or even my failure to secure the ceiling commission for myself, but with the awful realization that Michelangelo was once again to be a painter.

Chapter XI

I just don't understand how he got the Sistine," I said, following Bramante through his humming construction site.

"I made sure of it," he replied, flicking his hand to send workers this way and that, like a conductor directing a chorus.

"But why?" I was twirling my father's old paintbrush furiously.

"To get him off the tomb."

"But why?"

"So I can have his marble."

"Why do you want his marble?"

"For my church." Bramante extended his arms, gesturing to the bustling construction site of new St. Peter's Basilica.

The original St. Peter's had stood on top of its namesake's tomb for—what? Over a thousand years?—but now, it was all coming down to make way for a new church. The public was outraged by the destruction of the venerated old building, and, even though the program was Pope Julius's idea, people called Bramante *Il Ruinate* for heading up the

project. If you'd ever met Bramante, you would know that he was always desperate to appease—it's part of what made him so awkward at times—so he devised an unconventional plan: he didn't tear down the old church all at once. No. He began construction on the new St. Peter's at one end and only tore down the old building as necessary. I'd tracked down Bramante that afternoon at the seam of construction: on one side, hundreds of workers rolled in fresh blocks of stone into a clean, white space while, on the other side, the old church decayed like an abandoned nest after chicks take flight. Intellectually, I knew change happened, but to stand at the place where new devoured old—block by block—was terrifying. (That was—what? Twelve years ago now? Today, the new church has eaten away even more of the old—we keep hacking away at it, bit by bit—and soon, there'll be nothing left. At some point, will people even remember *old* St. Peter's? Will there come a time when *new* St. Peter's is simply "St. Peter's" and that once-glorious third-century basilica is wiped clean, not only from the landscape, but from memory, too?) Bramante growled, "I'm not going to allow some stonecutter to take resources from St. Peter's. The pope doesn't need a tomb. He needs a church. And any marble—or ducat—not spent on this project is a waste."

"But *maestro*, that ceiling is destined to be mine. You're papal architect. You control the pope's artistic program. One word from you and . . ."

Bramante sidestepped a donkey hauling in a block of travertine. "I maintain control of that artistic program because I pick my battles wisely, and you, my young Raphael"—he wagged his finger—"are not a castle for which I'm willing to die." With that, Bramante turned and marched farther into his construction site, leaving me behind. Sometimes you

have to admit when a situation—or a painting or a love or a life—is beyond repair, walk away, and find a different way forward, don't you? I pocketed my father's paintbrush and exited through the rotting old nave.

Michelangelo's *Pietà* was famously housed inside that old basilica. I could feel the marble masterpiece calling to me, but I couldn't face it, not that day, so instead I focused on the ceiling, counting each crack. As I approached the exit, a gold tile dropped off a crumbling mosaic. I squinted up and identified the picture quickly. That was *Navicella*, Giotto's legendary depiction of Christ walking on water. Oh, how I regret not sitting down right then and sketching that masterpiece. What I wouldn't give to be able to show you a drawing or describe the original in detail. Instead, I only have a hazy memory of a large-sailed ship, halos, and angels trumpeting in the sky. Even back then, I knew that Giotto's famous mosaics were coming down with the rest of the church. However, even when change is ordained, it's difficult to fathom how fast it will come and how unrecoverable it will all be, isn't it?

It didn't take me long to find Michelangelo's studio; everyone—priests, beggars, children—could point me in the direction of "the marble," which I assumed was some local way of referring to a sculptor. But then I entered that piazza and saw that it was filled with about forty giant blocks of actual marble, all standing on end, every piece taller than I, like a forest of great, white, branchless trees. I knew what this was: Michelangelo's marble for Pope Julius's tomb.

It didn't take an alchemist to divine the location of the sculptor's studio. One door handle was powdered thick with marble dust. I knocked like a wryneck woodpecker. "Michelangelo?" I swear the door *fell* open; I didn't even

have to push. Inside, a long, narrow staircase—low ceiling and lower light—led up to another door at the top of the stairs. As I ascended, I rehearsed: "A sketchbook is like a man's heart, *maestro*. You've already taken my ceiling, you aren't also going to steal my heart, are you?" You know how Michelangelo is when he's at home: like a wolf, making a lot of noise to let you know he's ready to defend his den. But that day, I didn't hear a thing. "Michelangelo?" The door at the top of the stairs was open, too; not only unlocked, but left ajar. Believe me when I say that I assumed he was inside. I never, not once, thought I was entering his studio when he wasn't home. You make sure and tell him that.

"Michelange . . ." The studio was a mess: carving tools, drawings, chalk, paper, pieces of stone, clay models, all covered in a layer of white marble dust. He wasn't there—there was no one in there—but I could still feel his pulsating, frustrated energy, a fury of work. The only *escape* from work was a small wooden crucifix hanging on one wall, but from the looks of those straining muscles, he'd even carved that, too. I started searching for my sketchbook, picking through piles of papers on tables, on shelves, in boxes, on the windowsill. And that's when I spotted Michelangelo, down in the square below, walking through his forest of marble, headed back toward the studio. If he found me in there, trespassing without permission . . .

I quickly closed and locked the door and then looked for an escape, but all I could see were sculpting hammers—one on the table, another in the chair, two on the floor. My head ached as I imagined them cracking through my skull. One glance out the window told me it was too far up to jump. There was a second door on the other side of the room, but it was locked. I needed a key. Where had he hidden it?

Doorjamb, floorboard, windowsill . . . No, no, no. The door below banged, and those unmistakable work boots clomped up the stairs. At least he was slow and deliberate about stair climbing.

This second door was an escape, an escape, an escape . . . *Sì certo*, an escape! Sure enough, there was a key hanging behind that crucifix. My hands shook as his footsteps came closer and closer, but I turned the lock before he reached the top step. I opened the door to find a dark corridor. No windows, no torches, and I didn't have time to light one. Where did this hallway lead? Was there any way out the other end? Michelangelo's key slipped in the front door. I tossed my key under the crucifix, hoping he would think it fell there, and as the front door opened, I pulled the door closed behind me and was encased in darkness. I had no choice but to head down that corridor, blindly, and hope the Fates were still on my side.

Chapter XII

Y ou know how if you move your eyes all the way to one side, you can see your brow curve into the bridge of your nose? Now, look down and you can see a ghosted outline of the tip of your nose, and beyond that, your chest. That passageway was so dark that I couldn't see any of that. I raised my arm up . . . Nothing. And that was the arm with the sleeve still attached, a shimmering cream color that I should've been able to see . . . *Maria Vergine*, to go blind and never see color again.

I could hear Michelangelo clomping around his studio, so I moved through the darkness quickly. If I could hear him, then he could hear me. I slid each foot forward along the slick stone floor, hoping to feel a ledge before I walked off it. *Uno, due, tre, quattro* . . . The corridor smelled of grassy mold and—what was that? Blood? Maybe Michelangelo had caught me after all and beaten my head in with his hammer; maybe this was what it felt like to be dead. I walked faster. The corridor echoed with plunks and squeaks—what were those? Rats? I started to run. Was that someone breathing? Was there someone in there with me? My foot hit a wall, and my

hands came up without thinking; I'd smacked into . . . what? Was that a handle? And were those hinges? Yes, yes. A door! I pulled on the handle again and again, but it was locked. Why did those squeaking rats sound so loud? I knocked on the door. "Help!" I kicked and cried, "Please open up!" and—

The door swung open. I stumbled forward, desperate to be out of the darkness, but a man blocked my exit. "Who are you?" He raised a torch to my face.

I held up my hand, a shield from the sudden blaze of light. "*Per favore, signore . . .*"

"Where did you come from?"

"A friend's workshop."

He pulled the torch away. My vision adjusted. He was a cardinal, dressed in official reds. Short with humped shoulders, he had one of those stereotypical friar's heads: a semicircle of gray hair curling his bald skull. He said, "Michelangelo does *not* have friends."

My breath caught. The cardinal knew this passageway connected to Michelangelo's studio? I leaned in the doorway like any good courtier, as if I didn't have a care in the castle, and said, "As much as one can be friends with any *sculptor*, Your Eminence."

The cardinal peered back down the corridor behind me. "Is he following or . . . ?"

"He has something to finish in the studio before . . ." I'd exited onto a landing of a nondescript spiral stone staircase; there were no clues on which to fabricate a fiction. "He sent me on ahead."

"Without a key?" The cardinal took in my rough appearance but also seemed to register the quality of my leather boots, fine velvet vest (despite the rips), *and* papal summons conveniently poking out of my pocket.

I smiled easy and said, "Knowing him, he probably thought it was funny."

The cardinal chuckled. "And you are?"

"Pardon my impertinence." I swept into a low bow. "Raphael Santi of Urbino."

When I stood, his eyes were dancing. "Ah! Bramante's protégé! I've heard of you. You're subject to my cousin, Francesco Maria." Urbino's duke was cousin to the pope *and* this cardinal? How many of his family *were* there in power? "I'm Cardinal Raffaello Riario," he said. "Cousin to His Holiness. Call me Fafel."

"Nice to meet you, Your Eminen"—off his scolding look I corrected—"Fafel . . . Although I wish I could stay and hear what kind of *joke* Michelangelo played on *you*"—in courts, always assume everyone has been wronged by everyone else—"if I don't have this meeting properly prepared by the time the sculptor follows . . ." I let out a low whistle.

"You're meeting with who? Bramante?"

I exhaled, relieved that he had provided me with such an easy answer. "*Sì*. Bramante."

"I saw him heading to the papal apartments. Is that where you're meeting?"

I nodded.

"Don't be nervous," said the cardinal. "His Holiness is predisposed to like you. He enjoys stoking competition— especially when he's the beneficiary of the fruits." A door down the other end of the corridor clanged, and those familiar work boots clunked toward us. My eyes must've widened because the cardinal said, "Go. I'll stall him."

"Thank you, Your Em . . ." I started up the stairs, but the cardinal grabbed my arm and pointed down. "*Sì certo*, down

. . . it's my first day . . . I'll master this place soon . . . Thank you, Fafel. I won't forget the kindness."

"Anything to thwart one of Michelangelo's . . . jokes."

My heart tapped fast as I scurried down the stairs. One glance at those papal seals emblazoned in the halls proved that the corridor had taken me back to Vatican palace. Michelangelo had a secret passageway connecting his studio to the Vatican? He was even more powerful than I'd feared. Any sane man would've found the nearest exit to avoid finding his neck on the wrong end of a noose for trespassing in the Vatican against the expressed will of the pope, but what kind of an artist would I be if I gave up so quickly? An unemployed artist, that's what.

You don't need to hear me flatter my way into the pope's apartments—do you? By now, even considering my rough appearance, surely, you can trust that I'm able. So, let's skip forward. As I entered the pope's private office, Bramante looked incredulous. "Raphael! What are you doing here?"

I pulled a scroll out of Bramante's quiver of plans hanging across his back, marched across the room, unrolled the parchment—blank side up—on top of the pope's cluttered desk, and took out a piece of chalk. I pulled up my one remaining sleeve, rolled my wrist four times with an artistic flourish, and put my chalk down to draw. His Holiness raised his ringed hand, halting his approaching guards. Keeping my eyes on the pope's face, I grabbed a quick portrait: deep-set eyes, tired but with a spark of stubborn; long nose widening like a bell; jaw square as Emperor Augustus. I finished the sketch fast as able and snapped the page forward. "Your Holiness had expressed a desire to see my

trifles, and I would not be a good servant to the church if I didn't make my utmost effort to fulfill that request."

The pope looked at my drawing. Did he like it? Hate it? Would he hang me? Hire me?

That's when I felt Michelangelo barrel into the room behind me. "*Cosa fai?*"

If this pope, indeed, liked to stoke competition as Fafel claimed . . . I went against my courtly training in humility and said, "Your Holiness, there's nothing like a younger, more talented rival to push other men to miracles."

The pope looked at me with an expression of . . . what? Surprise? Amusement? Awe?

Michelangelo snatched my drawing off the desk. He looked at it and muttered, "How do you make everything look so easy?"

I shrugged and said, "His Holiness makes it *easy* to capture life." (While we're on the subject, have you gotten an early look at Baldassare's new manuscript? Castiglione; you must know him . . . I think he's calling his latest *The Courtier* for now, although I think he could use a more compelling title. He hasn't released it yet, but you should ask him to show you pages. He calls this appearance of ease *sprezzatura*. I love the way that sounds, don't you? *Sprezzatura*. He keeps showing me passages obviously written about me, thinking it's going to upset me, but, to be honest, I find it flattering. At any rate, when Michelangelo reads it, he'll never stop taunting me.)

Michelangelo gathered his composure and spit, "This is nothing but a parlor trick, Your Holiness."

"So, does that mean the young man can repeat it at will?" the pope said with a lilt, and the gathered courtiers—cardinals, aides, visiting royals—chuckled appropriately.

Michelangelo said, "I mean that it's nothing compared to what *I* can do."

"Oh, go prove it, Buonarroti," the pope grumbled and then turned to me. "You'll return tomorrow to help paint our apartments. Best of luck, Raphael Santi of Urbino. We'll be watching."

And *that's* how you land a job in the Vatican.

Chapter XIII

"Michelangelo, wait!" I spotted him across the piazza outside Vatican palace, his shoulders hunched like a defensive turtle. "*Basta*," I cried. Following his head bobbing through the crowd, I dodged around mangy pilgrims, prostitutes in their yellow dresses, and dealers of cheap church trinkets, but Michelangelo was—as always—quick. "Stop, please!" But he didn't stop, he turned one corner, another, and another . . . I hurdled a puddle, scooted around a donkey, sidestepped a group of children playing dice in an alley. "Michelangelo!" Under a tree, over a pile of horse manure, around a broken wagon . . . I grabbed for his elbow and missed, but with the second swipe, I caught his arm and bashed us both against a wall of brick. Of course, it *had* to be one of those Roman alleys trimmed with hanging dead bodies. I took a gulp of rancid air and searched for something to say to convince him that I wasn't out to harm him or . . . "I wanted to warn you that the Duke of Urbino wants you dead."

"You chased me down to tell me someone wants to kill

me?" He leaned over, hands on his knees, breathing hard. "Welcome to Rome . . . what's your name, again?"

"Raphael Santi. Of Urbino."

Michelangelo spit into the dirt. "Leave me alone. Raphael." He marched through the maze of swaying corpses.

I shielded my eyes with my hands as I chased after him. "You stole my sketchbook."

"You're nicer than I am."

"What does that have to do with stealing my sketch-book?"

"I can't have the pope finding out that there are artists who are both nice *and* talented."

"You think I'm talented?"

"*Gesù.*"

"Wait, Michelangelo, I . . . I meant what I told the pope. I was never trying to steal from you. I admire you." I had to jog to keep up with his quick strides, but at least he didn't tell me to take a leap. "Gonfaloniere Soderini put your city hall cartoon on public display." *Was that a nod or . . . ?* I went on. "You heard that everyone raved?"

"About Leonardo."

"About you."

He slowed his pace.

"We all sat there, day after day, sketching *your* designs. They're remarkable."

He shoved his hands into his pockets. "I'm not a painter."

"You keep saying that, but you fought to keep the Sistine, and people don't fight for things they don't love. I'd fight to the death for the paint, my work, my *sketches* . . ."

He stopped walking. His eyes flicked down to my hands, and I balled up my fingers to hide the specks of paint that—no

matter how often I chipped them off—always returned. He whispered, as if confessing. "It's silent."

I leaned in and whispered, too. "What is?"

"The paint. It doesn't say a word."

"I don't understand . . ."

He glared like . . . *Dai*, you know how he glared: like I was a fool.

I asked, "Are you having trouble with painting?"

"Forget it." He stalked away again.

I hurried after him. "I've been a painter since before I could walk, so if you're having trouble, I can help . . ." He was wearing his satchel across his body. Maybe my notebook was still inside. Could I open the flap and grab my sketchbook before he could stop me? "But you have to tell me what . . ."

He whirled on me, that vein in his forehead thumping teal. "My marble sings. It cries and speaks and tells me how to carve. Each block has a different voice, but it's always there, guiding my hand. But paint won't tell me anything. No matter what I try—wooden panels, canvas, walls, tempera, oil, fresco . . . It won't say *anything*. How can I make it speak?"

I looked past the hanging corpses—telling myself they were only fish, down by a port, dangling on lines—and said, "The beauty of paint is its silence."

He shook his head—with denial or bewilderment, I wasn't sure.

I went on. "When you paint, sounds and smells recede, all thoughts drift away. Worry, fear, fires, floods, war, sickness, death . . ." I put my hand on his shoulder, over the leather strap of his bag. His muscles were hard from years of pounding into marble. If he hit me, it would hurt. "The reason I love to paint isn't because of the noise; it's because of the silence."

"I can't do this," he groaned. "I'll die painting that chapel. The pope might as well have sentenced me to decorate my own tomb."

My breath caught. "Are you saying that you don't *want* to paint the Sistine ceiling?"

"No, I don't want to paint that *blessed* ceiling. I'm a sculptor."

This changed everything. I took out my father's old paintbrush and began to twirl with excitement. "*Che grande,*" I replied with a grin. "That means you can give me the ceiling to paint, and you can go back to carving the pope's tomb and . . ."

He shook his head. "I've told the pope over and over again that painting isn't my art, but . . . ," and he marched off. I had to jog to keep up again. "I also said casting bronze wasn't my art, but then I cast his equestrian up in Bologna, so he doesn't want to hear that again." I'd seen his bronze equestrian, when passing through Bologna: Pope Julius II, looking more like a military leader than a spiritual one, sitting proudly atop a great stallion, cast in warm bronze with undertones of pink and yellow. The horse was surprisingly realistic—Michelangelo isn't exactly known as a great animal lover, is he?—but it was Pope Julius II's fierce glare that astounded me: furrowed brow, flared nose, intense eyes . . . Holy Mary, the things Michelangelo can accomplish, even when he says something is not his art. "And now Bramante, your countryman"—Michelangelo made a fist and pushed his thumb out between his index and middle finger in a lewd gesture, "flipping the fig" at Bramante—"has convinced His Holiness that unless I paint that ceiling, I don't get my marble. My marble that I quarried with my own hands out of the hills of Carrara; my marble that sings to me daily; my

marble, every piece already named. Paint a masterpiece, and I can return to my 'little stones.' But anything short of a miracle, and Bramante walks away with my marble. All of it."

"Don't worry," I said, trying to sound cheerful. "I'll help you. I don't know how, but, at least we both agree that you can't paint that ceiling . . ."

"But you can?" His anger had turned hot again, fast as a flame catching boiling oil. His eyes flashed, and his tone was mocking when he said, "'*That ceiling is far too long, far too high, far too curved, far too awkward for you, Michel, so leave it to the great Raphael!*'"

The great Raphael? I didn't know whether to be flattered or offended. I said, "You can't paint something you hate. You'll ruin it."

"You think I don't know that I'm being set up to fail. That I'm more likely to die falling off that scaffolding than I am to paint a masterpiece, but I'll do anything to return to my marble. Anything."

"You only have to convince the pope to change his mind. Bolster his ego. He who hath less power must have honey in the mouth." Off his confounded look, I added, "Mother Mary, you have to learn to play the game, Michelangelo."

"*Gesù Cristo!* When is anyone going to hear me that this is not a game? Not to me." He pulled my sketchbook out of his bag and pressed it into my chest. I wrapped my arms around it and squeezed it close. Then, Michelangelo pushed past me and stalked away. We had stopped on the edge of the piazza outside his studio. After flipping through my sketchbook to make sure no drawings were missing, I watched him walk through his forest of marble, fingers slipping along each trunk, and . . . was he *talking* to the stones?

He paused at one tall, gleaming rock and pressed his palm into the white marble flesh. His lips were moving; *what was he saying?* He leaned his face into the stone—had he kissed it?—and then he slouched over to the door leading up to his studio and shuffled inside. Once he was gone, I closed my eyes and listened carefully, but I couldn't hear a thing. Only silence.

Chapter XIV

Thank the Magdalena that Bramante invited me to stay in his rooms in Vatican palace until I could secure an apartment of my own because I didn't have a single *soldo* after those Orsini mercenaries stole my bag. (Have *you* ever been foolish enough to store all of your money in one place? You only do it once.) I couldn't bear to write to Evangelista for funds; it only would've worried him. So, as Bramante showed me to my room that evening, I asked, as nonchalantly as possible, "When do we get paid, *maestro*?"

"Please don't tell me that I've encouraged the pope to hire a"—Bramante's nose scrunched as if whiffing rotten eggs—"*struggling* artist."

"Of course not," I replied. "Struggling. Can you imagine? No. I'm planning for my staff and considering bringing on a chef."

"*Bene,*" Bramante shrugged. "When you unveil your work, you'll get paid. As long as the pope is pleased. I'm going to the tavern for supper. You coming?"

"No. *Grazie.* Exhausted from the road."

I borrowed a white tunic and pair of tights (worn but

not ruined like mine) from Bramante's steward, who also brought up a bowl for bathing and a bottle of rosewater. It took me the entire length of sunset—from first purpling to full moonlight—to pick all the grime from between my teeth and out from under my fingernails. I went to bed that night without eating. I couldn't sleep. The bed was small, the wooden frame creaked, the sheet was too thin. Yes, I'd had a couple of victories that day—impressing the pope, landing a job in the papal apartments—but my defeats loomed larger: Michelangelo had the Sistine, Michelangelo was a favorite of the pope, Michelangelo was a painter . . . I rubbed my neck, my arms, my temples, but I couldn't get those images of Michelangelo's Florentine City Hall cartoon out of my head. If he put something like *that* up in the Sistine, how would I ever catch him? I stretched one leg, then the other. I got out of bed to pace. The view from my window was nothing but brick. I straightened a crucifix hanging on the wall, adjusted the room's only chair to a more pleasing angle, and spent a good long while tidying the sketches in my notebook (Michelangelo had rifled through, even leaving a thumbprint or two behind, so don't let him tell you that I'm the only one who likes to copy).

I didn't plan on walking anywhere of import; if I had, I would've borrowed something more than a white tunic and tights. At least I might've put my shoes back on. I didn't know my way around the Vatican yet, and even if I had known where to find the Sistine, I wouldn't have gone—I only wanted a bit of air—but that's where I ended up. The door wasn't locked, so it's not as though I had to break in.

The chapel was empty. The moon was full and the light coming in through those high windows was bright pewter, so I could see the ceiling from the floor. One half was

obscured by Michelangelo's scaffolding, but the other half glowed white in the moonlight. The ceiling wasn't a clean rectangle or oval, but a wide, unruly spine with awkward triangles fanning out like the legs of a scorpion. Spandrels wedged into negative spaces. Semicircular lunettes capped windows. There was no architectural scheme or logic to the shape.

I should've felt relieved—that unruly ceiling wasn't my problem—but instead, I felt a crushing loss, and not only for me, but also for Michelangelo; he didn't deserve such an ugly scorpion sting. That ceiling was supposed to be mine. And Michelangelo deserved to lose himself in his marble, same as the cardinals who entered that chapel to pick popes deserved to pray beneath a bloom of beauty. If Michelangelo kept the commission, he would rush the job to return to sculpting. He would ruin that ceiling. He would be lost, his marble would be lost, the ceiling would be lost, the chapel would be lost, the pope, cardinals, paint, perfection, me, all would be lost. But Michelangelo wasn't going to give up the Sistine—even if it meant the whole world wasted—as long as *maybe, possibly, hopefully* it saved his marble. So, as I leaned against the wall and sank down to the cold floor, I saw that it was my job—no, my responsibility—to secure that chapel for myself and save us all.

Chapter XV

I must've fallen asleep because I woke to a door creaking open. I rubbed my eyes. Were those footsteps? The light of a fitful torch? *Where was I?* Ah yes, sitting on the floor of the Sistine in nothing but a white tunic and stockings. I hoped the person entering wasn't Michelangelo; he'd take my head for spying again. I looked around for a place to hide—a door, table, curtain—but there was nothing, not even a stray tarp. So, I pressed against the wall, held my breath, and looked down at my feet as though, if I didn't look up, he wouldn't be able to see me *or* my white tunic glowing in the moonlight.

Wood scraped against the floor; footsteps up a ladder; groaning scaffolding . . .

Had that worked? I opened my eyes. Yes, the torch *and* the figure were heading up toward the ceiling. Whoever it was hadn't seen me. Not yet. Yes, I should've ducked out the door to avoid being caught, but there was a problem: that *wasn't* Michelangelo. The figure didn't have the right gait, the right heft, the right smell. If some other artist found an intruder skulking around my work in the middle of the

night, I would hope they would investigate. "Michelangelo?" I called up. The figure stopped. "Michelangelo, is that you?" I peered through the scaffolding, but it was too shadowy to see. The person stood there, as if I couldn't see the torch. "Are you an assistant?" I crossed to the ladder.

"*Sì. Un assistente.*" His voice was deep; I didn't recognize it.

"What's your name?" I called, my foot already on the bottom rung of the ladder.

"Jacopo." Or at least it sounded like Jacopo; the word was mumbled.

I started climbing. "Did Michelangelo send you?"

"*Sì, sì.* I'm a guard. You. Leave." Why did his voice sound so halting?

"Who are you?" I ascended the ladder and climbed onto a curved staircase of the main scaffolding. From the floor, the scaffolding looked stable, but high up, it moved, no doubt designed to absorb the weight of workers; the swaying made me dizzy.

"Get out," the intruder called in an improbably low tone. Was he disguising his voice? Did I *know* him? Was it a cardinal? A rival artist? Maybe Michelangelo was right; maybe Bramante *was* trying to kill him, or at least sabotage him. It couldn't be the pope . . . *could it*? Whoever it was, he was fast. Billowing behind his back was—what? A cape? The moonlight caught his hands: a stack of papers.

"Are you stealing Michelangelo's sketches?" I took off, no time to count steps. The intruder turned up a staircase, down another—"help, someone help," I cried. I high-stepped over a railing and leapt off, dropping down, cutting off his path. When he turned back, his foot slipped, and then he was falling, and I wanted to shield my eyes—who wants to

watch someone crack to their death on a marble floor?—but instead I reached and felt something against my palm, so I clutched tight. It was his arm, his other hand now flailing for mine. I used my other arm, my leg, my knee, my elbow, to hold us onto the scaffolding. His weight pulled us, but I wedged a foot in a corner to stop our slide—"someone help!"—and when I reached over to pull him back up, that's when the moonlight illuminated that face.

I was so shocked that I almost let go.

Long black hair, smooth features, full lips . . . *It was a woman?* Yes, I took note of her bosom rising up out of the swooping neckline of her billowing gown, who wouldn't? Her eyes were wide, mouth open, legs swinging over the marble floor far below. I grabbed on with both hands and pulled. The lady twisted herself so that I dragged her up onto the scaffolding on her side and that's when I saw . . . "*Santa Monica,*" I blurted. "You're with child." I hadn't seen a woman so . . . so . . . *full* since my mother gave birth to my sister; why wasn't a woman that pregnant already in confinement? And her gown—not a cape at all—was long and black with flowing sleeves. Despite the curving neckline, those were widow's weeds, if I've ever seen them. Was the father of the child dead before the baby born? *How sad.*

As the lady clambered to her feet, clutching a stack of Michelangelo's drawings, she reached into her pocket and pulled out—what was that? A blade caught the light. *A sword?*

I stumbled backward. "What are you doing?"

Silver blade, sharp point—all right, it was a dagger not a sword, but in the moment, it looked long enough to drive through a horse—handle encrusted with rubies and was that a crest? Red and white stripes, red flower That's

right. I'm glad you remember. The crest of the infamous Orsini family. I was on a high scaffolding facing off against an Orsini. You're thinking about all those corpses hanging in the streets, aren't you? That was my thought, too.

"I apologize, my lady." I backed away on unsteady feet. "I didn't mean to interrupt your . . . your . . ." *What was she doing up there?* "Work. I'll let you return to it."

"I told you to get out of here. No one can know I was here."

"I won't tell anyone."

"No one." She pushed the dagger into my chest. One of my stockinged heels dropped over the edge of the scaffolding. I looked back. There was no railing. I tried to think of a Dante quote appropriate for such a situation but came up blank. She pushed the point of the dagger into the soft flesh under my neck. "You should've left when I said."

Women always elicit strong emotions in me. If I love a woman, I gush—a Petrarch for Laura kind of a thing. If I lust, I'm David with Bathsheba. If I feel protective, I'm Orpheus to Eurydice, traipsing off to the Underworld to take on Hades. So, it's not surprising with *that* woman I felt as fearful as a mortal facing Medusa. My second heel slipped off the scaffolding.

There's no point in dragging out the tension any longer; as you can see, I didn't fall to my death. I suppose I could invent some heroics. Others might spin a mistruth, make themselves out to be more than they are, because that's what we all must do to be noticed—isn't it?—be *more* than we are? But, no. The truth is, someone burst into the chapel at the right moment. If I'd been in ancient Greece, I would've said some goddess or another favored me, perhaps Athena; she championed Odysseus, so why not me?

"What's all that racket?" Two papal guards ran in. They must've heard me calling.

She pressed the blade into my chin. "If you say anything, I can do worse than a flaying."

"Who's up there?" A guard called.

I turned to see two guards ascending the scaffolding.

When I looked back, the woman was gone.

"Identify yourself," said the guard, pulling out a sword. *Oh no. Not again.*

"I'm a friend of Michelangelo's." My hand went up to my chin and came away with a splash of crimson. I pressed my thumb into the wound. "I'm . . . I'm . . . sorry for screaming. I fell. Cut myself." I showed them my thumb of blood. "It's nothing."

"Is *maestro* Michelangelo . . . here?"

That's when I remembered that I was standing there in nothing but stockinged feet and tunic. Oh, how it must've looked . . . "I was studying his drawings?"

Averting his gaze, the first guard lowered his sword. The second backed down the ladder.

Persephone. They hadn't taken my "studying his draw-ings" comment as a delicate way of suggesting . . . You know how common sodomy is among artists in Rome. It's nearly impossible to escape the rumors, and standing on another man's private scaffolding in nothing but tunic and tights I wouldn't care about such a rumor except for the whole threat-of-hanging-as-a-punishment problem. I wanted to come up with some courtier line to smooth over the moment, but I was so rattled all I said was, "*Prego.*"

The guards descended the ladder without another word, and I followed them out of the chapel. In the hallway, I incongruently blurted, "*Buongiorno*" to the guards and,

head high as possible, strode away. As I scurried down the hall, I checked behind—that woman wasn't following me, was she? I bolted my door behind me and pressed a kerchief into my bloody chin. At least I wasn't dead. Although, considering how Rome had treated me so far, I couldn't help mentally adding: *not yet.*

Chapter XVI

The rest of the night and into the next morning, my nerves were jangled as a bell on a brothel door in the weeks after Lent, but I had to put that terrifying Orsini woman out of my head and prepare for my first day of work in the Vatican. *The Vatican!* At daybreak, Bramante's steward brought up an extra simple black velvet jacket and belt; I could play it as stylishly understated. I peered into the reflection of a silver wine jug to inspect my eyebrows, hairline, and nose for stray hairs. I buttoned and rebuttoned my jacket and checked my boot ties twice. Since I was sleeping in the palace, I didn't need to cross even a single dusty street that morning, but I still waited for a kitchen maid to smuggle up a sprig of fresh lavender for my belt.

Bramante was waiting for me at the door outside of the papal apartments, arms folded like the king of Mycenae demanding labors from Heracles. He said, "You're in competition with every other artist behind this door. You aren't friends, you aren't colleagues, you aren't partners. Don't expect their help and do not be swindled into offering yours. If you fail, you will not only embarrass me and your duke,

but face the wrath of His Holiness. Understood?" He didn't give me time to respond. "*Andiamo*," he barked and led me through that door.

It's difficult for me now to separate my current feelings about the papal apartments from those early moments, but here's what I remember about that day: warm golden light flooding in through large windows overlooking the south end of the Belvedere Courtyard, still under construction at the time; walls and ceilings sanded down, prepped for paint; wooden scaffolding—the standard sort, nothing inventive like in the Sistine—standing on the floor of each room, rising up toward groin-vaulted ceilings. Up on those scaffoldings, painters frescoed those ceilings, while on the floors assistants ground pigments, mixed *intonaco*, organized brushes and tools . . . "So, the rumors are true," came a voice that rowed the oars of my memory. I looked up. Peering over the scaffolding were familiar eyebrows coming together in a sharp *V* over tiny eyes: my old teacher, Pietro Perugino. I recognized the others, too, poking over scaffolding and around doors: Luca Signorelli (Tuscan master of perspective), Lorenzo Lotto (Venetian captain of color), Guillaume de Marcillat (French stained-glass expert), Bartolomeo Suardi (known as Bramantino because he was an ardent follower of Bramante), and *maestro* Pinturicchio (the oldest and most revered of them all). I bowed low, but not so low anyone could take it as mocking, and said, "It's a privilege to work with you again, *maestro* Perugino. It's a privilege to work with *all of you* again."

"Raphael," Bramante called, waving me into a second room. "You'll help paint this ceiling, in the pope's library, alongside Giovanni Bazzi."

That's when one of the strangest men I've ever seen

descended that scaffolding. He wore purple-and-green platform shoes; violet tights woven with silver thread; and a cape patterned in orange and a tone of teal that was so sweet it hurt my teeth, all topped off with a hat of ostrich feathers. Not even Jester Dominic would be caught in his casket wearing such fripperies. The strange man had a wild tangle of black hair thick as an uncut mulberry tree and eyes oval as eggs. He leapt off the last few feet of scaffolding, slipped clumsily on the tarped floor, and swept into an ostentatious bow. At first, I thought the black raven perched on his shoulder was stuffed, but then it blinked a yellow eye at me. It was a *live* bird. (He walked around with that bird on his shoulder all the time. And he doesn't only keep birds, chickens, and cats in his house like other painters, but donkeys, badgers, and a creature he calls a monkey—it's the strangest animal you've ever seen, long tail, big ears. He used to smuggle that thing into the apartments until it left paw prints in the fresco, so I made him leave it at home.) That first day in the papal apartments, he smiled and chirped, "*Buongiorno! Mi chiamo* Sodoma."

My eyebrows no doubt lifted. The man called himself *Sodoma*? It's one thing for others to use such a tawdry nickname, but would *you* walk around the Vatican touting yourself as a Sodomite? Seems like a good way for your next term of employment to be as Hanging Man Number Eight-Hundred-and-Sixty-Three on Side Street Number Seven, doesn't it?

"*Bazzi* has completed most of the ceiling," Bramante said, emphasizing the painter's given name, "so you'll paint what's left." He handed me a scroll of designs, said, "*Buona fortuna*," and then exited, leaving me with Sodoma, as his raven repeated, "*Buona fortuna*."

"Come up," said the strange painter, and I followed him up the scaffolding. The design of that ceiling was tragically staid, rectangles and circles circumscribing a central heptagon—*what, were we painting back in the '70s?* In three of the circular panels, Sodoma had already painted creatures . . . Were they supposed to be women? Their emblems marked them as representations of *Philosophy, Theology,* and *Poetry,* but I'd never seen such ugly figures. And the scenes in the rectangular panels were even worse. One composition was so botched that I didn't recognize it as a *Judgment of Solomon* until Sodoma pointed out the man holding a baby by a foot. One panel was palatable: the figures were too elongated, but they were at least recognizable as the shepherd Marsyas challenging Apollo to a duel on a lute. (That panel still makes me laugh. Next time you're in those rooms, look closely: it's as if Apollo were tickling the underarm of the man crowning him with laurels. *"Tickle, tickle!"* Oh, ignore me.) I rubbed the back of my neck. "And I'm to paint the walls?"

"Oh no. We're not to begin the walls until the pope approves the ceilings. You can have that *tondo,* there. I haven't started it yet. It's to be *Justice.*"

I looked up at the small, circular panel prepped for paint. A thousand of those panels could've fit onto the Sistine ceiling. "I only get a single *tondo?*"

"That's lucky. The rest of us have been working for months," Sodoma said. "And the pope is scheduled to view these rooms and make his judgments any day now."

I unrolled a scroll of designs. Every scene, figure, and pose were laid out in awful detail. *Justice* was to be a flat, boring figure—no life, no inventiveness, no beauty. "Who drew these?"

Sodoma lowered his tone and answered, "Bramante."

My face pinched. Back home, Bramante had a reputation as a legendary architect, a renowned artist . . . I collected myself and said, "And we're supposed to base our work on these?"

Sodoma shook his head. "We must follow them precisely." Off my look, he shrugged. "It's the Vatican. Do what the pope says or . . ." He grabbed an imaginary rope hanging over his head and tilted his neck as if it had snapped in two.

"*Bathsheba*," I exhaled.

Sodoma's eyes bulged even wider—if that's possible—and he grabbed my collar. "Do. Not. Curse. Here." He looked this way and that. "The accursed Spaniard buried beneath doesn't like it. Does. Not. Like. It. Understood?"

"No. Who's the accursed . . ."

Sodoma slapped his hand over my mouth and whispered, "If you want to keep your pretty little head, never speak of the '*accursed Spaniard*' buried beneath ever again. Never. No one is allowed down there. No one."

I nodded. He released me, and I slumped down on the scaffolding. I was exhausted, broke, and working alongside a paranoid painter spouting conspiracies. How was I supposed to impress anyone—much less a pope—using atrocious designs to paint nothing but a tiny *tondo*?

The remainder of my first week in the papal apartments didn't go any better. Perugino turned the other painters against me. Lorenzo Lotto spit off the scaffolding every time I walked by—*spit!*—and one morning, the brushes I'd managed to borrow from Sodoma went missing, only the broken-handled and bristleless remained. (Stealing brushes? I felt like a twelve-year-old fending off fellow apprentices. At least, I kept my father's old brush secured in my pocket.)

I did manage to borrow an extra vest from Sodoma and trade drawings at the market for two more shirts and pairs of breeches, enough to cover me until my trunk from Evangelista arrived. I also traded sketches for turnips and pears down by the Tiber and supplemented this meager fare by scavenging for stale scraps of bread already picked over by the sparrows or asking Sodoma for a bite of his beans at the noontime meal—"I'm searching for the best recipe," I would insist. I wasn't exactly fed, but the snacks kept starvation at bay. For now. The Vatican provided us with basic supplies, but they had *not* given me an assistant—those were to come out of our own purses—so I didn't have anyone to mix me a proper plaster.

When I asked Perugino for a plaster recipe, he said, "Use a Florentine mix."

Thank the Virgin that my mother taught me how to swallow a laugh, right? A *Florentine* fresco mix? *In Rome?* How gullible did Perugino think I was? Yes, I'd spent most of my early career working in oil on wood, and this was my first fresco project to head up on my own, but even I knew that a Florentine recipe would be too watery for all that humidity. It would never dry firmly overnight. It would grow mold and have to be destroyed. I could lose days of work. I mustered a cheery tone and replied, "Ah yes, the Florentines *always* know best." I laughed. Perugino laughed. We nodded our "good days" and went about our business.

Perugino wasn't the only one who lied. Signorelli, Lorenzo Lotto, and even Pinturicchio (too old for such antics in my estimation) all repeated, "Florentine."

Frescoing. The technical process is straightforward enough, isn't it? Clear the wall of previous decoration. Sand down any irregularities. Lay a foundation of plaster. Let it dry,

sand it again. Then, mix the final layer of plaster from lime, sand, and water. Apply a small patch to the wall, enough to be completed in one day and one day only, and paint your water-based pigments—no need for a binding agent when frescoing—directly into that wet plaster. Finish that section in a single day before the plaster dries and start again the next day with a new patch of *intonaco* . . . So on and so forth until completion. The difficult part should be determining how much of the picture you can complete in a single day. The difficult part should be painting so seamlessly that the viewer doesn't notice the divisions between each *giornata*. The difficult part should be painting directly into wet plaster—quickly, yet confidently. The difficult part should be in creating the design, perfecting the perspective, balance, harmony. The difficult part should be painting.

Not mixing the plaster.

And then things got even worse when I spotted *her*. Same dark hair, same black widow's weeds, same pregnant belly, she was definitely the same woman who'd stolen Michelangelo's drawings and tried to dagger me off that scaffolding. She was leaning in the doorway, staring at me with her obsidian eyes. What was she doing in the pope's apartments? She crossed to me and said in a voice sweet as *struffoli*, "And who is this new addition to our apartments?"

The tip of my nose went cold. *Our* apartments? I bent my head and, with the calm of Jonah, replied, "Raphael Santi of Urbino. Newly appointed painter in the Holy Apartments."

She did not curtsey.

I found the fortitude to spread a smile across shaking lips and say, "So rarely do great virtue and great beauty dwell so well together, my lady."

"Lord in Heaven and Lucifer in Hell, only *courtiers*"—she

spit the word as if she'd called me a *cavolo* or worse—"quote Petrarch."

"Come, my lady," called Pope Julius from the next room.

She leaned over as if to kiss my cheek but instead whispered, "You're too nice for Rome."

"How can I be too nice for Rome?" I whispered back. "Rome is a city of saints."

She looked me in the eye and said, "How boring that would be."

"Felice!" the pope called again.

She curled her lip and then strode after him.

Felice? That's a man's name—isn't it?—and yet, I'd heard the name applied to a woman once before . . . Hadn't I?

Face gray as winter, Sodoma sidled up and whispered, "Do you know her?"

"I . . . I . . . No?"

Instead of speaking the words out loud, Sodoma mouthed them: *Felice. Della. Rovere.*

My stomach dropped like an anchor. Yes, that's where I'd heard that name. People call her the pope's "niece"—don't they?—however . . . When Felice was nineteen, she'd poisoned her husband because he was rumored to have heard about a potential plot to murder her "*uncle*." What *niece* do you know who goes around murdering their own husbands to protect their uncle? And when Julius was elected pope, he brought Felice down to Rome by sea, escorted by a dozen papal galleons at full sail. *A dozen papal galleons at full sail.* That's some welcome for a niece. I remembered the Orsini crest on that dagger she'd pulled on me. "The husband who she . . ." I made a slashing sign across my throat. "He's an Orsini?"

"No. Her *first* husband, the one who . . ." He repeated my

slashing sign across his own throat. "He was some no-name merchant from up in Savona. Her second husband is the Orsini. He's very much alive. For now."

"She's remarried?"

"His Holiness spent a year finding a second husband for her. She kept chasing off any suitor who threatened to take her out of Rome. He settled on using her to make an alliance with the Orsini. The violence *has* quelled some since their marriage."

"So, if she's married again, why is she still wearing widow's weeds?"

Sodoma shrugged. "To remind us all that she's unafraid of death?"

As Sodoma shuffled back to work, I took out my father's paintbrush and began twirling frantically. The woman I'd confronted in the Sistine wasn't only an Orsini, but a della Rovere, too, and the child she was carrying was a descendant of *both*. I leaned against the scaffolding to steady myself because how could I ever hope to survive in Vatican court— much less succeed in it—when I'd made an enemy of the daughter of the pope?

Chapter XVII

P eople are starting to talk," Bramante said one day, cornering me in the hall. "You're a *maestro* in your own right, it's time to get your own rooms."

"*Sì certo,*" I replied, adjusting my collar, so he wouldn't notice the stains. I'd been turning my shirts inside out so that no one would notice that I kept wearing the same ones. A trunk from Evangelista had arrived a week before, but it only contained one extra pair of shoes, one shirt, one jacket, two pairs of breeches, a small workbag, and a whole box of painting rags and brushes, so I still had to conserve my clothes. "I've been too engrossed in my work to look."

He squinted at my neck. "And if you need a recommendation for a barber . . ."

My hand flew up to cover the cuts. "My boy's still learning, but I like supporting youth."

"When you change your mind." He shrugged and departed.

My hand came away from my neck with a spot of blood. *Salome!* I'd never shaved myself before. Have you? I needed to swipe a sharper knife from Perugino's toolbox. Too

bad Evangelista hadn't sent one of those. Or food. At least Bramante's maid had handed me a kerchief of half-eaten cheese and figs that morning. During our first *encounter* under a table in the kitchen, I'd told her a bit about my financial troubles. She'd been slipping me Bramante's leftovers ever since. But no matter how generous she was, an unmarried maid living with her parents in a single room couldn't help me with my most pressing problem: I needed a new place to stay. Over the next several days, I hinted to the other painters that I needed a bed, but no one offered, and since they were already trying to sabotage my plaster mix, I hated to think what they might do to me in my sleep.

On Friday, Bramante was waiting again. "In Rome, landlords troll the streets for tenants."

I suppose I could've admitted the truth of my financial predicament, but during your first weeks in the Vatican, would you admit to such a thing? "Did I neglect to tell you?" I said. "I found a place. I'm leaving tonight. I only need to leave my trunk in your room until I can find a boy to help me move it tomorrow."

"I'll expect an invitation to dinner soon."

"Give me a few days to secure a chef worthy of your palate."

Moments later, with only the small workbag Evangelista had thankfully sent slung over my shoulder, I was pacing outside the Sistine. *I'm small, Michelangelo, I'll hardly need any space. A simple pallet. I could sleep in a chair. On the scaffolding.* I could dust his studio, prepare his meals, help him make preparatory sketches. The best artist among his assistants (he had dozens of them, milling about the chapel, all Florentine) was Francesco Granacci, a middling painter, at best, and his drawing skills are . . . *Beh,* Granacci's a nice

enough fellow. I'm only saying that Michelangelo could use a strong draughtsman.

The door banged open and out marched Michelangelo. When he saw me, he glared. "If you're waiting for me to leave so you can sneak up my scaffolding again, I've posted guards."

How did he know about . . . ? Never mind. I didn't have time to worry about it. "I need a favor." The whine in my tone must've sounded desperate because he paused. "I need . . ." *A place to stay, money, help.* Say something. Anything. "The recipe for plaster."

"What?"

"The others won't give me a recipe for a plaster mix that works well in Rome. I'm accustomed to painting in oils on wood, so . . ."

He looked this way and that, all guilty like, then he shrugged and said, "Use a Florentine mix."

"Oh? I should've guessed." I tucked my hair behind my ears. "Thank you."

His eyes landed on my poorly shaven neck. "Is that all?"

"Uh . . ." How could I ask him for a place to stay when he was trying to sabotage me with the same lie as everyone else? I shook my head. "No, that's all. *Buongiorno*," I said and felt him watch me walk away. He didn't call after me, and even though for the first time in my life I didn't know where I would sleep that night, I didn't look back.

Outside, it was raining. I pulled my jacket over my head. Twenty-five years old, and I'd never been goat-broke before, not even a *soldo* for a cup of ale. Scuttling from eave to eave, I sidestepped sagging-mouthed men sleeping in corners perfumed with piss. One man—too young to be so balding—knelt under a portico of a locked church, singing a hymn

I didn't know in a language I didn't understand. There was a woman—holding a child so young I didn't know whether a boy or girl—huddled under a bridge at the Tiber. I hated that I didn't have any food to give, so I gave her my jacket. Don't look at me like that; you would've done the same. All would've worked out fine, except some ruffian claiming to be from the Colonna family demanded that I pay him "rent" for sleeping under the bridge. I didn't believe he was a Colonna, but he did have a dagger, so I kept walking. This was late in the year, sometime after All Hallows, so it was cold. I knocked on a couple of doors, promising to repay innkeepers once I received payment from the pope, but would you have believed me, jacketless, poorly shaven, and drenched as a river rat?

I crossed the Tiber—put a bridge, a river, a world between me and the problems of the Vatican. I wished I could take out my sketchbook to draw, but all that rain would've ruined my paper. I would've liked to draw the world around me perfect: those columns unbroken, that doorway unsagging, that beggar's hand declawed, that child's nose whole once again. I came upon a hunk of a building: large, round, shadowy, story after story of crumbling arches. *Wait, was that . . . ?* Yes. The Colosseum. It was larger than I expected, even though only the top two stories of arches were visible above the centuries of dirt and debris. The marble's stripped away and looted, but the structure still has a feeling of grandeur, doesn't it? A feeling that only comes with hundreds of years of history: lion hunts and Gladiator games and martyred Christians. Now that I could duck under arches to protect my paper from the rain, I took out my sketchbook. I've told you how focused I get when I'm drawing, haven't I? This was one of those moments when my sketching pulled me deeper and deeper into my own head

and into the Colosseum. Then came a distant echo of monks chanting. I found out later that a near-extinct sect of monks lives in those ruins, but at the time, I believed it was the ghosts of martyred saints. I might've settled down in a corner and slept there for the night, except some vagabond jumped out of the shadows, and when he didn't find any coin in my pockets, he held me down and stole my shoes—*my shoes!*—and my sketchbook. After that, I decided to return to the Vatican; surely the guards wouldn't make me sleep out in the rain.

The problem? I had no idea where to find it. It was cold. The rain was coming down, and I didn't want to think about what was in the mud I was sloshing through in bare feet. The people sleeping in the streets howled and barked like animals, and shadows (bone black, charcoal, carbon, soot, slate, fog, flint, ash) cloaked alleys and overhangs. I felt as disquieted as when a plague sweeps up your street, and yet, paradoxically, the picture that kept coming to mind that night was Fra Angelico's *The Annunciation.*

My father used to keep a copy in his studio, so it was one of the first paintings I tried to visit upon arriving in Florence, but it's locked away in San Marco for only the pious to ponder. However, as my mother always said, persistence pays, so I convinced a young friar to allow me entry one evening during vespers. As the friars held services in an upstairs chapel, I snuck through the courtyard. The friars' prayers had the same eerie rhythm as the incantations of Fra Savonarola—*mi dispiace.* I won't say that name again. I promise. That was the church where "the madman friar" had lived, taught, preached. I closed up my ears and kept going; that's how badly I wanted to see that painting.

Fra Angelico's *The Annunciation* hangs at the top of a staircase. The colors are so bright that it gives off an ethereal

light even in darkness. I sat down to copy the angel Gabriel's exquisite multicolored wings and the Virgin Mary's delicate features. A slender column divides the two figures, each standing under their own graceful arch, the divine and earthly in the same painting, yet divided. To this day, it's one of the most beautiful paintings I've ever seen, and it always made me wonder: how could that madman friar spread such brutality when he'd lived among such beauty?

That question is why Fra Angelico's painting trailed me through Rome that night: how could a city sprouted from such beauty devolve into such ugliness, and if such a great Empire can fall so, what hope do we mere mortals have?

I'd been walking through Rome for Mary-knows-how-long when I heard a huff behind me. Was someone following me? Felice della Rovere perhaps? I walked faster, my bare feet slipping in the mud. I ducked down a small street, an alley, another street. Hanging corpse, hanging laundry, dead dog. Behind me, feet splashed through puddles. I looked back: too short and too many legs to be human. Animals. *Madre Maria*, how many of them were there? Five? Six? The huffs grew to growls. Across a piazza, I spotted a low dome atop a round building. It had to be a church. One bark, then another. I looked back again: pointed ears, scruffy necks, bushy tails, eyes yellow as yolk. *Wolves.* I took the stairs two at a time. Their claws clattered up the marble steps behind me, and as I lurched for the church door . . .

You're expecting me to find easy sanctuary, aren't you? You imagine me yanking open that door, slipping through a crack and slamming it shut on their chomping jowls just in time, don't you? Why does everyone think my life comes so easily? Let me ask you this: how many churches do you

know that leave doors unlocked all night, especially in a city full of vagrants?

When the door didn't open, I turned to face my attackers. There must've been—what? Eight of them? They were molted and skeleton skinny, but that made them even more dangerous, for they were hungry. Teeth bared, they crept forward. They must've been accustomed to humans with swords and were waiting for me to unsheathe mine, but my father's old paintbrush wouldn't do. There was a large wooden barrel next to the church door. I tried to squeeze behind it, but it was too heavy to slide. One wolf leapt forward. I swung an arm and yelled. The wolf stepped back, but the growls deepened. I put all my weight against the barrel, pushing and pushing, until the barrel fell over and hit with a thud. Liquid sloshed inside. The wolves yelped and jerked back. I thought they might scatter, but the smallest one—must've been the hungriest—let out a low howl and lunged. I hopped behind the barrel. They tried to struggle over—slipping off the curving wood—until one noticed that my right side was exposed. I turned the barrel, only to expose my left. One wolf snapped at my elbow; he got fabric, not skin. Another bit at my foot; I'm lucky I didn't lose a toe. "*Santa Veronica*, assist me in my final agony," I called. That's when one wolf tackled me and stood on my chest, his drool dripping off yellow teeth, hot breath panting down. He reared back to strike and . . .

Calm down, I obviously survived, and look, I even have all my fingers.

That's when a long, low howl called out over the pouring rain. The wolves perked. Out in the piazza was a huge creature—billowing and dark—rushing toward us. The wolves barked and turned to defend as it surged up the stairs like

an angry Cyclops wielding a . . . what was that? An axe. I've never been so relieved to see an axe. The wolf on top of me leapt at the attacker. I scrambled up and backed against the door, flat as I could, as my protector swung, but there were too many wolves—climbing, clawing, biting—and I thought we would both go down, until my defender raised his axe high overhead and brought it down—hard—on top of the wooden barrel. Two strikes, three, four, and the barrel exploded, splinters of wood and holy wine flying. The wolves yelped and scattered as if running from cannon fire. All except the small, hungry one, who crouched and barked. My defender grabbed one round end of the barrel, and, using it as a shield, lunged at the wolf. The wolf bore two swings before snarling off into the night.

I exhaled.

Axe and wooden shield in one arm, my protector turned and lowered his hood.

For the second time since my arrival in Rome, *he* turned out to be a *she*. Only this woman wasn't pregnant and menacing, but soft and beautiful and . . .

"As I predicted," she said, voice of honey and sarcasm, "it *was* a puppy that needed saving." Her jacket was made of dark green velvet—stylish cut with a high collar—and her eyebrows were fashionably plucked. She reached out—I thought she was going to touch my face, or heavens, brush my lips— but instead she picked my father's long-handled paintbrush out of my vest pocket, slipped the end of the handle into the lock of the church door, and worked it around until the lock clicked open. "*Dai*," she said. "The wolves will be back."

And I didn't hesitate to follow the lady inside.

Chapter XVIII

The door dropped closed with an echoing *thunk*. We were inside a cavernous church. Rain splashed across the marble floor, falling down in a great column through an open *oculus* in the domed ceiling, also letting in a dim pillar of cloudy blue moonlight. "*Santa Maria*," I whispered. "We're in the Pantheon, aren't we?" There's so much on which to ruminate when standing in the Pantheon; you could spend all of eternity there and still not think through it all: its extraordinary age, first conceived before Mary met Joseph and completed before word of Christ's resurrection spread beyond Judea; its polytheistic past, a great Christian monument that began life as a Roman temple dedicated to all gods; its role as witness to history, Emperor Hadrian holding court and Pope Boniface consecrating Christians; its architectural wonders, a dome so wide that a sphere fits inside without any internal columns or support, demonstrating one of Archimedes's great mathematical theories. And yet, I thought of *none* of that, because I was too distracted by that lovely lady wringing out her long brown hair in a glint of moonlight.

She said, "Mouth open, head tilted back, classic courtier on holiday." She took off her coat to reveal that she was wearing a long *yellow* dress. (She still claims that I gasped at that revelation, but I remember, in the moment, being impressed that I gave *no* reaction to it.)

Petrarch. Euripides. Sappho. Dante. Dante, Dante, and yet, when I needed my poets the most, not a single stanza or rhyme came to mind. I stood there stupidly, "Uh . . ."

"Even street mice can usually pull out a line from Virgil," she said.

Virgil! He would've been good, too. Since my tongue had apparently decamped for the night, I did the only thing I could: pulled a stub of chalk out of my vest and—no paper available—picked up the round end of the wooden barrel that the lady had used as a shield against those wolves and crouched down to draw. I usually start with the shape of a person's face, but—as she marched toward me, rage flushing up her cheeks—I started with her eyes: gently curving ovals bulging like eggs peeking out of feathers in a nest; swooping lids; fine bristles of lashes; smoky shadows whispering around the edges of . . .

She snatched the board out of my hands and said, "What's wrong? Never seen a *puttana* before?" But then she looked down at my sketch. Her lips parted. (They're full and pink and tempting as peach meat.) She blinked. (Her irises are the center of a sunflower—rich, warm brown brightened with gold.) The color faded from her cheeks. (Her unblushing skin is alabaster with a thin glaze of amber.) She pushed her wet hair off her forehead. (In that dim light, it was brown as peat, but on a sunny day, it flares bright as bronze.) Her eyes found mine. I didn't flash an amorous smile. I didn't raise an eyebrow. I didn't reach for poets. I held her gaze steady.

Silently, she handed the board back to me. She sat down, her yellow skirt floating around her in a pool of cold water. I sat down, too. I took my time capturing every turn of skin, every shadow along every ridge, every strand of hair falling along her face. I caught the ruffle of her yellow dress curving off her shoulders, the folds of her gown, the ribbons, her fingers . . .

Mi dispiace, I'm not supposed to be talking about this; I've made promises. She says that my story without her isn't the way things are, but the way things are supposed to be, and I understand that, but regardless, there is no version in which I'm the hero without her. *Basta.*

I don't know when the rain stopped. I don't know when the blue night turned purple, pink, gold. I don't know when we heard the first wagon roll past.

"The priests will be here soon." She gathered up her cloak and the round end of the barrel, bearing my drawing of her face. "I should make sure you get home safely." She offered her arm, and I took it. "Where shall I escort you?" she asked.

And I answered, "The Vatican."

I swear she bit her lip. *She* swears she gave *no* reaction to *my* revelation.

Outside, the sky was so clear it was sea blue, and the air tasted poststorm—crisp and grassy—and a breeze of lavender blew in from some distant hill as children splashed in the freshly flowing Tiber. Half-a-block from the Vatican, she said, "You should be safe from the wolves from here."

"From the four-legged kind, at least."

"I would've pegged you as a talented shepherd of the two-legged sort."

"The Roman breed has an unusually sharp bite. Are you sure you don't want to escort me inside and chase them away?"

"Do you always need someone to rescue you?"

"Ah . . . No?"

"Good. Because you won't last long in Rome if you wait around for someone else to save you." She kissed me on the cheek. Even after our night out, she smelled of honeysuckle.

She held out the end of the barrel, but I waved it off. "It's yours. To remember me by," I said, and she tucked the board under her arm. "Wait," I called as she walked away.

She paused and turned her head halfway back to give me the most perfect view of her perfect profile cast against a perfect blue sky.

"I'm Raphael Santi, painter from Urbino."

"Margherita Luti. Lady from . . . Rome."

"Where might I pay you a visit? Margherita Luti?" Even her name is splendid, isn't it?

"Even if I tell *Imperia*"—she dragged that name out long enough that its meaning became clear—"that you're my brother, she'll still demand coin."

I didn't let my voice crack with the disappointment that my purse—for now—was empty. No, I kept my tone light and confident when I said, "Tell Imperia that she should demand as much gold as made up the statue of Zeus at Olympia because every visit with you is surely worth more than a Wonder of the World."

"If I could take that golden tongue of yours as payment, I would."

I watched her go—amber hair curling halfway down her back—until she disappeared around a corner, and then I marched back into the Vatican. I no longer needed to impress the pope and win a commission and secure a payment and beat Michelangelo for such trivial things as my safety and my career and my ego and my hopes and my promises. No. Now, I needed to win . . . for her.

Chapter XIX

Bazzi?" I said, mounting the scaffolding.

He crinkled his nose at my appearance: I hadn't yet changed into fresh clothes or dug my extra pair of shoes out of my trunk, still in Bramante's rooms. I was barefoot and no doubt stank. "How many times do I have to tell you, it's Sodoma. Sodoma, Sodoma, Sodoma."

"*Dai, mio amico, dai.* I'll oblige from here on out, I swear . . . if . . ." I slid closer and whispered, "You take me downstairs, to where no one else ever goes . . ."

His eyes bulged wider than usual. "To what's buried beneath?"

I nodded.

He violently shook his head.

I slung my arm around his shoulder and said, "I know a dealer up in the hill towns who specializes in rare birds."

His raven squawked, "Rare birds," and with that, Sodoma led me away.

The downstairs hallway was so cold that my breath hung in the air. Spiderwebs collected in corners. Dust thickened

on floorboards. I recounted our steps. "We're directly beneath Pope Julius's apartments, aren't we?"

Sodoma's hand paused on the handle of a closed door. "I shouldn't be here. *You* shouldn't be here." He backed away from the door. "Let the accursed Spaniard be," he said and then turned and stumbled back up the stairs.

"Thank you, Sodoma," I called but got no response. His fumbling footsteps faded.

I was desperate for a place to sleep—I couldn't survive those wolves again—but thinking about what was buried down there made my stomach wobble. Would I find the *accursed Spaniard*—whoever he was—lying in a sarcophagus or hanging from the ceiling or rotting in some arcane torture device? The door handle—bronze with a crusty patina of teal—opened with a light touch. The hinges creaked.

I put my arm over my mouth and nostrils and stepped into the room. There was no window or torch, so it took several moments for my eyes to adjust. Tarps covered the ceiling, walls, furniture, floors. I moved through the adjoining rooms. More tarps, but no coffins or dead bodies. I lowered my sleeve and took in a hesitant breath—musty and dusty but no hint of rot. I found a window and pulled back the drapery, letting in light. Dust billowed. Behind another tarp, I found a cabinet. The handles were rusted, but the drawers were empty. Wipe them out, and I could keep a few clothes inside. My foot caught on one of the floor tarps; it moved, exposing blue-and-white tile floors. Wait, were those *Spanish* tiles? The back of my neck tingled.

Santa Sara. I knew where I was.

I tore tarps off walls and ceilings. It wasn't a body buried down there, was it? No. It was worse than a hanging corpse

or ghost. What was buried down there—in those rooms, covered by tarps, shrouded from view—was fresco after fresco after fresco decorating those walls. Masterpiece after masterpiece after masterpiece.

I'd copied copies of those paintings since I was an apprentice—St. Sebastian arrowed into martyrdom; St. Barbara fleeing her tower; the angel Gabriel's Annunciation to Mary; Mary's Visitation to Elizabeth; the Resurrection, the Assumption—but copies couldn't capture the originals. Those compositions were complex, the figures alive, all with their own unique expressions, gestures, and features. And, oh, those colors: emerald, ruby, and sapphire. I couldn't believe I was walking through those rooms—the Hall of Liberal Arts, Hall of Saints, Hall of Mysteries, by goddess!— all frescoed by Pinturicchio for . . . ? You know the name of the patron now, don't you? Go ahead. Say it. That's right. Those were the private apartments of Pope Alexander VI.

The first time Sodoma mentioned "the accursed Spaniard" I should've known he was referring to the Spanish-born Borgia pope. When Pope Alexander and Pope Julius were both still cardinals, they were notorious rivals: smear tactics, death threats, assassination attempts. When Alexander was elected pope, Julius fled the peninsula, living up in France until his rival died. And once Julius himself became pope, he refused to move into his rival's old rooms and instead moved into new apartments upstairs—the rooms I'd been hired to help paint. However, while working up in those rooms, I hadn't considered what had happened to Pope Alexander's old apartments. Now, I knew. Pope Julius hadn't turned those rooms into privies for the staff. No. He'd gone further—much further—shrouding them, locking them away, *burying them beneath*, punishing

the paintings for the patron's trespasses. I felt a pang in my chest as I thought about Pinturicchio working alongside the rest of us in the apartments upstairs, forced to create new images for a new pope, while his old masterpieces rotted away in the cellar. How must he feel knowing *he* was the one buried beneath?

Sodoma was right. I shouldn't be in those rooms. They'd been locked away for a reason, and Pope Julius would hang anyone found in enemy territory. I ran my finger along a dusty molding. Why would anyone come down here under the threat of the pope's noose?

That afternoon, I returned to Bramante's rooms, retrieved my few clothes out of my trunk, and gave the chest as a gift to Bramante's maid (I couldn't get caught bumping that trunk downstairs, could I?). Luckily, she was too intelligent to take that gift as even a hint of a proposal. I returned to the old Borgia apartments that night, wiped away dust and spiderwebs, and carefully put away my few clothes. Then, I fashioned a makeshift bed out of one of the tarps, curled in, and stared up at Pinturicchio's paintings.

Do you know the punishment for traitors in ancient Rome? *Damnatio Memoriae.* A person's name, likeness, every reference removed from monuments, buildings, historical records. Erase the memory of a man, erase the man himself. I know what you're thinking: at least the Romans never succeeded in erasing a whole man, right? But I ask you this: if they did it correctly, how would we ever know?

Chapter XX

Now that I had a place to sleep, it was time to find a proper plaster mix, and Margherita Luti was right: no more waiting around for someone else to rescue me. So, every day, I tested plaster after plaster, mixing in more sand, more lime, less water. I slathered patch after patch of plaster onto my small section of ceiling, the smell of wet sand becoming nauseating as, every morning, the patches remained damp. A few weeks in, suffering from insufficient food—my maid had a harder time slipping me scraps now that I no longer lived in Bramante's rooms and the cooling weather meant fewer bites of bread left on windowsills for sparrows—I had some midnight delirium and decided that perhaps the mix needed *more* water, not less, so I arrived in the apartments the next morning determined to mix a plaster so wet you'd thicken it to drink. I absentmindedly touched the first patch I'd left drying overnight: still damp. *Maybe I should leave the lime out completely.* Second patch: mushy. *Maybe the recipe didn't call for sand at all.* The third patch: dry. *Was there some special ingredient in the water or . . .*

Wait. Could it be . . . ?

I reached back up. *Dry.*

I pressed my hand against the plaster and came away clean. I licked it: chalky with not a hint of salt. (Sodoma watched me with horror, and at noon, he pretended he wasn't hungry and let me eat his entire helping of bread and beans.) I mixed that same plaster recipe in three separate buckets—*six full parts* drier than Florentine—and daubed one patch where the ceiling caught the most shade, another on the sunniest spot, and a final in the middle. All three patches remained pliable all day and dried hard as marble by morning.

Now, it was time to work. I only had a small *tondo*, but as Plato said, "Better a little well done, then a great deal imperfectly." Yes, the designs were already dictated, but like any artist worth his wine, I was determined to improve upon them. I maintained *Justice*'s traditional pose—right arm raised and wielding a sword, the left holding a scale—but twisted her knees hard like a Michelangelo. I retained the prescribed clouds but made the *putti* weightier. I used the suggested color scheme—golds, creams, purples, green, red—but to find the best tints and tones for the light in that room, I spent days sticking chips of colors on the ceiling and lying on the scaffolding to watch the sunlight sweep along them like a boy watches clouds cross the sky. I also threw out the face of *Justice* in the dictated designs. I knew who I wanted to use as my model, but when I tried to recall her . . . Was her nose straight or did it curve at the end? Was it as small as I remembered or was that a trick of my imagination? How did her cheeks turn? I searched the foggy backwaters of memory, but everything was a haze.

Was even the memory of my mother gone?

I drew an idealized face: high forehead, arching brows, downturned eyes, straight nose, curved lip, strong chin, but at least I managed to capture a bit of her spirit in that image—kind, yet strict, loving in her demands, fair in her delivery of justice, a spirit powerful enough to bend the entire world toward beauty.

But my opinion didn't matter, did it? Artists' opinions never matter, do they? No. It's only the opinion of the patron that counts, so in this case, the only opinion that mattered was that of the pope.

Chapter XXI

1509

The pope is coming! The pope is coming! To view our work, the pope is coming!" You've never seen tarps bundled so hastily, buckets stored so quickly, or scaffolding pulled down in such a rush. Mother Mary forbid the pope see that frescoing took *work*.

"Why didn't I paint faster?"

"I haven't had time to add the gold leaf yet."

"Can he hang me for painting ugly?"

Unlike the others, I felt relieved. My right arm had turned tingly from reaching up toward the ceiling day after day, the left side of my leg—from hip to ankle—ached all night, and my shoulder blade clicked every time I moved. Listen. You can still hear it. *That's* from those early days in the Vatican. (This is one thing that I will grant Michelangelo: his back, legs, and arms must've truly hurt from painting that enormous ceiling over the course of—what? Four years? Neck and back bent, hips and belly pressing forward, arm stretching overhead, face pointed up collecting paint splatters like an old tarp. After I stopped work on my *Justice*, I saw spots of paint for weeks. I can't imagine how he must've felt.) All

this to say, I was glad that my task of painting that scrap of ceiling was finished.

When a pope enters a room, he doesn't only bring himself, does he? No. He brings holy rings, holy walking sticks, and a holy entourage of cardinals, servants, and advisers. He brings the smell of incense and—more often than not—strong red wine. But most noticeably, a pope brings the feeling of fear. This was especially true for Julius II. Everyone was nervous. It was a cold morning, and yet, there was Perugino patting sweat off his balding head. Lorenzo Lotto kept pulling his collar away from his throat. Bramante mimed *"take a deep breath"* to Bramantino. (Do you still think of Bramante as my unwavering protector? No. He was always on the side of "Little Bramante.") Sodoma was so anxious he was breathing hard as a dog after a hunt. I, too, felt nervous but stood firm and kept my hands clasped behind my back with an easy smile, even after I saw Cardinal de' Medici and Michelangelo, leaning in a doorway near the back, looking annoyingly relaxed.

His Holiness, wearing white cassock and skullcap, extended his elbows. "We're ready."

The papal entourage rippled as a cardinal I didn't recognize—tall and wiry, with a walk so slow and purposeful that he projected the confidence of a royal—took the pope's left arm. And then, guess who stepped up to the pope's right hand. No longer pregnant, but still in her widow's weeds. That's right. Felice della Rovere Orsini. I leaned over to Sodoma and whispered, "Why is she here? Aren't new mothers usually home with their babies?"

Sodoma hissed, "Don't talk about that."

"Why not? Was it a girl? Fathers should really learn to appreciate daughters."

"Worse. A boy."

"What?"

Out of the corner of his mouth, he said, "It died. The baby boy died."

"*Che?*"

"She lost the baby."

A memory flashed: Felice hanging off that scaffolding, mouth open, face white, belly swaying above the marble floor. How careful had I been when I pulled her back up onto that platform? Did the wood scrape her stomach? Had her breathing come too quick? Did her heart beat too fast? I accidentally caught her dark gaze. Her eyebrow arched. If she'd hated me before . . .

"We shall begin in this room," said the pope, banging his walking stick.

I reminded myself to breathe.

Bramante called out, "Masters stand under your sections," and Bramantino, Lorenzo Lotto, Luca Signorelli, and Pinturicchio moved to four separate corners of the first room.

The first ceiling was a staid design of geometric shapes, flowered spirals, cherubs, and grotesques. No story, no grace, no inventiveness. Their sections had clearly been dictated, too. However, despite the prosaic designs, Bramantino's figures were quite good—even the cherubs' hands and feet were realistic, and you know how difficult hands and feet can be. I expected to find the pope nodding, but instead, he was frowning as that mysterious cardinal whispered in his ear. The pope said, "We declare it unremarkable."

Unremarkable? I blushed on behalf of Bramantino, who dropped his head.

The pope flicked a ringed finger at the next artist. "And you are?"

"Lorenzo Lotto from Venice, Your Holiness," he replied, hairline damp with sweat.

Lotto's colors were the best of the four—not surprising for a Venetian—but again, the mysterious cardinal whispered, and the pope frowned. *What was going on?* His Holiness said, "I agree with Cardinal Alidosi: satisfactory."

Cardinal Alidosi, Cardinal Alidosi, I silently repeated, committing that name to memory.

"*Grazie mille,*" Lotto said, bowing several times. "Your Holiness does me much honor."

I tucked my hair behind my ears. Were we expected to grovel at such . . . could you even call that praise?

"Now for the Tuscan." The pope moved under Luca Signorelli's section of ceiling. I looked up. Signorelli was a talented painter, but his section was far too cluttered to be confused with perfect. Yes, his foreshortening was genial, but his brushwork and features were—I hate to say it—*dated*. Signorelli was what? Nearly sixty by that time? The pope would be well within his rights to excoriate him. However, after that cardinal whispered—this time with smiling eyes—the pope declared, "Now *this* makes a pontiff proud!"

Who was this Cardinal Alidosi who held so much sway over the pope?

Next, the pope's eyes softened—as well they should—when alighting on the beauty of Pinturicchio's brushwork. With a dark glare, Cardinal Alidosi leaned in to whisper, but the pope waved him away. I was about to exhale—at least Pinturicchio would be spared humiliation—when Felice leaned in to whisper to the pope. This time, His Holiness nodded at *her*. "Bernardino di Betto?" I'd never heard anyone call Pinturicchio by his given name. Never. "We hear

you've been frequenting a certain villa owned by that Imperia woman," the pope said.

My ears perked at that name. *Imperia.* That was the name my Margherita had dropped.

"A man needs a release at times, Your Holiness," replied Pinturicchio, trying to give off a feeling of ease, although his cheek reddened. "I am, after all, not a priest."

We all tittered. Seeing a courtesan certainly wasn't a reproachable sin—not in any court I'd ever attended.

"But," the pope said, his gaze uncomfortably dark. "We heard that you have brought such a lady into the halls of this very palace."

Perugino's hand flew up over his mouth. Cardinals shook heads. Lorenzo Lotto dropped his face into his hands. I could imagine how a pope's painter openly bringing such women into the Vatican could be a scandal, but I didn't expect what came next: "You're relieved of papal service," said the pope. "You're at liberty to collect your things."

My heart hiccuped, but I tried my best to keep my face calm. The apartments fell heavily silent. Somehow, Pinturicchio found the will to bow. "Thank you for the opportunity to serve my Church, Your Holiness. Your will be done."

Felice whispered in her father's ear again, and the pope added, "On your way out, please remember to reimburse the treasury for all materials used."

"Yes, Your Holiness," said Pinturicchio. "It shall be my honor."

I don't know what happened to the color of my skin, but at least I refrained from slapping a hand over my mouth in horror. We had to pay back what we'd used in materials if we were fired? How much gold leaf had I slathered on that

tiny *tondo*? A year's—maybe two years'—salary? I'd heard rumors about merchants who shirked on debts to the pope. A season in the belly of Castel Sant'Angelo was the most promising scenario.

The pope led us into the library, and my stomach lurched with fear at what he would say about *my* section of ceiling, but then he waved us onto the next room. "We'd like to see Perugino next," he said, delaying my verdict for a few moments. (Pinturicchio stayed in the first room to gather his brushes. Oh, how I wanted to tell him that his Borgia apartment frescoes had given me such comfort recently, but I couldn't talk about such things in front of the pope, and after that day, Pinturicchio left Rome, and I never saw him again. Now, he's buried in some grave up in Siena, I believe, and I don't think telling his sarcophagus would have the same effect.)

I don't know, exactly, what happened under Perugino's ceiling. I know there was looking and pointing, and the cardinal whispered and there were praises all around, but my ears were ringing too loudly to hear specifics.

"Now for the final room," the pope said.

As Felice walked by me, she raised her chin. I took it as suggestion of a hanging. Wouldn't you? *Uno, due, tre* . . . Oh, what was the point in counting? I was a dead man.

By the time I entered the room, everyone was grimacing at the ceiling. The pope looked as angry as if the French army had invaded Rome. I looked up. Thank Mary that they were standing under one of Sodoma's sections—Adam and Eve eating from the Tree of Knowledge, but you've never seen perspective so poorly managed. The pope scrunched his nose. Cardinal Alidosi's mouth pressed into a firm line;

he didn't even need to whisper. His Holiness said, "And where's your section, Santi?"

Every eye turned on me.

I raised my arm and pointed to the *tondo* above me.

As the pope's face turned slowly toward the ceiling, my temples pounded so hard that it felt as if Felice had already fitted a vise. That's when Cardinal Alidosi—face painfully pinched—leaned into the pope's ear. I felt dizzy; maybe if I fainted, then His Holiness would step over my lifeless body and forget to fire me.

Then, the pope raised his hand, silencing the cardinal.

I inhaled with hope.

But then Felice leaned in, and my stomach turned again.

You won't believe what happened next. His Holiness raised his other hand and silenced her, too. He stepped forward to stand directly under my *tondo*, and do you know what he did? He smiled. *Smiled!* Gums and all. Bramante gave a proud wink (as though he'd supported me, not Bramantino, all along). Perugino stared at his shoes. A thrill rose out of my stomach, through my chest, up my neck, and rushed between my ears, but then . . .

Felice said, "The young painter's style does not fit with the others."

Cardinal Alidosi seconded, "She's right. The young Urbinite's work will stand out too much and destroy the flow of the rooms."

I should've responded, but my tongue refused to parry.

"I've taught the boy," Perugino added. "And I can attest that while he's good at copying, he's never been able to adjust to match his collaborators."

I'm fairly certain that's when I stopped breathing.

"Adjust how, Perugino," came a voice over the crowd. "By lowering his work to yours?"

One of the pope's eyebrows raised, and he turned—with the rest of us—to stare at the latest speaker: Michelangelo.

"That young painter's too nice to say it," Michelangelo continued, striding forward, the crowd stepping out of his way like waves before the prow of a galleon. "But the only reason his work stands out is because it's so much better than the rest of this outdated dribble. Are we to silence those who pull us into modernity? Prize safety over innovation? You can't fire someone for being *too* good, Your Holiness."

Gasps swept through the crowd fast as Hermes. During my lifetime, Florence had always been at the top of the pack culturally, artistically, financially—perhaps not militarily, but everything else. I'd never heard any Florentine give any credit to any citizen of any other city-state, duchy, or kingdom. And why should they? What would they gain by praising such lowly competitors? We were the ones chasing them.

Bramante—the proudest Urbinite in the room—immediately pounced on the Florentine's misstep. "So, you, Michelangelo Buonarroti of Florence, are willing to admit that the best painter in the Vatican is Raphael Santi of Urbino?"

Michelangelo pulled back his shoulders. "He's the best in these rooms, but he'll never be the best in the Vatican. Not as long as I'm here."

Pope Julius rapped his walking stick against the marble floor and, loud as Zeus's thunder, declared, "I agree with Cardinal Alidosi."

Everyone fell silent. I dropped my chin. *What good was keeping up appearances now?*

"The young man's work is far too distinctive," the pope went on. "As long as he's painting beside the others, there will be no flow, no harmony, and no consistency in these rooms."

Cardinal Alidosi straightened his collar smugly. Felice flashed a smile.

"Therefore, Raphael Santi of Urbino, I have no choice but to fire . . ."

Bramante shook his head. Perugino widened his shoulders. Michelangelo shoved his hands deep into his pockets.

"Everyone except you," said the pope.

My breath caught. *What?*

"*Cosa?*" Perugino said, echoing my thoughts.

"Raphael," the pope said, turning his gaze on me. In this light, his eyes no longer looked black as onyx, but a warm tawny brown. "You have put the loveliest woman I've ever seen on our ceiling, and we want more. These rooms—all of them . . ." He held out his ring. "Are yours."

Cardinal Alidosi's lips parted. Felice gave me a look—anger or awe, I couldn't tell. Luckily, my courtly instincts took over, and I dropped to my knee and kissed the holy ring. "*Grazie*, Your Holiness, for putting your faith in me."

He said, "You can see the treasurer to collect your salary."

I exhaled. I would eat tonight.

"And the others are dismissed."

Perugino slumped down hard on a stool. Sodoma squeaked. Lorenzo Lotto spit, this time not at my feet, but at his own.

I didn't know whether to applaud, cry, or hug Michelangelo. (Can you imagine if I'd hugged him? Have you ever tried? *Oh*, what did he do? Punch you, scream, run away in holy terror?) I didn't do any of those things,

sì certo. I stood politely as everyone gathered to offer their congratulations.

As we all filed out of the rooms, I chased after Michelangelo. *"Maestro,* thank you," I said. "I can never repay you for . . ."

He whirled on me. "You think that had anything to do with *you?"*

I blinked hard. Twice. "Uh . . ."

"That had nothing to do with you. It's your country-man Bramante who seems to think when someone is too good they no longer deserve a job. That was for him. I'll die before I let an Urbinite beat a Florentine. Die." He turned and marched away.

As I tucked my hair behind my ears, the pope—with Felice on his arm—sidled up next to me and grinned after the departing Michelangelo. "Why, this is shaping up to be a wonderful competition, isn't it?" The pope said with a musical lilt. "A Florentine in the Sistine, and an Urbinite in my apartments. May the best painter win."

Chapter XXII

As soon as I collected my first payment—a handsome hundred ducats tied up in a fine leather pouch—what did I do? Eat a lavish meal? Go to the barber? Secure a proper set of rooms? Of course not. I asked around about where I might find a certain lady.

"Don't even speak that name inside the Vatican," admonished Bramante. "You saw what happened to poor Pinturicchio."

"I'm not going to march one of the ladies through the palace; I only want to visit."

He shook his head but allowed me to join him and several cardinals headed that way, including Cardinal Riario. (You remember him: Fafel, the man who greeted me when I exited the corridor connecting Michelangelo's workshop to the Vatican. The gossipy fellow related to the pope, my duke . . .) Now, if I were as charitable as legends make me out to be, then I might skip the story that Cardinal Riario told me on the walk over, but I find it instructive to know why he didn't like Michelangelo and . . . *beh*. I also find it funny.

"A few years ago," the cardinal told me. "I bought a marble

statue of a sleeping cupid promised to be from Ancient Rome. It had the right heroic build, proper boreholes in its hair, and was scuffed up as though it had been buried for hundreds of years. It was only after I laid down a hefty sum that I learned it was not, as advertised, an ancient artifact, but a fraud by some precocious Florentine sculptor—you guessed it—Michelangelo."

I laughed. "Michelangelo began his career as an art forger?"

The cardinal nodded. "I graciously forgave the prank and brought the sculptor down to Rome—even paid for his passage—and hired him to sculpt another statue. Oh, but Raphael, that man was mocking me. The *Bacchus* he carved was fat and slovenly, mouth open, eyes lulled with drink. There was no heroic grandeur to the thing, so, of course, I refused to pay and dismissed him." He put his hand on my shoulder. "I feel responsible for bringing that lout to Rome, so if there's ever anything I can do to help you . . ."

That notorious villa is closer to the Vatican than expected. (Stop acting so coy, you know where it is. In Piazza Scossacavalli. The villa with that frieze of a nude Venus cavorting in the countryside . . . Yes, that one. I painted that frieze a few years ago—did you not know?—in appreciation of Imperia's exemplary goods and services.) That night, as always, the villa was bubbling with music and merriment. As I jogged toward the entrance, Cardinal Riario chuckled. "When I was young, patience wasn't my cut of veal, either."

The women inside were as intoxicating as poppies, and a swarm of red-hatted cardinals buzzed like bees from petal to petal. Cardinal Riario introduced me to the lady of the villa—tall, curvy, amber hair tumbling down shoulders, dress embroidered with gold thread. She flicked her fingers,

and I showed her the contents of my pouch (*Beh*, I mean that literally—my money pouch). Her name was Imperia. No last name or city of origin, simply *Imperia*. (I'd like to get away with that one day, wouldn't you? Forget the "Santi" or "from Urbino," just *Raphael*!) I complimented her on the elegant *disegno* of the frescoes adorning her ceilings, and she replied that most men were more taken by the color of her carpets.

She guided me through the dining room, music hall, reading salon (her library is an impressive collection of bound books in Italian *and* Latin) and inquired after my *preferences*. I said, dark hair over light; witty rather than serious; large eyes, sparkling, the color of dark peat found along riverbanks. As Imperia pointed out suggestions, I batted back excuses: *Hair too dark, that one too light, lips too pink, what kind of lady has such short fingers?* I eventually spotted Margherita Luti through a half-open door, bare feet dangling in a large, steaming bath. She was engaged alongside several other women, entertaining a man. I jerked my chin. "She's a strong cup."

"From which someone else is already drinking," Imperia replied. "Perhaps I can interest you in this spicy red over here."

I waited long enough to avoid suspicion before extricating myself from *signora*'s clutch: "I'm in need of a privy." I doubled back to that door. Margherita's back was to me—I couldn't see her face—but I did have a full view of the man at the center of that bouquet. He was lying along the rim of the bath and wearing a *yellow dress* he'd apparently borrowed from one of the courtesans; it was too small so didn't tie up all the way, showing off his chest hair. It had ruffles around the collar, full sleeves, and a long flowing skirt. I'd never seen

such a man before, although I'd read about them, *sì certo*. (I don't judge; if I had an inclination to don ladies' clothing, I'd try it, too, if for no other reason than to understand women a bit better.) But it wasn't the dress that shocked me; it was his face, for I recognized him.

That was *Cardinal Alidosi*, the man who had spoken against me in the papal apartments. Did the pope know that his trusted adviser spent his nights, dressed in women's clothing, in that notorious villa?

Beh, I didn't have time to worry about such things because that's when Margherita Luti spotted me, slipped across the room, and grabbed the door as if to close it on me. I clasped my hands behind my back to resist my instinct to hold that door open; my mother always taught me that if a woman wants to slam the door on your nose, you must let her. But Margherita did not slam the door on me; instead, she leaned her hip *into* the doorway. "While I'm happy to see you, puppy, I'm already engaged for the evening."

"Ah, then, since I've sworn on every star in the sky to spend my days granting your every wish, I shall leave you— as is your command—despite my own desires." I took my time offering a deep bow.

Oh, the way she brushed my hair out of my eyes . . . "*Dai*, he won't notice if I'm gone for a moment." She slipped out the door and into the hall.

"If you went missing, I'd notice in a blink."

She shook her head but offered her elbow.

Up in Margherita's room—no bigger than the pigment closet in my old Florentine workshop—she closed the door behind us and started untying her bodice. "We only have a minute."

I took her hands and said, "Spending only a brief time

on such divinity would be worse than spending only one day painting an altarpiece. I prefer to wait until I have unlimited time, my lady." (And if you believe that, then I have an ancient statue of a sleeping cupid I'd like to sell you.)

As she relaced her bodice and I straightened the trifles on her cabinet—hair combs and tweezers, vermillion for lip pigment, and powders made of white lead and mercury—I told her how I'd unveiled my work that day, and how the other painters were fired, and I'd been hired to decorate the papal apartments by myself, and how the pope told me that he wanted each of the four walls of his library to correspond to a different subject of his books—one for Religion, one for Law & Virtue, a third for Poetry, a fourth for Philosophy—and how I wanted to use one of those walls to finally paint the world's first perfect painting.

She said, "Where would you even start to accomplish such a thing?"

I opened my mouth to tell her that I would start by perfecting my fresco technique on the ceiling, and then perfecting composition and perspective on the *Religion* wall, shadow and balance on *Law & Virtue*, color and rhythm with *Poetry*, and then put it all together on my *Philosophy* wall, all painted directly into wet plaster in perfect *buon* fresco—not a *single* mistake corrected in *a secco* on the dry wall—with every brushstroke perfectly applied, and thereby create a painting so perfect that it would bend the Vatican, bend the city, bend the peninsula, bend the entire world toward beauty. But instead of saying all of that, I took a deep breath and said, "Where do I start? I have no idea."

Chapter XXIII

The pope ordered all the other frescoes in his papal apartments chipped off the ceilings to make way for mine, but I insisted on saving the best: Sodoma's panel of Marsyas challenging Apollo to a duel on a lute, *si certo* (remember, *tickle, tickle*? Still makes me laugh); many of the grotesques that Lotto, Signorelli, and Bramantino had put on their ceiling; and every part touched by Perugino's brush. (Regardless of what the *maestro* may think of me, he *was* my teacher.) I saved those paintings because they deserved to be saved, but the act also helped me in an unexpected way: it made me such a hero that some of the other fired painters returned and offered to join my workshop as assistants. Even though the pope had fired them, His Holiness didn't prohibit their return: "We have no opinions on assistants; we leave such minor decisions up to the *maestro*." So, I welcomed into my workshop the Frenchman Guillaume de Marcillat (originally trained in stained glass, so a brilliant colorist), Sodoma (when he agreed to join, he negotiated a higher salary; he's not as foolish as you might imagine), and yes, even Lorenzo Lotto (who used to spit off the scaffolding at me every day).

"I hear Michelangelo's using *pozzolana* instead of sand in his plaster mix," Lotto said one day, as he added a ruled grid over the top of one of my preparatory drawings.

"*Je suis surpris* he's not using marble dust," chided Guillaume, using a piece of chalk to enlarge one square of a preparatory drawing onto a larger page by a factor of five.

"Maybe Michelangelo knows something we don't," Sodoma chimed in, as he ran a tracing wheel along an already-enlarged drawing, incising each line of that drawing with thousands of tiny holes. "Maybe we should try it, too."

"Let Michelangelo use volcanic ash if he wants," I said, using a bag of charcoal to pounce dust over the incised holes of another cartoon to leave an imprint of the design in a patch of wet plaster. While the others were working on the floor, I was up the scaffolding preparing to paint a new *giornata*. "We'll stick with river sand." The plaster mix we were using for the ceiling had been drying into an impeccably smooth surface. "We can't waste time chasing trends. There's nothing more perfect than perfect."

I saw the others exchange looks, but no one argued. They never argued back then. No matter how often I told them not to call me *maestro*—that we were all *maestros* in those rooms—they treated me like their boss. Is there anything more tedious?

I would've forgotten all about our conversation about Michelangelo's plaster mix except for what happened a few days later. I'd just finished the final *giornata* of the ceiling when Bramante burst into the library. "Your Holiness, Michelangelo has ruined the Sistine."

Pope Julius and his cardinals looked up from their war plans. (His Holiness had moved his desk into the library, saying that my happy countenance relieved his stress,

especially during arguments with military advisers.) As I wiped my fingers on a rag, Michelangelo stormed into the apartments, face purple as pomegranate. By the looks of him, he hadn't fed himself in weeks. Or bathed. "I told you, I'm no painter."

As Bramante and Michelangelo yelled over each other, assistants tumbled up to the door behind them. I slipped down the scaffolding and sidled up to Michelangelo's head assistant, Francesco Granacci. "What happened?" I asked.

"The fresco mix was wrong. The plaster's growing mold. He's going to have to tear it all down and start back over. Three months' work, gone."

"Did he use ash instead of sand?"

Granacci looked alarmed. "We were supposed to use ash?"

"If he didn't use ash, what did he use?"

"A Florentine mix."

"What?"

Granacci searched my face. "That's what everyone told us to use."

I pushed past the others and sprinted out of the apartments.

Work inside the Sistine had stopped in a rush: partially pulverized pigments tumbled out of tipped mortars, wooden spoons bobbed in buckets of lumpy plaster, a half-eaten crust of bread soaked up a puddle of red wine. I grabbed a ladder and climbed up to the scaffolding. The day's light was fading fast, but once my eyes adjusted, I easily found the platform from which he had been painting, littered with drawings, rags, and brushes. He hadn't started painting at one end of the chapel, which would've been a logical place to begin, but between the *second* set of windows. *Why start*

in such an out-of-the-way place? Probably because his fresco was . . . *lousy*. He seemed to have rushed in with the hope that he'd figure out what to paint while painting. I picked up a few drawings off the scaffolding floor. The overall design for the ceiling was extraordinary. Elegant architectural elements divided the awkward space into a series of neat panels and spandrels. Each panel along the spine would contain a scene from the Old Testament, while prophets, sibyls, and ancestral families filled each side and lunette. There had to be—what? Over a hundred figures planned? The overall scheme was complex and dramatic—brilliant, even—but the individual panel above me was . . . *uffa*. A sea of figures crawled over one another in a chaotic mess. Was that a tree? And a . . . what? A boat. No. *An ark*. Was this fresco supposed to depict Noah's ark during the Flood? The composition was so cluttered, it was nearly unrecognizable. The figures were sculptural and powerful—I'll admit—grotesquely twisting and straining as they fought against the rising tide, but the overall composition was . . . Let me put it this way: Michelangelo should've been on his knees thanking that mold for making him tear it all down and begin again.

Speaking of mold, I'm not exaggerating when I say there were fields of crystalized salts growing across that fresco. I ran my finger along the ceiling, and pigment flaked off in my hands. There was no way any painter could've missed this. Had Michelangelo grown the mold on purpose, so he could throw the competition, let me win, and return to his marble?

I heard Michelangelo's clunky work boots and a herd of other footsteps climbing the scaffolding. I didn't have any place to hide, but luckily, His Holiness ascended first. If Michelangelo had found me up there alone, he no doubt

would've tossed me over the edge. But, already in trouble with His Holiness, all Michelangelo could do was throw me a nasty glare. The pope looked up at the ceiling and grimaced. Cardinal de' Medici rubbed his face and muttered, "Good God," and Cardinal Riario said, "Did you do this on purpose?"

The way Michelangelo shook his head told me that he had not intended on ruining that painting. It really had taken him three months to notice that mold. *But how?* That paint screeched so loudly that my ears hurt. Perhaps he thought it was supposed to screech like that; perhaps it reminded him of his talking marble. That vein over Michelangelo's left eye thumped teal. "I've told you that I'm not a *Matthew-Mark-Luke-and-John* painter!" (He did *not* say the Gospels there.)

"It's horrendous, Your Holiness," sputtered Bramante. "And not only has his paint molded, but he threw out my designs without permission. He's disrespectful. He should be . . ."

The pope sniffed. "We gave him permission to throw out those designs."

My ears perked. *Michelangelo had been allowed to throw out Bramante's designs?*

"The original designs were terrible." Michelangelo bit his knuckle like a curse. "A tedious pattern of geometric shapes and figures. There was no story, no feeling, no glory. This will be better. It will be . . ."

"Your Holiness," interrupted Bramante. "This fresco is awful, proof that you must return this wretched Florentine to Florence. Right now. Without *my* marble."

As His Holiness looked up at the ceiling, Michelangelo kicked papers off the scaffolding. "Michelangelo, we . . ." The pope sounded tired. "Bramante is right, we can't have this

on our ceiling. This is . . . We fear we have no choice but to dismiss . . ."

For years, I used to stay awake at night repainting that moment in my head, not composing it as it *was*, but as it *should've been*. What might my life have been if only I'd quoted Plutarch or Bonaventure and dashed off a drawing of *Adam's Creation*? "*Magnifico, Raffaello, eccolo!*" the pope would've said. "*The ceiling is all yours.*"

When I was a boy—I had to have been, what? Seven?—I'd never seen a beggar before. There weren't any in Urbino, as we were a small enough city to take care of our own. But one spring, my parents took me to Venice. My father was picking up pigments from the best *vendicolori* on the peninsula, and he thought it would be beneficial to expose me to all those colors. (We took a boat out to Murano, too, to watch the glassmakers work the furnaces, making emerald green goblets and blue vases with threads of gold and glass flasks painted with jesters and kings. That was the first time that I realized there were other crafts like painting with studios and assistants, special tools, special processes, special languages . . .) We were walking back to the inn after supper—over a little curved bridge, my father's torch reflecting in the canal—when my mother dropped a coin in the hands of a beggar woman wearing tattered clothes, holding a baby wrapped in a muddy-brown woolen blanket. I whined, "But I could've used that to buy blue," and my mother bent down and told me, "It's nice when you have things that you want, but only after everyone else has what they need."

So, there I am, in the Sistine, silently arguing with my dead mother: "But Mamma, I *need* that ceiling." "*Yes, but, Michelangelo* needs *his marble, too.*" And I'll be *blessed* if I couldn't see a way to get us both what we needed, so, out

loud I said, "Your Holiness, you're missing an opportunity if you dismiss Michelangelo today. This painting may be a mess, but it's proof that he's a sculptor. A painter lays out the scene first because that's what painting needs; only once we find our composition do we populate it with figures. But Michelangelo will always focus on the people first, which is what you want in the sculptor of a great tomb filled with forty marble figures. You don't have to choose between a tomb and a ceiling, Your Holiness. You can have both. Him marble, me paint."

Did Pope Julius nod? Was that a gleam in his eye? Was he about to give me the Sistine, send Michelangelo back to his marble, give us both what we needed? He inhaled to speak and . . .

"I was wrong, Your Holiness," said Bramante. "Michelangelo should keep the ceiling."

"What?" I'm not sure which one of us said it or if all of us did.

"I overreacted," Bramante continued. "No one should lose employment over such a minor setback. Anyone can provide Michelangelo with a proper plaster recipe. Santi is a wonderful craftsman, so, yes, it will probably take a miracle for Michelangelo to beat him in paint, but don't you—and this chapel—deserve a miracle, Your Holiness?"

I don't need to tell you that off that line, the pope demanded that Michelangelo keep the ceiling and make him miracles, now do I? A few moments later, I chased down Bramante in the hall. "*Maestro*, why did you do that? The pope was about to hand the Sistine to me."

"And he was also about to send Michelangelo back to his marble. Did you see that ceiling, Santi? Even when he does get the right plaster mix, that composition was a disaster.

He's going to fail in the most magnificent manner, and when he does"—Bramante patted me on the back—"you'll get his ceiling, and I'll get his marble."

As Bramante strode down the hall with a self-satisfied step, my shoulders dropped. But it wasn't Michelangelo's failure weighing me down; it was my own. I'd spent months perfecting plasters and techniques—done it all the right way—whereas Michelangelo had thrown himself in without the slightest thought, and yet, somehow, that sculptor still had the Sistine?

I walked back into the apartments and looked up at my own ceiling. It was pretty. Nice. Yes, my technique was perfect, but technique alone would never be enough. So, as the pope and his cardinals came back into the room—arguing about whether to keep the papal alliance with the French king or join with the Venetians against him—I told Lotto that he was in charge of applying the gold leaf and sat down with my sketchbook to begin working on my designs for the first wall I would conquer: *Religion*. Michelangelo had no feeling for composition, no delicacy, no style, no grace. And yet, he was the one throwing out papal designs and inventing, while I was busy perfecting a plaster mix like some common craftsman. It was time for me to stop being a technician and start being a painter.

Chapter XXIV

Summer 1509

How am I supposed to make a perfect painting if I can't even settle on a decent composition?" I said during one of the rare moments when the pope was out of the room, so I could talk freely with my men. Having the pope's desk in the library was a compliment, but also a challenge. You want patrons to believe that masterpieces flow from your fingers easy as wine down a fat friar's gullet, not that it's a struggle to draw even a single usable line.

"I liked the idea of using Masaccio's *The Tribute Money* as inspiration," said Lotto, as he unrolled a large scroll of paper that we would eventually use for the preparatory cartoon for our *Religion* wall. *Eventually.* I wished Lotto would stop fiddling with that paper; it only reminded me how far away I was from needing it.

"*Oui, oui, The Tribute Money,*" seconded Guillaume, grinding pigments that—at this rate—I wouldn't need for months.

I shook my head. Although the pope had agreed to let me throw out Bramante's designs and use my own for the walls, he'd dictated that my *Religion* fresco was to be a scene

of the *Disputation of the Holy Sacrament:* fifty or so religious figures standing around talking about the mystery of the Eucharist. How was I supposed to make a *conversation* interesting? "But if I copy the Masaccio, I'll leave the upper half of the arch empty."

Sodoma, feeding crusts of bread to the bird on his shoulder, said, "So?"

Before I could reply, Lotto answered for me in a mocking tone, "So, then it won't be perfect."

The pope and his advisers came back into the room—arguing about Venice or the French, I don't know what, but it wasn't conducive to deep thought—so I tossed Lotto my smock and said, "You're in charge."

Outside, it was hot and humid—one of those awful summer days in Rome when the sun is so bright that you think you'll melt fast as candle wax—but the heat felt good. That past winter and spring, it had rained like washbasins, as if Michelangelo beginning the Sistine with a painting of *The Flood* had reminded God that there was plenty of ugliness that still needed washing away. A chill took hold. The ends of my fingers wrinkled with wet. Frescoing's impossible in all that rain; the plaster turns to cold pottage. Not that it mattered because I'd spent that entire winter, spring, and the early weeks of summer not painting, but making hundreds—no, thousands—of sketches. And yet, here I was at the end of June, no closer to starting to paint than I'd been in January.

On the other hand, Michelangelo, I'd heard, had identified a good plaster mix and started painting. Again. He was starting for the second time before I could begin my first. Of course, no one knew how progress on the ceiling was coming along, as he'd hung tarps beneath his scaffolding to

hide his work. He also threw planks at the heads of anyone who tried to climb up for a look—even at the pope. *Planks!* At the pope's head. Can you imagine? "You'll see it when I'm finished," he would bellow.

I walked back to Piazza Scossacavalli, where I'd recently secured new apartments with my papal salary. (Thank Elizabeth that I didn't have to sleep in the Borgia pope's old apartments any longer. They'd treated me well, but they were cold, and I swear I could hear ghosts whispering.) I nodded hello to my staff and ascended the stairs. (While we're on the subject, yes, my rooms are nice, but Michelangelo's claim that I live like a prince is exaggerated. I am—as any good courtier should be—a paragon of moderation. Yes, I like nice furnishings and insist that window treatments be of pleasing colors, but it's not as if I'd bought some ostentatious villa and filled it with gold leaf. My rooms were comfortable, but not princely, no matter what he says.) Up in the large salon I used as my private studio, I closed the door. Unlike the papal apartments, which were always chaotic—assistants scurrying in and out and the pope and his advisers always leaving war plans strewn about—my private studio was immaculate: brushes in neat rows, jars of pigment organized by color, and drawings catalogued in tidy stacks. Hanging on walls and propped on stands were my paintings—Madonnas mainly—which I worked on in my spare time to quiet my mind.

But today, I didn't have time for Madonnas.

Evangelista had recently shipped yet another trunk down to Rome, containing some of my old sketchbooks. I hadn't had time to organize them yet and thought the activity might provide a useful distraction. I found drawings from when I was young—awkward but with a hint of

beauty in some—and notebook after notebook from my years in Perugino's studio: copies of every one of the *maestro*'s masterpieces, but also copies of paintings by Signorelli, Piero della Francesco, Castegno . . . Then came the years in Città di Castello when I started stepping into my own style. I spent so long marveling over a stack of preparatory drawings for my Baronci altarpiece that darkness fell. I lit candles. Next came piles of drawings from Florence: copies of Leonardos, Botticellis, Donatellos, and, yes, Michelangelos . . . There were copies of one of Andrea della Robbia's blue-and-white ceramics—a delicate Crucifixion with beautiful winged angels—and I remembered Sarto and me sitting at its base, trying to see which one of us could copy it best. That's when I flipped to another page and . . .

Have you ever been to the hospital of Santa Maria Nuova in Florence? It's the oldest hospital in all of Tuscany. I hope you're never in need of its services—I wouldn't wish sick on anyone—but you should visit sometime, because there's a wonderful collection of art inside, including a detached fresco of *The Last Judgment* by Fra Bartolomeo. It's an obscure painting, so I'm not surprised you haven't seen it. I, myself, had forgotten all about it until I came across my copy of it. I flattened out the paper and pulled a candle down close to see. In the top half of Fra Bartolomeo's altarpiece, Christ sat in a glorious heaven thick with clouds, surrounded by angelic figures, while in the bottom half, earthly figures writhed on terra firma . . .

My heart tapped fast, and I took out a fresh piece of chalk. Pull up sleeves, roll wrist, start to draw. Whereas Bartolomeo's space felt constricted—figures pressed up against the picture plane—I used perspective to give the scene a grand scope. I removed the cross-bearing angels

from the middle space to clearly delineate between the earthly realm and the heavenly. On Earth, my figures didn't scream and cry for release from damnation like Bartolomeo's but gathered around a central altar, in civilized groups, rising and falling in a rhythmical debate. Above, in heaven, I copied Bartolomeo by placing Christ in a large, golden halo and surrounded him with saints, angels, and clouds— heaven triumphant over the chaos of Earth—but I added a large semicircle of heavenly light to the top of the arch that I would eventually slather with gold leaf. It took me all night, through the next morning, and late into the next afternoon, but eventually, I sat back and looked at my drawing: the composition was clear, yet regal; dramatic, yet harmonious. Perfect. This was it. This would be my design for my *Religion* wall.

I got up and splashed water on my face. I hadn't slept much in the last few days so went back to my bedroom to nap. I was sound asleep—dreaming of gold leaf—when a rap on my door jolted me awake. I sat up, confused and bleary.

"I can get you up the scaffolding."

I rubbed my eyes. The room was dark; had night fallen? Who was in my doorway, holding a torch? *"Maestro* Bramante? *Buongiorno,* I . . ."

Bramante grabbed a jacket off the back of my chair and tossed it to me. *"Andiamo."*

I got up and checked my appearance in my old mirror. My hair was disheveled, I hadn't had a shave in two days, and there were red creases along my cheek. "Where are we going?" I pulled a wooden comb through my hair.

"I can get you up Michelangelo's scaffolding."

All I could picture was Michelangelo charging at me

with a cocked marble hammer. "Why would I want to go up there?"

"To see what he's painting, so that you can best it."

"I've already seen what he's putting up on that ceiling. Does his *Flood* jangle a bell? If you think I can't beat that panel of slop, I might as well quit now." I crossed back to bed. "Now, if you'll excuse me, I'm tired and have already lost the day, so . . ."

He was across the room faster than I would've thought capable for a man his age. His grip on my shoulder was tight. Architecting must keep a man fit. "He's improving. The rumors about the new paintings . . . What's going up now is . . . you need to see it," Bramante hissed with a panicked look that I recognized: desperate, fearful, awed, the same feelings I had after seeing Michelangelo's city hall cartoon up in Florence.

I grabbed my jacket and said, "*Andiamo.*"

Chapter XXV

S he was a gargantuan female figure—twice as tall as I, even though she was sitting down. She looked like a sculpture, but when I touched her, she was flat. I never would've thought to mix those colors—that sea green gown with highlights of yellow, terra-cotta orange drapery, sky-blue cape, and gray head covering should've clashed— but together, they were extraordinary. She was sitting in a painted niche holding a scroll, and her eyes were wide and earnest, looking off to her left, lips parted as if spotting some future menace. She was afraid, she was knowing, she was a sibyl—*Delphica*, according to the nameplate. My mythology knowledge is acceptable, but I sometimes confuse mystical seers. I believe the Delphic sibyl is a daughter of a sea monster who predicted the Trojan war in riddles, but don't quote me on that. From so close to the fresco, I could see the lines separating each *giornata*. *Uno, due, quattro . . . otto . . . dodici?* It had taken him *twelve* days to paint that single figure? Twelve? Every hour was worth it. Under Michelangelo's brush, she was sculptural, urgent, alive.

While Bramante stayed on the floor to keep watch, I

propped my torch in a burned-edged bucket and sat down with my sketchbook to copy. Michelangelo's two completed pictorial panels—one of the repainted *Flood* and the other a scene of Noah's sons finding him naked and drunk—were both cluttered, unbalanced, ugly. But when Michelangelo focused only on a single, large-scale figure . . . *Che roba*.

A *bang* jerked me out of my copying. I said, "What's that?"

"While I'm gone, fix that fresco." Bramante's voice echoed from far away. Was he down on the floor?

"What?" I called.

"Not the one you're under," he called. "The one of Zechariah. Over the entrance wall."

I carried my torch to the end of the scaffolding until I found the prophet named on the ceiling as "*Zacharias*." Minor prophet from the Old Testament. Predicted the rebuilding of the Temple, I believe. That figure—like its sister the Delphic sibyl—was superb: a large-scale prophet sitting in profile, reading a book. He was full, sculptural, real . . . "What about this fresco do you think needs fixing?"

"Whose face is in that painting?" That was not Bramante speaking; that was the voice of a woman. I peered over the scaffolding, but I was too high up to see anything except a black void. The woman called up again, "Whose features did Michelangelo use for Zechariah?" That's when I recognized her voice: *Felice della Rovere*.

I raised my torch toward that figure on the ceiling. Bald head, heavy-lidded eyes, large bell of a nose. "Pope Julius?"

"Pope Julius," she repeated with a tone of confirmation. "Michelangelo is mocking my father."

"Ah . . ." I stammered. "It's a time-honored tradition to include a portrait of the patron in the work. This is an honor, not an insult."

"And do you also think it's an honor"—I didn't have to see Felice's face to hear the sneer in her tone—"for that boy to be flipping my father *the fig?*"

I squinted back up at that fresco. Michelangelo had included two boys—too old to be *putti*, too young to be men—peering over the prophet's shoulder. The boy in the back had his arm slung around the shoulders of the boy in front, so that his hand was in the foreground. I stood on my toes to get a closer look and stifled a laugh. That boy's hand was resting in a loose fist with his thumb pushing out from between his first and second fingers, quite possibly flipping the fig at Pope Julius II. "I don't think that's what this is," I called down in a cheery tone. "He's only balling up his hand a little, a very common gesture for . . ."

"If you're defending him," Felice called up, "I'll climb up there and push you off."

"I'm not." I sighed. "It'll never be visible from the floor. Even if it's what you say, it'll be Michelangelo's own private joke."

"Joke!" Felice screeched.

I heard rustling. "Signora Orsini, please calm down," Bramante hissed. Was he having to restrain that woman to keep her from charging at me?

"It was probably done in a fit of anger that he now regrets, my lady." I tried for a conciliatory tone. "If he knew it upset you, he'd change it." Of course, he'd change it. If the pope heard about such an offense, it was enough for excommunication. Or worse.

"Fix it, please, Raphael," pleaded Bramante. "I'd do it myself but I'm not good at painting hands."

"For Mary's sake, *maestro*, it's fresco. I would have to tear the whole thing down and start again." I didn't want to admit that I had no hope of replicating that figure. Not yet.

"I watched you correct mistakes on the dry ceiling in my father's rooms," Felice said, and I got a chill thinking about her watching me. "Do it. By orders of my cousin—your duke."

I stepped away from the edge of the scaffolding. I don't know why I hadn't thought of it before. The Duke of Urbino was nephew to the pope, and Felice was His Holiness's daughter, so, of course, they were cousins. Threatening violence must be a family trait. "I'm not altering another painter's fresco," I called down. "Maybe nobody else would notice, but what about when Michelangelo comes back?"

"If we have any luck, Michelangelo will not come back," called Felice. "Ever."

My stomach turned to porridge as a memory flashed: that white vial of poison in my duke's armored hand. Did wanting to poison Michelangelo run in the family, too? Torch in hand, I raced down the scaffolding, searching for their voices—*where were they?* I descended, one platform after another, moving so fast that I almost toppled off the end when I reached the bottom rung of the scaffolding, where the ladder should've been. I was far enough down now to make out the ladder lying flat on the floor below me. From down on the floor, Bramante called up, "Don't bother trying the other exits." He stepped up next to the fallen ladder. "All the ladders are down."

I rubbed my face with my hands. "You've trapped me up here?"

"We've given you incentive to help us," came Felice's voice.

"What's wrong with Michelangelo?" I asked.

"He's sick," said Bramante. "A fever. Brought on by working too hard perhaps . . ."

"He may or may not recover," Felice added. Did I hear a lilt of glee in her tone?

Yes, poison was still on my mind—it was Rome after

all—but Michelangelo was, no doubt, obsessive enough to work himself to sickness, so . . . I called down, "Who's taking care of him? There's nothing worse than being alone when you're sick. No one—not even Michelangelo—deserves . . ."

"Don't worry about Michelangelo," Felice said, stepping into the pool of flickering light cast by my torch. "Worry about blotting out that accursed thumb."

I sat down defiantly on the scaffolding. They were the ones who needed my help, after all. "Why do you want to hurt Michelangelo?"

She crossed her arms. "I don't want to hurt anyone."

"And yet, here you are, trying to get me to mar his fresco."

"Not mar. Improve."

"What about the first night I met you, when you were stealing his drawings?"

"How dare you suggest I'm some common thief," she snapped. "That night we met, I was being a loyal daughter, stealing plans for my father's *tomb*." She dragged out that last word like a lament. "How would you feel if some sculptor were carving your father's tomb while he was still alive, tempting the Fates to take him from this Earth before his time?" She didn't know how close she'd hit to my own wounds; I, too, would've done anything to protect my father. If I could've. "I had no choice but to steal those designs. I'd do anything to save my father. And now, all I want to do is protect him from heartache." That's when the daughter of the pope dropped to her knees, her black widow's weeds pooling around her. "Raphael, loyal subject of my cousin, painter for my pope . . ." I knew her countenance well: she was playing courtier, telling me what I wanted to hear. "Please help me ensure that my father is not mocked inside his own chapel. Let him be as he wishes: adored by Michelangelo. Adored by everyone."

Make the world not as it is, but as it should be.

I must've nodded, because Felice stood up and said, "Thank you, Raphael, for helping me to protect His Holiness. I'll tell your duke of your loyalty, and if Michelangelo doesn't recover, then this ceiling will be yours. I'll make sure of it." She turned and marched out of the chapel.

"Cover up the thumb with a good dose of shadow," Bramante called up. "And when I come back tomorrow morning, I'll let you down." And with that, Bramante exited the chapel, too. I sat there for a long time—twirling my father's paintbrush, picking paint out from under my nails, shining my shoes with spit—waiting for Bramante to return and tell me he was only jesting, but did he come back? No.

Finally, I exhaled and climbed back up to the platform under the figure of Zechariah. I found a bit of umber and quickly mixed a color to match the shadows already in that fresco. Instead of using Michelangelo's brushes, I took out my father's old long-handled paintbrush. I pulled up both sleeves, rolled my wrist, dipped my father's brush into the brown paint, wiped each side on the edge of the bucket, and raised my hand toward the ceiling.

Don't judge me. That thumb was hardly visible; it would only take a few strokes to cover it. It would be good for my career. Felice was right. His Holiness didn't deserve to be mocked on his own ceiling; isn't protecting the pope a worthy cause? And yet, I couldn't stop thinking about how I was marring someone else's work, someone who wasn't there to defend it, someone who might die and never make another mark of paint ever again . . .

I lowered my arm. I didn't touch even one bristle of paint to that ceiling.

Like I said, don't judge me.

I hurried back down to the lowest platform of the scaffolding. All of the ladders were—as Bramante had said—lying on the floor, and I was too far up to jump. Any other scaffolding would've required plenty of rope to secure it, but up that ingenious contraption, there wasn't even a single length of rope. *Grazie mille, Michelangelo.* There were, however, plenty of tarps, hanging over railings, around each platform, between each section of fresco. I pulled one down and, with the help of a trowel, ripped that tarp into long strips, which I tied together and then tied one end to a plank. (All right, I tied it *six* times around that plank; I've never been a trustworthy knotter of rope; only tongues.) I'd lose my nerve if I looked down, so I lay on my stomach and scooted my legs off the edge until my hips hinged down. My feet fumbled to latch on to the first knot. I yanked on the line of tarp—*Martha, sister of Lazarus*, let it hold—and then counted to four before finally closing my eyes and lowering off the platform. I didn't expect the line to sway so much, but still, I shimmied, one knot after the other, down. My forearms were burning and fingers throbbing—I couldn't hold on much longer—when my feet finally hit the floor. I didn't look up; I didn't want to think about where I'd been. I ran across the chapel, unbolted the door, and . . .

The door was chained shut. I had to crouch down and contort my body to squeeze through a slender crack under the loop of chains. How long had it taken to escape? I don't know. I only hoped that I could still make it to Michelangelo in time.

Chapter XXVI

It was still onyx dark when I arrived at Michelangelo's studio. I tried the door, but it was locked. "Michelangelo?" I called. No answer. I worked my father's paintbrush in the lock like I'd seen Margherita Luti do at the Pantheon but couldn't make it click. *How did she do it?* The only window was far up, and even if I found a ladder, how would I squeeze through such a small space? So, I did what any reasonable man would do: I ran to *mia cara* for help.

As I climbed the thick ivy up to her window, the lady across the street waved hello; she was accustomed to me by then. "I think it's charming that you need so much rescuing," Margherita said as she climbed out her window and followed me back down the ivy. At Michelangelo's, she used my father's paintbrush to unlock the first door with ease, and we raced up the stairs, where she unlocked the second door. The workshop was dark and silent.

"Michelangelo?" I hurried through the dimness toward the room's other door—the one leading to that windowless corridor. "Help me move that chest in front of this door."

"Why?"

"It leads to the Vatican."

She not only helped me move a chest, but a table and trunk, too.

The workshop smelled of sweat and dust. I checked under the table, behind a chair, inside the wardrobe . . . Then, Margherita gasped and stumbled away from a corner. I pushed past her and yanked back a blanket to find Michelangelo lying in a corner. He was unconscious, pale, shivering, clothes soaked through with sweat. "Go get rags, wine so watered down it's almost translucent, and candles," I said tossing her my money bag. "Lots of candles."

"Leeches?"

"I don't think they work."

While she was gone, I wiped Michelangelo's forehead, lips, and hands with a rag, but then, with nothing else to do, I had to find some way to calm my nerves, so I sat down to sketch from memory those prophets and sibyls from his ceiling. My chalk lengthened out the bodies of those strong, sculptural figures, smoothing their curves, pushing them toward tender. I drew and drew until Margherita returned. "My friend, a midwife and herbalist, will be here in a couple of hours. Why all the candles?" she asked.

"I don't know, but the priests always burn lots of them."

That afternoon, the midwife came with stocks of fish broth, elder, and peppermint and ordered me to leave; she needed to treat Michelangelo's body with herbs, and in order to do that, she had to strip him.

I returned to the Vatican and excused my two-day absence by showing the pope my new designs for the *Religion* wall; he was so pleased that he said I should work from my studio in my own apartments more often. The next day, I received a letter from Margherita assuring me that

Michelangelo was improving. The next week, she sent a note that he'd woken up and wasn't questioning their story that they'd been sent by the Vatican to care for him.

Eventually, Michelangelo returned to work. He told people that he must've worked so hard that he drove himself to sickness. (See? My theory about poison probably was only paranoia.) Someone had told him that I'd snuck up the Sistine scaffolding to copy his work while he was sick. I didn't contradict the rumor, and I don't know who told it, but when I passed Bramante in the halls, he wouldn't look at me. I spent the rest of that summer with my head down, drawing figure after figure for my *Religion* wall, perfecting each tunic, each shadow, each finger, fold, and toe, pushing toward those sibyls and prophets from the Sistine. I obsessed over every detail. I drew the bottom of Jesus's foot six dozen times.

I didn't see Felice again until—what? It must've been two months later. August, maybe? She was standing in the doorway of the papal apartments, watching me, arms crossed. I swallowed hard but went back to my work. She never did tell anyone of our second encounter in the Sistine, so I figured that she was happier keeping our secret rather than exposing it. And so, I did the same.

Chapter XXVII

Prior to the unveiling of my *Religion* wall, I'd always thought of perfect perspective only as it referred to pictures: everything organized along perspective lines receding back to a single vanishing point; the atmospheric purpling of distant towns and mountains; the foreshortening of arms and hands reaching out toward the viewer; all of those tricks that painters use to transform a flat picture surface into a real world, expanding into the distance, deep and wide. However, on the day of the unveiling—with the pope, cardinals, artists, assistants, and guests packing into the papal library—my perspective on perspective changed.

After nearly a year of obsessing over every detail, I was so close to my *Religion* fresco that I couldn't see whether it was good anymore, so I'd come to the unveiling determined to not look at the picture again, but to watch the faces of those experiencing the painting for the first time. I'm not sure how much I learned about my fresco that day, but I did gain *perspective* on the cast of characters populating my life.

His Holiness was fixated on the preponderance of gold leaf. If he said, "Smell all that fish glue? If only every room

could smell so rich," one time that day, he said it a hundred. That gave me the *perspective* that the once-poor-fisher-boy-from-Savona-turned-pope prized wealth above all else. Felice never once looked at the painting but kept her eyes on her father—all she cared about was *him*. The same held true for Cardinal Alidosi. Bramante is an egotist who commented only on his own portrait in the lower left-hand corner ("I'm not that bald, am I?" "What book am I holding?" "The purple drapery I usually wear is a tone darker than that."). Sodoma, Lorenzo Lotto, and Guillaume wanted to ensure that they got credit for their involvement, so they kept congratulating one another. ("That green you made, Lotto, is heavenly." "The final touches of the gold leaf, Guillaume, are flawless." "The plaster you mixed, Sodoma, is smooth as a fine polish on a Michelangelo marble.") Cardinal Riario kept pointing out that I was a stronger painter than Michelangelo, while Cardinal de' Medici pointed out the opposite (they both had their own *perspectives* on which side should win). And when Michelangelo and the pope fought about whether to use gold leaf on the Sistine ceiling—the pope insisted that he must, Michelangelo cried that the Old Testament figures and prophets were poor, so gold leaf would be inappropriate—I saw that the Florentine sculptor screamed not because he was angry, but because he was trying to brush over his hurt.

I also stepped outside of myself and got some perspective on me. When I told the crowd that I hoped my painting would "bend the world away from the earthly realm of violence, anger, and war and toward the heavenly ideal of harmony, love, and peace," I saw the man my mother had always wanted me to be, and I was proud.

Once perfect perspective is achieved in a painting,

and you lock it in by setting a specific vanishing point and drawing in your mathematically calculated lines, it doesn't change, does it? No. It's the foundation upon which you build your entire picture.

Too bad that perfect perspective *on life* never lasts.

Chapter XXVIII
March 1510

The life of a painter can be exhausting, can't it? You struggle—over months or maybe years—to conceive, execute, and complete a painting, and then, even if you're lucky enough to deliver a masterpiece, it's all for . . . what? So, you can find yourself standing—once again—in front of yet another blank wall, wondering how you'll ever put anything of value up there, much less something that will surpass your previous effort. And it's not as if we painters suffer from some eternal punishment handed down by an Olympian power. No. We knowingly choose this life as Sisyphus, don't we? I watched my father pushing the same rock up the same hill over and over again, and I exclaimed, "*Sì, sì, sì! That's what I want to do, too!*"

However, some artists don't seem to struggle. The elegant design for the Tempietto church supposedly came to Bramante in a dream; Botticelli's painting of Venus's birth apparently arrived so fast it was as if the wind god Zephyr was blowing at the artist's back; and all Michelangelo must do to make miracles in marble is "set the angel already living inside each stone free." Is that what it's like for you or are

you more like me? I fumble around a dark room for months, striking at the flint of my mind until I create a spark. The first spark, no doubt, goes out. I have to make at least a hundred sparks before I catch the char cloth, and then that flame always smokes out early. It takes a half dozen or more flames—each from another hundred sparks—before I finally make a flame large enough to grow with breath and kindling. I repeat the process with that same tiresome piece of flint for every figure, face, gesture, color . . . If having to work hard at something means you're in the wrong craft, then I must've been born a bricklayer.

Don't worry, I'm not going to make you listen to me fumbling around in the dark for months again, finding perfect compositions for the other three walls in that room, but do me a favor and mentally revisit that bit I told you about struggling with the design for my *Religion* wall and understand that I went through all of that again and again for each fresco in that room—and for each and every painting for the rest of my life.

So, let's skip forward to March, shall we? To Carnevale to be exact. I was working in my personal rooms away from the Vatican and hadn't left my private studio for a single festivity. Not even *Martedì Grasso*—with Ash Wednesday and six weeks of Lent on the horizon—could tempt me away from work.

"Raphael. You have to take a break," Margherita said, taking the chalk from my hands.

I took out another piece, pulled up my sleeves, rolled my wrist, and kept drawing. "I can't leave until I find it."

"You're painting crowds of people, right? Maybe you should be around people."

"I promised I'd be finished with *Poetry* by spring."

"Promised who? His Holiness?"

"What if I don't finish until summer? Or the end of the year? Or next year?"

"Your fingers are staining red."

"What if I've used up all my flint and can't make fire, ever again?"

"If you don't come with me, I'll never let you touch me again."

"What if Michelangelo makes a flame first and burns the rest of us down?"

"Raphael. If you don't come with me, I'll never let you *draw* me. Ever again."

Chapter XXIX

T hanks for making me come," I said, sketching yet an-
other woman twirling through the glittering crowd.
Margherita Luti leaned her chin on my shoul-
der. We were usually fearful about being seen together, but
at Carnevale, such propriety was unnecessary. Tonight, any-
one could be seen with anyone and forgiven come morning.
She tapped my sketchbook and said, "I was hoping you would
come without this, but . . ."

"Capturing the moment in the moment is such a mod-
ern idea," I told her, sketching Lorenzo Lotto, hips leaning
against a wall, one leg crossed over the other, sketchbook
resting on his knee, bending over to draw. As we'd entered
the villa, a greeter had presented each artist with a sketch-
book and asked us to capture the night in chalk. We drew
the hundreds of guests crowding into that grand banquet
hall, gorging on one final night of indulgence before Lent.
"We're all capturing such different things, too. Bramante's
getting the architecture, Sodoma's drawing the exotics"—
giraffes, camels, ostriches—"and did you see the lace-mak-
er's daughter sketching fabrics? She's good."

That's when our host, Agostino Chigi (yes, *that* Chigi, the wealthiest man in all of Rome with a shock of red hair and blue eyes the color of the Adriatic), clapped his hands and his servants pulled cords, bringing the walls, columns, doors, and even the ceiling of that banquet hall *cascading down*—to gasps from the crowd—and landing in a pile of tapestries on the floor. "Thank you, Holiness, for your kind words, but this is not my banquet hall," called Chigi, as the servants rolled up the fake marble floors out from under our feet, exposing simple wooden planks. "These are my stables." As grooms led horses—chestnut, cinnamon, silver—into wooden stalls, I couldn't sketch fast enough to capture all the surprised faces. "Change perception, change the world." Our host clapped again, and a band of musicians led us into the real banquet hall (at least we assumed it was real, although I did keep checking behind gold-framed mirrors and under multicolored rugs).

That night, my fingers sparked flame after flame inside my sketchbook. I didn't even stop for my usual sleeve-and-wrist routine; I just flipped pages and kept drawing. "Before the night's out, I'll have all of the remaining walls in the papal library captured in these pages," I whispered to Margherita as I caught Bramante bending over his notebook with a group of aspiring architects watching him draw. While others dined on cured meats, herb tarts, and fried cheeses, I feasted on faces and colors: a woman, wearing watermelon red, gaped at a life-sized dancer made out of sugar; four men debated whether the blue-and-green peacocks were alive or stuffed; a couple fed each other balls of golden saffron bread. (I drew so much, I didn't have time to eat. Besides, with Felice della Rovere in attendance, I was still worried about poison so didn't even taste the veal

drowning in truffle sauce, one spoonful of which probably cost more than my entire set of rooms.)

"This banquet was an impressive display of wealth," Pope Julius said, as servants cleared away dishes. "But it's nothing if you hang onto the same old plates year after year. A man as wealthy as you should commission a new set of dishes with every meal same as you slaughter a new pig."

We all chortled as if it were the first time we'd heard that joke from the pope, but Chigi leaned forward as if at a negotiating table with a warring duchy. "And if I were to take you up on your challenge this year and prove my wealth in such a manner, would you grant me a request?"

Pope Julius picked up his plate: a mythological scene painted with a heavy hand of ultramarine and rimmed with gold. "You'd throw away your dishes?"

"Who needs such trifles?"

"What's the request?"

"A game."

His Holiness's eyes narrowed. We'd already enjoyed jousting, pig-rolling, and a Barbary horse race through the courtyard. "Another game?"

"In the spirit of Carnevale."

Carnevale celebrations in Rome are unlike any other—aren't they?—as if the ancient gods come out to play, turning the world topside down: dark is light, good is bad, men are women, nothing as it seems, nothing as it *should be*. Cardinals dress as clerks and carpenters; bankers as butchers and bakers; maids as masons and miners. On the way over to the villa that night, we'd run into Cardinal Riario, and he and I had traded outfits—I wore his red robes while the cardinal wore my painter's smock. Margherita Luti was dressed as the most beautiful gravedigger I'd ever seen, while our host Chigi

was dressed as Aphrodite, wearing a white gown and blond wig. Chigi's companion for the night was Imperia, dressed— if you can call it that—as Botticelli's Venus, her long ruddy red hair wrapped around her *nude* body. She and Chigi told everyone that she was wearing a flesh-colored suit, but that woman was definitely nude. Michelangelo was the only one not dressed up; he wore his same old dirty tunic, same work boots, same layer of marble dust.

The pope—even he wore a jester hat—asked Chigi, "A game between you and us?"

"Heavens, no. This is a competition for workers."

"Workers?"

"With a handsome prize for the winner."

Earlier in the day, Pope Julius had thrown ducats out his window to the people; he wasn't likely to turn down such a public offer now. "If you keep up your end of the bargain, we see no reason not to reward such a winner. To Carnevale."

We raised our glasses. "Ho, ho!"

Servants cleared away plates, platters, crystal wine-glasses, gilded forks, spoons, and even toothpicks, and Chigi waved us to follow them out of the palace and across the manicured gardens—brightly lit with torches—to the Tiber, where servants stepped up, and on three—*uno, due, tre,* we counted in unison—they threw the entire set of dishes into the river.

"On with it, Chigi," the pope said, pulling his cape tighter around his shoulders in the cool evening air. "What kind of game warrants such a show?"

"A competition to find Rome's best . . ." Another clap of his hands and servants scurried: one stood in front of Guillaume, one in front of Bramante, one in front of me . . . "Artist."

The pope repeated. "Artist?"

"All artists were given sketchbooks when they entered the villa this evening. Those are your entry forms. The prize for the winner? A commission from me." The crowd fizzed. A commission from Chigi would likely be the most lucrative of any career. Imagine truffle sauce for breakfast. "If it's a painter, I'll order a painting. A sculptor, a statue. An architect, a building. A goldsmith, a saltcellar. I want the best. You will each select one drawing you made tonight—and one drawing only—as your sample. Best drawing wins."

Lorenzo Lotto turned pale. Pia—the lace-maker's daughter—flipped frantically through her drawings. I'd made a gorgeous sketch of Margherita sitting by the fountain. Her eyes were bright, pulling in the viewer, pulling in me . . . It wasn't only my best drawing of the night, but arguably one of the best drawings of my life.

"The winner," Chigi continued, "will get to keep his—or her—sketchbook. The losers? In with the dishes." He waved to the balcony.

"You're going to throw the other artists into the Tiber?" That was Michelangelo, sì certo.

"Not the artists," chuckled Chigi. "Your sketchbooks."

I don't know how the others reacted because my ears started ringing. "You're taking our sketchbooks?"

"They're my sketchbooks, Santi. The price for playing the game."

I tightened my grip on that notebook. I couldn't re-create the drawings inside; I couldn't even recall everything I'd captured that evening. I wouldn't only forget the colors— the basket of apricots, the dove-white marble, Cardinal de' Medici's hair laced with pale-green grapes—but also the faces, the people, the details, the energy, the life. No

commission, no matter how lucrative, was worth dousing *that* fire. I called, "I would like to decline your generous offer, signor Chigi."

"*Mi scusi?*"

"I already have a commission, *signore*, in the Vatican. I wouldn't want to interrupt my work there."

Chigi said, "You don't want to be considered the greatest artist in Rome?"

"Raphael *is* the greatest artist in Rome." That was the Duke of Urbino, laying a hand on my shoulder. The duke was visiting Rome for Carnevale and had come to the party dressed in a purple cloak, fake gold crown, and a wreath of bejeweled necklaces; he kept introducing himself as *King of Urbino*. Now that I was the official painter of his uncle's private apartments, he seemed to have forgotten that I'd turned down his generous *offer*. I was, once again, a favorite son of Urbino.

I said, "The others should have an opportunity for such an extraordinary job."

"He's afraid of losing." That was Michelangelo again.

"He's not afraid of losing," barked the duke. "Tell them you're not afraid of losing."

"Perhaps we should both step down, *maestro* Buonarroti," I said, as the duke squeezed my shoulder. Hard. "We both have good jobs."

"Chigi said I could carve marble," Michelangelo said, opening his sketchbook. "Pick a drawing, *signor* Chigi, any drawing." He flicked sketch after sketch onto the ground as though they were nothing, but they weren't nothing, *sì certo*. He'd spent his evening copying Chigi's collection of ancient marble statues. Each drawing was more brilliant than the next.

Pope Julius eyed me. "If you don't think you're capable of competing at this level, Raphael, we aren't certain why you have such a prominent a position in our palace."

"Raphael, don't humiliate me," the duke hissed.

What else could I have done? I said, "Thank you for the honor of considering my work, signor Chigi." My hands shook as I flipped through my sketchbook. If Chigi were looking for the most perfect drawing, he would no doubt choose me; I've always aimed for traditional markers of greatness: balance, harmony, clarity. However, this probably wouldn't come down to an academic judgment. The final decision would come down to Chigi's preferences. I looked over at Michelangelo sifting through his drawings. Did Chigi prefer beauty or tension? Balance or asymmetry? Grace or power?

I made a calculated decision. I didn't choose my *best* but pulled out the drawing that I needed most to finish my frescoes. Guillaume had come dressed as a shirtless beggar, and I'd caught him in an unusual pose: lounging on stairs, leaning back on his elbow, head turned to look at a sketch, one leg dropping onto the stair below. As the party swirled around him, he was lost in thought. He was the perfect centerpiece for my *Philosophy* wall; I could build the entire fresco around that one figure. I pulled out that drawing, and the servant took away my sketchbook. I closed my eyes and mentally cataloged the images I'd captured that night so that I could race back to my studio as soon as this foolish competition was over and redraw as many as possible: Felice della Rovere also wearing cardinal reds talking to her Orsini husband dressed as an Eastern princess in a bright amethyst and lead-tin-yellow gown; two cardinals costumed as peasants draped in flaxen tunics; Margherita

Luti's earlobe; Margherita Luti's jawline; Margherita Luti's collarbone . . .

A throat cleared. I opened my eyes to find Chigi standing in front of me, grinning. All of the servants held their sketchbooks over the edge of the river. All except the one holding *mine*. "I believe," Chigi said, bouncing his eyebrows, "it's time to name a winner."

Could it be? My stomach flipped; my ears burned; I started to smile.

"Hold on, Chigi." That was the voice of Cardinal Alidosi. My cheeks dropped. *Not him again.*

"It's not fair for you to judge your own competition." Alidosi had not used Carnevale as an excuse to wear his own yellow dress, as other men had. No. He'd come costumed as a buttoned-up book-binder. "We should have an impartial judge. Don't you agree, Your Holiness?"

Cardinal Riario called out from the back of the crowd, "Oh, stuff it, Alidosi, no one likes you." The crowd chuckled. The pope shook his head. (As I've said, it's amazing the things men can get away with during Carnevale.)

The duke sneered, "Who do you propose as judge, Alidosi? Yourself?"

As Alidosi raised his hands toward heaven—*why not me?*—I smiled wider. *Not Alidosi. Anyone but Alidosi . . .*

"You have no training in art, no eye, no style. *Uncle*"—the duke hit that word hard—"you should appoint me judge."

"You obviously have a preference." Alidosi gestured to me.

The duke replied, "And you obviously prefer the Florentines."

Alidosi flushed red as mulberry. "You only support the pope because he's your uncle."

"You only support him because he's your—"

"*Basta!*" Pope Julius rapped his walking stick.

Everyone fell into strangled silence. The duke's fingers rested on the hilt of his sword, as Alidosi reached into his bookbinding bag—I assume there was a dagger inside, although he never pulled it.

Thank the Virgin Mary that the pope broke the tension: "Cardinal de' Medici shall judge."

"But, Uncle," the duke protested, "Medici is obviously biased for Florence."

"Cardinal de' Medici has more education in art than all of us combined," said Alidosi, looking satisfied with the pope's choice.

Cardinal de' Medici, dressed as Bacchus—white toga, green grapes in his hair, goblet of dark red wine sloshing—stepped between the two. "Don't worry, duke, I've had enough of my alter ego's drink to make me tell the truth." He took a gulp of wine.

Everyone except the duke laughed. "I don't care how drunk you are, Medici, by being such a patriot to your country, you turn traitor on ours."

"Wonderful," said Chigi, clapping his hands. "Cardinal de' Medici, I would be honored to have you judge my competition." Chigi caught my eye and shrugged: *Too bad. We gave it a go.*

My stomach turned, and I could no longer recall a *single* drawing in my sketchbook. Cardinal de' Medici, loyal Florentine, man who'd grown up alongside Michelangelo as his brother would never choose me. At least I had the one drawing of Guillaume. I tried not to grip it so tightly that it ripped. The Medici cardinal first flicked away Sodoma, holding a drawing of a giraffe. As a servant dropped Sodoma's

sketchbook over the balcony—*plunk* into the water—I felt sick, but then everything got worse—much worse—when Chigi took Sodoma's drawing and tossed it into the river, too. It fluttered into the river like falling ash.

"He doesn't get to keep his best?" I blurted.

Chigi shrugged. "Out with the dishes."

Jezebel, I silently cursed and flipped my drawing around to memorize every line, fold, and shadow. I willed Cardinal de' Medici to take his time moving down the line, flicking away Lotto, Guillaume, the sugar sculptor. He didn't dismiss Bramante straightaway—the architect had caught an impressive angle of the colonnade of Chigi's courtyard. Nor Pia, the lace-maker's daughter, who'd captured Sodoma's fairy costume quite dramatically. Medici made it to me too quickly. I had no choice but to turn my drawing around for judgment. Medici's face was impassive. His hand went up—the noose around my neck tightened—and his fingers flicked.

However, he didn't flick *me* away. No, he waved away Pia first. Then Bramante.

I caught my breath as their sketchbooks splashed into the Tiber. There were only two of us left: me and Michelangelo. He'd drawn a torso of one of Chigi's ancient marble statues—no legs, no arms, no head—but, as always, despite its brokenness, there was life under that skin.

Hands shaking, I turned my drawing around. Forget the lines, try to memorize the energy, the feeling, the *spark.* Don't pay attention to the cardinal taking Michelangelo's drawing in his hands, pulling it close, lips parting. Focus on *my* drawing, tuck it into my heart and prepare to run back to the studio and capture it before the flame smokes out.

"Raphael."

I looked up. Cardinal de' Medici, holding Michelangelo's drawing limply in his hand, looked as shocked as everyone else at the word that had come out of his mouth.

"What did you say?" the pope asked.

"I swear on my father's grave, *Il Magnifico* himself, that Raphael Santi has made the best drawing." Cardinal de' Medici crumpled up Michelangelo's drawing and threw it into the river.

Chigi clapped—"We have a winner!"—and the crowd erupted as a servant pressed my sketchbook into my hands, and the duke threw his crown in the air, and Margherita clapped, and the pope repeated, "Santi, Santi, Santi!" Michelangelo's nose flared, and then he marched away from the river, disappearing beyond the torchlight.

I despise being so self-referential—I do—but have you ever seen my St. Michael panel? Either version—the large or small one—will do. They both depict a winged St. Michael vanquishing a foe—dragon or Satan, depending upon the version—but it's that feeling of triumph upon which I want you to focus: legs strong, chin up, shoulders back. That was me, in that moment. I'd slayed Michelangelo in a drawing competition where I hadn't even shown my best. So, when Bramante hugged me and whispered, "The Sistine will be yours in no time," I believed him.

Chapter XXX

I must've been nine or ten—my mother and sister had been gone a good while, but my father had yet to show signs of sick—when a fat-bellied patron filled our doorway with feathers and fussiness. He was dressed like a duke, but he was probably only some new-money merchant putting on airs or else my father never would've behaved the way he did. I was hiding behind an altarpiece with only one eye peering out, so my memory of the scene is off-balance, the door pushed to the left of my peripheral vision, while my father's cluttered studio—wooden shelves sagging under jars, knives, trowels, raw minerals—fills up the right; it's all on a diagonal, too, the world sliding off to one corner. My father's shoulders sagged as he declined the man's request for a commission; he was too busy working for the duke, in the studio, with his son. He recommended Perugino's workshop, instead. Oh, how I wanted to run after that man and assure him that we could handle his commission—I was *not* a burden—and that we wouldn't disappoint anyone. Ever.

I'm still not good at turning down commissions. I'm not

certain that I ever *have* turned one down, as I always make polite excuses and promise to get to it when I have time. But that Carnevale night, in Chigi's villa, I'd never even attempted to demur before. "Signor Chigi, the commission you're offering is magnificent," I said, as he—Imperia on his arm, still nude but pretending not to be—walked me down the empty halls of the upper floor of his villa, giving me a tour of my new dominion, wall after wall, ceiling after ceiling of clean white plaster prepared for paint.

"Why do I hear a 'nevertheless' in your tone?" Chigi's eyes creased with kind.

"I meant what I said, signore. The Vatican project is too important, and as Aristotle said, only pleasure in the job puts perfection in the work, so . . ."

"Working for a pope is prestigious," Chigi said, leading us outside to a balcony overlooking his gardens and the Tiber beyond. I leaned against the balustrade next to Imperia. I didn't see how she was standing out there unclothed on such a damp shivery evening.

"There's also the allure of *certain* chapels." Imperia bumped me with her hip.

Blessed Mother, were people talking of my Sistine aspirations? Such rumors would make me seem like a climber. "I wouldn't dare aspire to such . . ."

"What they say is true," Imperia said. "You are too nice for Rome."

Before I could argue, Chigi said, "Look there," and pointed to a crowd of servants by the Tiber. They leaned toward the river, and then back out again, repeating the motion with grunts, in and out like rowing a boat. What were they doing? Hauling in nets? The fish in those nets caught the moonlight and shimmered white.

"I thought you were a banker," I said. "I didn't know you also managed a fishing business."

Chigi chuckled. "Do those sound like fish to you?"

The fish did make the strangest tinkling sound, like . . . like . . . *what was it?* Porcelain against porcelain? I squinted. *Mary Magdalena* . . . was that . . . ? Those servants weren't hauling up a catch of fish, were they? No. They were hauling up net after net of Chigi's dishes.

Rome is a city built on deception. Marble covering stone, gold flake brightening dulled paint, nothing as it seems. Consider the city's founding legend: twins Romulus and Remus born the sons of a Vestal Virgin and the god of war, but their uncle king, perceiving the twins as a threat to his rule, ordered them murdered as children. But a river god saved them, and a she-wolf nursed them through their infancy. Throughout their youth, the twins were unaware that they were at the center of a complex drama of kings and gods, but when they learned the truth, the betrayed twins set out for a war that eventually led Romulus to kill his brother Remus for control of Rome. Yes, the story is more complicated than that, and most histories don't focus on the deception part, but that's the root of the rot, isn't it? A lie like that can bring down men's souls. I'm not comparing such an epic deceit to Chigi's prank—a few dishes not truly tossed into a river to trick a pope into playing a game to hire an artist—but it all felt like peeling paint to me, the beginnings of a blight that could eventually destroy the entire facade.

Chigi didn't seem to see the danger. With a wink, he said, "Change perception . . ."

And Imperia finished his thought: "Change the world."

"When you're ready for paint, not politics," said Chigi, circling his finger in the air, "these walls will be waiting for

you." They walked away, leaving me to stand at that balcony alone and watch the servants fishing out each dish, serving spoon, and goblet (I assume the banker lost a few gilded forks and toothpicks in the ruse). I was wondering which perception Chigi thought *I* should change when someone once again leaned against the balcony beside me, looking out at the servants hauling in those nets of dishes.

"When my uncle hears about this, he'll laugh." It was my duke. We hadn't spoken face-to-face since that day in my father's studio—how long ago had it been? Two years? I started to bow, but he clasped his hand around my shoulder and held me straight. "His Holiness loves a good fooling." The duke leaned in so close that I could smell the roasted liver on his breath. "My cousin tells me you've learned how to tell a lie."

My eyes followed his to find Felice della Rovere, standing down the hall. "I don't know that I can boast of lying, my Lord," I said, "but I can keep a secret."

"And I hear you still want the Sistine."

Persephone, how many people were talking about that?

"*Bene.*" He brushed his other hand along his cape, flashing a dagger hanging off his belt. I hoped, rather than believed, it to be an accidental exposure. "I'll help you, if you help me."

I would've stepped away—I've proven once that I will defy that man—except his hand was gripping my shoulder. He seemed to take my stillness as acquiescence.

"I fear I've gotten off on the wrong toe with Cardinal Alidosi," he said. "Any friend of my uncle should be a friend of mine. I need you to help me sink that proverbial cannon."

Felice della Rovere called down the hall, "There you are, Cardinal Riario!" The duke pinched my shoulder. I didn't

dare speak. *Would you?* "Signor Chigi is looking for you. That way." She pointed back down the hall. Footsteps clacked away. She turned and jerked her chin: *all clear.* Felice was standing guard. What was the duke planning on doing to me?

"I need you to paint Alidosi's portrait."

I met his eyes. All he wanted was a portrait? I could paint a portrait. A portrait was *not* poison.

"It's a gift for His Holiness." He pressed a heavy money pouch into my hand. "Don't tell him who hired you. Those of us trying to protect the pope must stick together. Yes?"

The center of my chest told me to say no—this had to be dangerous, what with Felice standing guard, the duke's general temperament, and everything feeling so off-balance—but my brain could find no logical reason to turn him down. It was a portrait. Nothing more. A gift for the pope. What could be the harm in that?

Chapter XXXI

Lent 1510

Cardinal Alidosi accepted my offer to paint his portrait and never asked the patron's identity. I have no explicit reason to say this, but I believe he thought it was a request from the pope himself. The cardinal said he was flattered to sit for a painter "in such high demand," and apologized for speaking against me. "I've admired Michelangelo for a long time, and, unlike you, he always seems to need support."

He sat for me probably—I don't know—a dozen times in his private salon at his villa in town. (If Michelangelo thinks I live like a prince, then he never visited Alidosi's palace. Talk about ostentation: a gold-leafed clavichord that I never saw him play, colorful maiolica pottery decorated with lavish mythological scenes, and even glass in *all* of his windows— can you imagine such an extravagance?) As I sketched his thin face, beaked nose, and intense gaze, Cardinal Alidosi told me stories of when he was young, traveling to France alongside Cardinal della Rovere (before he was elected Pope Julius), and how Alidosi helped foil one of Pope Alexander's attempts to poison his dear friend: "It's because of me that

he's still alive to be pope." Alidosi tried to play it off as though he were embarrassed to share the story—too humble, *si certo*—but it was a not-so-subtle boast. He was pleasant enough, though. And polite. I didn't dislike him. I didn't.

A few times, His Holiness stopped by. You heard me right. The pope let himself into Cardinal Alidosi's private home and made his way up, without escort, to find us in the cardinal's private rooms. They would tilt their heads together and share a moment of hushed conversation—I couldn't hear any of it—and the cardinal's fingers would linger on the pope's arm. Then, the pope would disappear in the direction of the cardinal's bedchamber, and the cardinal would become agitated and encourage me to make an excuse to leave.

I know, I know, none of this should've surprised me. I should've already guessed the depth of their *friendship*. Even retelling this story, I've noticed a half dozen places where I should've picked up the hint, but I swear to you, before those sessions, I'd never considered what was passing between them. Wherever you were at the time, I'm sure people were happy to exchange whispers on the topic, but down in Rome—inside the Vatican, right under the pope's chin—no one dared breathe the rumor; no one even exchanged looks about it. I had no idea, until I did, and then I could only regret not ingratiating myself to the influential cardinal earlier.

On the day of his last sitting, I showed the cardinal my drawings. Sadness shaded his smile when he asked, "Do you always see the best in people?"

"I try, Your Eminence."

"Then, I shall try to live up to the goodness of the man in this picture."

The next day, the pope sent the cardinal away to try to convince the Bolognese not to join with the French against the papacy. In the days following, discussions of war escalated—how dare those French barbarians invade our peninsula, invade our cities, invade our women—and the pope looked older by the hour. Sometimes, I would hear the pope mutter, "I miss his counsel."

I painted the cardinal in his official reds against a simple black background, no signs of wealth and power, using as inspiration Leonardo's portrait of the silk merchant's wife, signora Giocondo. Have you seen that portrait? Even though the *maestro* took it with him when he went to work for the French, and I don't know what happened to it when Leonardo gave up the ghost, you must find a way to see it. Copies do not do it true. Is she smiling? Maybe not. I used that lady's pose for Alidosi—body turned three-quarters, hands in lap, face toward the viewer, eyes catching our gaze—and, yes, I idealized his features, too; in reality, Alidosi's hair was not so carefully trimmed, his face was thinner, his neck more wrinkled. I also used that portrait to perfect my handling of shade. Not that the portrait of the cardinal is dark. Cardinal Alidosi's face and torso are flooded with light, but that only makes the shadows more distinct. I spent weeks working the shadows of that lowered hood resting on his back, those in his hair, and in the creases in his hat and sleeves. No wonder Leonardo spent a lifetime working shadows; after a hundred lifetimes, you could still lose yourself in another detail of shade.

When I finished the portrait of Cardinal Alidosi and presented it, His Holiness hung the painting in his bedchamber. I imagined him asking it for advice late at night.

When Felice asked what I'd learned about Alidosi during

our sittings, I rebuffed her with quotes about the goodness of godly men, and when the duke wrote to ask if I noticed whether Alidosi drank red or white wine, I pretended that the letter had been lost and ignored it. I was proud for side-stepping their attempts to use me to work in the shadows. At the time, that portrait seemed inconsequential; an unimportant detail in my career, not worth mentioning. It was a brief encounter. A small panel picture. At the time, it meant nothing. Nothing.

Chapter XXXII
Summer 1510

I forbid you to go." Felice della Rovere's voice cracked like cannon.

"If anyone in this family does the forbidding, it's me," fired back the pope.

"Since I'm a part of you, perhaps you should listen to me, then."

"Oh, go back to your sewing, Felice."

Such shouting around the pope's desk was constant in those days. Sometimes it was Felice, sometimes a company of cardinals, and sometimes a squadron of staff, advisers, or friends, but they were always there, trying to talk the pope out of marching *himself* off to war; the only battle the Vicar of Christ was supposed to lead was for men's souls, they said. But Pope Julius II always imagined himself the way Michelangelo cast him in bronze: a warrior astride a stallion, bravely marching into battle. And now that Cardinal Alidosi had sent word that the very city where Michelangelo's bronze equestrian stood—Bologna—was joining the French to rebel against papal rule, the pope wanted to march in on a *real* stallion—as

opposed to the sculpted sort—and prove that his authority was as indomitable as that bronze. His advisers disagreed:

"If you die, the French will march on Rome."

"The Florentines will make a grab for the papacy."

"Romans will riot."

"Construction on St. Peter's will end." (That was Bramante, *sì certo*.)

My men had similar fears. "We aren't half finished with the first room. If this pope dies, a new pope will tear down our work and start again," whispered Lorenzo Lotto as we huddled on top of the scaffolding while the pope and Cardinal de' Medici went around and around again down on the floor ("*Per favore*, Your Holiness, send me in your place." "And let you get all the acclaim? The other Florentines would have me deposed and you on the throne before the gunpowder cooled.")

"If the pope's killed, we'll probably be buried beneath, alongside the accursed Spaniard," whispered Sodoma, nervously peering down as if a ghost might rise up through the floorboards.

Guillaume added, "Unless the new pope is French, *bien sûr*. Then, you'll have to beg me for a job."

"Lord, help me and keep this pope from war," whispered Lotto with folded hands.

I patted him on the shoulder. "As Aristotle said, fear is nothing but pain arising from the anticipation of evil. Don't fear, *mio amico*. I see the *real* purpose behind all this fighting." I passed out blank pieces of paper to my men. "This is the Fates of old helping us with our fresco."

"Call a priest," muttered Lotto. "We have a demon of delusion amongst us."

I ignored him. "What's happening before us is a philosophical debate: What does it mean to be pope? Can the Church and violence coexist? What's the meaning of morality? What we need to do is capture the rhythm of this debate for our *Philosophy* wall." I pulled up my sleeves, rolled my wrist, and set to work.

Achieving rhythm in a painting is difficult because—unlike perspective or realism—there's no objective standard by which to judge. You must develop a feel for how your lines keep the eye moving. But although rhythm is mysterious, it's also essential. A painting is a static thing, so without rhythm, a painting dies. I'd landed on a melodic rhythm for my *Poetry* wall, lively as the bubbling water flowing from the pool in the middle of Mount Parnassus. Some figures stood, some sat, some danced and played, some pointed and turned, their gestures and colors leading the eye around, up and down the mountain and back again. If I could find a rhythm equally pleasing and appropriate for my *Philosophy* wall, then I would be well on my way to perfection. But the rhythm of poetry and philosophy are different, aren't they? How do you create a rhythm for the profession of questioning everything? By listening to those arguments with the pope, that's how. They provided my beat. A rush and pause, meander down one line, drive back up another, never fully stopping, never fully moving, never fully anything, like philosophy itself, rolling in and out, up and down, the only constant is change . . .

Just when I was becoming accustomed to working to the cadence of debate, change came again: arguing ended, and the apartments fell quiet once more. Word traveled fast that the papal army would march out to put down the rebellions *without* the pope. Lotto said, "How does everything always work out for you?"

I didn't contradict him; let him think that if he wants. The day the papal army marched out of Rome, everyone gathered in the square outside of St. Peter's to wish the soldiers safety and strength. I've marched in processions to ward off plagues and attended an Easter celebration marking the half-millennium, but I'd never seen such a crowd. Every Roman must've gathered in that square along with legions of foreigners from across the peninsula and beyond. I even heard Turkish spoken. *Turkish!* The crowd was buoyant, cheering, whistling, waving flags. I stood with the other courtiers at the front of the makeshift dais next to Cardinal Bibbiena. After my victory at Chigi's villa, he'd commissioned me to paint his portrait—*sì, sì, cardinal, I'll get to it when I have time*—and he was pressuring me to meet his "niece." By the looks of his bone structure, the girl was probably pretty, but . . . I spotted my Margherita—alongside a few boys—climbing a column to get a better look at the army. How could I consider a cardinal's "niece" when Margherita Luti was so . . . so . . . *Luti.*

I took out my sketchbook and began to draw the procession: horses, flags, helmets, sword, pikes, spears, crossbows, cannons, a rolling sea of armor. I hated thinking about all those men marching off to war. I grew up in the middle of the peninsula, so from the time I was about ten years old, watching the horizon for war was as normal as watching for weather—take this route here because on that hill there a battle has broken out and ammunition might fall on your head like hail. And while you might think that constant exposure to war would inure me to it, the knowledge only makes me more afraid: I know how easy it is to die in war, and I know how painful those deaths can be. How familiar are you with war? *Allora*, you've seen Paolo Uccello's *The*

Battle of San Romano painting, right? I know we're usually so focused on the masterful foreshortening of those kicking horses that we forget we're looking at a bloody scene, but, next time, look closely, because it is a good representation of battle: a mad scramble of men and braying horses; clashing lances, bows, arrows; bodies of slain soldiers and horses in the foreground (the dead never fade into the background—do they?—but always stay right up there, front and center). Do you know the main difference between Uccello's version of war and the real thing? Uccello's has crisp, clear lines, while real war always has a dulling gray glaze over it. It must be all the smoke; it smells like death.

That day, looking out over that papal army, I couldn't help but wonder whether those young soldiers knew what they were about to face. They looked so excited. Even the experienced men looked eager to get going. Cardinal de' Medici, astride his horse, urged the army forward. There was Chigi, too, smiling and waving as though in an Easter parade; he was financing the war, so he joined in to oversee his investment. He'd given me the keys to his villa and instructed me to work only when inspiration struck: "I have no use for uninspired paintings." I was surprised to see Bramante among the army; he hadn't told me he was going to war. Then, the procession rippled. What was that noise erupting from the crowd? A groan? Screams? Cheers? I stood on my toes to see over the bobbing heads and horses and . . .

Maria Vergine.

Cantering through that army on a white stallion, holding a lance and wearing full body armor—red cape fitted tightly over the bulky metal—was Pope Julius II. Cardinal Bibbiena and I exchanged looks, as the pope marched to the

front of that army and raised his flag. It was the strangest sight to see the Vicar of Christ at the head of an army as the faithful threw flowers. Would the pope launch a cannon or wield a lance against another man? And if an enemy fired a shot that struck His Holiness, would it be a sin equal to any death in war or would it carry a special sentence in hell? I leaned over to Cardinal Bibbiena and said, "Surely God will protect His Holiness?"

Bibbiena said grimly, "Satan may never win the war, but he can always win a battle."

"*Signori*," said someone to my right. My stomach swirled when I identified the speaker as Felice della Rovere.

"Please accept my apologizes, signora Orsini," Cardinal Bibbiena fumbled. "I didn't see you there. I wouldn't dare speak ill against His Holiness—I would never even think of his demise—I only meant . . ."

"I know exactly what you meant, cardinal," she said, her dark eyes turning on me. "What you meant is, if Raphael Santi here indeed believes that he can use a bit of paint to bend the world—even if only a little toward peace—now would be the time to do so."

Chapter XXXIII

The most difficult element of painting to master is harmony, don't you think? While different artists define harmony in different ways, I define it as unifying disparate elements of a painting—line, color, gesture, movement, landscape, pattern—so that they all tell the same story. Tell the same story, and you have harmony. Tell differing stories, and you have a mess. In my *Poetry* wall, every figure, color, prop, and shadow could celebrate poetry and music. But how was I supposed to create such unity on my *Philosophy* wall when philosophers—by their very nature—are in conflict, working in a discipline founded on questioning, debate, and criticism? These concerns were taking over my every waking thought, but I had to push those worries away for one final day so I could first finish my wall of *Poetry*.

My assistants had laid the final patch of plaster for my *Poetry* fresco that morning, and now, it was evening, and the plaster was hardening fast. I'd chased my assistants out so I could concentrate; they were waiting at the tavern to celebrate. I didn't have much time left to finish this section before the plaster dried. If I didn't finish, I'd have to tear

down this final patch and start over tomorrow. I'd never before painted such a magnificently turned-out foot as I had that morning, and the Vatican deserved that foot. I leaned in to add another flick of blue.

"Where's His Holiness?"

I startled but, thankfully, pulled my brush *away* from the fresco instead of across it. From atop my scaffolding a few feet off the floor, I glanced over. Michelangelo stood awkwardly in the doorway, hands in pockets. I flicked my fingers at him, then pulled up my sleeves, rolled my wrist—*uno, due, tre, quattro*—and moved in to add another stroke of paint.

He cleared his throat and said, "I've finished the ceiling."

My eyes flicked up. "The entire thing?"

"The first half."

I nodded. Half-finished meant there was still another half for me.

He said, "I have to take down the first half of the scaffolding and build new scaffolding under the second half of the ceiling before I can continue, but I don't have the money for more wood." I could feel his gaze on my brush, so I changed my stance. It's one thing to glean inspiration from another man's designs, but quite another to steal brush technique; the way I work my brush is as uniquely my own as the way I work a woman. Let Michelangelo find his own moves. "I can't continue to work until I get more money," he said.

"That does seem like a problem, but I can't help you, and I have work to do, so . . ."

He shuffled into the room. "Is His Holiness here or . . . ?"

"You think the war is over after two weeks?" Another line of blue; the plaster was sluggish. I dipped in fast for more color.

"What war?"

"You didn't notice the army gathered out front?"

"What army?" The scaffolding groaned. *Was Michelangelo climbing my scaffolding?*

"The papal army marching off to war," I said. "Did you not notice the procession?"

He landed on the top of the scaffolding and leaned over my shoulder, casting a shadow over my hand. "I need the pope."

I jerked my elbow, hoping to nudge him backward, but he didn't back up. I said, "You mean the man who marched out at the head of his army? Horse, armor, lance . . ."

"The pope headed up the army?"

Flick, flick, flick went my brush.

"When will he be back?" he asked with more urgency.

"When the war is over I suppose. Now, if you'll excuse me . . ."

"He hasn't paid me in weeks." Michelangelo paced. "How can he expect me to keep painting when he won't pay for new paints? Does he pay you regularly?"

I kept my eyes on my brush.

"He does, doesn't he? *Che cavolo*, how stupid am I? He hasn't paid me *un grosso* for a year." He kicked a stack of sketches. I cringed. It would take half-a-day to reorder them again. "I'm not good enough to get paid, am I? I should starve." That's when he sat down on my scaffolding. *Sat down!*

"I can loan you money if you need food. You could go to a tavern or . . ."

"I'm too sick to eat." He dug his heels into the boards, shaking the scaffolding. "My favorite brother is sick. My father's terrified, yet here I am, stuck in Rome, not working,

watching you getting paid enough to buy a whole wall of pigments."

I started to snap back some rude response, but that's when I realized that I needed a little harmony—not only in my painting, but with Michelangelo. I needed us to tell the same story. So, I said, "Your brother's sick?"

"That's what I said."

"Where is he?"

"Florence."

I turned to him. He did look too sick to eat. "Then, you should go to Florence." I grabbed his hand and pulled him up. "Go. While the pope isn't here to tell you no." I ushered him toward the ladder. "If I had family who needed me, I wouldn't be here."

Michelangelo paused on the ladder. "The pope said if I ran away again, he'd hang me."

"The pope isn't here. He's up in Ferrara. Or Bologna. He won't be back for weeks. He won't even know you're gone." My eyes darted back to my drying plaster.

"That's true." *Thank Eve*, he started to descend, but then he stopped. "But my work . . ."

"After you help your brother, go find the pope at war. Convince him to pay you."

His forehead wrinkled. "This pope does respond well to demands."

"Exactly. Now go. You should get out of town before the gates close." He still didn't move, so I added, "If your brother is that sick, every hour counts."

His eyes flashed with concern. He descended the ladder quickly that time and called from the door, "Thank you, Raphael," and then he was gone.

I finished *Poetry* just in time and went to the tavern to

raise a glass with my men. When I told them what happened with Michelangelo, Lorenzo Lotto said, "*Maestro*, if you can find unity with that sculptor, then finding harmony amongst a gathering of painted ancient philosophers shouldn't be a problem."

Chapter XXXIV
Winter 1510

When my mother gave birth to my sister, I listened to her birthing cries from our dim little parlor, crammed with two couches, three tables, four dressers, and countless stools. My father sipped from a strong-smelling cup of purple wine and stoked the fire. The birth lasted for hours. I missed a night's sleep, only closing my eyes once my mother's voice became hoarse. Anytime there was a moment of silence, I popped open my eyes, fearing she'd died. Then, came the howls of my baby sister, and a midwife escorted us into the bedroom. My mother's face was splotched pink, and her chestnut-brown hair was matted with sweat. The bedsheet was crumpled. I crawled into bed beside her and begged, "Never do that again, Mamma."

My mother pulled me close and whispered, "Oh, don't worry, little one. I most certainly *shall* do that again. For God erases such pain from memory, so that we will walk through the tribulation of love again and again." As the nurses laid my whimpering sister in her arms, I decided to save my arguments for another day. However, I never had another

chance to make those arguments because my mother never had another chance to give birth to another baby.

Back then, I didn't understand what my mother was saying about pain, but now I do because God must *also* erase the pain of birthing a painting, for if I could recall all that agony after it was over, why would I pick up a paintbrush ever again?

My *Philosophy* wall had been stewing in my mind for nearly two years, yet even after that prolonged pregnancy, the birthing of that painting was as tortured as any. I made thousands of sketches: from my first thoughts scribbled in inked *pensieri*; to detailed drawings of gestures, draperies, faces; and complex designs of figural groupings. Then, when the designs were complete, my hands turned to painting once again. I didn't sleep much and only ate what my assistants put in front of me. I contracted a cold that turned to a cough. I wrapped wool scarves around my neck, balled my trembling fingers into shirtsleeves, and sneezed into chalky rags. My assistants tried to get me to rest—"We can do it for you, *maestro*. Let us help"—but no one had been able to give birth for my mother, and no one could give birth for me.

Whenever I remember the struggle—the aching fear that you're never going to finish, that you're ruining the painting, your career, the world—I wonder why I keep doing it. How much easier it would be if I could be content in a little town with a little house, garden, wife, family. I'm jealous of men who open their shops at nine, close for noontime siesta, lock up before dark, play with their children along the Tiber. Oh, to be a planter on someone else's farm. But me? I'm chained to my work by these golden shackles of hope—awful, wonderful, painful, tempting hope—of something big, something important, something life-changing landing in my lap,

of glory and fame, of being praised, being acclaimed, being the greatest.

So, that's why I was still there, in the Vatican, coughing and sneezing and pushing so hard that when I went to sleep at night, all I could see were lines of my painting falling in my vision like fireworks dripping down a night sky. And that's why I continue to fight and scream and howl and cry to this very day, all to give birth to . . . what? Love? A child? A life? No.

A painting.

"He laid too large a patch of plaster. He'll never make it in time."

"Five *soldi* says he will."

"Make it a ducat, and I'll take that wager."

I'd been up my scaffolding working on a single *giornata* on my *Philosophy* wall for twenty-three hours straight. (It was wet and cool that winter—not *too* cold to fresco, though—and the weather extended drying time. If my men laid plaster after sundown, a *giornata* could remain pliable until dusk the next day, giving me a few extra hours to perfect each patch.) I'd divided my painting into forty-nine *giornata*. Forty-nine full days of work. In those weeks leading up to Christmas, parties of cardinals, priests, wealthy Romans, and foreign pilgrims all packed into the apartments to see if I could finish each section before it hardened. With every new *giornata* came a new crowd, including Imperia and some of her ladies, now tending to the Vatican without fear of the papal noose. (My Margherita, however, refused to step foot inside the palace—"the dangers are still too great," she would say and send me back alone.) With the pope off at war, those rooms were a bacchanal nearly every night.

"I wish Leonardo were here. He'd love to see his face

going up in those quick flicks of that brush." I was using Leonardo da Vinci's face as the model for Plato, who (along with Aristotle) stood at the center of my painting of that philosophical debate unfolding on the steps of ancient Athens.

"No, Leonardo wouldn't want Raphael to rush; he would want legions of time for each individual hair in that beard."

Applying a brushstroke of water-based pigment into wet plaster is different from using oils on wood or canvas—isn't it?—although the goal is the same: make each stroke invisible. With oils, your brush can attack paint with abandon—wide blocks, long lines, quick staccatos—because with oil there's nothing to fear: make a mistake? No problem. You can change it. Oils are pliable for ages; you can retouch, push, pull, bend. It's why Leonardo loved oils: oils allowed him to feed his constant discontent. And even once oils dry, change becomes them. When you add a new layer, colors don't muddy, they become more vibrant, interest bubbling beneath. In oils, a perfect brushstroke is all about blending layers. No wonder oils are so good at capturing life: like people, oil paintings are created by blending together weeks, months, years of layer after unexpected layer.

Applying pigment into fresco, on the other hand, is terrifying. You get one chance—one day—when the plaster is wet, and once it dries, you can't change it. And you can't mix colors in fresco, either; they'll muck brown. During the first hours of frescoing, when the plaster's so wet that it doesn't want to absorb pigment, you must press hard with a dry brush, but not so hard that you destroy your smooth surface. Once your basic blocks of color are drawn in and the plaster starts to dry, build up your colors with quick, confident strokes—a hundred brushstrokes a minute; your arm will

never burn like it does during this stage of frescoing. I don't even stop for pulling up sleeves and rolling wrists during this stage; there isn't time. Near the end of the drying process, the plaster laps up paint like parched soil, and your brushstrokes must be short and true because they harden fast as polish.

As dusk dropped that winter day and the plaster dried hard, I touched in the final bit of Plato's white beard; if I'd needed one more stroke, I wouldn't have made it. I lowered my brush; my arm—shoulder to fingertips—throbbed. My eyes scanned the blue sky and clouds under that central arch all the way down to Plato's aging face and scraggly beard . . .

I don't want to boast about how those crowds reacted whenever I finished a new *giornata*. Do you like talking about the reception of *your* work, or do you prefer when someone else does the lauding? But, for context's sake, I should provide a couple of details to help you understand how I felt in those days. Please, forgive me. I'll be brief. I promise.

Imperia said things like, "He's too good. Tell the pope to give that man a set of red robes." (Promoting me to cardinal? Honestly? Yes, it was a nice fantasy with which to rock myself to sleep at night, but it's not as if I ever believed it would happen. I didn't. I swear.)

Then, Cardinal Riario took off his own red hat and tossed it to Lorenzo Lotto, who plopped it on my head. "Why stop at cardinal?" Riario cried. "Let's make him the first painter pope!" (That's so ridiculous that I can't even look at you when I say it, but that was the suggestion—not by me, by others—so now perhaps you can start to understand why some of it was going to my head.)

"He can't be cardinal *or* pope," called Cardinal Bibbiena. "He's marrying my niece."

"I'm not marrying anyone," I called over the cacophony. "Not until I achieve perfection."

And Guillaume grinned. "*Mais oui*, at this rate, *mon ami*, that won't be long."

Basta. I'm finished. They liked what I was doing. You don't need more than that.

The only reason I even tell you all of this is so that you understand that, like my mother, I was beginning to suspect that what I had birthed might have been well worth all that pain.

Chapter XXXV

This one time, *per favore, mia cara,*" I begged, "we can dress you up as a messenger boy and sneak you in and out in under an hour. No one will know you were there."

"No," Marghertia replied. Even with her jaw set, she's beautiful.

"I need the love of my life to see my greatest work." I flashed a smile that usually moves anyone in my direction.

But she was unwavering as marble. "I won't risk my life or your career to see some painting."

"It's not just some painting."

"*Basta,* puppy."

I tilted my head and said, "There's this cardinal who's trying to get me to marry his niece. He said she'd be happy to see my paintings."

With that, Margherita got up out of bed. "Get dressed."

I pursed my lips. That tactic had been all wrong, hadn't it? Ah well. What do you do after stepping into a pile of excrement? You try your best to clean it off, don't you? "*Mi dispiace,* I didn't mean to upset you."

"We're going out." She pulled on her dress.

Outside, she marched ahead as I dutifully followed—not a word, not a grin, nothing to further upset her—down one street then another and another until we came to a narrow side street by the Tiber. The dirt of the road was packed hard with deep grooves from wagon wheels and horse hooves. It smelled of manure and garbage. The buildings were shabby storefronts: a cobbler, haberdasher, blacksmith. A group of soot-faced children played knucklebones on a stoop. A hollow-cheeked maid dumped a chamber pot. "Where are we?" I asked as we reached the end of the street where two little boys leaned in a window, arms perched on the sill, staring up, mouths open as if witnessing a miracle. I peered in. That was no miracle. They were only watching a loaf of bread rise. Margherita pushed open the door to that shop. A bell tinkled as she led us inside.

The bakery was cramped—low ceilings, tables too large for such a small space—and hot from all the ovens. But that shop smelled of yeast, creamy butter, and melted sugar, and had a wonderful feeling of creation—flour dust, rising dough, rolling pins. "Hello?" called Margherita, and there came a great crash—pans, knives, Mary-knows-what— from some other room, and then a back door burst open, and in barreled a short, round man with flour smearing his nose, cheeks, and hair—or perhaps his hair was graying, it was difficult to tell. "Ah, there you are," he exclaimed as if we'd been hiding from him for hours. He hustled over to Margherita and took her hands and held them wide—"Let me look at you"—and then he turned to me and said, "You must try this and this and this," and as he shoved loaves and buns and rolls into my arms, I laughed—it's impossible not to when faced with such exuberance—and was starting to

wonder why it had taken me so long to visit such a magical shop owned by such a magical man, when Margherita sighed, "Please, stop, *Papà.*"

On that word, I dropped that armload of bread. As they scrambled to pick up the fallen goods, I took a step back. Margherita had brought me to meet her father.

Oh no. It was my teasing about marrying that cardinal's niece that had brought this on, hadn't it? She was going to bring it up—wasn't she? *Marriage.* And I was going to have to break her heart. Everyone at the Vatican knew she was one of Imperia's ladies, and I'd lose my job and my position at court, but if I didn't marry her . . . *Uffa,* to see that look on her face, to hear her voice shake—"*It's time to stop hiding me behind painter's tarps, Raphael Santi*"—and inside of her father's shop, no less, in front of him. I took out my sketchbook. Pull up sleeves, roll wrist, *uno, due, tre, quattro,* capture the faces of those two boys leaning in the window, watching the bread rise: chubby cheeks, disheveled hair, eyes turned up in awe.

In the background, her father exclaimed, "He's an artist?"

And Margherita pled, "Father, no, not that."

Her father was beside me, holding a round board. "You're a painter?"

I pulled my nose out of my drawing and nodded.

He shoved the board into my hands. "My daughter saved a monk from a pack of wolves."

I looked down at the round board. On one side, there was a sketch done in chalk; I recognized the author, as it was done in my own hand. I looked closer at that sketched face: it was Margherita Luti. I'd almost forgotten about drawing her on the end of that old wine barrel the night we'd met in the Pantheon. I'd certainly forgotten that she'd saved it.

"That monk drew this of her." Signor Luti kissed the tips of his fingers: *excellent.*

"A monk drew this? Really?" I asked, raising eyebrows.

"Raphael doesn't want to hear this, *Papà*," she said, trying to take the board from me.

"He most certainly does want to hear it," I said, pulling the board back. She gave me a pleading look, but I said, "Go on, signor Luti." Margherita closed her eyes and looked as if she'd like to crawl into one of those ovens alongside the bread.

"My Margherita had been outside the gates tending to the sick—she does that often—when she saw a monk, hiding up a tree, and a pack of wolves circling that tree, snarling and barking. So, what did my Margherita do? She picked up this board and used it to chase off those wolves. Grateful that she saved his life, that monk sketched her face right on this board. Then, that holy man blessed her and the wood, promising that this painting would make her and the board that had protected him immortal. He said that my daughter is destined for greatness."

"That I do not doubt, signore," I said.

"And now you . . ." He tapped my sketch of the two little boys in the window. "You're destined to be here, too."

The old panic was back. Her father was going to bring up marriage now, wasn't he? I took a deep breath. I would have to say yes. I would have to find a way. I would . . . "And tell me why I'm destined to be here, signore. I shall do as you ask, I swear it." I crossed one finger over the other in an "x" to seal my promise.

"You can finish this painting," he said, his eyes gleaming. "You can make my daughter immortal."

I looked down at the old *tondo.* He wasn't asking me to marry her?

"Father, we have to stop now," Margherita said, again trying to take the board from me, but I refused to let go. "You don't have the money for such a commission," Margherita went on. "Raphael is an important painter at the Vatican. He can't be bought with a round of bread."

"Signor Luti," I said, holding his gaze hard as if I were grasping his hand, "I promise to paint your daughter again and again, until I make her immortal. And payment of bread will be quite enough." I said, picking up a roll covered in a sugary glaze.

It took us I-don't-know-how-long to extricate ourselves from his shop, and as we walked down the Tiber, Margherita said, "I'm sorry about that, I went home the morning after we met, and . . . I couldn't keep that *tondo* at the villa. Imperia would've asked. I had to tell him something, but how could I admit . . . And I didn't want him to . . . I'm gone for days sometimes. He gives away all his bread to widows and orphaned boys in the neighborhood, and if I didn't bring home money . . . But he would never allow . . . so I tell him . . . I tell him . . ."

"You tell him the story as it *should be*. Nothing wrong with that."

"That"—she tapped the wooden *tondo* under my arm— "is not why I took you there. I had no idea he would bring that out. Although he shows it to most visitors, so I should've guessed."

I looked down at my shoes, splattered with orange and blue. Once again, at an important moment in my life, I'd neglected to put on a fresh pair. "I know why you took me there."

"You do?" her tone sounded small and unsure.

"'Gita," I said, and then corrected myself. "Margherita

Luti." Now was a moment for proper names, if there ever was one. "I know, despite what you have to do for your . . . that you're a proper woman, who deserves to be a wife and . . ."

"No. No." She pulled away and waved her hands in front of her. "This is what I feared. You can't start talking of marriage. You can't." She dropped her face into her hands.

I took a step forward but didn't dare touch her.

"I want . . ." Her voice was shaking. "I wanted to show you that I have someone else to tend to. I can't give up taking care of my father to take care of a husband. He didn't give me up after my mother. But if *you* asked . . . I never want to have to say no to you."

I wrapped my arms around her and pulled her into me. The weight of her body felt warm. I should've felt relieved. Margherita didn't want to marry me. I didn't have to give up my career or risk my reputation or position at the Vatican. I didn't have to trade the needs of my paints for the needs of a wife. We could be free. We could be happy. We could be together. I didn't have to break her heart. So why did my throat feel so tight when I whispered, "Then, I promise, my dear 'Gita, never to ask you anything to which you must answer no."

Chapter XXXVI

O n the morning of Epiphany, I arrived at the papal apartments before first light; it seemed like an appropriate holiday for the task at hand, as I felt how those Wise Men must've felt arriving at the manger: nervous, excited, wondering what I would find. The pope hadn't returned from war yet, but I couldn't bear to wait any longer to view my painting, so I'd had my men remove the scaffolding, and I stood in the middle of the room, eyes on my shoes—I'd put on a fresh pair of honey leather—and waited until dawn broke and golden light filled the room. I'd memorized every hair in my fresco of *Philosophy*, and yet, looking at it whole and finished would be—in many ways— the first time I would see it. I rubbed my hands on my pants twice, took out my father's brush and twirled it four times for luck. Then, I looked up.

Over fifty painted teachers and students were gathered on steps in ancient Athens, talking, debating, exchanging ideas. The composition was balanced and harmonious. The perspective lines were delineated in the square tiles of the floor, pushing back through classical arches. The colors of

tunics and togas—pine greens and rusty oranges, eggplant purples and yolked yellows—were contrasting, yet complementary. Highlights gleamed contrasting with shadows pooling in folds of draperies. The figures were graceful, yet sculptural; no two figures had the same pose or expression. Every face was an idea; every gesture flowed into the next. I searched for a flaw: an awkward finger, unrealistic shadow, botched foreshortening. Was there a seam of a *giornata* or a bristle of a brushstroke showing?

I heard my father's voice: "Do you know what all of this means, Raffaello? It means we might be the ones to reach perfection first. Have we done it?"

I squinted. *Had we?*

Santa Madonna . . .

You've seen my *Philosophy* wall, so I'll let you be your own judge. Besides, I loathe people who wave their own ribbons about, don't you? It's obnoxious. If you want an opinion about my work, ask others, not me, *per favore*. I will say that none of it felt real until I found Cardinal de' Medici—fresh home from war, robes muddy and tattered, chin bruised, shoulders drooping with memories of battle—staring up at my painting, mouth open, eyes glistening. He whispered, "*Perfetto.*" (That's not coming from me, mind you. No. That's coming from the son of *Il Magnifico* with the best art education on the peninsula. But I don't like talking about it. It makes me uncomfortable. Let's move on.)

At the time, I thought that achieving . . . achieving . . . achieving *that* with my *Philosophy* was the most important thing that had happened in my entire life, a fulfillment of everything my father had ever wanted. Now, *sì certo*, I know that it wasn't even the most important thing to happen in Rome during that Christmas season. In retrospect, the most

important thing that happened during those weeks was a then-unknown monk, making his first trip to Rome and experiencing the sin, excess, and corruption that drove him, a few short years later, to nail those infamous ninety-five theses to the door of the Wittenberg chapel and a stake through the center of the Church. I often think back to those winter weeks, wondering if I saw him among the crowds. I wonder if he was in the papal apartments while Imperia and her ladies danced for captivated cardinals, or aristocrats gorged on enough meat to feed a village of peasants, or pilgrims indulged on too much wine. I worry that he heard my men telling Sodoma (oh, how I blush at the thought of him hearing the name *Sodoma)* that the priests and maids we could hear bumping in the Borgia apartments downstairs were the ghosts of the *"accursed Spaniard."* I wonder if he calculated how many alms for the poor could've been bought with the gold leaf I'd slathered across my *Religion* wall or if he counted how many ducats it would've cost to cover my *Philosophy* in such brilliant blues, oranges, and pinks. Many of the philosophers in my painting were modeled on people I knew (Leonardo as Plato, Bramante as Euclid, Sodoma as the Greek painter Protogenes, even my own face—pushed off to the right side—as one of Euclid's followers), but some were strangers I'd sketched in the streets. I've since studied those faces in my *Philosophy*, wondering whether this figure here has the doughy face of a Northerner or if that chin there has the right cleft . . . Is it possible that among my crowd of philosophers I captured a glimpse of the now-famous, world-changing monk, Martin Luther?

Back then, I thought that since everything was perfect, it would stay that way: Margherita and I were together; I was the toast of the Vatican; the pope was happily off

fighting his war; the Church was whole. Now, I know that when everything seems perfect—perhaps *especially* when everything seems perfect—you must appreciate it because somewhere around some corner, far in the future or just up ahead, things won't always be so good.

Chapter XXXVII

Spring 1511

I believed my painting had bent the world, if not all the way to perfect, then close.

Priests, pilgrims, and aristocrats who'd reveled in wickedness and wine all winter now filed reverentially through the papal apartments to stand before my fresco of *Philosophy*. Cardinals offered me commissions to paint and nieces to wed. Chigi returned from war. He spoke briefly of his ears still whistling from exploding cannons and his eyes unable to stop seeing the piles and piles of dead. He also told me about the expansive encampments of French soldiers—"hill after hill of campfires, milling men, French flags. There were two, three, sometimes ten thousand Frenchmen, how many in total, I can't guess"—but then he brushed off those stories with a flick of his fingers: "I'd rather disappear into your perfect paintings, Rafa." After his return, Imperia and Margherita spent more and more time at his villa. Therefore, so did I, and my ideas for his frescoes came fast as fire. I started with a celebration of the mythological Galatea, daughter of a sea god. Galatea's love for a Sicilian shepherd eventually ended in that shepherd's death at the hands of a

jealous Cyclops, but for a time, Galatea and her dear shepherd were young and in love, not a care in the world. That's how Chigi and I both felt in those days: our loves might be forbidden, they might be dangerous, they might have us on a road to ruin, but for now we thought only of our seas of passion. For that great fresco, I drew cherubs and dolphins, tritons and sea nymphs, sea gods and seashells frolicking in the ocean under fluffy clouds, an orgy of Roman decadence.

Even Michelangelo seemed to bend a little. When he returned to Rome, he was buoyant with triumphant stories of his brother overcoming illness, his ride up to Bologna to demand a meeting with the pope, and the pope, in turn, demanding that the papal treasurer pay him. "And when he sees this painting," he said with a shockingly friendly demeanor as he stared up at my *Philosophy* wall, "the pope won't be able to argue with putting you in the Sistine, and letting me go back to work on the tomb. Me marble, you paint."

Spring rolled into Rome crisp and sunny, with birds singing, the rotted stench of the city fading beneath flowering honeysuckle. I'd painted so much and so well that I'd bent the world toward good. I'd kept my promise to my father. My quest was over. Nothing more to do but enjoy the love and life and beauty I'd created with my brush.

Then, one day, Margherita and Imperia were lying half-naked in a pile of my drawings as Chigi and I strolled up and down the loggia, trying to choose the best section of wall for my *The Triumph of Galatea* fresco when we heard servants calling, "*Basta*," and a figure barged in. It was Bramante, hair disheveled, face scratched and bruised, breath coming heavy and fast. "What in the name of Mount Olympia?" said Chigi, as we hurried over to take the architect's shaking arms. We led him to a bench and helped him sit.

"It's Bologna," Bramante said, trying to catch his breath. "We lost Bologna."

"To the French?" Chigi asked.

"To the French," Bramante confirmed, and Chigi sat down hard next to him. "I built cannons, fortifications, but it wasn't . . . it wasn't . . ." he stammered. "It wasn't enough."

"I'm sure you did everything you could," Chigi consoled.

Bramante wiped muddy sweat from his brow. "No wonder we call the French barbarians, they come with cruelly curved swords that split men in two with a single swipe, and their horses are bigger than ours, and their soldiers stronger. They have no mercy. God save us all." He shook his head as though trying to shake away the memory.

But still, the old architect looked like he'd ridden too fast and too hard to only be reporting yet another loss on the battlefield, no matter how gruesome. I found my tongue to ask, "Is His Holiness . . ." I cleared my throat. "Did he . . . ?"

"He's alive," Bramante replied without me having to finish the sentence. "There was one cannon shot that almost . . . Thank Our Father in Heaven for guiding it away from the holy head. But Bologna . . ." He shook his head. "He was determined not to lose it."

Chigi glanced up at me and added, "His Holiness will be enraged."

"He was. Is. Won't eat, sleep, shave—his beard grows fast and white. But it's even worse than that." Bramante hardly took a breath before adding, "Cardinal Alidosi is dead."

I lost my breath. Cardinal Alidosi wasn't always the best to me, but I'd enjoyed painting his portrait. I slumped down next to Bramante and asked, "In battle or . . . ?"

"Murdered," said Bramante. "Assassinated on the way to a meeting with the pope."

Margherita and Imperia wrapped each other in a hug. Chigi rubbed the back of his neck. I felt my cheeks cool with a loss of color. *Assassinated?* The pope's dearest friend, confidant, and . . . "Who would dare?" I whispered.

Bramante dropped his head into his hands. "The pope's own nephew, Francesco Maria della Rovere." He lifted his gaze to meet mine. "The Duke of Urbino."

"Cardinal Alidosi was murdered by our duke?" I cringed at the word *our*. "Why?"

Bramante shook his head but managed to stammer through an answer. "There was an argument over who was to blame for the loss of Bologna: our duke, the head of the papal army who fled leaving the people undefended, or Cardinal Alidosi, the unpopular papal ruler who dressed up like a maid to escape the city before the invasion. The duke blamed Alidosi, *sì certo,* and Alidosi blamed the duke. The pope summoned both of them to Ravenna to make their case. His Holiness swore that whoever was deemed responsible for the loss of that great city would pay with their life."

"Blessed Mother," I muttered. I didn't say this out loud at the time, but I'll say it now: think about all those times when Alidosi whispered in the pope's ear, touched the pope's arm, followed the pope back to his bedchamber . . . The pope never would've ordered Alidosi's execution. Never.

"I was part of the duke's entourage," Bramante went on. "While we were on the way to the meeting, we met Cardinal Alidosi on the road by chance. I was hoping it was fortuitous. I thought maybe the two men would stop, talk it over, find common ground. Perhaps they could both blame the French or the revolting Bolognese or maybe even the Venetians—it's always easy to blame the Venetians—anyone but each other. Maybe they could land on the same side,

unify for the benefit of the Church, save both of their necks, but before a conversation could start, the duke called out 'traitor' and . . ." Bramante made the sign of the cross.

I couldn't sit any longer. I got up to pace. *Uno, due, tre, quattro, uno, due, tre* . . . "Was it poison?" I asked, thinking back to that white vial in the duke's armored hand.

"Nothing so civilized. He stabbed him, right in front of me. The cardinal's blood splattered across my cheek and ran through the grooves of the cobblestones at my feet." Bramante's voice cracked. "I've seen a lot of ugliness at war: that desperate look in a soldier's eye when he realizes he must kill or be killed, boys weeping over friends and fathers, men beheading other men, but I'd never seen something so depraved as to kill a cardinal."

I took out my father's old paintbrush and began to twirl. "That's bad."

"That's bad," seconded Chigi.

"It's bad," repeated Bramante.

We must've all looked very pale, because Margherita said, "I understand how this is all bad for the duke, but why do you three look like you're the ones slated for execution?"

"Because," Chigi said, "Bramante and Raphael are subjects of the duke. So . . ."

"So?" said Margherita sitting up straight.

"So, they'll be held responsible for his crimes."

"But that's not fair," said Margherita. "Raphael wasn't even in Bologna."

Imperia put her hand on Margherita's arm. "When your country's leaders do something good, you get to celebrate the victory as your own, so why shouldn't you share in the blame when they do something bad?"

"It's every patriot's duty to bear," said Chigi grimly.

My fingers missed a beat, and I dropped my father's paintbrush. I picked it back up as I thought about what it might mean to be an Urbinite at this moment—the whispers, the loss of work, loss of friends. Would we be asked to leave the pope's service? Asked to leave Rome altogether? And then, my fingers started twirling again with a new worry: my portrait of Cardinal Alidosi—ordered in secret by the duke, given to the pope as a gift, hung over the pope's own bed—hadn't somehow been a part of this plot, had it? No, no. I started pacing again. *Uno, due, tre, quattro, uno, due, tre . . .* That portrait was nothing—nothing. *Uno, due . . .* Right? *Tre, quattro . . .* I had no blame in this. *Uno, due, tre . . .* Did I?

Chapter XXXVIII

June 26, 1511

P ope Julius's beard was long, scraggly, the color of salt. His eyes cast downward. His mouth drooped. When he'd marched out of Rome a year before, he'd ridden atop a stallion with pride, but now, he was tucked into a slow-moving carriage surrounded by a tattered army. Lances dragged, cannons stuck in mud, carts carried piles of wounded. This time, we courtiers didn't stand on grand platforms draped in flag and song but stood solemnly in our mourning browns, as the crowd wailed. Packed in with the others, I was unable to move so couldn't count my steps; I tapped my foot instead—*uno, due, tre, quattro*—anything to calm my mounting disquiet. During the campaign, the papacy had lost territory in Ferrara and Bologna, the lives of countless men including Cardinal Alidosi, and even the faith of the faithful: a group of cardinals were now calling for a schismatic council to declare His Holiness unfit for rule and depose him.

My perfect world had collapsed under the weight of reality.

The papal procession stopped outside St. Peter's, and

the pope disembarked his carriage and trudged up broken marble steps—construction on the new church had stalled with the pope and Bramante both off to war. At the top of the stairs, His Holiness nailed a piece of paper to the door, and then, shoulders hunched, he disappeared inside, the doors of the church dropping heavily behind him. I tucked my hair nervously behind my ears as we all pressed forward to see. I feared reading a bull dictating that all subjects of the Duke of Urbino were to be hung in retribution for the death of the pope's friend, but, instead, it was a declaration calling for a meeting to counter the schismatic cardinals; the pope may have been defeated in Bologna, but he wasn't done fighting. Not yet.

As we courtiers walked back to the apartments to wait for the pope—*uno, due, tre, quattro, uno, due, tre*—Bramante grabbed my sleeve, and we dropped to the back of the pack. It wasn't difficult to separate ourselves; no one wanted to be seen with us. "All may not be lost," Bramante said under his breath.

"How so?"

"There are many who didn't like Cardinal Alidosi and aren't upset by his death. They're helping the duke make a case that Alidosi turned traitor. If public opinion turns against Alidosi for any reason—his incompetency in Bologna, his heavy-handed influence over the pope, his"—Bramante cleared his throat—"*reputation . . .*" His tone made clear that I was to be thinking of the cardinal at Imperia's, the cardinal wearing a dress, the cardinal and pope disappearing back to his bedroom . . . "And if the rumor about their . . . *relationship* . . . catches, then the pope will have no choice but to not only forgive the duke, but thank him for ridding the papacy of such filth."

So, it wasn't rumors of *betrayal* that were going to turn public opinion against the dead cardinal, but rumors of *love*? I didn't want those of us from Urbino to be punished for the duke's crimes, but I also didn't want murder to be condoned as long as it was against *a man like Alidosi*. The other courtiers were watching, so even though I was silently rolling my wrist to counts of four, I kept my face serene as if we were talking of the weather. "If we hung every man entangled in such rumors, we'd have few men left. You don't honestly believe that a man should be murdered for such a reputation, do you?"

"That's the official line. Get on board or else we all hang."

An hour later, the doors opened, and His Holiness entered leaning one arm on Felice and the other on Michelangelo. The sculptor hadn't spoken to me since the cardinal's death. Alidosi had been his trusted friend and supporter, and like everyone else, I'm sure Michelangelo blamed those of us from Urbino for the murder. The threesome stopped in front of my *Philosophy* wall. That was the first time the pope had seen it. "Perfect," he muttered. He looked old and tired, beaten and spent. Then, he let Felice and Michelangelo guide him across the room and behind a private door. I looked down to pick a blotch of brown paint off a fingernail.

Guillaume joined me in a back doorway. I said, "You shouldn't be seen with me."

He replied, "*Eh*, I'm French. It's my country at war with the papacy, and my army that now marches down the peninsula. *Je pense que* I'm more traitor than you."

I kept picking at the spot of paint, but it wouldn't come loose. "Do you believe the cardinal turned traitor on the pope?"

"*Quelle histoire.*" Guillaume shook his head. "We all know, *bien sûr,* how loyal the cardinal was to the pope. But the other rumors?" Guillaume shrugged. "In France, it's not so much a problem, but here? Here, those rumors stick, painfully so, especially when . . ." Guillaume looked at his shoes. "Especially when the pope hangs a portrait of the suspected man in his . . ."

I smoothed down my vest. "You think my portrait is part of . . . ?"

Guillaume wouldn't look at me.

My hands turned clammy. I tucked hair behind both ears. Was that why the duke had commissioned that portrait from me? That painting wasn't a gift—was it?—but a trap, a way to fan the flame of suspicions about the relationship between the pope and the cardinal. *Uno, due, tre, quattro, uno, due, tre . . .* "But the duke commissioned that painting before Alidosi even left for Bologna, long before the war, long before the loss."

Guillaume shrugged. "But not before the duke knew that the cardinal was becoming too powerful, with too much influence over the pope, and the duke might one day want to hurt Alidosi or have . . . how do you say? *Leverage* over him."

I brushed imaginary dirt off both of my shoulders. "The duke used me."

Guillaume shook his head. "This is no one's fault except the man who held the dagger."

He was trying to be nice, but all I could think was: why would he try to reassure me that it wasn't my fault unless people thought it was? I ran my tongue over each individual tooth, counting as I went. Guilt is distasteful as spoiled egg, isn't it?

The pope didn't reemerge until hours later, with Michelangelo by his side. "The first half of the Sistine ceiling is complete," the pope announced, his voice tinged with a renewed edge of strength. "We'll unveil it on the Feast of the Assumption. A day commemorating the Virgin Mary's rise to heaven is an appropriate day to celebrate the rise of my ceiling in honor of "—and my foot tapped faster than ever as the pope's eyes landed on me when he said—"our fallen friend, Cardinal Alidosi."

Chapter XXXIX

August 15, 1511
Feast of the Assumption

"Mﾟay our Lord Jesus Christ absolve you, and give you pardon and peace," Pope Julius II's voice echoed down the nave loud as a drum during a funeral march. "Thereupon, may the Lord absolve you from your sins"—he made the sign of the cross—"*in nomine patris et filii et spiritus sancti.*"

And Francesco Maria della Rovere, Duke of Urbino, kneeling before His Holiness at the altar of the Archbasilica of St. John Lateran, responded, "Blessed be to God."

"His mercy endures forever."

It seemed as if all of Rome had packed into that ancient cathedral to watch the pope absolve his nephew for the sin of murdering a cardinal. I was seated in the fifth row, alongside the other courtiers. The Archbasilica of St. John Lateran had burned two hundred years before, and reconstruction was coming along in fits and starts, so the nave had the feel of ruin about it. It seemed appropriate considering the ceremony. "Brethren, please embrace our duke," said the pope, taking his nephew's hand and helping him to his feet. "Thank him for protecting us from harm, and hail every Urbinite as a hero."

As the duke made his way down the aisle to calls of gratitude and blessings, I received my own share of thanks and handshakes. I smiled and nodded and laughed—what else could I do?—but kept my foot tapping. When the duke arrived in Rome, His Holiness welcomed him with open arms—servants threw laurels at his feet—but I'm a portraitist, so not easily fooled by masked features and false words. I could see the pope's anger churning. Publicly, he may have been forced by rumors to forgive the duke for assassinating his friend, but privately? I tucked hair behind both ears and wiped imaginary dust off both my shoulders before following the procession out of the church.

As we walked back across town—*uno, due, tre, quattro, uno, due, tre*—my stomach swirled fast as mixing raw umber with a fresh batch of boiled oil. Romans threw flowers in celebration. Girls sang. Boys played drums. Della Rovere flags unfurled out of windows. But the pope's step was too buoyant for a man who'd just pardoned his friend's killer, even if that killer was his nephew. Something was askew. So, as we entered the Vatican and filed into the Sistine—I paused outside the door to add in another small step, tucked my hair, wiped both shoulders, and smoothed down my vest before entering—I didn't look up at that ceiling but kept my eyes on the pope's face as he tilted back his head. He squinted. His mouth pursed. I couldn't read his expression. Did he love it or hate it?

I didn't need to look up to know my own mind; I'd been up the scaffolding enough to know that the ceiling was a chaotic mess, so I wasn't surprised to hear the crowd speaking in strained, overly polite tones, as if struggling for something nice to say.

"The colors are . . . are . . . there are lots of them," said Cardinal Bibbiena.

Cardinal Riario patted the pope on the back and said, "It's certainly a change from the old blue sky with gold stars."

"My eye is . . . is . . . not bored."

"I never would've imagined there could be so many figures."

"It will no doubt have people talking."

The hollow praise went on and on.

Cardinal de' Medici—even more desperate than the rest to praise his fellow Florentine—offered an actual truth: "The sibyls and prophets are magnificent."

I took my eyes off the pope long enough to look at Michelangelo. His face was scarlet. He shook his head. Granacci tried to comfort him, but he pointed angrily at the ceiling. I could read his lips: *You can't see any of it!*

"I know that panel there is *The Flood*," someone said—I believe Bramante—"but what's that one?"

Michelangelo's face pinched. Can you imagine having to explain the subject of your painting? How humiliating. "*The Sacrifice of Noah*," he said.

"And that?"

The teal vein in his forehead thumped. "*The Drunkenness of Noah*."

I looked back at the pope, but his face was still impossible to read.

Felice leaned over to me and whispered, "You were right about one thing: amongst that mess, no one will ever notice that one little thumb."

That's when the pope caught me looking at him. His eyes flashed, and like a candlewick catching a flame, his face lit up with . . . what was that? His smile was strangely wide—even showing off his gums—and his cheeks were raised and brightened, but his eyes seemed glazed with carbon black.

"It's magnificent," the pope said in an overblown, theatrical tone. "Exactly what we would've painted if God had given us a brush, instead of a robe."

As everyone else exchanged confused murmurs, I looked up. The scaffolding was down, and tarps were removed, presenting an unobstructed view: one half of the ceiling was blank white plaster waiting for paint, but the other half . . .

Uffa.

It's difficult now to mentally separate the first half of that ceiling from the whole—isn't it?—but the next time you're in the Sistine, take time to look at that first half objectively. There's little rhythm, balance, harmony, or grace. The central panels depicting scenes from the Old Testament are so cluttered with tiny figures that they're nearly impossible to read from the floor. And what was going on with those nude adolescent males perched atop painted pedestals like grotesque statues, twisting and turning into strange poses? Too young to be men, too old to be *putti*, they have no story purpose at all, only decorative, *if* you can even call them that. The first half of that ceiling was an affront to everything I'd been working toward in the apartments. So, if I'm right—and I was right—why was the pope proclaiming, "It's wonderful, simply wonderful. We're very eager to see what he does with the second half"?

I wasn't the only one who seemed confused. "*Che cavolo,*" a voice called out from the back. That was my duke shoving through the crowd. "You promised when I came here that all was forgiven, and you wouldn't hold any of this against my countrymen."

I silently pled, *Please don't be referring to me. Please don't be referring to . . .*

"Raphael Santi of Urbino," my duke spit, "is the far superior painter."

I closed my eyes and exhaled to the count of four.

The pope's tone was disquietingly pleasant when he said, "And we've kept that promise, nephew. We've proven that we side with family over climbing cardinals. However . . ." I opened my eyes. Not only was the pope's tone too pleasant, but also his entire countenance had a sweet coating like a dessert fritter at a royal wedding. He said, "The only thing that I promised you is that I would give your countryman the remainder of the Sistine *if* his work was better."

"I'm no art expert"—the duke flung his arm skyward—"but even I can see that's awful."

"Precisely," said the pope in a happy, lilting tone. "It's an ugly, chaotic mess."

"So, why, Uncle, do you sound happy about that?"

The pope replied, "Because it was intentional."

I exchanged raised eyebrows with Cardinal Riario, and even Michelangelo looked bewildered when he said, "*Che?*"

The pope turned his eyes back to the ceiling. "After the fall of man with Eve eating the apple and the expulsion from Eden, looking so ghastly there"—he pointed to the single panel combining both the *Temptation* and the *Expulsion*—"that's what happened to humanity, isn't it? We devolved into messy, awful, ugly chaos. Michelangelo is making a perceptive theological statement about man's desperate need for God's grace and salvation."

Michelangelo's lips parted, and he—along with everyone else in the chapel—looked back up at the ceiling, and I swear, all—even Michelangelo—exhaled a collective "Huh."

The pope went on. "But now that we're moving down the ceiling, backward in time, away from the fall, into the

creation"—the pope gestured to the half of the ceiling prepped for paint with white plaster—"we'll move out of chaos and into some new *Michelangelean* insight." The pope grinned—a big, mawkish grin—and bounced on his toes.

My duke said, "I don't mean to argue, Uncle"—(*Then don't argue,* I wanted to scream)—"but Eve was created before the Fall, and look at her, she's . . . she's . . . Is that even a woman?"

We all looked up at the panel of the *Creation of Eve.* We could already see that it would eventually be the center panel of the entire ceiling. (Have you ever wondered why the *Creation of Eve* is in the center of that ceiling, not the *Creation of Adam*? I'm not surprised that someone would put Woman at the center of creation, but *Michelangelo*? He's not exactly known for his love of women, is he?) In that panel, Eve rose up out of Adam's side with thick legs and bulging biceps. She was, as the duke had intimated, awkward, ugly . . .

"Why are you complaining?" Michelangelo said. "I gave her long hair."

Cardinal de' Medici, standing near me, muttered, "I knew I should've insisted that he see at least *one* naked woman when we were young."

"The point is, Uncle," the duke said, "that panel—before the Fall—is as ugly as the rest."

The pope hardly had to pause before finding his counter. "Yes, that's because Eve was the cause of the Fall. Woman is the mother of all chaos. She should be ugly."

Felice della Rovere expelled a strangled yelp but quickly recovered her composure.

The pope went on. "The point is, nephew, Michelangelo will complete this ceiling, while your countryman, Raphael"—the holy eyes didn't dart to me, but stayed on the

duke—"now that he's finished with my library, will begin work on a second room in my apartments."

I exhaled. At least, I wasn't being fired, excommunicated, or hanged. Not yet.

"However, we will take your *other* suggestion," said the pope with an unnerving lilt. My foot began tapping again.

The duke's brow knotted. "Which one?"

"That whichever painter proves best will inherit Bramante's job as papal architect," said the pope as Bramante nodded. The old architect was nearing seventy by then, so whether because of illness or a more permanent sleep, the pope was being practical in selecting a successor now, instead of waiting for the inevitable. "*Maestro* Bramante," the pope continued, "will stay on as an adviser to the new master of our artistic agenda, and—this part of your recommendation we particularly liked, nephew—we will give the winner control over every other painting in the Vatican, future *and* past. No more locking unwanted paintings behind closed doors. No. Our new master will have the right to keep what he wants and tear down everything else."

Tear down . . . ? Several people inhaled sharply. Bramante became a student of his shoes. I'm guessing my complexion turned white as a Dark Ages Madonna by Nardo di Cione.

"And since you've made clear, nephew"—that word had long ago begun to sound like a curse—"that your countryman, Raphael, will take a chisel to this ceiling and replace it with—how did you describe it, again? 'A vision worthy of Urbino'?"

Michelangelo's scruffy head snapped toward me. I should've cried out that the duke was lying, that I would keep as many prophets and sibyls as possible, but did I?

No. What do you think I did? I smiled. *Sì certo*. Smiled and smoothed down my vest *and* my breeches.

The pope turned to Michelangelo. "So, now, we're interested in knowing what Michelangelo will do with Raphael's paintings in our private apartments if he wins."

The master of the Sistine turned his gaze heavily toward me. "When I win, and I will win"—he said darkly—"I'll carry my sharpest chisel into those rooms and chip every stroke of Raphael Santi's paint off those walls, erasing it, just like men do to other men. And when I cut it down, I won't replace it with some easy beauty, some pleasant harmony, some perfection that doesn't exist."

My smile dropped. *Easy* beauty? As if I didn't have to work at my perfection. As if nice and pleasant and generous made me—what? Simple? My pulse quickened—I counted my heartbeats, too—but I couldn't find my tongue.

"No," Michelangelo spit. "I'll tear it all down and replace it with a miracle."

That's when my tongue found me, and I said, "There's no such thing as miracles."

And Michelangelo replied, "Maybe not for you, but there are for me."

My jaw hitched to one side as I held Michelangelo's glare. That's when the pope clapped. "A competition as I like it," he said, with a tone fit for a Carnevale celebration. And for the first time since Alidosi's death, his eyes gleamed. "One winner takes all, in art as it is in life."

Chapter XL

S itting on the marble floor, leaning against my *Religion* wall and drinking directly from a large-mouthed flagon of unwatered wine red as dragon's blood, I stared up at my *Philosophy* fresco. The library was complete, the ceiling and all four walls: *Religion*, *Poetry*, *Law & Virtue*, and *Philosophy*. I should've been proud, surrounded by those frescoes, but instead, I felt limp as watery pigment dripping down a dry wall.

"He asked me to return this to you," came a voice.

I lulled my head to the left. The figure in the doorway was barely illuminated in the crumbs of pewter moonlight, but that was no doubt Felice della Rovere holding my portrait of Cardinal Alidosi. "I don't want it, either," I said. "Burn it."

She crossed the room—for once her widow's weeds seemed wildly appropriate—and propped the portrait against the wall next to me. "You've done a great service to your duke."

I knocked my elbow against the portrait so that it fell face down on the marble floor with a clack. "Is that what I've done?"

"You'll be rewarded."

I lumbered to my knees and crawled over to my stack of supplies. "Yes, it'll certainly be a memorable reward when Michelangelo chisels my paintings off these walls." Paintbrushes, mortar, knives, more paintbrushes . . . *where is it?* "I can only hope that your father has ordered me hung by then, so I don't have to witness it."

"Your duke won't let him hang you."

I picked up a leather pouch and crawled back to the portrait. "So, you admit His Holiness has already measured the rope. *Che grande.*"

"My father is angry, but he knows what you can do with a brush. If he didn't, you'd already be . . ." She exhaled long and hard as if expelling a final breath. "He wants you here, alive, competing with Michelangelo, making him miracles."

I dumped the contents of that pouch onto the back of the portrait: char cloth, striker, flint. "There's no such thing as miracles." I didn't even bother to pull up my sleeves or roll wrists before picking up the flint and striker to work a spark—what was the point of counting anymore? What was the point in anything anymore?

She pressed her hands over mine. "Don't. You'll start a fire."

"That's the goal."

"Not inside the palace."

"This place is made out of stone. It won't spread beyond this room. And this room is slated for execution, so . . ."

She grabbed one end of the portrait. "Cardinal Alidosi should've kept his distance from my father, their relationship was too dangerous, and this portrait made it possible for us to . . ."

I let go of the portrait. "Keep it if you must, but I don't

ever want to see it again." I slumped back down on the floor and poured wine out of the spout of my flagon and into my mouth. It splashed down my chin. I didn't bother to mop up the mess.

"I wish you understood what you've done for my father and for the papacy."

"I'm not as naive as you assume," I said with a resigned shrug. "You and the duke wanted Alidosi gone because of his cozy relationship with your father, and you used me and my painting to help force the pope into forgiving the duke. My little portrait may not have delivered a fatal blow, but I helped the duke get away with the deed."

Scraps of moonlight reflected off her dark eyes. "You think you're clever."

"Cleverness is a detriment to any courtier, my lady, lest we outshine our ruler; however, attentiveness to humans and their relationships is necessary for keeping your head. It's also helpful as a portrait painter, although in this case"—I waved my hand at the Alidosi portrait—"that talent has tied my noose." I took another drink and stared up at my *Philosophy*. "I create the world's first perfect painting, and yet . . . I work harder than everyone else, I'm nicer than everyone else, I'm more gracious, more polite, more perfect, perfect, perfect . . ."

She slid down the wall next to me. "You and I are more alike than I thought. I do everything right. To protect my father, I sacrifice my own happiness, my own safety, my first husband . . ." She picked up the flagon in two hands and took a drink. "Too bad. He was almost as handsome as you."

I was feeling fearless—that's what believing you're meant for the noose will do—so I said, "According to rumors, you're the one who delivered the poison to that handsome husband."

"Like I said. Sacrifices." She took another drink and passed the flagon to me.

I drank, too. "Michelangelo puts up a mess on that ceiling—acts like a mess, *is* a mess—and yet people love him, hire him, choose him. Why?"

"Does my father thank me for keeping the peace between my husband's family and the Colonna? No. He gives all the credit to this cardinal or that cardinal for their 'talks' when all the real thanks should go to the time I spend in my own bedchamber."

"When Michelangelo rips down these paintings, it'll wipe me from history. Who will ever remember a nameless, faceless Urbinite painter of pretty little Madonnas?"

"When I was ten years old," she said, "my father's sworn enemy, the Borgia pope, sent his men to capture me and hold me captive until my father—still cardinal at the time—surrendered himself in exchange for me, as any good father would. They would've tortured him, forced him to sign a document of loyalty to the Borgia, presumably hung him." Her dark eyes found mine; in that light, the color looked like flecks of moss floating in thick mud. While you'll never catch me describing her eyes as kind, that night I saw that they weren't *always* so murderous. "In the dead of night, my father's men put me on a ship in the Mediterranean, sailing north to Savona, where my father's family had sworn to protect me. However, the pope ordered his men to hunt me down. Papal galleons quickly caught up to us, and the pope's men boarded our ship. I refused to serve as bait to lure my father into the hands of his enemy, so I . . ."

"Killed the pope's men," I interrupted.

She has a nice laugh. Too bad she doesn't use it more often. "I jumped off the ship."

"Into the Mediterranean?"

"In a heavy dress my mother had put me in to greet my father's family."

"You were how old again?"

"Ten."

"Could you even swim?"

"I'd been to the Port at Ostia. Once." She shook her head. "I remember my skirts billowing in the water, first holding me up, then pulling me down. It was dark. Cold. I splashed and flailed until . . . One of my father's men was already in a rowboat—he'd obviously been fleeing the scene, although he claims he was waiting for such an emergency. He plucked me out of the water and rowed us to shore under the cover of darkness. We rented horses, and he rode with me to Savona. And after all that, who do you think got credit for protecting my father?"

I didn't need to think about it. "The man who pulled you out of the water," I said.

"*The man who pulled me out of the water*," she repeated. "He got a bag full of ducats and a stretch of land, while all I got was married off to a man who turned out to be a Borgia spy. Too bad. He really was handsome."

"My lady, I hate to tell you this, but you and I are nothing alike. You're a far better person than I, for I wouldn't be here if it weren't for the ducats and laurels." Our eyes caught. She has a nice smile, too, when she uses it.

"You know what our problem is?" she said. "We make it look too easy. I do all my saving of my father under a veil of darkness, and you don't even add any rough patches to your paintings so we can see how difficult the perfect parts must be. And instead of cursing a few times an hour while you

paint, you always look so blessedly happy. You should act more frustrated. Show a little anger."

"Would you rather I take a page from Michelangelo's sketchbook and throw a plank or two at your father's head?"

"You wouldn't dare." She extended her hand and bit the side of her finger, in a playful gesture threatening violence, but she was smiling.

I smiled, too, but then . . . "I should go home. Or maybe not home because of the duke and all, but back to Florence or Città di Castello. They like me in Città di Castello." I sighed. "I really am too nice for Rome, aren't I?" I asked, repeating the criticism she'd leveled at me the first day we met in the papal apartments.

She nudged me and repeated my own words back from that day: "How can you be too nice for Rome? Rome is a city of saints."

And I repeated her own words back to her: "How boring that would be."

She linked her arm through mine. "Men are made in Rome, Raphael. You can't leave. My father would be too disappointed for me to allow it."

"But why should I spend another year on a new room if it's only going to be destroyed?"

"For a man who claims to be an expert on people, you're awfully dense sometimes."

"Michelangelo *will* cut down my paintings when he wins."

"That I don't doubt. It's my father you're misreading. Saving your work is simple."

I sat up straight, took out my father's old paintbrush, and began twirling. If anyone could give me the key to

impressing her father, it was Felice. "Tell me what to do. I'll do anything."

"Win."

I sank back down. "Considering your father's understandable anger with everyone hailing from Urbino, I think that would take a miracle, my lady."

She shrugged. "So? Deliver a miracle."

"There's a problem with that plan, signora Orsini."

"What's that?"

"How can I deliver something that I don't believe exists?"

Chapter XLI

My talk with Felice set me back on my trail. Now wasn't the time to give up; it was time to fight. So, I stayed up all night drawing a new image with red chalk on a large piece of paper. At dawn, I took out a ladder, leaned it against my *Philosophy* wall, and climbed up. To the left of center—in the open space that gave my fresco its balance and stability—I pressed my drawing face-down against the wall and smoothed it flat. Then, I peeled it away, leaving a ghosted imprint of that chalk drawing: a solitary figure sitting on the steps of Athens. Then, I took out a chisel and hammer, pulled up both sleeves, rolled *both* wrists—*uno, due, tre, quattro*—put the blade against that blank spot on the stairs, and—

Crack!

I drove that chisel into my perfect painting.

I pulled back and cracked again.

I heard footsteps coming but kept hammering.

"*Mio Dio,*" Bramante cried from the doorway. "What are you doing? It was perfect."

I cracked into that fresco once again, and a chunk of

plaster fell off and hit the floor. "Apparently, that was the problem."

I finished that new figure in a single day. He sits on the steps of Athens, hunched over his paper, right in the middle of everything, and yet, he's solitary, uninvolved in collaboration like the rest of us (certainly unlike my own portrait, one in a crowd of many, pushed off to the side). He's Heraclitus—*sì certo*—the ancient weeping philosopher, the eternal pessimist, grumbling about how nothing is constant except change. But you know who he truly is, don't you? It's not as if I tried to disguise his features: scruffy head, flared nose, brooding glower, wearing that familiar faded tunic and those heavy work boots. I'd even painted him in his own style: sculptural, heavy, epic, however you want to describe it. No one could mistake him as anyone other than Michelangelo.

Cardinals and courtiers filed through to look at that new figure. They murmured that the addition was so seamless that it seemed he'd always been there. They said that my new figure was as realistic, weighty, and sculptural as any figure on Michelangelo's ceiling. Maybe better. Even the pope—despite a nagging cough that had started after the Sistine unveiling and worsened with every hour—hobbled through and smacked his lips happily. Rumors of my newest achievement spread fast and thick through the halls of the Vatican.

That night, after the pope's coughing subsided and the apartments settled into their nighttime quiet, I made a show of leaving—"I have an appetite that needs feeding. I'm off to the tavern to gorge"—but I hid among my stack of supplies. It was barely dark—I hadn't even become sleepy yet—when I heard those familiar boots clump down that hallway. The

orange light of his torch flickered against the darkening walls. A man's ego is so predictable, isn't it?

Michelangelo found the figure of Heraclitus quickly and pulled his torch up to look. I was positioned behind him so I couldn't see his features, but he sunk to his knees and muttered something like *"son of Bathsheba."* He fumbled through his satchel. I sat up straight in case he pulled out a marble hammer and I needed to jump up and stop him from attacking. He bent over toward the floor. Then, he looked back up at the painting, back down, back up, back down ...

Wait, he wasn't ... Was he?

I silently rose to a crouch to get a better look.

Naomi and Ruth! My hand came to my lips. Yes. *Yes.* Michelangelo was copying *my* painting. And that's the moment when I realized that maybe Michelangelo and Felice were right and miracles did exist; it's only that I had to make them for myself.

Chapter XLII

August 1511

F elice's right," the pope said, after yet another coughing fit. Felice pressed a white kerchief to the holy lips, and it came away splattered scarlet. "I want you to decorate the next room of my apartments with miracles. Perhaps by painting them, you shall summon them, too."

I shot Felice a glare but kissed the holy ring as offered. "Yes, Your Holiness." When the pope asks you for something on what may very well be his deathbed, you don't demur, do you? Still, I kept my foot tapping. *Uno, due, tre, quattro . . .*

"Paint the Liberation of St. Peter on one wall." He sat back against his pillow, his holy forehead beading with sweat. "And the Mass at Bolsena miracle is also a favorite of mine."

"Inspired choices, Your Holiness."

"But begin with the Expulsion of Heliodorus. Second Maccabees, chapter three," he said, as a priest took out a box of leeches. "When the King of Syria sent his servant Heliodorus to rob the Temple of Jerusalem of money reserved to help widows and orphaned children, God sent a horseman and two angels to expel that thief from His Temple. I

want you to paint those angels driving out Heliodorus, same as I'm going to drive those damnable French off our land. And as you paint it on that wall, let it be so on this Earth." He doubled over coughing but still managed to swat that box of leeches out of the priest's hand.

In whispers outside his door, I told Felice, "Painting scenes of miracles isn't the same as summoning real ones. My paint can't turn the tide of the French army."

"As your rival down the hall says, the danger for most of us isn't in setting our sights too high and missing them, but in setting them too low and hitting our mark." She tapped her temple—*think about it*—then returned to her father's bedside.

I hardly had time to begin selecting the best paper and chalk for my designs before the world started devolving around me. By cutting a new figure into my perfect *Philosophy*, it seemed I'd cut into the world. The pope's fever spiked; he fell unconscious. Felice insisted he'd only caught a cold during a hunt, but there were rumors that he'd been poisoned. Either way, the palace braced for his death: servants swiped silver; cardinals who believed their rears fitted for the papal throne paid out ducats to secure votes; His Holiness's allies shipped treasure to family in safer lands. Even if the pope *did* survive, the schismatic cardinals announced a date for their council to depose him. And then Felice brought word that her bedroom diplomacy had failed: her husband's family, the Orsini, were fearful about losing their hold on power if the pope died, and they'd started rioting in the streets. The other old Roman families had quickly followed their lead. We could smell the smoke even inside the Vatican.

I tried to lose myself in my designs—miracle, miracle, how to create a miracle? *Uno, due tre, quattro*—but for

once, the scratch of my silverpoint couldn't quiet the noise. The Vatican felt like a pot of boiling oil, every new bubble adding to the pressure, threatening to blow the lid.

"The rioters have taken Imperia's villa," said Lorenzo Lotto one day. Outside, the sky was black, not from night, but smoke.

"Imperia's?" My Margherita . . . I rubbed my face; my hands tasted of chalk. How long had it been since I'd wiped them? When I stood, my legs tingled; how long had I been kneeling? I smoothed down my hair, my vest, my breeches, but everything still felt uneven. My Margherita . . . "Mary in heaven, I have to go."

"No one is allowed in or out of the Vatican," Lorenzo said. "This is all rumor." I tried to push past him, but he grabbed my shoulder. "What did I say? No one is allowed in or out. No one. I just thought you'd want to know." He patted my arm and walked away.

No matter how hard I begged, the papal guards refused to let me exit. "It's for your own safety," they insisted.

"What about the safety of those on the outside?"

"All of Rome can burn, but it's our duty to safeguard the pope."

You mean the pope who might be coughing his last at this very moment, I thought, but didn't say, because who wants to hang for such careless treason?

Every door was guarded the same, except for the secret door leading to Michelangelo's workshop, but it was locked firm. I yanked on the handle, kicked and pounded, but that door didn't open and no one came to help. I tried to work my brush in the lock but couldn't make it click. I had to get to Margherita, help her, save her, protect her. *Uno, due, tre, quattro*, there had to be a way out.

When I was a child, my mother taught me that whenever I was feeling hopeless, I should close my eyes and let my mind wander: "You already know the answer," she would tell me. "You only have to show yourself the way."

So, that day, twirling my father's paintbrush, I followed her orders and closed my eyes, letting my imagination bob through that locked door and down that dark corridor and then come to Michelangelo's studio, where I remembered back to that day when I'd first arrived in Rome, when I was up in that workshop, and Michelangelo's clunky work boots were mounting the stairs, and I was searching desperately for an escape, an escape, an *escape* . . .

My eyes flew open. Yes. Yes, there *was* a way out. Like that long-ago day, the only thing I needed was a key. And I knew just where to find one.

"Leave me alone. I'm tending to my father," barked Felice, waving me away.

"But I'm here to beseech you to *save* your father, my lady, as only you can."

She used a rag dipped in wine to blot his holy lips. The pope's eyes were closed. His breath rattled. "If you'll leave me alone, then I can tend to it."

Any other man, I suppose, might've grabbed her arm and dragged her from the room—it's not as if the cardinals holding vigil would've questioned me if I'd told them she was having a "moment"—but I *never* take something from a woman that she doesn't want to give. "This building is shaking; don't you feel it?" I said in a pleading tone with nary a finger on her elbow. "The rioters are trying to get inside, and your father isn't strong enough to withstand an attack. If you stay here, you might as well tell St. Peter to open the gates for a new resident."

Her eyes blazed. "You want me to go outside and fight off the rioters with a stick?"

"Your father didn't marry you to an Orsini only to keep you in Rome, did he?"

Her hands paused over his damp forehead.

I went on. "He married you in hopes that you—the good wife, the good daughter—could keep the peace if it came to that. *Allora*, it's come to that. You have to go and find your husband, make him make peace with the other families. If you don't calm them, and they breach these walls . . ." I pressed my hands together in prayer and wagged them four times for good luck.

She started to nod, but then her eyes narrowed. "Why are you in here telling me all of this? What good does it do *you*?"

"I want to help save your father, save the papacy, save the Church."

She shook her head then grabbed *my* arm and dragged *me* out of that room, right past those cardinals holding vigil, who, as suspected, didn't even look up. Once we were alone, she whirled on me. "What do you want?"

"I want to help save . . ."

She crossed her arms and gave me this I-have-you-pegged-you-foolish-fool look. She said, "You have another motive; everyone always has another motive. Tell me the truth and remember 'People are more inclined to believe bad intentions than good ones.'" (I don't know about you, but I *never* mind a woman willing to quote Boccaccio.)

However, I didn't have time for courtier games, so I fought my instinct to bandy back a bawdy Boccaccio quote and instead admitted, "The Vatican is locked. I need the key

to the secret corridor leading to Michelangelo's studio, so I can go out there and save my girlfriend."

"Why didn't you just say that?"

"Because I knew you'd be most amenable to helping me if you thought it was to protect your father."

"You're not wrong."

"About how to end the riots or the best way to manipulate you?"

I couldn't tell whether she smiled—her eyes and mouth are never in concert on this point—but she did say, "Meet me at that door in the time it takes to deliver a quick sermon on a busy Sunday," she said, "If you're not there, I'm going without you."

Chapter XLIII

I f you'd let me stop to light a torch, then we'd be able to move faster," I said, shuffling along behind Felice with my hand on her elbow. I hoped she'd take it as a gentlemanly attempt to keep her on her feet, but by the way she adjusted her arm whenever I slipped on the mossy floor of that dark corridor, I suspected she knew it was an attempt to keep me on mine.

"If a guard had seen us with a torch, they would've asked where we were going."

"You could've said we were going to a chapel to pray for the soul of your father." It was so dark, and I was so frightened, not even counting was helping.

"Ah yes, that's the rumor I want all over town: that I'm gallivanting off to some dim, private room with a handsome rake on my tail." We reached the end of the corridor—*thank Josephine*—and she started fumbling with the keys in the lock of that door.

"All I'm saying is that wasting all this time stumbling around in the dark might mean the difference between life and death for the people we love." I smoothed down my

eyebrows and tucked hair behind ears, but nothing was helping. Nothing at all.

"If my husband heard a rumor about us stumbling around in the dark together, the only death we'd be talking about is yours."

"You don't care about my life."

"You *are* clever. *D'accordo,* I'll admit that, but . . . *Porca miseria,*" she cursed as her ring of keys dropped to the floor.

"*Madonna,* let me try."

"'*Madonna, let me try,*'" she repeated in a mocking, high-pitched tone as she elbowed me back and continued to jangle with the keys. "Can you please learn an actual curse?" And then she let out a string of curses worthy of Michelangelo.

All of our bickering must've stuffed *both* our ears because when that key finally turned that lock, neither of us seemed prepared for what we found on the other side of that door: several looters—four, maybe five, all in leather armor brandishing torches—ransacking that studio. They obviously didn't know what was valuable in that room because they'd pushed Michelangelo's sketches onto the floor and were going through shelves as though searching for gold.

Felice shoved me out of the way and yanked the door closed behind us. As the marauders paused a beat to exchange confused glances—violent men don't need to be clever, do they?—Felice fumbled with her key. Protecting the Vatican—*her father*—from those thieves was her primary motivation. Mine was getting out of that workshop alive so I could save my Margherita, so you'd think that I would've ducked under the table or slid for the door, letting the men have Felice and the corridor and the pope and anything else they wanted, but for some half-stewed reason I stepped in front of the lady, grabbed a chair, and pointed

its legs toward the men as if taming a wild boar. Yes, one of them laughed; can I blame him? I'm wiry, at best, and was gripping my "weapon" no firmer than a paintbrush. One of them swiped a paw, and the wooden chair flew out of my hands and shattered against a wall. He grinned—in my mind he only had half-a-mouth of teeth, but that may only be my prejudices about men of such a sort—and spit. The lock clicked behind me—*thank Mary*—and then Felice said, "Why are you just standing here? Hoping to paint your way out of the situation?" She stepped in front of me and said in this silky tone, "Gentlemen."

Felice must be accustomed to men pausing anytime the veil of her widow's weeds *accidentally* drops off her shoulders, because as those men stood there ogling a bit of her bare flesh, she kicked one of them off his feet, swiped a torch, and lit one of their jackets on fire before any of them even made a move toward her. One stumbled backward and fell, and she lit his boot on fire. Then, she screeched and squawked in the most discordant manner—like a bird of prey swooping in on a scavenger attacking her nest—and lit papers, chairs, and beards on fire. As the men scrambled away, one threw his torch at her, and it caught her skirt, but that only seemed to drive her forward faster. The men climbed over each other, fighting to see who could make it out the front door first.

And all of this before I could even brandish a new weapon. But I wasn't wholly useless. Once she slammed the door behind the last man, I grabbed her and rolled us both across the floor to smother the flames rising up her skirt, used my jacket to tamp out the last few burning sketches, and then dunked her torch into a bucket of water—or what I thought was water; the acrid smoke told me it was more

excrement in nature. The point is, the flames were out, we were alone and safe, lying in a pile of charred wood and paper, breathing hard, when Felice turned to me and groaned, "We should've let the place burn."

That was not the sentiment I was feeling in that moment, so I pushed my hair out of my eyes and said, "*Cosa?*"

She grabbed a stack of charred sketches off the floor and threw them at me.

I flipped through the drawings: a great architectural facade, three stories tall, with niches and an array of muscular figures. "I stand by my earlier assessment: *Cosa?*"

She crawled around the floor—still breathing hard—and pushed sketch after sketch at me like a wild dog kicking dirt over his . . . his . . . you know. "These are all drawings for my father's . . ." She didn't say the word "*tomb,*" but I heard it nonetheless. "This is why he's so sick. That *blessed* sculptor is still tempting the reaper."

I flipped through Michelangelo's drawings of that tomb—one was more miraculous than the next. "You can't honestly believe that."

She glared at me with the same look that Michelangelo gives me every time we speak: *You're a fool, aren't you?* "Aren't you the painter who believes that you can bend the world toward perfect with nothing but a bit of paint?"

I wiped ash off the end of my nose.

"So, why couldn't Michelangelo also use a drawing or two to bend the world toward death?" She pulled the drenched torch out of the mucky bucket and tossed it at me. I spun away from the splatter. "Go outside and fetch a new flame. We'll light the place on fire. No one will ever know it was us. They'll think it went down in the riots."

I didn't want to waste more time, not when I needed to

be rescuing Margherita, but also I wasn't going to light *any* art on fire; not even Michelangelo's. I shoved those drawings into my satchel. "No."

"No?" She said that in the tone of a woman unaccustomed to being refused. She pushed aside a fold in her scorched skirt. The handle of her dagger gleamed.

I stood up. "I need these drawings."

She marched on me.

I stumbled backward. "To save your father."

She paused her advance. Her dagger disappeared back into the folds. "Go on."

"If I want to paint a miracle powerful enough to help your father, then I need to study Michelangelo." I smoothed down my tattered vest and breeches. "I need to copy him, bend these drawings away from death and toward life."

Her eyes narrowed. "And once you finish copying them, you'll destroy them?"

People will believe anything they want to hear, won't they? I closed the flap of my satchel over that stack of sketches. "Once I turn the world in your father's direction, I'll destroy every one of these drawings. I swear it."

She nodded—satisfied, I suppose, or perhaps also anxious with wasting time—and pressed her ring of keys into my hands. "Keep these. If I make it back, the guards will no doubt let *me* into the Vatican. You might not be so lucky." And then—you'll never guess—Felice della Rovere, wife of an Orsini, daughter of the pope, raised up on her toes and kissed me.

Dai, I was more surprised than you. Even retelling this story today, I haven't been able to find a single moment to embellish to build to this event properly . . . not that I would've hinted at it because I wanted you to experience

the same shock as I. If women knew how impossible it is for us to read them, they would be plainer in their desires, wouldn't they? Apparently, wanting to kill me and kiss me looks very much the same. Looking back, I suppose she was afraid, heading out into riots—fires, lootings, smoke, violence, dying father and all—so perhaps she was having a last-night-of-the-world-kind-of-a-feeling, but at the time, it felt very incongruous. Not so incongruous that I backed away, *sì certo.*

When she released me, she said, "Wish me *in bocca al lupo?*"

That old expression of wishing luck—*into the mouth of the wolf*—made my stomach coil, but still, as we both crept out of that studio and into the riots, I responded in kind: *"Crepi il lupo." May the wolf die.* And I meant it.

Chapter XLIV

The only thing thicker than the smoke that night was the heat. It felt as if Savonarola's bonfire had rolled all the way down to Rome and was devouring the entire city, no longer content with a few pictures and bone dice. I pulled my jacket over my nose and mouth, but my eyes stung, my throat burned, and my ears rattled from the cacophony of shouting, braying, and barking. People stampeded through the streets, carrying armloads of clothes, pots, torn bags with grain trickling out. A chicken flapped by in a furious panic. A horse reared with nostrils flaring, teeth bared, muscles tensing. A boy riding a donkey plucked the hat off my head. One man climbed out of a broken window carrying a pile of shoes, looting the neighborhood cobbler. He didn't get far. The cobbler leapt off a balcony—his cape billowing in the air—and chased after that thief, tackled him, and beat him with a board adorned with long rusty nails. I slipped and fell and rolled under a crashed wagon to avoid more trampling feet. I grabbed a plank of splintered wood, although I didn't know how to wield it.

Thoughts of Margherita trying to fend off rioters with

nothing more than a silver plate or candlestick compelled me out of my hiding place. As men scuffled, I moved with defiant confidence. My mother always taught me that to succeed in this world, walk like you know where you're going and why—especially if you're afraid. Others will follow for fear you know something they don't. I doubt my mother intended that I use her advice to navigate a riot, but I suppose mothers can never know how their children will apply well-meant lessons.

Imperia's villa was dark. The door hung open. "'Gita? 'Gita," I called as I hurried inside. The carpets were torn, upholstered chairs were in shreds, curtains scorched. "Margherita!" I took the stairs two at a time, but she wasn't in her little room, either. Drawers were open and emptied. A table was toppled over. A yellow dress was ripped in two. For once, I didn't think of picking up a sketchbook and redrawing the world perfect. "Margherita!" I slipped, and my backside landed in a puddle. My palm came away wet and sticky. It was too dark to see, but one sniff confirmed my suspicions: blood.

Holy Mother, where is she?

That's when a hand dropped on my shoulder. I whirled around, flailing with that old hunk of splintered wood. "It's me." Chigi—eye swollen, lip bulging—stood over me. "We must be quiet," he whispered, as he helped me to my feet and hurried me into a small, dark closet stacked high with costumes, masks, ribbons, and women.

"We were attacked," said Imperia, caressing the hair of a crying young woman huddled in her arms. "And it wasn't just part of the rioting. They were intent on hurting us. Someone doesn't like what we do."

I scanned each face but didn't see her. "Where is she?"

They all exchanged looks. No one answered.

Why won't they answer? Is she dead? "Where's Margherita?"

"We couldn't stop her, Raphael," said Imperia. "She insisted on going."

"Where?"

"To protect her father."

By the time I stumbled back outside, rain had started to fall. The city now stank of smoldering smoke and wet coals. When I found her father's narrow street, it was eerily empty. Wagons were splintered. Broken doors swung off hinges. Was that motionless mound a dead cow or a dead man? I didn't look closely enough to find out.

The bakery was smoking. Black soot charred the facade. The door was split in two; someone must've axed through it. I waded through splinters, toppled tables, broken bread. "'Gita! 'Gita!" I called, not caring whether rioters or the entire French army heard me. A wild boar snorted past; I jumped out of the way. "'Gita!"

I found her in the back room, among her father's pans. She was sitting up, breathing, alive—thank Mary—but . . .

Her father's head was in her lap, hair slick with blood, skin too white, eyes open but blank. She rocked back and forth, as he sprawled across her lap like Jesus in a *Pietà*. Margherita's sobs strangled her. "Help him, save him, make him, make him . . ."

Make him as he *should* be.

I dropped to my knees in front of her.

More times than I care to count, I've wished that I could paint over all the ugliness and turn it into flowers and perfumes and pretty. I've wished it so often. But I've never wanted to paint over the world more than I did in that

moment. And I've never felt more incapable of doing so. "This place," she moaned. "After my mother . . . he wanted a better life for me, but he never should've brought me here. Never. Rome kills everything good. Everyone good."

You'd think after all these years of confessing my own losses, I'd know how to comfort someone at such a moment, but what is there to say? Nothing can make it better.

"I can't stay here," she choked. "I have to leave." She dropped her father to the floor and scrambled toward the door like that frantic, flapping chicken I'd seen earlier that night. I went after her, grabbing her, holding her as she flailed, fought against me, pushing, punching. "Let me go, I have to go, I have to get out of here, out of Rome, out of . . ."

I held her tight. "You can't leave."

"There's nothing left for me here."

I took her face in my hands and pulled her back so I could look in her eyes. "Isn't there?" And yes, standing in that burned-out building with rioters screaming outside and her father's body at our feet, I kissed her. I held her in my arms and rocked her, "*Uno, due, tre, quattro, uno, due, tre . . .*," hoping my counting would calm her, too.

We buried him in the dirt of the little cellar under his shop. We didn't have a coffin, so we filled his grave with loaves of bread. She knelt over that mound of dirt and murmured for a long time. I knelt and renewed my promise to finish painting the *tondo* of his daughter and make her—at least—immortal.

Chapter XLV

A re the riots over?" Felice asked when I returned to the Vatican two days later and found her standing in a doorway, watching her husband and the heads of the other Roman families gather around her father's bed. "The city's as quiet as a cool morning after Michaelmas," I replied. I'd waited to leave Margherita—at Imperia's, surrounded by friends—until the violence had abated. The air still smelled of smoke, and there were piles of debris in piazzas, alleys, and intersections, but it had been a calm morning, with even a few birds chirping.

"Relieved to hear it," Felice said with an unmistakable lilt of pride. "He'll be pleased." She jerked her chin at His Holiness sitting up in bed, cheeks warm with color, waving his walking stick, threatening to beat in skulls.

"I'm glad to see he's feeling better."

"He sat up for the first time right after I brought word that my bedroom diplomacy had succeeded once again. He stopped coughing that very night. Nothing like victory to heal a man."

"So, you've ended the riots?"

She smoothed out her skirts and said, "They're about to sign a peace agreement." The *Pax Romana*, as it became known in the months to come, was a groundbreaking agreement between the papacy and the old warring families; they didn't agree to stop hating each other, *sì certo*, but they *did* agree to stop killing each other. At least for a while. As I stood in the doorway watching Felice watch the head of each family sign that agreement and congratulate each other on a peace well-earned, I couldn't help but think that *"any man who pulls a woman out of the water"* always gets the credit. Yet, Felice didn't flinch when the men ordered her to leave and tend to her sewing. "Seamstresses and painters," she'd said with a wink on her way out the door. "The true makers of miracles."

Since my perfect painting had failed to bend the world as I wished, I decided to follow Rome's lead: destroy the world in hopes of achieving peace on the other side. After all, Michelangelo had spit in the face of perfection and won, so why not me? I sat down on the marble floor in the middle of my newest room in the papal apartments—each wall prepared with blank, white plaster—pulled up my sleeves, rolled my wrists, and began to draw. I started by sketching a perfect temple: perfect balance, perfect perspective, perfect columns, perfect altar. But instead of painting my new cast of characters in a perfect rhythm as I had in the library, I aimed for something different. Over the next several weeks—as papal courtiers tended to the healing pope and my assistants built new scaffolding—I made countless drawings of figures that would twist and struggle and fly across my picture. I drew the rearing horse I'd seen during the riots—muscles tensed, nostrils flared, hooves flailing—trampling over the armored thief Heliodorus. I drew

priests and faithful scattering—like Romans running away from fires—and arranged them around the periphery of my design, leaving the middle space open—no, not open, but exploded. At the center of this burst, I drew an angel—muscular and handsome, cape billowing, like that cobbler who'd jumped out of that balcony and chased after that thief—arms extended, leg back, body like cannon fire blasting a hole in the center of my design. I took the energy of those riots—violent, fearful, unknowing—and injected it into my lines. And the more uncontrolled I drew my figures, the neater I kept my stacks of sketches and rows of chalk, the more times I smoothed my eyebrows and jacket, the more times I brushed off my shoulders and checked the ties of my shoes, the more times I counted wrist rolls and steps, the harder I was on my men to make everything else around us perfect, perfect, perfect. Although I once again included my own face in the painting—off to the side, just one of the servants helping to carry Pope Julius's litter so he could be a part of the miracle—I felt like that central angel, sent to expel danger, expel violence, expel *Michelangelo* from the Vatican.

And near the end of that year, I started receiving signs that I was headed in the right direction with my paint and my meticulous routines—my own Christmas miracles, if you will.

First, the nine schismatic cardinals who were rebelling against Pope Julius finally met in Pisa and voted to depose the pope. While this was not taken as good news in the Vatican—I've never heard such cursing or seen so many walking sticks come down over the heads of cardinals—there *was* a rim of gypsum for me because, you see, Florence's government had backed the schismatic council;

Florence had turned traitor against the pope. And every Florentine would have to share in the blame for the sins of its leaders. Michelangelo was no longer the cherished son; he was a patriot to the enemy. Whereas a few months before, thanks to my duke's murderous activities, it was Urbino that was like the spoiled paint at the bottom of the jar, now, it was Florence's turn to grow a little mold.

The second good omen came with word that Michelangelo's bronze equestrian statue of Pope Julius had been melted down by the Bolognese, who used that bronze to cast a cannon mockingly called *La Giulia*, named after the pope himself. Now, if the papal army tried to invade again, the Bolognese would use *La Giulia* to fire back. Michelangelo's great statue was no more. I put on a suitably severe face when I heard the news of the destroyed statue and didn't dare tell anyone of my glee. I wouldn't even admit it now, except that the pope is dead, so there's no one to hang me for the treason. But privately, I smiled because by exploding perfection in paint, I had finally started to bend the world away from Michelangelo and in the direction of me.

Chapter XLVI
Spring 1512

T he French have breached the walls!" guards cried as they burst into the papal apartments. A guard grabbed the pope by his underarms and began spiriting him toward the exit, as his stockinged feet dragged behind.

I looked up from working on my final preparatory cartoon for the *Heliodorus* wall in the room of miracles. As soon as the riots had ended, rumors started flying fast that the French army of twenty-five thousand men was marching down the peninsula toward Rome. War—with its smoke and booming cannons and blood and screams—was coming to our door.

What do you remember about Gaston de Foix? *Allora,* he was general to the French army, nephew to the French king, and known as the "Thunderbolt of Italy" for his lightning-quick attacks against Italian cities. He was young—twenty-one or so—handsome, brilliant, and an enthusiastic warrior. According to rumors, Gaston hummed children's songs while he sliced necks with his sword, and now, that sword was pointed at the pope. A few years before, the pope had been in an alliance with King Louis XII against Venice,

but then the pope teamed up with the Venetians and pledged to "evict the French barbarians from the peninsula." King Louis took the betrayal personally. He didn't only want the pope's territory; he wanted the pope's head. And Gaston de Foix had been charged with bringing it back.

"Gaston himself may already be inside the palace," said one papal guard, holding the pope's arm in one hand and a spear in the other. "We must get you to safety in the Castel. Now."

The Castel Sant'Angelo, that huge, hunk of a round, stone fortress sitting on the banks of the Tiber like a fat warrior. Have you ever been inside? It's dark. Dreary. Feels like a tomb. No wonder, since it was originally built by Emperor Hadrian as a mausoleum. Did you know that it's connected to the Vatican via secret passageway? The *Passetto*, it's called, a corridor that shuttles popes to safety whenever Rome is under attack. If the pope was moving into the Castel, it meant danger from the French was imminent.

"Pack up," I ordered my men, and we grabbed a few supplies—our best paintbrushes, sketchbooks, a stack of gold leaf, anything we couldn't afford to lose—and joined in with the entourage hustling after the pope. Cardinals ran down halls, servants hid silver, guards waved us along, "*Quickly, quickly . . .*"

Felice dropped back in the pack alongside me. She was pregnant again, her intensity only heightened by her condition. "You can't go to the Castel," she whispered.

"Why? Is the pope still that upset about the portrait? I wasn't the one who . . ." I couldn't even say the word *murdered*.

She waved her hand dismissively. "He'd happily have you. But you have to stay behind."

"There are *assassins* in the Vatican."

"Maybe. Or maybe this is only panic."

"And if it's true?"

She shrugged. "They're hunting for the pope, not his painter." I'd like to see her shrug if it were *her* life we were bandying about like dice.

"Are *you* going into hiding?"

She shot me *that* look. "Haven't I told you the story of enemies kidnapping daughters to get to their fathers?"

"Then, I'm going into hiding, too."

She tapped her temple. "Think. We'll all be away. My father, cardinals, Michelangelo . . ."

"Why does everyone always choose Michelangelo over me?"

"No, you fool." She sighed like I was a two-year-old who wouldn't stop asking why horses drop manure. "Once Michelangelo is in the Castel with the rest of us, you'll have free reign in the Vatican. You can get up his scaffolding." She lowered her lashes. "He won't let me see the ceiling again. He doesn't trust me anymore."

"I can't imagine why."

"He won't even let *my father* up there. We have no way of knowing whether he's putting pro-Florentine, antipapacy blather on that ceiling. What if he's covering my father's chapel with support for that wretched group of traitorous cardinals trying to depose him? I must know." She glanced around to make sure no one was looking and then put her hand on my arm. "*Per favore,* I need you to do this for me."

"Why do you always pick me for these schemes?"

"I don't. It's that you only hear of the ones I ask of you."

My forehead wrinkled, wondering how many other machinations she'd orchestrated.

"Besides," she cooed, "you can read the imagery, symbolism, and details better than anyone else."

"I'd like to see that ceiling, too, but it's not worth risking my head."

"My father is desperate for an official portrait," she said, taking her hand off my arm and straightening her glove. "He's been thinking of hiring Michelangelo to paint it, but now that the Florentines have forsaken us . . ."

My eyes narrowed. "You can't get me the pope's portrait."

"Can't I?" Her eyes flicked up to meet mine. "Do this for me, and I guarantee it."

The pope's portrait? Such a painting would live forever in the history of the papacy, the Church, the world. Yes, many of us included *unofficial* images of His Holiness in our work—I was putting up a portrait of him on my *Heliodorus* wall at that very moment—but an official portrait? My tongue raked the back of my teeth. The last time I'd made an alliance with Felice and her friends over a portrait, it hadn't turned out well, but how could the pope's portrait be dangerous? Painting His Holiness could only be seen as an honor. But was I willing to risk my life for such a commission? "Not even for a pope's portrait." I lengthened my stride.

"I hear Michelangelo is painting fast as Hermes," she said. My step slowed. "If you don't get in there soon, you might not get a chance. Do you want to see his ceiling for the first time with everyone else?" Her stride caught up to mine. "Imagine if he's doing something new with the second half. Imagine if you're putting outdated images on your walls, while he's marching up some new mountain . . ."

I didn't need to verbally assent. She could see the hunger in my eyes.

While I twirled the thought of the pope's official portrait in my head instead of twirling my father's old paintbrush, the guards hurried the pope toward safety in the Castel while a few of us stopped briefly in the Sistine to fetch Michelangelo. But that sculptor is never so amenable to other people's plans, is he?

"I'm not leaving my work unprotected," he called down from the scaffolding. "If the French destroy this building, my frescoes will go down with it. I'll stay behind and fight them off, one by one, if I have to."

Felice pled—"Michel, it's not safe here. You have to go. We're all going. Please"—but Michelangelo waved her off and disappeared back up his scaffolding.

As we exited the chapel without him, I sighed with relief; maybe the assassins would burn down the Sistine with Michelangelo in it, and I would get the portrait by default. At least, I would be safe. But as I started to follow the others down the *Passetto*, Felice grabbed my arm. "What are you doing?" she hissed. "You're supposed to peel away and go back."

"That was only if Michelangelo went with you."

"You still have to find a way to see that ceiling."

"You expect me to break into the Sistine?"

There was *that look* again. "If it were that easy, I'd do it myself," she said, pushing at my chest, away from the exit, away from the Castel, away from safety. "You're going to have to convince him to invite you up."

"You're turned by the tides."

"Now's your chance. When the Vatican is empty, his guard will be down."

"His guard is never down."

"Rafa," she said, nudging me like one courtier daring another outside a maid's window. "If anyone can convince him, it's you. After all, I've heard, the great Raphael can charm anyone."

Chapter XLVII

Michelangelo was an admirer of Dante. Perhaps I could sneak back to my personal rooms, scrounge up one of my bound copies of the *Inferno*, wave it in front of him and . . . No. He wouldn't be deceived by that. Besides, what if I encountered the French army as I crossed the piazza? Michelangelo might feel sure of his prowess with a marble hammer, but I wasn't so confident. Maybe I could light a torch, barge into the chapel, pretending to be an invader and . . . *what?* Make him even more paranoid? Maybe I could light the Sistine on fire and smoke him out. But if the pope discovered that I'd burned down his chapel, he'd burn *me* at the stake.

I sighed. Pacing up and down a windowless staircase hour after hour—*uno, due, tre, quattro*, twirling paintbrushes, rolling wrists, dreaming up featherbrained ideas—wasn't helping. I needed to *do* something. How do I usually charm people? I smile and laugh and get them talking about themselves; people love talking about themselves. "Charming people's no different than painting a portrait," I

said out loud to absolutely no one. "First, you need to understand your subject."

By the time I exited the stairway, night had fallen. With everyone in hiding or home protecting their families, the Vatican was eerily quiet, except for irregular creaks of the old building. I imagined rounding a corner and coming across a company of soldiers. I wished I'd at least thought to tie a trowel to the end of a stick. Not that I'd know how to use it.

I paused in front of the Sistine door. I needed all the luck I could get, so I turned around and approached on a perfect count of seven and then meticulously went through my *newest* routine: tuck hair behind both ears, wipe dust off each shoulder, smooth down my jacket and breeches, and check the ties on my shoes. Twice. Then, I slipped into the Sistine through the back door by the altar. When I was young, I used to sneak into my father's studio to watch him work, long after I was supposed to be in bed; I know how to be quiet. I hunched down and crept forward. It was dim; the only light was from a silver moon shining in through high windows and distant torches up near the ceiling, casting Michelangelo's flickering shadow across tarps hanging under the scaffolding: he was standing up, his hand was raised, paintbrush in hand, head bent back. The scaffolding creaked with a familiar, comforting rhythm.

He was painting.

I settled down and waited for the torrent of curses that would surely come soon; didn't he say he swore by the minute when painting? Sure enough, it didn't take long to hear something. *What was it?* Soft, with the resonance of Michelangelo's voice, but it wasn't a curse, was it? Was it a prayer? No. It was . . .

Humming?

What was that tune? Ah yes, my mother used to sing it on Easter morning to wake us. What were the lyrics, again? "This glorious morn, the world newborn, in rising beauty shows; How, with her Lord to life restored, her gifts and graces rose."

Michelangelo was swaying, too, his body moving with his brush and song.

Santa Madonna . . .

This was even more frightening than armies or assassins or French generals wielding swords. Because that wasn't the hum of a man who hated to paint, was it? No. That was the song of a man who loved it. I'd always taken comfort in Michelangelo's insistence that he hated to paint, because a man who loves his work—me—will always outdo a man who hates it—him—but now . . . I stood up and took a step backward. His humming grew louder. His shadow danced.

Michelangelo had fallen in love with painting.

I backed up, my feet falling over each other, desperate to escape that chapel, to get outside, to breathe, to think, to . . . I tripped over a bucket, *sì certo*. It made a great clatter as I landed hard against the marble floor. "*Uffa!*"

"Who's there?" Michelangelo barked. He leaned over the scaffolding with a torch. I couldn't see his face. Only the flame.

I cringed at the pain in my backside. I feared he would see me before I could hide, so lying seemed pointless. "Don't worry, Michelangelo. It's only me."

"Me who?"

That stung worse than the fall. If Michelangelo called

up my scaffolding, I'd know his voice immediately. I, apparently, am not quite so memorable. I called up, "Raphael."

And he said, "The one from Urbino?"

"The one from the pope's apartments."

"Get out of here. Unless you want me to knock off your head and tell the pope I thought you were an assassin." He ducked back behind the scaffolding.

I rode the first lie that came to mind. "There's someone in the apartments," I called.

"Who?" At least he didn't throw a plank at my head.

"I don't know," I said. "They came in, I ran. Soldiers, maybe? Everyone else is gone, I didn't know where else to go and . . ."

His torch leaned over the scaffolding again. "You thought I would protect you?"

"I thought two was better than one. Besides, you have a high scaffolding and . . ."

He snorted—*snorted*—at that. "I'm not putting my ladders down for anyone."

I shrugged. I hadn't really expected it to be that easy. But at least I had him talking. "Will you at least throw down a tarp for me to hide under?"

He didn't answer, but there was shuffling, and a few moments later a tarp fluttered down. That was good. If you can get someone to do one favor, it's easier to extract another and another. "*Grazie mille*," I said, grabbing the tarp. "I hope you don't mind if I hide down here."

He snorted again but resumed painting without argument. He was no longer humming, but his shadow worked his brush in quick, short strokes. He must be coming to the end of the *giornata*'s drying time. I waited until his arm

dropped, and his shadow slumped down with the look of a man spent. He dropped his torch in a bucket. It went out. After a long *giornata*, my defenses are always down, so . . .

"Do you hear something?" I whispered.

"What? No."

I moved a bucket to make a screeching sound.

"Stop making noise," he said.

"That wasn't me."

There came a creaking, and a few moments later, he was down on the bottom tier of the scaffolding, peering over the edge. "Do you still hear them?"

"Not anymore. But I assume they'll keep looking until they find the pope. Do you think I look like a pile of paints?"

He grunted, and then came the most *wonderful* sound: the groan of a ladder lowering and landing on the floor. "If you're coming, come on."

I scrambled across the floor and up that ladder, glancing behind me, trying to appear as frightened as possible. At the top, I helped him pull up the ladder—"*dai, dai, dai*"—our hands working together. (Don't ask me why, even though he was only painting in those days, his hands were always covered in marble dust.)

In the moonlight, I could see that there were tarps hanging everywhere along that scaffolding: around every platform, every interconnected footbridge, dividing each turn, each railing, each stair. He didn't let anyone else up there, so from whom was he trying to hide his paintings? Himself? It stank up there, too: rotting fruit, stale wine, chamber pots; when was the last time he'd emptied them? "If you're in the middle of a patch of plaster, you can go work if you need," I said, making a show of sitting down. "I'll stay here."

He sat down on a set of curved stairs leading up. "I've finished for the night."

I looked over the edge. The floor was far below. If I said the wrong thing, he could toss me over. I smoothed my breeches and waited for him to speak first.

Eventually, he did. "I finished a new panel tonight. A creation scene."

"Congratulations," I said without looking at him. I didn't want to look at him the wrong way, either. "There are—what? Only nine panels on the ceiling?"

He grunted. I took it as assent.

"How many *giornate* did it take?" I asked.

"One."

I looked up. His features were obscured in shadow, but he sat there, elbows on his knees, presumably glaring at me. My mouth went dry. Considering their size, I would've thought each of those panels would take a week or two—at least—depending upon complexity. "You finished an entire panel in a single day?"

"*Sì.*" Without being able to see his face clearly, I couldn't discern whether he was lying, taunting, testing, or . . .

Whatever bait he was casting, I didn't bite. I needed to hook *him*, not be yanked about on his line. So, in a tone fit for schoolboys tossing a small ball on the field, I said, "Have you seen that new knock-kneed cook? I hope she's safe from the assassins' swords, don't you?" I leaned back on my elbows. He didn't respond, so I tried again. "Do you prefer the almond-eyed daughter of the apothecary? She's too skinny for my tastes, but maybe you . . ." He still wasn't responding, so, what can I say, I shot a stray: "*Mi dispiace*, is it the apothecary's *son* that you . . . ?"

"What do you want?"

"What do you mean, I . . ."

"What do you want. Here. With me?" He sounded gruff, and all of a sudden, I could see what he was doing: he'd planted himself on those stairs to block my ascent. He hadn't fallen for my ruse; he was standing guard.

I tucked my hair behind my ears, but once I get something in my mind I have a hard time letting go—I'm like Dante with Beatrice—so I insisted, "I wanted a place to hide from the assassins and . . ."

"*Basta.* Try being honest for once in your life."

My chin pulled back. I thought people saw me as polite, nice, charming . . . Did people think of me as a liar? I smoothed down my jacket. "I did hear strange sounds— truly—creaking and all kinds of . . ."

Even in the dimness I could see him fold his arms.

"I needed an excuse to come in here," I admitted.

"Why?"

Because I want to look at the ceiling, because I want the pope's portrait, because I want to copy you and beat you and become the greatest painter in history, but instead of saying any of that, I said, "Because I don't know how to be alone." I started picking at a speck of paint on my thumbnail; it was too dark to see the color, maybe ultramarine. "I always surround myself with people: assistants, courtiers, lovers. Any kind of people. Always . . ."

He didn't move. He didn't answer.

It's funny, isn't it? Michelangelo is drawn to marble because it speaks to him, and I'm drawn to paint because it doesn't, and yet, I'm the one who can't handle silence between people. When I was painting Francesco Maria's portrait, back before he was duke, he attributed this one

quote to Plato, but I've never come across it anywhere, and sometimes I wonder whether Francesco Maria has ever read *any* Plato, so I don't know if it's real or not but what he said was: "Wise men speak because they have something to say; fools speak because they have to say something." Regardless of who said it, I guess that made me the fool that night because I'm the one who blathered on. "But you? You lock yourself up here alone for days, weeks, maybe you go for years without a friendly conversation. You don't care whether people like you or not—how do you not care whether they like you? You don't even try to be civil. All you need is yourself. So, I'm jealous." No one could accuse me of lying now.

"*You're* jealous? Of me? For the way I handle *people?*"

"You don't need them. That must be a relief."

"It's awful." I heard him uncork something—maybe a bottle—and take a drink. "Everyone thinks I don't want friends. But my brothers are all up in Florence. So is my father. Granacci left. Alidosi is . . ." I heard him take another drink. "'Vanni—sorry, Cardinal Giovanni de' Medici," he snarled. "He used to pinch my neck when I was a boy. Hard. He left bruises. We're the same age, so why does he always treat me like I'm the younger, stupider brother?"

I twinged with jealousy. Oh, how badly I wished to be treated like a stupid little brother.

He said, "I don't choose to be alone. I just am."

"So am I." That didn't feel like a lie at the time. In that moment, I didn't even remember that Margherita Luti existed. (It's strange—isn't it?—when you forget the people you love while they're still alive. If I thought about it too much, I'd feel awful about it. People don't last forever, so how could I forget them while they're still here? And yet,

sometimes I do. Sometimes, no matter how often she kisses me, I feel alone. Why is that?)

"You're not alone," he said. "You have lots of friends."

"Name one. But if you say Felice, I'm coming over there to kick you."

"No one would ever accuse Felice della Rovere of being a friend. What about Cardinal Riario?"

"He only likes me because he doesn't like you."

"*Sì*, I gather that. Do you know why he doesn't like me?"

"Because of that marble cupid you sold him. Told him it was a Roman antique?"

"He's still angry about that?"

"You sold him a forgery. Wouldn't you still be angry about that?"

"It was my broker's idea."

"*Beh*, he blames you."

"What about Bramante?" he asked.

"What about him?"

"Don't you dine on Chianti and fresh moray every evening?"

I laughed. "Can you imagine sharing a drink with Bramante?"

"What about your assistants?"

"Who? Lotto and Sodoma?"

"And the others."

"I like them, but they're my employees, and they treat me as such."

He sighed. "Granacci started treating me like I was his boss. It was awful." Even though he was obscured in shadow, I could now see him cork his flask and roll it across the boards to me. It landed against my leg. I picked it up—small, round, glass, with a crest etched into one side. I ran

my thumb over that crest: five balls in a pointed semicircle with a crown on top. The Medici crest. I said, "You really grew up at the Medici palace, didn't you?"

"Grew up is an exaggeration." I could hear the shrug in his tone. "Lived there from fourteen to . . . about four or five years."

I uncorked the flask and sniffed it. Wine so watered it smelled pink. "By the time I got to Florence, *Il Magnifico* had been gone a long time. What was he like?"

"You know how Leonardo from Vinci is impossible to describe without meeting him?"

"Of course." I took a drink. The wine was warm, smooth, and soft.

"Same with *Il Magnifico*." It surprised me—and gave me hope—when he kept talking unprompted. "He had enormous expectations, especially for his children. I'm lucky I wasn't one of his real sons; it would've been impossible to live up to his hopes." Despite his words, I could hear the longing in his tone. No matter what Michelangelo said, he'd wanted to be a Medici son. I wasn't surprised when he changed the subject. "What about your family. Where are they?"

"Gone."

"North?"

"Dead." I recorked the flask and rolled it back. "My mother and sister died when I was eight. My father when I was eleven."

"You're an orphan?"

"I hate that word. *Orfano*. And it can't only be my own bias; objectively it's an ugly word, starting with that awkward *o* and that *f* in the middle interrupting the flow. It sounds like a curse." I barked out an awful whoop that

echoed awkwardly through the empty chapel. It was supposed to be a laugh.

He didn't laugh with me. "Your entire family is gone?"

"I have an uncle. And . . ." *Who else, who else?* "My father's old assistant."

"Your father's old assistant." The way he said it made it sound pathetic.

I was glad it was too dark for him to see me flush. "He's a good man."

"Who did you apprentice under?"

"Perugino."

"Oh." He sounded relieved. "Are you close?"

"He hates me."

"I didn't think anyone hated you."

"He calls me a thief."

"Are you?"

"I don't . . . I don't . . ." I stammered. "Perugino's figures are so static. He has no rhythm, no ease, no grace, and all of his colors are thin. If I'd copied him directly, he would've loved me. He only accuses me of being a thief because I improved upon his work, but what was I supposed to do? Paint poorly so as not to offend him?"

And that's the first time that I ever heard Michelangelo laugh, a snort that grew into a chuckle that kept rolling and rolling, like a staccato under his words as he spoke. "I felt the same way about my teacher. Ghirlandaio was so *quattrocento*." He kept laughing until I started laughing, too, and then he stopped, took a drink, and said—with an incongruously merry lilt still hanging in his tone—"To lose everyone so young . . ." He rolled the flask back to me. "You must've been born under one unlucky star."

"Actually, I was born on Good Friday, and if you believe

my mother, it was the clearest spring night in memory, and at the moment I was brought into this world, a choir of boys stood outside our window and serenaded us with Easter songs." I found another chip of paint under my fingernail and began picking at it. "Too many people credit Perugino with my earliest training, but I didn't join his workshop until I was eleven. *Eleven!* Do people think I didn't pick up a brush until I was *eleven*? I understand why people want to give him credit, though; it makes for a good story. He was down here in Rome, painting frescoes for a pope, while my father was only some court painter up in a hill town. And while students all over the peninsula still copy Perugino, the only student who ever copied my father was me, but I *did* copy him, every day, since before I can remember, so to crown Perugino as giving me the gift of paint . . . that's . . . that's . . ." I pressed hard, but the paint wouldn't come free. "My father was a painter. Why shouldn't he raise a painter?"

"You had a painter for a father? I take it back; you were born under a lucky star. My father wanted me to take a government position."

"He didn't want you to carve marble?"

"Beat me for it." He dropped his voice low and gruff and growled, "'Michel, you'll ruin the family name by being a craftsman.'"

"So, was it your mother who encouraged you to sculpt?"

"She died when I was six."

We both sat there, silently for a while. Finally, I said, "Do you truly believe that you can—I don't know—paint miracles?"

"That's why they hire us, isn't it? To deliver miracles? If artists aren't miracle makers, what are we?"

I looked at my feet dangling over the scaffolding like a boy. "I don't know."

That's when he ambled over and sat down next to me, legs also dangling over the scaffolding. He took the flask from my hand and took a drink as I continued picking paint off my nails. "At least I like that you have a bit of dirt under your nails."

"Oh, that's not dirt. It's paint. I try to chip it off, but it keeps coming back. It's annoying."

He looked me up and down and with a wry smile responded, "Sì. It *is* annoying to try to get rid of something that keeps coming back." He nudged me and said, "I know the feeling."

Our eyes caught, and we laughed. Me and Michelangelo. Sitting there laughing.

And I felt like an annoying, tagalong little brother.

We sat there until daybreak. I told him about growing up at court and some of Jester Dominic's bawdier jokes. He told me about growing up in the Medici palace and his troublesome younger brother who'd once burned the family house down. At one point, sometime before dusk when we were giddy with lack of sleep and too much pink wine, I probably could've asked him to take me up the scaffolding to see the ceiling, and he probably would've obliged, but he didn't offer, and I didn't ask.

When you tell him this, he'll probably say that I was afraid of facing my competition, afraid that I'd see something I couldn't beat, afraid that I'd see I wasn't as good as him, but that wasn't it. It was . . . I don't know. He'll never believe me, but . . . For that one night, I didn't feel like taking something that Michelangelo didn't want to give.

Chapter XLVIII

You'll be happy with the ceiling," I said when Felice found me in the pope's rooms a few days later. The warning about the invading French had come too early—the army was still days, maybe even weeks away from the city—but, while many assistants, courtiers, and cardinals had come out of hiding, the pope remained in the Castel for safety.

"He's not painting lewd gestures?" Felice called up from the floor. My men had laid the first patch of plaster for my *Heliodorus* fresco that morning, so I was up the scaffolding, at the top of the wall, painting the bronze arches of the Temple of Jerusalem. I was glad to have an activity on which to focus while she questioned me. It would help keep my tone even.

"No, nothing like that," I said. If I turned out to be wrong, I could always play dumb: *Gasp! "I had no idea that was a slight against the della Rovere!"*

She climbed my scaffolding. Should she be climbing a ladder while so pregnant? Mary forbid I be responsible for

another loss. She asked, "Did you check every part of that ceiling?"

"Twice." *Eyes on the wall, eyes on the wall. Flick, flick, flick, flick* went my brush.

She landed at the top of the scaffolding. Her gaze heated my cheek. "Truly?"

"Truly." Yes, I considered telling her the truth. Or at least a partial truth, as I would've claimed that I'd done everything in my power to see that ceiling, but Michelangelo had, unfortunately, come after me with a marble hammer. However, if she'd known the truth, then she never would've put in a good word for me regarding the pope's portrait, so . . . "Your father's ceiling is in good hands."

"So is it good or"—she leaned in so close that I could smell the lavender on her neck—"an embarrassment again?"

"No, no, no." I won't lie to you; I also considered telling her that Michelangelo had put heresy on that ceiling. I considered making up stories about all sorts of boys flipping figs and a whole host of Florentine crests hidden in the details—such lies certainly would've helped my cause—but Felice is the kind of woman to demand specifics, and then when she saw the ceiling for herself, she would've known I was lying and ordered my head on a silver platter. "There's nothing embarrassing about it. Nothing at all."

"Nothing at all?"

"He's grown as a painter." Off her skeptical grunt, I added, "Your father will be proud." Surely, I could find something in the second half of the ceiling to support that claim. Art is subjective; I could subjectively claim to like anything. Besides, surely, he'd improved in *some* way. Surely, it couldn't be worse than the first half. *Could it?* And even

if it were, I could always play delusional like the pope: "*I thought that mess was the plan!*"

"How proud . . . ?" she asked, skepticism in her tone.

Flick, flick, flick, flick with my brush. "*Very* proud. You can tell he loves to paint now."

"*Sì?*" She sounded surprised.

"You weren't lying about him working fast, either. He told me he'd finished one of the panels—a creation scene, no less—in a single day."

"He *told* you that?"

I nodded.

"And did you see this miraculous panel?" She was biting her bottom lip. I'd never noticed the habit before, but her lips were cracked and bloody with worry.

I put my eyes back on the fresco. "I told you. He showed me everything."

"You told me you saw everything, not that he showed it to you."

"Same thing."

"How did you convince him?"

"Like you said, I'm charming."

She grabbed the end of my paintbrush to keep me from making another stroke.

I said, "You wouldn't want me to share all my secrets, would you?"

Her eyebrow arched.

I'm not proud of the lie, but I had to come up with something. "Let me put it this way, Michelangelo is as fond of a handsome smile as any chambermaid."

And with that she laughed. "*That* I believe." She let go of my paintbrush and leaned against the railing. After that,

she seemed to take my word as true. "So, you think it's good. Truly good?"

"I do." I turned my back on her and continued adding quick strokes of umber. "I don't believe he'll defeat *me*, but he's a sculptor, so did anyone expect that? But overall, I think it'll be seen as a victory."

"A victory?"

"*Sì*. In comparison to the first half? A victory. Absolutely. Michelangelo will have a victory inside the Vatican." *Flick, flick, flick, flick.*

"A victory."

"A victory!"

"That's . . . that's . . ." she stuttered. "That's terrible."

I jerked my brush away from the paint and turned to her. Her face was flushed and her eyes flamed with . . . Fury? Protectiveness? Revenge? "Victory is a *bad* thing?"

"Of course, it's a bad thing," she spit.

"*Mi dispiace*. I thought you'd be happy that your father's painting would be seen as a triumph. How is that bad?"

"You are so . . ." She exhaled like my mother did that time when I tried to use the bread flour to mix a new pigment. "Michelangelo is a Florentine. His *David* is a symbol for all those antiestablishment, pro-Republican Florentines who joined with those damnable Pisans to depose my father; that statue is a stick in the eye of anyone who values the papacy. A stick in the eye of my father." She started pacing. "Now imagine if such a Florentine declared victory inside the papal palace, right under my father's nose. Imagine how it would be like a rallying cry for my father's enemies. Imagine." She bit her bottom lip again—hard—and drew blood. "The only thing worse than Michelangelo putting blasphemy on that ceiling is him triumphing inside the Vatican. The danger my

father would face . . ." She sounded panicked as a half-witted nun who's caught you kissing in the confessional. "I have to stop him. I have to stop the Florentines once and for all." And with that, she was off the scaffolding with great speed for a woman so pregnant, marching off to Mary-knows-where to launch some new scheme with some new player.

I turned back to my *giornata. Flick, flick, flick, flick.* What else could I do but paint? I felt bad—I did. How could I have guessed that the lie I told would *hurt* Michelangelo? I swear, I never thought I was setting that woman's sights on him. Never. When you tell Michelangelo this, I'm sure he'll say—in his paranoid delusions— that it was my plan all along to sabotage him, but, honestly, how could I have known—how could I have even guessed—that the rumor of a Michelangelo victory could have *possibly* helped me?

Chapter XLIX

Before we can properly deal with Felice's determination to squash the Florentines under her heel before they could squash her father under theirs, allow me to pause and address Ravenna. The French army was mounting a deadly siege of that seaside town east of Bologna. There were rumors of massacred families, beheadings, nuns raped on the altars of local churches. Yes, the battle was happening far away, up the peninsula, but it all felt like a forecast of what would soon come to Rome when the French army finally arrived on our doorstep. Rumors flew fast and free, and the atmosphere was intense and growing more fearful by the day.

"And now, a monster's been born in Ravenna," Sodoma exclaimed, bursting into the apartments, while I was up my scaffolding painting my *Heliodorus* fresco.

Lorenzo Lotto put down his mortar and pestle. "A monster?"

"A deformed child. Born of a monk and nun," Sodoma said, panic coloring his tone.

Lotto shook his head. "Didn't Ravenna suffer a quake of the Earth recently, too?"

"A few weeks ago," said Guillaume.

"And what about that red-colored moon last week?"

"These are bad omens, indeed."

"Signs that the French are fated to win."

"Signs of the Second Coming."

Guillaume called up, "Paint faster, *mon ami*, you won't want to keep Christ waiting."

That spring, I painted fast as able, as if—somehow—the pope was right, and I could put a powerful enough painting on that wall to summon a miracle and turn the tide of an army. His Holiness briefly came out of hiding for Easter. Bearded, angry, and consumed by rumors of the invading French, he presided over brooding services in the Sistine, where Michelangelo's tarped ceiling spread over our heads like a blotted moon. Pope Julius preached about a great coming battle and how we would all have to march into the fire to protect our Church. Then, he went back into hiding—"I must prepare for war!"—and I went back to my paint.

Then, came the day when I received a note from Margherita, scrawled in a fast hand: "Meet me on via Flaminia as soon as possible." I found her outside the gates of Rome, pacing up and down the pilgrimage route as a line of citizens, merchants, and pilgrims fled the city. She said, "We have to get out of Rome. Now."

"I can't leave, I have to work." I turned to march back through the gates, but I couldn't reenter the city without a proper dose of luck, now could I? Not at this precarious moment. So, I started to go through my latest routine: tuck my hair behind both ears, wipe dust from each shoulder . . .

She grabbed my arm. "You're not coming with me? Not even with the latest from Ravenna?" her voice was shrill.

I thought of Sodoma's strange tales of earthquakes and red moons and: "Are you worried about the monster, too?"

"What monster?"

"I don't know."

"I'm talking about Easter."

"What about Easter?" *Was she talking about the pope's strange Easter service?*

"The streets are full of stories," she said. "How have you not heard about Easter?"

"I've been working."

"Inside the Vatican," she snapped. "You should know more than I do. The siege has ended. The French attacked. There was a great battle on Easter Sunday." The tremor in her voice compelled me to stop and listen. "They killed each other. On *Easter*. Over ten thousand dead. The French fired their cannons for hours. Helmets, heads, severed limbs all flying; the ground dyed red with blood; ditches overflowing with carnage; Ravenna fallen . . ."

I'd been to Ravenna: a city of tan, orange, and sienna with hills of emerald green and sky of clear blue. Had the city's trove of Byzantine mosaics survived the attack? Would I ever again be able to ride up the coast of the Adriatic to copy those mosaicked scenes of Jesus presiding over his flock as the Good Shepherd or the Byzantine Emperor and his wife cavorting at court? My heart squeezed with the fear that, perhaps, those thousand-year-old mosaics had already fallen alongside the other corpses of war. I shook my head. "There's nothing I can do, but paint." *Tuck hair behind both ears, dust off each shoulder . . .*

"The worst battle in history, they say." Margherita took

my hands in hers, stopping my progress. "The papal army was destroyed. The French won. Now, nothing stands between them and Rome. And when Gaston de Foix and his murderous men arrive here, they'll spare none of us. We have to leave."

"If we leave, war will only chase us."

"We can't stay here!"

"Where I grew up, in the middle of the peninsula, you're constantly surrounded by booming cannons, smoke always over the next hill, this kinsman murdering that kinsman, only stopping when a plague rolls through." I pulled my hands away from hers and tucked hair behind both ears. "Death is front and center here in Rome, yes, but *war* has only been a backdrop." I wiped dust off each shoulder. "It has yet to beat down our door and set up shop as our constant neighbor." I smoothed down my jacket and breeches. "The safest I've ever felt—despite it all—is holed up in the Vatican. Please let me finish!" I barked when she grabbed my hands to stop me from finishing my routine by checking my shoe ties.

"So, you expect me to sit here and do nothing, just wait to die?"

"Not nothing." I wrested my hands from her grip again, but instead of trying to force my way through my routine, I pulled her into my arms. "We'll do what we can."

"Which is what?" she said into my chest.

"You take and provide comfort." I kissed the top of her head "And I try to paint a miracle."

Margherita stepped back as if to run away, but then she looked me in the eye. She smiled, shook her head, and kissed the tips of her bunched fingers—it seems she liked what she saw. Then, she went through my routine quickly

for me: tuck hair behind both my ears, wipe off each shoulder, smooth down my jacket and breeches, and check each shoe tie. Twice. Then, she took my hand and helped ensure that we crossed through the gates back into Rome on a perfect count of seven. As we hurried toward the Vatican, she asked, "Do you think you can you paint faster than the 'Thunderbolt of Italy' can attack?"

"I don't know. But I can try."

Chapter L

We've won. We've won!" the pope declared, marching into the apartments, his face finally shaven clean. "We swore we wouldn't shave until the French were defeated, and now, our beard is gone with the enemy." The apartments filled with courtiers, cardinals, papal staff, assistants, Romans, people I knew, people I didn't—and the rumors came winged and wild:

"Gaston de Foix, 'The Thunderbolt of Italy,' was killed in the Battle at Ravenna."

"They may have won the battle, but we delivered the hardest blow."

"The French unraveled without him."

"They retreated."

"God chased them off the peninsula."

"God saved the pope."

"God saved us all."

When I'd finished my *Heliodorus* fresco, I'd covered it with a tarp, so that others couldn't see it before His Holiness, and now, the pope called, "Let us see our painting!"

I yanked a cord to pull down the tarp and . . .

I'll never forget Pope Julius's gasp when he first laid eyes on my *Expulsion of Heliodorus* fresco. He took a step forward and then—I'm not exaggerating—His Holiness dropped to his knees. Everyone else followed his lead, including me, and then the pope said, "As God sent those angels to rescue his temple from that thief, He sent a miracle to save my peninsula from the French. You did it, Raphael. As you painted the world, so it became."

The crowd surged, clapping, praising, hugging, lifting me into the air like that billowing angel from my painting.

A few days later, Felice came in, carrying a baby boy, and as she stood in front of my fresco, she said, "My father says I should thank you for the birth of my son."

I cocked one brow. "That's not *my* doing."

"He says that as you painted miracles on his walls, so they arrived in the world." She tipped the baby toward me. His nose looked like the pope's.

"Your father exaggerates."

"Blasphemy," she winked.

For the next several days, all of Rome celebrated the unexpected victory against the French. The pope paraded through the streets on a stallion like a great military leader. Three thousand Romans carried torches, children threw flowers, poets called out verses, choirs sang, cannons blew off the ramparts of the Castel, alms were delivered to the poor, criminals were released from prison.

I didn't see Michelangelo even once during those days. The rumor was that he'd locked himself up his scaffolding to work, but it felt as if my *Heliodorus* wall had expelled him from the Vatican, same as it had expelled the French from our land. The only talk of Michelangelo in those days wasn't about his ceiling or his marble or his *great art*, but his identity as a Florentine.

The Florentines had sided with the French. The Florentines had tried to depose the pope. The Florentines were traitors. Felice started whispering, and people started asking, what *was* Michelangelo putting up on the Sistine ceiling? Why wouldn't he let anyone see it? Perhaps the pope should order it torn down and repainted with a "sea of Raphael's miracles." That's not me talking. That's what *they* said.

And through it all, the pope kept me—me!—by his side. "I need you to paint my portrait," he told me during another *festa* at Chigi's—giraffe races, peacock parades, ribbon dancers, saffron soup, roasted duck. "I need the people to love me. In short, I need another miracle. And so, I need you." He offered his ring.

And I kissed it.

Later, I ducked out of the festivities and went back up to the papal apartments alone, where I rifled through my sketches until I found the stack I wanted. Then, in my room of miracles, under my *Heliodorus* wall, I took out a bucket and lit a fire. Once the flame was blazing, I dropped in each of those sketches—one by one. I'd never bothered to copy them. As far as I knew, no one had ever copied them. They could never be brought back. But that night, I kept my promise to Felice that I'd made during the Roman riots. That night, I watched Michelangelo's sketches burn.

And when I went back outside to join the rest of the courtiers watching fireworks to celebrate the pope's victory—"to celebrate miracles called forth by the brush of Raphael," declared the pope—I believed, for the first time in many, many years, in the existence of miracles.

Because I believed in my ability to create them.

Chapter LI

I t makes me tremble with fright," said Cardinal Riario, shaking his jowls. "*Brrr.*"

"I cringe," said Cardinal Bibbiena, screwing up his face, "as if he might step out of that painting and strike me over the head at any moment."

"I've never seen such ferocity in a portrait. The Warrior Pope, indeed," said Bramante, patting me proudly on the shoulder.

I nodded, but . . .

Were we looking at the same painting?

Oils on wood. His Holiness sitting on a throne with finials of golden acorns, a tribute to the della Rovere family. Dressed in a red papal cape and hat. White cassock. Body and face turned three-quarters. Ringed fingers. Scraggly white beard. Simple green background. Yes, it was indeed my official portrait of Pope Julius II.

But what were the others seeing?

When you put a painting out into the world, you have no control over how it's received, do you? You spend all of your time worrying about every shadow, every hair, every crook,

every wrinkle. You convince yourself that the angle of the head, the turn of a knuckle, the number of folds in a drapery will be considered and counted; you convince yourself that it's all so meaningful, but... Then, people see what they want to see. A drooping mouth becomes a snarl. Downcast eyes become a glare. Age becomes youth. Weakness becomes strength, and you question why you wasted so many nights lying awake, worrying about the turn of the sitter's knees when, apparently, no one takes the painter's choices into consideration.

I'd spent countless hours fretting about how to fulfill my promise to the pope and make people love him. Pope Julius II wasn't exactly warm, was he? He was as likely to curse you as bless you, fire you as praise you. I had to work to find that man's humanity. I looked past his legendary temper and the pomp of his holy office, and I painted a *man*. An aging, slack-jawed, wrinkled, lonely man. I didn't paint him as he was in the days after the French retreat—jubilant, fierce, strong. No, I painted him as he was before: bearded, beaten, worn, like any man battling through life. I didn't find the pope's beauty in his power, but in his frailty, a symbol of how youth and strength fade, even when buffeted by power. Death comes for us all, and not even a pope can stop it. When a man as powerful as a pope shows his vulnerability, you feel for him—don't you?—and you can't help but love him.

That's the portrait that I painted.

But that's not what they saw.

"It's powerful."

"Intense."

"Calls for action."

"It will make the people fear us." His Holiness turned to

me with that sagging, toothless smile of his and said, "You've done it, Raphael. You've made another miracle."

And although it wasn't my intention—it was not, believe me—those around the pope used my portrait to fan his flames of anger against those traitorous Florentines.

"Now, it's time to behave like the man in this portrait," said Felice, arm linked through her father's. "Strong, decisive, aggressive. The people will want to follow this man as he conquers those who have rebelled against him." Her eyes darted to me, then back to her father. "Like the Florentines."

"Felice's right," nodded Cardinal Riario. "The Florentines must pay for supporting a scheme to depose you, or else what will be the deterrent for others rebelling against you?"

"I agree," said Cardinal de' Medici, stepping up to the pope's side. (I noticed that Medici, for one, had not remarked upon the portrait's ferocity—he'd seen it for what it was—but he hadn't contradicted the others, either. When something pours in your direction, why push back?) "Now's the moment to bring Florence back under the rule of the Medici."

"You mean, bring Florence back under the rule of the *papacy*," corrected His Holiness.

"Exactly," said Medici. "Florence has rebelled and been a Republic for long enough. It's time for us to assert control once again. Take Florence back for *our* side."

So, that's how it came to be that the pope and his advisers huddled around my portrait and hatched their plan to invade Florence: Cardinal de' Medici would head up an army of five thousand soldiers and retake Florence in the name of the pope. A Medici's presence at the head of the army would hopefully quell some of the resistance; perhaps serious damage to the city could be avoided, but Florence's

rebellion would be squashed, and all Florentines would suffer the consequences of turning traitor. The statement would be clear: any city that breaks with His Holiness would pay. When the discussions were over, the pope and his advisers all patted me on the back and told me that this new plan wouldn't have been possible without my powerful painting.

Don't hear me sideways. I'm proud of my portrait of Pope Julius II. I am. It's only that I'd like to make clear that it wasn't my intention to promote marching off to war. Don't believe me? Look at the painting with your own eyes. It's proof that I didn't want anyone to go to war. I didn't. I wanted peace.

But as long as the pope was determined to go to war, I was glad it was against the Florentines.

Chapter LII

Cardinal de' Medici and his papal army made quick work of their march up the peninsula. When they invaded Prato, the smoke seen in Florence was so thick and black that members of Florence's Republican government—including Gonfaloniere Soderini—fled. So, by the time Cardinal de' Medici marched through those gates, the remaining citizens of Florence didn't fire any cannons but threw flowers and ribbons in celebration: the Medici had returned. Those were good days: the pope was ecstatic with his easy victory; I was working on a new fresco, *The Mass at Bolsena*, for my miracles room; and Michelangelo was still locked up on his scaffolding, refusing to come out and face the whispers about the now-defeated Florentines. Everything seemed to be going so well until . . .

"*Maestro!*" Sodoma cried, barging into the apartments.

"I don't have time for your gossip today, Sodoma, I have more miracles to make."

"But *maestro . . .*"

"No more ghost stories, no more conspiracies, no more rumors."

"But this is about Imperia."

I looked up.

"There's been a tragedy."

The scene outside of Imperia's villa was chaotic: crowds had gathered, people pointed and whispered, rumors flew fast as feet, women spoke in quiet tones, men stood slack-jawed. The sun was bright, the colors washed out. Inside, women huddled and cried. There was a distant wailing. A portrait of Imperia hung askew on the wall; I straightened it. I headed into the music room, hoping to find her lying across the lid of the harpsichord, laughing at her *glorious* ruse, but she wasn't there. Instead, I found Chigi, the whites of his eyes red as his disheveled hair, forlornly fiddling with an empty wine goblet. "Is it true?" I asked.

He nodded. "Imperia's gone."

I rubbed my face, four times, even though no amount of counting and brush twirling could bring her back. Imperia, dead? Impossible.

We found Margherita in the library, blotchy eyes, sniffling, dress askew as if she'd pulled it on in a rush. I pulled her into my arms and said, "I can't believe the rumors that she would've done this to herself."

Margherita pushed me away and shook her head. "That's only what they want you to think."

"I don't believe it, either," Chigi said. "Yes, I'd found a new lover in Venice and yes, I've talked about bringing her to Rome, but Imperia knew my affections for her hadn't wavered. She was planning on inviting us to a private supper, just the three of us. She wasn't distraught. She was excited."

"And it's supposed to have been poison?" I whispered.

"If it was her, she would've chosen a more dramatic tableau," said Margherita.

"A knife through the breast would've made for her kind of show," seconded Chigi.

"Did she . . ." I was twirling my father's old paintbrush; I hadn't made a conscious decision to pull it out, but there it was. ". . . leave a note?"

Chigi shook his head. "Only a will."

Margherita added, "There's no evidence that she did this. None at all. That's only what they want us to think. Right?" She raised a brow at Chigi.

Lips pursed, he nodded.

"So, who?" I asked.

Margherita pulled a bound copy of Sappho's poetry off a shelf and flipped through it as though looking for an answer. Chigi wiped his nose.

"One of her clients?" I offered.

Margherita sighed. "She did know the secrets of a lot of powerful men who see their destinies as sitting on the papal throne. We all know such secrets."

"It could've been anyone, half the men in Rome, and the entire population of the Vatican," added Chigi.

"I can't believe this," I said, once Margherita and I were alone up in her room. "What will happen to the villa?"

"I don't know, and I don't care." She dumped a drawer of clothes into a traveling bag. "I'm leaving."

I tried to pull her into a hug. "This threat of leaving is becoming tiresome, *mia cara* . . ."

"I'm not staying here." She pulled away and swept a knot of jewelry into her bag. "Alidosi, Imperia, my father . . ." She stuck a serrated knife into her belt. One of her father's old baking knives, I presumed. "Everyone in Rome dies."

"There are a lot of us still alive." I took her traveling bag out of her hands, put it on the bed, and pulled her into my arms. This time, she let me.

She turned her face toward mine and said, "Run away with me."

"*Cosa?*"

"Let's leave Rome, go someplace where there's no money, no power, no papacy."

"No money and power? How do you expect me to keep a profession?"

"You'll paint pretty Madonnas for churches, and I'll bake bread, and . . ."

It was my turn to pull away. "I can't leave Rome."

"We can leave. Together." She trailed behind me, reaching for my fingers, my elbow, my sleeve. "I grew up in Siena. It's not exactly a small town, but not nearly as deadly as Rome."

"I can't leave. Not now."

She threw up her hands. "You keep saying that. 'I can't leave. I can't leave.' *Ma dai,* not even now, when Imperia's dead, probably killed by someone desperate for power at your precious Vatican. How is it still 'not now,' 'Gita, not now, not now, not now' . . . ?"

I took her face in my hands. "The Vatican is finally turning in my direction."

She stepped out of my reach. "Whatever direction the world is currently turning, it's not the direction in which I wish to move."

"The pope has just invaded Florence."

"And that makes things better?" The bite in her tone was harsh as black on ivory.

"Michelangelo is a Florentine. As he falls, so I rise."

She crossed her arms.

"I'm allied with powerful people, now, 'Gita: the pope's nephew, his daughter . . ."

"What is it that you need from me? Tucking hair and smoothing breeches? I can do that." Margherita started

going through my routine, but I grabbed her hands to stop her.

"Stop mocking me."

"I want to leave." She picked up her traveling bag off the bed. "And I want you to come with me."

I shook my head. "His Holiness thinks I create miracles."

"I thought you didn't believe in those, Rafa."

"I don't . . . I do . . . I . . ."

"Only when you make them, I suppose."

"I love you, 'Gita. That's enough of a miracle for me."

"I'm leaving Rome. Now. I don't want to be trapped in this den for one more night." She crossed to the door. Before exiting, she turned back. Her eyes caught the light shining in through the room's only window and glistened honey. "Are you coming?"

My lips opened, but my tongue was too heavy to speak. I shook my head.

"Good luck, Raphael Santi of Urbino. May you get every miracle that you deserve."

Chapter LIII

*M*aestro, I'm confused." Guillaume wrinkled his nose at a drawing of a tall, winged angel in a flowing gown. "Is this figure for *The Mass at Bolsena*?"

"No, for *The Deliverance of St. Peter*." I pointed to stacks of papers neatly collected under the arched northern wall of my miracles room. That new scene would be dark—dark prison, dark walls, dark armor of dark guards—contrasted with a brilliant blast of light as an angel exploded in the middle of the blackness to liberate St. Peter. "And these"—I handed him another stack of drawings—"are for the ceiling, and these are for the fire scene."

"*Pardon*, there's a fire scene now?"

"I don't know where it goes yet." It was only an idea for a wall; I didn't know the story yet, but I had this vision from the riots—fires burning among ruins, people passing jugs of water, women flinging hands toward heaven, a naked man climbing out of a burning building. A scene worthy of Michelangelo. "Make a separate stack. I don't care where. Somewhere."

Guillaume bumped into Lotto as they hurried in opposite directions across the room. In the weeks after Margherita's departure, work was frantic. Driven by unspent energies, I drew fast and hot. As my men built new scaffolding, enlarged preparatory drawings, mixed plaster, and ground pigments, I drew hundreds of drawings for five or six different frescoes. If I could convince the pope to promote me to Bramante's job, then I would be powerful enough to rebuild Rome in my own vision and keep Margherita safe. *Wouldn't I?* Then, I could convince her to return to Rome. If only . . .

It seemed all of my incessant painting worked because one day, without warning, Bramante was standing over me and saying, "The moment has come."

I stretched my aching hands. "What moment?"

"The pope's going to appoint you as my successor."

I smoothed down my chalk-smudged vest. "Now?"

"He's summoned me and asked me to bring you. His nephew is with him now. We're to have an audience as soon as they're finished."

I stood and smoothed out my breeches, too. Today of all days to wear breeches instead of tights . . . "Do I have time to change?"

"No," Bramante said, adjusting his lapel (a fine velvet green jacket with red trim. *He'd* had time to don a new set of clothes).

"*Va bene,*" I said, looking back at my men. Sodoma grinned, Lotto's eyes were wide, Guillaume waved me onward. A promotion for me would mean their rise, too.

"Now that Florence is defeated, His Holiness can't promise the job to a Florentine," said Bramante as I followed him out of the palace and into the papal gardens—manicured and green with pleasant pathways and cypress trees. "Now

is our moment to solidify power for Urbino. How old are you, again?" He looked me up and down but didn't leave me even a breath to answer: *not yet thirty.* "With this appointment, an Urbinite could remain in power of the papal program for decades. *Decades.* And as Urbino's legacy solidifies in history, so shall mine."

We came around a low stone wall to see Pope Julius, in his bright papal whites and reds, strolling through a maze of emerald green bushes beaded with ruby red petals. My duke, wearing a long green cape—matching the color of the grass—and Felice, as always in her black widow's weeds, walked behind him. Bramante stopped us along the edge of the manicured garden, but we were close enough to hear the voices of the pope and his companions. "You can't give it to him," said Felice, her voice red with fury.

The duke shot back, "Did you honestly expect him to give a governorship to a *woman?*"

"I expect him to give it to one who is most worthy," she retorted.

"Thank you for proving my point, *signora,* because there's not a woman alive more worthy than any man," said my duke, and I looked down at my shoes, smudged with charcoal. A thread along the toe was frayed. Why hadn't I put on a fresh pair?

"My nephew shall have control of Pesaro," declared the pope. "And Felice shall have . . ."

"My sewing," she snapped, turned on her heel, and marched away.

As the duke dropped to his knees to give thanks, I whispered, "Perhaps we should come back later, *maestro?*"

"Why?" asked Bramante.

"Our alliance has been arguing, over . . . over . . . whatever

that was," I said, gesturing after Felice. "We should talk to the pope when things are more unified."

"Raphael." Bramante put his hand on my shoulder. "When everyone on your side is working together, *that's* when you should be worried. It means that the people on your team think they need one another in order to solidify power. But when those on your side start fighting against one another, that's when you know that your side has secured power—at least for now—and you must use that limited time to scramble for your stake." The duke bowed to the pope and strolled away. His Holiness flicked his fingers toward us, and Bramante said, "Let's go get our share."

As I followed Bramante through the maze of hedges toward the pope, I smoothed my eyebrows, rubbed the corners of my mouth, a whole host of checking in addition to my usual routine. When His Holiness saw me, he held out his hands, and I landed in front of him on a perfect count of seven. I was grateful to kneel, so that my knees didn't buckle under me with nerves. The pope offered his ring. I kissed it, and he put his hand on my head. "Raphael, you are a great light for your country. And for our Church." The pope's fingers rubbed the top of my head. I've not—in a long time—felt like such a beloved son. "Bramante has assured us that you will follow his plans for St. Peter's, ensuring that his vision—our vision—for our church is realized."

Somehow, I kept my voice steady when I replied, "Yes, Your Holiness." I felt as awed as St. Peter kneeling as Christ handed him the keys to heaven. (That's right; at the moment of my most important triumph, I felt like I was in the middle of a Perugino painting, and not just any painting, but his fresco *Christ Giving the Keys to St. Peter* on the walls of the Sistine. I'd spent my career trying to surpass Perugino and

the last three years trying to outstrip Michelangelo, and yet, at my moment of victory, I was anchored back to a painting by that old teacher, decorating a wall beneath that sculptor's ceiling.)

The pope went on. "Although we cannot officially appoint a successor until the Florentine unveils his work, we shall give you a commission today that proves our intentions." The pope put his craggy finger under my chin. "We commission from you a painting, a *Sistine* altarpiece to honor our uncle, Pope Sixtus IV. It's to decorate the altar in Piacenza, newly under papal control after the French fled. As our influence spreads across the peninsula, so shall yours, Raphael. Include my uncle's namesake, St. Sixtus, as well as the great martyr St. Barbara, a favorite in Piacenza. As for the central subject matter, perhaps a Madonna with Child . . . you choose. Just make it beautiful. Make it perfect. Make a miracle."

As my chest swelled with pride—I was the pope's favorite, the pope's promised, the pope's future architect—I kissed the holy ring, and that's when Michelangelo himself rounded the corner, saw us framed there so perfectly in the gardens—I couldn't have timed it better if I'd painted it myself—and called out, "The ceiling is finished."

Chapter LIV
October 31, 1512

The night before the unveiling of the Sistine ceiling, I was too excited to sleep. I kept imagining the pope looking up at that ceiling, striking Michelangelo over the head with his walking stick, and howling to the heavens that he should've hired "my painter of miracles, Raphael!" Or maybe the pope would laugh—a loud cackle—and the cardinals would join in, pointing and mocking the sculptor who tried to be a painter. Perhaps His Holiness would have me kneel in the middle of the Sistine and anoint me papal architect right then and there. Perhaps my men could construct a new scaffolding overnight, and by morning, I could be chipping off Michelangelo's frescoes and preparing that ceiling for my own miracles.

At dawn, I stopped trying to sleep and got up. I tried on four different shirts, settling on fashionable sleeves that were so full they could've been wings. I'd personally designed my gray-blue taffeta vest, trimmed with a gold brocade of holly and oak (an homage to the della Rovere family crest). After checking my boot buckles four times each and smoothing my eyebrows four, eight—all right,

fine, sixteen times—I set out for the palace, arriving on a perfect count of seven.

There wasn't a scrap of garbage nor a streak of mud near the entryway of the Vatican that day; the groundskeepers must've been up early to prepare. Cardinals dressed in ceremonial red robes, and dignitaries festooned in feathered hats streamed into the palace. The hallways smelled of lily and rose. Music—lutes, flutes, singing—lilted through rooms.

His Holiness wouldn't officially consecrate the ceiling until mass on All Saints Day—when, if all went well, he might not consecrate it at all, but give it to me instead—but the pope was scheduled to view it for the first time before the rest of Rome during vespers the night before, with a fortunate few of us by his side. We would all have to wait until sunset to see the ceiling, but first we enjoyed a full day of All Hallows Eve festivities: morning prayers and songs, a noontime meal to honor the ambassador of Parma, poetry praising the papacy, a comedy show with competing jesters (they were good, but my jester from Urbino, Dominic, would've outperformed all of them with his juggling fireball act), and a tour of the papal apartments, including the most flattering description by the pope: "This is the room of Raphael's miracles that produced miracles for us all!"

Michelangelo didn't attend a single event. Yes, I'm sure he'd say that he was busy preparing the Sistine, but if it had been me, I would've been by the pope's side, laughing at all of his jokes, complimenting his refined tastes, cowering at his curses. On such an important day, I would've left no politeness untried. But Michelangelo? He left me to play the part of court painter. His loss.

People watched me and whispered about me all day—*"the best painter in the Vatican, the painter whom*

Michelangelo can't catch, the painter who will be proven the best in history in a few short hours." I laughed harder than usual; the heat of all those gazes does that to me. A wealthy, powerful Roman banker—not of Chigi's level, but close—Bindo Altoviti, admitted he was nervous to meet me. "I hear you capture a man's soul with the flick of a brush," he said and then begged me paint his portrait. A new commission, just like so. At lunch, the pope invited me to sit next to him as we dined on meat pies and pomegranates. Once, His Holiness nudged me as he told a joke. Nudged *me*. In front of all of those people. Can you imagine?

Michelangelo's name did not come up. Not once.

Then, as we paraded down the halls, approaching the doors of the Sistine, the pope flicked his fingers, beckoning *me* to his side, Felice on his right, me on his left. As the pope's grooms reached to open the doors, I broadened my shoulders. I'd bested every one of my earlier opponents and was now about to face off against my last. This time, I'd not only painted my best, but even politics was on my side, too, so as the doors of the Sistine opened and we started to escort the pope inside, my victory was all but guaranteed.

Chapter LV

How do you recall the most transformative moments of your life? Are they crisp and clear like a painting by Lorenzo de Credi, or are they fuzzy as if captured by a Venetian's brush in the soft lines of a dream you can't quite forget? Usually, I amass major memories as if from my father's brush: simple, plain, pretty. But I picture that day in the Sistine quite differently. *That* moment looks like the scene reflected in the mirror hanging on the wall in the back of that famous wedding portrait—you know the painting from up north? (I've only seen copies, never remember the title, and always butcher the pronunciation of the painter's name; how do you say *Van Eyck*?) The mirror in that painting hangs on a wall behind the couple, and the reflected scene bulges along the arched curve of the looking glass. Like that mirror, my memory of that day in the Sistine is of that massive ceiling bulging out as the pope congratulates Michelangelo front and center, while I'm nothing but a receding speck, standing in some distant doorway.

I didn't need to see the faces of the cardinals and courtiers and pope to know. I didn't need to hear their

exclamations—*"Che grande! Magnifico! Miracoloso!"* I didn't need to feel the rumble of their applause in my chest to see the truth.

The scaffolding was gone, no tarps, nothing between the floor and that vast expanse of paint crashing overhead. That ceiling was loud as its maker, but it wasn't only the size of the thing or the volume of paint and figures that overwhelmed. No. The details were spectacular, too. Vibrant sibyls twisting and turning; God straining to touch Adam's hand, their fingers separated by only a breath of space; Jonah, presiding over the altar wall, leaning back in his chair, knees jutting out as if sculpted in marble; God, robed in pink, twirling, swirling, tumbling, building up enough energy to create an entire universe. Had one of those panels truly been painted in a *single day*? Did it matter? And it wasn't only the scenes that captivated, either. No, worse—even worse—was that Michelangelo had developed skill—no, not skill, but *mastery*—of painterly techniques, and not only of figures, as one might expect from a sculptor, but of design and line, brushwork and color. *Santa Madonna*, those colors. And the foreshortening? Arms, knees, hands reaching out into space while bodies receded backward. A sculptor carves into physical stones; a sculptor doesn't need tricks of the eye to make figures recede into space. A sculptor does not need foreshortening. So, how had this *sculptor* learned these techniques so . . . so . . . so. The first half of the ceiling, which had once felt like such a mess, now felt as if it had always been planned, as if it, indeed, depicted the devolving of humanity after the Fall. There wasn't a painter alive—not a painter in *history*—who could've conceived that ceiling better.

While I'd been trying to explode perfection down the hall, here had been Michelangelo exploding the thought of even *hoping* for such a quaint idea. It was as if perfection didn't exist, couldn't exist, would never exist because the world *was* this explosion of energy on that ceiling and nothing could stop the flood, and we're all riding the wave from the force of God's hand creating the universe, flinging us all forward through history.

Do you want to know the worst part—as if there haven't already been enough worst parts? The worst part wasn't that everything for which I'd ever aimed, ever tried, ever wanted had been rendered obsolete. The worst part wasn't that that ceiling was better than anything I'd ever seen, ever done, could ever . . .

The *worst* part was that shiver, trilling up my spine not because of jealousy or disappointment, no—it was worse, *far* worse than that—but because I, too, was swept away by the force of that ceiling.

The worst part was that I loved it.

That's when I saw the truth: God *does* grant miracles; he just doesn't grant them to me.

I've never felt so small or so foolish. I could only hope that no one remembered me strutting into that chapel. Now, the crowds gathered around Michelangelo, kissing his cheek, patting his back, hugging him, praising him. And there I was, off to one side, unnoticed and unseen. And maybe that was where I *should* be. Maybe I'd been obliterated along with my work, and maybe that was for the best. As Michelangelo and the pope dropped their heads together—brother to brother, patron to painter, father to son—and gazed up at the glory of that ceiling, that's when

I saw—that's when it tumbled down over me true as falling rain or rays from the sun or moon—that I couldn't win, I'd never win, *Santa Madonna*, I can't . . .

And I turned and ran out of that chapel.

Chapter LVI

After seeing the Sistine, what did I do? Rent a horse and ride out of Rome fast as able? Take a chisel to my paintings in the papal apartments? Climb a bell tower with the intention of flinging myself off it? All of these actions—considering my understandable devastation—would've been logical decisions, wouldn't they? But did I do any of them? Of course not. I decided that it was the perfect moment to rub lime in my wounds by heading directly to Old St. Peter's to face something that I'd been avoiding since the day I arrived in Rome. I decided it was finally time to face Michelangelo's *Pietà*.

The nave of Old St. Peter's was empty. Everyone was still gathered up the palace, so I was alone. Dusk was falling, so shadows darkened the wilting church. My breath smoked in the cold air. I knew where to find it: up the nave and to the right. I'd always been able to feel it there thumping—some-how—against the side of my face whenever I walked past, although I'd always refused to turn my head to look. But that day

I closed my eyes. He was right; I could hear it, *couldn't I?*, a low, baleful hum. I exhaled to the count of seven. Then, I turned to look.

Even from across the dimming nave, that great marble masterpiece of the Virgin Mary cradling her crucified son flared white as if lit from inside. It's a pyramidal composition—balanced and stable—but with an undulating curve cutting across the middle, it doesn't so much sit as flow. I approached slowly, taking in every line, turn, shadow, highlight, and when I reached it, I knelt and ran my fingers along the smooth marble. There was the sculptor's name, just as rumored, scrawled across the Madonna's chest in Latin: *Michael Angelus Bonarotus Floren Facieba.* "Michelangelo Buonarroti, Florentine, made this."

I pulled out my father's old paintbrush and began to twirl, but on that night, it gave me no comfort, and when my fingers missed a beat, I dropped it. I remember hearing it clatter against the floor, but I didn't bother to pick it up. I just let it roll away.

My hands started shaking first, then my chin, then my entire body. I'd always been certain that my designs were better than Michelangelo's. My lines. My colors. My brushwork. All were better. I'd worked at painting all day, every day, since I was a child, and yet . . . I'd always told myself that he only won because he raged more, cursed more, demanded more, but now . . . *Now* . . . Michelangelo hadn't won because he was louder. He didn't win because of Florentine politics or because he had supporters close to the pope or because the ceiling was bigger, taller, grander, did he? No. Michelangelo won because he was *better.*

I hadn't kept my promise to my father, and I never would.

That's when I looked—really looked—up at that Madonna. Before seeing his *Pietà*, I'd always imagined that it would be Jesus's dead body that would dislodge me. I'd always feared facing his white skin, limp limbs, lolling head. I'd feared that upon facing that image of marble death, I would feel so much pain that I would throw myself off some cliff into the eternal blackness. I'd feared it for so long, that's why I hadn't been able to face it before.

But even though I expected that level of grief—welcomed it even, hoping that it would fuel my anger at Michelangelo, anger at the world, anger at myself—when I looked up into that Madonna's face that night, grief was only a distant echo, and what overcame me was the Holy Mother's sweetness, her steadiness, her serenity. Jesus was no more, so he could no longer carry the load. It was up to her.

Michelangelo's statue had sprung out of a long tradition of *Pietà*s in painting and sculpture, but he hadn't copied anyone else. He hadn't fallen into tropes or traps. He'd found a moment pure and real, and in that moment, he'd found life, even in the face of death.

It had long been my habit to pull out my sketchbook at times like this and copy, to capture a thing on a page, push it further, make it better, but . . . I don't know. I'd been chasing everyone else for so long—my father, Masaccio, Perugino, Leonardo, Michelangelo . . . I'd been so focused on catching them all, besting them all, making them all better than they'd made themselves, that I'd . . . I'd . . .

Oh, how I wish I could tell you that it was dropping my father's paintbrush or a heavenly whisper from my mother that made me get up and walk out of that church that day, but it wasn't my parents who gave me the push. As much

as I hate to admit it, it was Michelangelo who taught me
that the only person I needed to chase, catch, and best . . .
was me.

Chapter LVII

I hadn't left the walls of Rome in four long years—I'd hardly even left Vatican palace—so those first moments out in the countryside were like escaping a corked bottle. As my horse galloped along, I felt as if I'd entered a hilly landscape from the backdrop of a Piero della Francesca painting—wild, unclaimed, and free. (Although, the farther north I went, the more I saw signs of war with the French: grooves of heavy artillery wheels dug into roads like scars, burned-out houses and villages, black gunpowder blasted across splintered trees, makeshift graves of soldiers, a stray shoe. I didn't stop to see whether there was still a foot inside.) I headed north on a good pilgrimage route, galloping dawn to dusk for what must've been three or four days. (I spent twelve hours a day riding. I'd stop at stations to trade out horses but then kept going. After only a few hours in the saddle, the pain in my delicate court painter's behind made me long for the rack.) I'd packed my travel bag, pockets, and boots with enough ducats to pay off inevitable thieves, and once they discovered that I was happy to pay an ample protection fee, the robbers became downright amiable; I

even promised one young, unemployed mercenary a tour of the Old Forum, if we were ever back in Rome at the same time. Despite the signs of war and my throbbing backside, the farther I went from Rome, the better I felt. The Vatican was Michelangelo's territory now, and, probably, no one had noticed my absence. The tightness in my throat released. My shoulders relaxed. I didn't count, not one step. I even laughed with no political motivation!

About two days into my journey, I started showing pictures to peasants, traders, and pilgrims. That's one nice thing about being a painter. Instead of having to rely on ineffectual words, I get to draw what I seek. South of Siena, a young woman on foot driving a pig to market recognized one of my pictures. "Ah! The baker!"

I dismounted my horse and followed her and her pig into town, up one hill and another and another. I hadn't climbed such hills since my days in Urbino, and the burn in my chest felt like home. We walked past the cathedral— ornate facade of pediments and sculptures, black-and-white striped marble. The girl with the pig asked if I wanted to stop for a prayer, but I urged her on. "I'll return to draw later." Up another hill, down a narrow street, around a corner—I don't know where, I was focused on silently rehearsing my speech—when suddenly we were in front of a tiny storefront, the smell of baking bread hanging in the streets, and the girl was leading me inside, and a bell on the door was tinkling, same as when I'd entered the baker's shop back in Rome.

Her back was to me, bent over an open oven. When she turned and saw me, Margherita dropped her loaf, and the pig squealed, and the girl tumbled off her feet, and the pig rooted around for the bread, and Margherita scrambled to

save it—flour and pans and gowns flailing—while I stood in the doorway, grinning. Margherita eventually sent the girl and the pig away with bread. The bell tinkled again as they passed out the door behind me.

Margherita pushed hair and flour off her forehead and said, "What are you doing here?"

I had my whole speech planned, laced with references to Petrarch and Dante and even this bit about Clytemnestra from Aeschylus's *Oresteia*—it would've been good—but . . . Margherita always makes me lose my tongue, doesn't she? I was holding a wooden *tondo* in front of me. I turned it around for her to see. I'd lashed it to my horse for the ride north and carried it under my arm through the streets of Siena while I'd followed that girl with the pig, and now I was there, and it was what I had to offer. It was that old end of that wine barrel from the night we'd met at the Pantheon, the *tondo* her father had given me along with the commission to make his daughter immortal. For years, it had been only a ghost of a drawing, created quickly that night on the floor of the Pantheon in chalk, but after the unveiling of the Sistine, I'd spent days—maybe a week, maybe more, time blurs—locked alone in my private rooms, away from the Vatican and the ceiling and the court whispers, and I'd filled that painting out and in, adding forms and lines, curves and shapes, strokes and colors, eyes and hands. It wasn't finished, but it was a good beginning. It was a painting of Margherita Luti as the Madonna, sitting in a little chair—a *seggiola*, they call it up in Tuscany—hair in a scarf, looking out at the viewer, arms wrapped around a fat, cherub-lipped Jesus, as young St. John peered over her knee. Soft colors, soft lines.

Wiping her hands on her skirts, she came forward and

took that *tondo* from me. Her lips parted. "Is this how you see me?"

I shook my head. "It's how you are."

My *Madonna della Seggiola tondo* in hand, she leaned her hip against the floury edge of the counter and gazed into her own painted features.

Forget Dante. Forget Petrarch. Forget Aeschylus. Forget anyone else. "There's something I must tell you." My mother always told me that when you present yourself to a lady, you must present yourself as you are, honestly and fully. If she accepts you, good. If not, bow and take your leave. "When we met," I said, "I had the honor of presenting myself as a painter from the Vatican, but I must regretfully inform you that the title is no longer mine—or if it is for the moment, it soon will not be. I don't have a shop. I don't have a patron. I have no position on which to stand. I'll never achieve my destiny of being the greatest painter—not in history, not of this time, not on this peninsula, not even inside the last building in which I worked. If you accept me, you doom yourself to be the wife of a painter of portraits and devotionals, nothing more, selling my wares to any man willing to part with a *soldo* or two. What I can vow is that I will spend the rest of my days trying to keep my promise to your father to fulfill your destiny. Without the power of the Vatican behind me, I don't know whether I can make you immortal, but I promise to never stop trying. I'll paint you and paint you and paint you on every panel and altarpiece, on every bread box and wine barrel I find." I dropped to one knee. "I present myself to you, Margherita Luti, as a humble beggar of your hand."

She looked up from the *tondo* as if in a daze. "What about Rome?"

"I've given that up, as I should've long ago. You were right. That city destroys everything good. I don't want what it has to offer. I don't want anything but you."

"But you can't leave Rome."

"I was wrong, 'Gita, you were right, I want to stay here, in Siena, with you."

She shook her head. "I was the one who was wrong. I only said that when I thought you were just some painter."

"I *am* just some painter."

"That was before I saw this." She held up the *tondo*. "Is this the kind of thing you put up on the walls of the Vatican?"

"Yes. No." I was beginning to feel foolish, still down on one knee. "Different."

"Are your paintings in the Vatican as good as this?"

I heard my mother's voice: *be honest*. "Better."

"Then, we have to go back." She grabbed my traveling bag off my shoulder and started shoving in knives, recipes, a few fresh rolls . . .

I stood up tentatively. My knee was numb. "There's no reason to go back. It's over. I know it's hard to hear, but I lost, 'Gita. I failed."

"Do you still have a job?"

"I don't know. I left without asking."

"Then, there's still a chance." She flung my traveling bag over her shoulder.

"What about your bakery?"

She put her hands on her hips. "You think a woman can own a bakery?"

"I don't know. You're here. Baking . . . so . . ."

"The church owns this shop. They let me bake some of the bread for the convent. *Andiamo*." She brushed past me toward the exit.

But I didn't follow her out the door. "I've asked for your hand, 'Gita. I need an answer."

"You can't rise in the Vatican with me as your wife."

"Then, we have a problem, because I'm not going back *unless* you're my wife."

"Rafa . . ."

I crossed my arms.

Her jaw cocked to one side. "Fine," she said. "We can get married."

I don't need to embarrass myself with a description of my uncourtly behavior, do I? Clapping, whooping, picking her up and twirling her around, you can imagine . . . After my immature outburst came to an end, she put her hands on my chest and said, "But I won't risk my life or yours, so as long as you're working in the Vatican, we're keeping our marriage a secret."

"That shouldn't be for long."

"If it's up to me, it'll take a lifetime."

I tucked my arms in tighter around her waist. I made sure my tone was serious when I said, "Margherita, the fight is pointless. I've lost. I can't achieve my destiny."

"I'm not asking you achieve *your* destiny, Raphael Santi." She pushed the *tondo* into my chest and said, "I'm asking you to achieve *mine*."

Chapter LVIII

Margherita Luti and I didn't have an official "taking of hands" ceremony; there was no bickering between fathers about dowries. We were just two orphans who came together in a simple service in the garden of Chigi's villa. Chigi served as officiant while his new Venetian lover threw peony petals—symbols of love *and* discretion. I completed the ceremony by slipping a ruby ring onto *my wife's* finger. "There may not be a dowry," called Chigi, clapping over his head, "but that doesn't mean we can't feast." Servants came out with a large table, chairs, and plates of roasted pheasant, flamingo tongue, and fig tarts, as Margherita fed me a dripping spoonful of truffle sauce. After dinner, we threw our dishes into the Tiber, and Chigi promised that—this time—there were no nets to save them.

Margherita hung my *tondo* over our wedding bed—"Let it protect us while we're too busy to look out for wolves"— and the next day, she accepted an invitation to stay in Chigi's villa. She was determined to keep our union secret—even from my servants—and Chigi was happy for the intrusion: "I hope that her presence will tempt you to spend more time

painting *my* walls, instead of the Vatican's." He got his wish: in the days after our wedding, I spent all of my time at his villa, sketching Margherita and working on preparatory drawings for my *Triumph of Galatea* fresco for his loggia. I drew fast and easy, not stopping to pull up sleeves or roll wrists, not counting to four or seven or any number, only drawing, like when I was young at my father's feet. I took my time grinding just the right pigments for my *Galatea*: bright blues and greens for the sky and sea, a range of flesh tones for cupids and gods, and the richest red I could make for Galatea's drapery billowing in the wind. And while I'm certain that some masterpieces influenced me—Botticelli's *The Birth of Venus*, no doubt—I didn't directly copy any other artist for that fresco. I drew from my own mind, heart, eyes. "I'll use your features for my heroine," I told Margherita, positioning her as my model.

She dropped her face. "No."

"I promised to immortalize you in paint, and without the Vatican, this is my best chance."

"Perhaps. But this painting should be of someone else."

"There is no one else."

Margherita stood on her toes to whisper in my ear, and I smiled, conjured a memory, and drew *that* face as my Galatea. When we showed Chigi, his eyes teared, and we all stayed up late into the night, telling stories of the legendary Imperia.

Just as things settled into a pleasant rhythm, and I'd begun to forget that we were in Rome at all, Bramante entered the loggia, face as white as the day he'd told us of Alidosi's murder. "So, this is where you've been hiding."

I put down my chalk. "What's wrong?"

"You have to come back to the Vatican."

"Why?" I waved off Margherita. "I know the pope favored the Sistine."

"It no longer matters what Pope Julius thinks."

Chigi and I exchanged looks. "How can the pope's opinion not matter?" I stood up. Had the schismatic council won? Had His Holiness been deposed? Had he been poisoned, assassinated, stabbed . . .

"He fell ill after the unveiling and didn't have time to appoint Michelangelo to anything. The court has kept it quiet so far, but it won't be quiet for long. He's failing."

"The pope is *dying*?" Chigi asked and hardly waited for Bramante to nod before sprinting off. He, no doubt, had friends to inform, treasure to protect, and cardinals to bribe to elect the *next* pope.

As Margherita handed me my jacket and hat, Bramante asked, "Do you know who's been appointed Dean of the College of Cardinals and is the favorite to be elected the next pontiff?"

I shook my head; I couldn't fathom this pope gone, much less another on his throne.

"Cardinal Riario."

"*Fafel?!*" I said, my voice echoing down the loggia.

"Fafel," confirmed Bramante.

"The short balding cardinal who enjoys hearing himself talk?" Margherita asked. "Isn't he Julius's cousin?"

I nodded, unable to speak.

Margherita looked from me to Bramante and back again. "Upon the news of a pope's demise, why do you both look so happy?"

"Because, young lady," Bramante said, rocking from heel to toe, "there is nothing in this world that could convince Cardinal Riario to appoint Michelangelo, a cheating art

forger who once made a fool of him by selling him a faked ancient cupid, to be his official papal architect, certainly not over his favorite painter . . ." And with that Bramante gestured grandly toward . . .

Me.

Chapter LIX

1513

Pope Julius II had run out of miracles. He breathed his last on the 20th day of February 1513, a day so cold and gray that you'd think the heavens mourning. Two of my paintings accompanied his body during the funeral procession. Cardinal Riario, the pope's cousin, led a group of young priests carrying my official portrait of His Holiness, while Felice carried a devotional that she'd picked out herself: my *Madonna of the Veil* of baby Jesus, wriggling in bed, playing with the Madonna's veil as Joseph, standing in the shadows, watched over her shoulder. A tender, vulnerable family scene to escort the Warrior Pope to heaven. As his holy body paraded through the streets of Rome, women kissed the pope's purpled feet, children threw berries, men wept like widows.

The next few weeks were frantic. Cardinals hurried up and down halls, whispered in corners, bribed one another for silence, secrets, and votes. Riario, Bramante, and my duke—who stayed in Rome after the funeral to use whatever talents he could to influence opinion—paced across the papal apartments, sharing hourly rumors of hypothetical

scenarios: if this faction of cardinals votes this way, then this faction votes another, and that puts these two cardinals up for grabs and . . . I couldn't keep up. I suppose I could try to detail all the highs and lows of that campaign season for you, but, I'm bored by political machinations, aren't you? Don't hear me wrong; I understand why people were plotting. There was a lot at stake in that election: enormous political power and money, not to mention my position in the Vatican, but I didn't want to win the job because of politics. Would you? Yes, the thought of Cardinal Riario becoming pope and anointing *me* Bramante's successor was terribly grand, but it also seemed, I don't know . . . disappointing. I wanted to win the job in a flood of my own beauty not because this cardinal over here bribed that cardinal over there into voting for that other cardinal on the other side of the room . . . you understand. However, Bramante made a good argument: "If Michelangelo is appointed papal architect, the first thing he'll do is tear down your frescoes. He knows how good they are; he'll never leave his rival's work on those walls." So, I did what I could to help the cause: I added Cardinal Riario's image to the crowd of my *Mass at Bolsena* fresco, so that as cardinals scurried in and out of those rooms, they would see Riario's face already gracing the walls of the papal apartments and believe he was destined to be there. (You know where Riario is in the fresco, don't you? Standing over to the right, in his red robes with that tuft of curly hair circling his balding head.)

And, yes, it all really did seem to be sliding in my direction. The night before the College of Cardinals was to convene for conclave—locking themselves in the Sistine under Michelangelo's ceiling, where they would sleep and eat and remain until two-thirds could agree on who should be the

next pope—Fafel entered the apartments and stood beside me, as we both peered up at his image in my fresco. "Soon, we'll cover the world with your miracles, Rafa. Very soon." And, it's hard to remember now, but . . . I guess I believed him?

While cardinals debated and voted behind locked doors, I finished my *Mass at Bolsena* fresco. (It's an obscure miracle, so I don't know why you would've heard of it, but it was one of Pope Julius's favorites, so I was pleased to leave it on the wall in his honor: in 1263, at a church in Bolsena, a doubting priest was conducting mass when the bread began to bleed, leaving a cross-shaped stain on the tablecloth, proving that the bread and wine indeed turn to the Body and Blood during the Eucharist.) In that fresco, to the left, at the front of an adoring crowd of faithful, I included a painting of Margherita, tall and bold, in a long, flowing yellow dress. (*D'accordo*, it has more of a golden tone than the sunflower dresses of such notorious ladies; I couldn't overtly paint a *puttana* on a miracles fresco in the Vatican, now could I?) That single figure among a crowd would never be enough to immortalize her, but it was a start. I remember thinking: if Cardinal Riario becomes pope, I'll cover the entire Vatican with Margherita's face.

Then, on the cold afternoon of March 9th, word came that the cardinals were going to vote again. And this time, so went the rumor, one man had the necessary votes to be pope.

"Is that smoke?" asked Bramante, as we all packed into the square outside the Vatican, waiting for smoke to rise out of the chimney atop the roof of the Sistine Chapel and tell us there had been a vote: if no pope had been elected, black smoke would rise. If one man had enough votes to be

pope, then we would be greeted by a puff of white smoke and cheers. The duke stood with us as we stretched our necks trying to get a glimpse of that slender, cylindrical chimney. "Is that . . . ?" Bramante exclaimed again, but it took another five gasps for him to be right. Eventually, the chimney coughed . . .

White smoke.

The crowd cheered, "A new pope, a new pope, praise God Almighty, we have a new pope."

"It doesn't have to be Riario for this to be a victory, you know," Bramante whispered, sounding nervous. "Bibbiena would also be good."

"The Farnese cardinal, too," said the duke. "He likes me."

"And he praised your *Madonna of the Veil* at the funeral," Bramante added to me.

And now, despite all my bravado, the moment was upon me, and I was nervous. No, I didn't want the job for political reasons, but if I did get the job—even *if* for political reasons—I could use that position to reach even higher, paint even better, and one day maybe even surpass . . . I reached for my father's paintbrush to twirl. *Beh.* Right. It was gone. (I'd searched Old St. Peter's for that paintbrush many times since that night in front of the *Pietà.* I still look for it sometimes, but it's never turned up. It's gone.)

A voice cried out in Latin: "*Annuntio vobis gaudium magnum: habemus papam*," and the crowd passed along the traditional announcement: "I announce to you a great joy: we have a pope." As the people in front of us turned to pass these words back, and we turned and repeated the same words to those behind, I felt a thrill. We, in that square, would be the first to greet a new pope, a new leader of our

Church, a new voice of God. And I couldn't stop thinking: Which name would Fafel—Raffaele Riario—take? Pope Julius III after his cousin? Pope Sixtus V, after their uncle? Could there be a Pope Raphael?

Bramante stood on his toes. The crowd held its breath.

And then, the doors of that Vatican Palace balcony opened and . . .

Do you know what I saw first? Before my eyes registered the pope's ceremonial white robes or golden staff or papal tiara—before I saw any of that—my eyes landed on the misshapen, bulging, flaring nose of . . .

Michelangelo.

I felt sick. Dizzy. Sweat beaded along my forehead. I might've stumbled backward or run my hands through my hair, I don't know. But there was Michelangelo up on the papal balcony. There was Michelangelo standing next to the new pope.

"Medici."

I heard the name before my eyes registered his face.

"Medici, Medici, Medici."

Standing on that balcony, no longer dressed in cardinal reds, but in the brilliant bright, white vestments of the holy pontiff was—wide shoulders, round head, jowls thick as ever—Cardinal de' Medici . . . *Mi scusa* . . . No longer cardinal, but pope. The crowd passed his papal name back, and my tongue felt heavy as I turned to repeat the news to those standing behind me: "Cardinal de' Medici has taken the name Pope Leo X."

"Oh God, no," muttered the duke, as he stumbled backward out of the crowd. (I guess Francesco Maria was right to flee that day. A short time later, the Medici pope drove

him out of Urbino; without his uncle on the throne to protect him, he's in exile now, miserable and powerless, as he should be.)

While Bramante found his courtly instincts and began to cheer, waving up at the pope as though he'd plotted for this outcome all along, I stood there feeling numb because Michelangelo's ceiling had been strong enough to bend the vote his way. Because the Florentine ally of my rival was now pope. Because Michelangelo's victory was sealed.

Chapter LX

"God has given us the papacy, let us enjoy it," cried the new Florentine pope, and with that, I left the celebration in the square—songs, banners, ribbons, fireworks—and returned to the papal apartments alone. Soon, the new pope would move in with his *brother* Michelangelo, and my frescoes would be . . . I sank to the floor in the middle of my room of miracles.

"Here to say good-bye, too?" came a familiar voice. I looked up to see Felice della Rovere standing in the doorway. She wore the same black widow's weeds as always, but now they felt weightier. "A Medici pope," she said, kneeling beside me. "I'll never be allowed in these rooms again."

"*Salute*," I said, raising an imaginary jug of wine. She raised one, too, and we "clinked."

"At least part of *you* will always be here," she said, pointing to my portrait, staring out of the crowd off to the right side of my *Mass at Bolsena* fresco.

I nodded but said, "Ah, but so shall you."

She gave me that look—*why are you such a fool?*—and I pointed to the crowd of faithful gathered at the left side

of that same fresco. She followed my finger and . . . "No. No." She got up and crossed to stand under that fresco. She looked back at me. "No."

"*Sì.*"

She looked back up, into her own face in the crowd— painted in profile, dark hair, honey skin, dressed in black, *sì certo.* Felice's hand went up to her chest; was it was an intentional mimic of her gesture in the painting or . . . "My father didn't ask you to include me, did he?"

I wish the truth had been different. "No. He didn't."

Her shoulders dropped. "He used me for negotia- tions, but heaven forbid he embrace me as his daughter. He encouraged them to call me 'niece,' did you know that? Didn't want to be like his rival, the Borgia pope, flaunting his *bastard* offspring."

"Your devotion was—is—beautiful. That's where you belong. Looking up at him, looking after him. The world as it is *and* as it should be."

"After all I did to you, and yet . . ." She shook her head. "I was only trying to protect him."

"If I could've protected my parents, I would've done any- thing, too."

"Thank you." She crossed back and sat back down on the floor next to me. "Now, I can be with him. Forever."

I shook my head. "Don't delude yourself. You and I will both be wiped from history."

"Maybe we'll get lucky," she said, nudging me. "Maybe henceforth, historical records will be filled with tales of wives and daughters and polite painters of Madonnas. Besides, maybe Pope Leo will only lock these rooms away like my father did to the old Borgia rooms. Maybe Leo will move downstairs and tear down the Pinturicchio frescoes instead."

I found a speck of green paint on my fingernail. I didn't bother to try and pick it off. No matter how often I tried, it always came back. "Even if this pope does decide to save my walls and move back downstairs, some future pope will only lock his new frescoes away, move up here, destroy mine, and the cycle will continue, pope after pope, painter after forgotten painter."

"Oh come, now, Raphael, you're usually such an optimist. Don't leave me without a hint of hope."

Sometime around then—I don't know when—a throat cleared, and we turned to see Bramante standing in the doorway. Felice got up, brushed off her skirts, and curtseyed. Then, she was gone. (Did you know that she became a widow again a couple of years ago? In the will, her Orsini husband left her in charge of the family estate, and why not? No man could manage it better. Independent and wealthy, she'll never have to marry again. I still see her sometimes, striding across a piazza, head high, widow's weeds swishing.)

Bramante waited for Felice's footsteps to fade before speaking. "I spoke to His Holiness."

Those two words evoked the image of Julius for me. It would take years before the picture in my head matched reality; it still doesn't sometimes.

"It's good news," Bramante went on. "His Holiness promised that I can keep my position as long as God will allow, and as long as I have my position, you have yours. And, as you know, with a new pope there will come new turns, new alliances, new opportunities . . ."

I nodded and offered a weak smile. At least I could tell Margherita there was still hope.

"So, don't worry, my young countryman," Bramante said, standing over me and staring up at my fresco. "Now, all I have to do is outlive the pope."

Chapter LXI
Spring 1514

You can't give up now," Chigi said, as we waited for Bramante's coffin to make its way down the nave of Old St. Peter's. It's ironic—isn't it?—that the architect was being buried inside the same building that he'd been assigned to destroy and rebuild.

"I thought you wanted me to give up the Vatican and spend all my days covering your villa in paint," I whispered back, as Pope Leo led the funeral procession down the aisle.

"Oh, my young Sparrow, what patrons want most is to support the best artists," said Leonardo da Vinci standing on the other side of me. Pope Leo—determined to play host to every great artist on the peninsula—had lured the Master from Vinci down to Rome with a heavy purse. Leonardo might not care much for the demands of papal painting, but he did enjoy the bounty of the papal treasury. (He didn't stay in Rome for long, though. Soon after this period, Leonardo left the Vatican, left Rome, left the peninsula, and then left this Earth. I still regret not making it up to France for his

funeral.) That day, Leonardo added, "If the pope anoints you as best, it proves Chigi's impeccable taste."

"Can I quote you on that, *maestro*?" Chigi said. "Leonardo from Vinci says, 'Chigi has impeccable taste.'"

Leonardo nudged me. "It also doesn't hurt that you being named papal architect would increase the value of your work at his villa by tenfold."

Chigi bounced his eyebrows. "At least."

We crossed ourselves as Bramante's body passed. Bramante had walked the Earth for seventy years; he had no children, no widow, the only thing he left behind was the construction of new St. Peter's, which everyone knew would take centuries to finish. And yet, although it wasn't a tragic, youthful kind of death, it was still devastating for me. My countryman and my protector was gone.

"But I don't want you to rise only for my sake, Rafa," Chigi told me as we sat down for service. "I want you to rise for your own."

"For once man has tasted flight"—Leonardo spoke in a similar rhythm to the pope reading The Word—"his eyes will always turn toward the skies, for there he shall long to return. And you, Sparrow, have flown in the clouds for a very long time now."

"I'll get used to toiling the soil again, *maestro*," I said, between recitations. "It won't be all bad. At least after I'm fired, I'll be free to tell the world that Margherita is mine." Yes, I'd told Leonardo about our union. The *maestro* may be garrulous at times, but he knows how to keep a secret. "No more hiding in the dark. I can love her and paint her openly." Over the past year, Bramante had helped me salvage Pope Julius's final commission, the Sistine altarpiece.

I'd used Margherita's face for the Madonna. Would it be enough to make her immortal? I didn't know—perhaps I'd never know—but at least I'd had a papal commission with which to try.

"Let me see the summons again," Leonardo whispered while everyone else's head was lowered in a moment of silence.

I slid the parchment out of my jacket pocket and passed it to Leonardo. A messenger had brought it to me, two days after Bramante's passing. The summons was written in flowery calligraphy on thick paper, stamped with the papal seal. It requested my presence at a meeting two weeks later when Michelangelo and I would both present our best work, so that the pope could decide which one of us would inherit Bramante's job. "This leaves the decision open," whispered Leonardo, passing the summons to Chigi.

"What this does is leave the Medici pope free from criticism," I whispered back. "No one can accuse him of playing favorites if he gives me a chance. If you don't already know that the Medici pope is going to hire his Florentine brother to be his next papal architect, then those flying machines of yours have gone to your head, *maestro*."

"Rafa, I don't want to live in a world where a man like you gives up on his ambitions and just lets a man like Michelangelo win," Chigi said, handing the summons back to me. "With no competition? It doesn't seem right."

"But I'm not giving up, signor Chigi," I whispered as we filed out of the pew to receive the Eucharist. "I'll *never* give up. It's only that I've decided to fight for what's truly important."

Chapter LXII

"Come by yourself today?"

"*Buongiorno* to you, too, Michelangelo."

"You're usually such a bravo with your band of brothers," Michelangelo shot back. Yes, I'd come to the meeting alone, although I don't know how he'd seen that, since his gaze was focused only on a marble statue on display in the Vatican's newly completed Belvedere Courtyard. That courtyard, with its elegant clean lines and classical colonnades, would make for a handsome backdrop of a future painting. Too bad, after today, I might never see it again.

I nodded to Michelangelo's entourage: Francesco Granacci, a handful other Florentine assistants, and the sculptor's two brothers, Bounarroto and Giovansimone, whom I recognized from Florence. "And you're usually the hangman, alone on your scaffolding," I replied.

Giovansimone snorted a laugh. Buonarroto elbowed him and tugged at his ill-fitting jacket. Both Buonarroti brothers were dressed uncomfortably for court. Giovansimone was failing to pull off whatever fashion he was attempting: short, belted white tunic; red velvet tights; knee-high white boots.

I, on the other hand, had dressed conservatively for my execution: cream shirt, black jacket, black tights, simple black cap. I'd grown a beard—a trend ever since Julius's grizzly growth during the war—and had trimmed it short and neat that morning.

While we waited for the pope to arrive, Michelangelo kept his nose buried in that marble statue of the *Laocoön*, a depiction of that ancient priest and his sons being strangled by a serpent, punishment by an angry god for *Laocoön's* attempt to warn the Trojans against accepting the Greeks' gift of that legendary wooden horse. The powerful marble statue had been unearthed nearly a decade earlier. Michelangelo, I'd heard, had been present at its excavation. The bulging muscles of Laocoön and his two sons fighting against that giant snake reminded me of the tension in one of Michelangelo's own compositions. The sculptor could've carved this very statue, if only he'd been alive a thousand years before. Did Michelangelo worry that no one today knew the name of the sculptor of that famous, ancient statue? Or did he only care that the marble itself had survived?

Pope Leo X finally entered Belvedere Courtyard with a coterie of cardinals, none with whom I had any particular relationship. A crowd of Michelangelo devotees, no doubt. The pope turned to me and asked, "Are we waiting for anyone else, Santi?"

"It's only me today, Your Holiness."

"Very well," said the pope with a shrug. "So, who's firs . . .?"

"Michelangelo can go first," I interrupted.

The sculptor didn't pull his nose out of the marble. "You

can go, if you want. No reason to follow me." He hadn't even put on a new tunic for the occasion.

"The honor is all yours, *maestro*," I insisted.

Pope Leo looked to Michelangelo—for his approval, I thought grimly—and the sculptor shrugged, "Fine with me." The pope clapped. "To the Sistine?"

Michelangelo nodded. "To the Sistine."

That walk to the Sistine . . . What can I say? His Holiness and Michelangelo led the way, prattling on about some blood sausage they'd shared at some dinner when they were boys. I trailed behind. I'd avoided the Sistine since the unveiling—even playing sick a few times to skip services— but now there we were, and . . . That ceiling . . . It was even more spectacular than I remembered. *Santa Madonna* those colors.

Michelangelo and the pope were already discussing the future papal architect's projects: St. Peter's, new roads, new buildings, new paintings . . . "And Julius's tomb?" Michelangelo asked, unable to hide the excitement in his tone.

"What's a tomb, my brother, when compared to St. Peter's? You've given us one miracle already." He gestured to the ceiling. "We expect you to deliver more."

No one looked at me, but I smiled, chin up, *si certo*.

"Would you like to say something?" Pope Leo asked Michelangelo.

The scruffy sculptor looked up at his ceiling. Everyone waited, as only Michelangelo can make people wait. Eventually, he shook his head. "My work speaks for itself."

The pope smiled. Cardinals nodded. Buonarroto and Giovansimone nudged each other with brotherly

admiration. Leave it to Michelangelo's uncourtly style to win the moment.

"How many times have you told us that painting is not your art, Michel?" said the pope. I cringed at the name *Michel*—a boyhood nickname between brothers. The pope turned to me, his brow knotting pityingly, and said, "He *did* offer to let you go first."

I nodded.

"To Raphael's apartments," the pope said, waving the others toward the door.

"Wait," I called, not moving from my spot.

Pope Leo turned back. "Yes?"

"I don't want to take you to those apartments today, Your Holiness."

The pope's brow lifted. "You have better work somewhere else?"

I wanted to stare at my feet, but "*chin up, Raphael, chin up,*" came my mother's voice, so I did. "Your Holiness, while I appreciate your kindness in considering me for this illustrious position, I, like you, can see . . ." I raised my eyes to the ceiling again. "That."

The Buonarroti brothers—all three—smiled.

The pope exhaled sadly at my truth.

I went on. "So, instead of spending my audience with you today arguing for a position that I'll never receive, I prefer to spend my limited time arguing for something more important."

The pope nodded; he knew a papal audience was precious, especially for a man on the way out the door. "You're welcome, son, to use your time for anything you desire."

I bowed. "Thank you, Your Holiness." Michelangelo shushed his whispering brothers as I said, "I understand

that when this day is finished, my colleague here"—I tilted my head at Michelangelo—"will be papal architect, and it will be up to him to decide which art goes and which stays. So, what I'd like to do today is fall at your feet"—I dropped to my knees—"and beg you to protect a few bits of paint from the crack of Michelangelo's chisel."

The pope raised his brow. "You want to save a painting?"

"A *series* of paintings."

Did I hear a snicker? The pope ignored it. "A single room?" he asked.

"A *set* of rooms."

Someone in the crowd snorted with derision and whispered, "*Desperate . . .*"

I held the pope's gaze—this pope who was raised by one of the greatest art patrons of our time, whose boyhood home was filled with art, with artists, with humanists and paintings and sculptures . . . "Very well," the pope said, "Whichever paintings you choose shall be protected."

I exhaled. "*Grazie,* Your Holiness, *grazie, grazie, grazie,*" I said, too relieved to show courtly restraint. I stood up. "Now, if you'll follow me, I'll show you which ones."

"As if we couldn't guess," someone murmured—a cardinal, Granacci, I don't know who, except that it wasn't Michelangelo or the pope. Everyone followed dutifully along as I led them out of the chapel, down the hall and . . .

"Oh, Raphael," called the pope.

I stopped and turned back.

"The papal apartments are that way." Pope Leo pointed down the hall in the direction of my *Disputa,* my *Philosophy,* my *Heliodorus . . .*

"I know, Your Holiness, but I already said that's not where I want to take you today."

"It's not?" The surprise in the pope's tone was echoed by the murmurs of cardinals.

"Not unless you'll allow me to keep *two* apartments worth of paintings?"

The pope smiled. "One apartment is quite enough."

"In that case, Your Holiness," I said, "while I dearly hope that you decide to keep those paintings for your own pleasure, there are others that are more important to save."

His Holiness and Michelangelo exchanged looks, but the pope turned to me and, with a tone of curiosity, said, "Then by all means, young man, lead the way."

Chapter LXIII

As I led them downstairs and into a dim, stone hallway, the pope sneezed from all the dust. "You realize that if your paintings are stored down here in secret, Santi, Michelangelo might not have known to destroy them?"

The coterie of cardinals chuckled. My mouth was too dry to swallow. I felt slow, as if wading through a bucket of plaster, but when I put my hand on the bronze door handle, crusted with teal, the color of Botticelli's sea in his *Birth of Venus*, the thought of my old hero gave me the courage to push open that door. Margherita and I had snuck in the day before to prepare those rooms: we'd removed all the tarps; dusted floorboards, moldings, furniture, ceiling, walls; and opened the windows wide. Daylight slathered the room in a thick glaze, making the frescoes on those walls dazzle brighter than polished plates at a Chigi feast.

At the sight of those walls, one cardinal stopped short. Others piled up behind him. Lips parted. Fingers pointed. Necks craned. I wondered how many of those men—working and politicking in the halls of that very palace—had

never laid eyes on those frescoes. Pope Leo, who'd been made cardinal when he was only thirteen years old, had no doubt seen them going up on those walls. His eyes widened with recollection as he walked from wall to wall, room to room, drinking in Pinturicchio's masterpieces in the old Borgia apartments.

I stood in the center of the Hall of Mysteries, surrounded by those jewel-toned frescoes: *Birth of Christ, Adoration of the Magi, Resurrection*. When His Holiness ambled into the room—eyes on those walls, red velvet hat in hand—I spoke: "Dante Alighieri said, 'Worldly fame is but a breath of wind that blows this way, and that, changing name as it changes direction.' And it's true, Your Holiness. Pinturicchio was once the most famous painter on this peninsula, but now new generations hardly know his name." I gestured to a cardinal, gaping at the *Assumption of the Virgin* fresco, who looked young enough to still require a tutor. "But that's a disgrace, Your Holiness. We should all know Pinturicchio. Some people, I suppose, might call copying our predecessor's work thievery." I glanced at Michelangelo, head back, mouth open, staring up at the *Annunciation*. "But I call it progress. Painters have built entire styles atop Pinturicchio's innovations, and these paintings have personally given me inspiration, comfort, protection." I thought back to those dark nights, when I'd slept in those rooms when I had no others. "So, I'm asking today that you save *these* paintings, Your Holiness, open *these* rooms, unbury *these* walls. These masterpieces don't deserve to be buried beneath. They deserve to be seen. They deserve to be saved." I dropped my head with a note of finality and stared down at my leather shoes, a fresh pair for the occasion, with not a single frayed thread or speck of paint.

There was thick silence—not a sniff or cough or shifting stance—and then the pope said in an incredulous or frustrated or defeated tone (I'm not sure which because I didn't look up to see his expression), "Why in heaven's name wouldn't you save your own work, son?"

"Your Holiness," I said. "Even if you destroy everything of mine inside the Vatican, I can paint new paintings. Because, as you see"—I extended my arms—"I'm still alive. But Pinturicchio? He's gone from this Earth. He'll never paint anything again. And the world doesn't deserve to lose him."

The pope shook his head—his expression was impossible to read—but before he could speak, a new voice called from across the room, "Allow *me* to show you what the world doesn't deserve to lose, Holiness."

The pope and I exchanged a bewildered look and then, along with everyone else, turned to see who had interrupted.

Agostino Chigi—dressed in a gold-trimmed purple velvet cape and hat—held open the door as servants wheeled in a platform supporting something covered in a tarp. It was tall and rectangular. *What was going on?* Michelangelo glared at me as though I'd planned it, but I shrugged—*I didn't have anything to do with this*—as Chigi said, "Young Raphael, here, told me of his grand *plan*." He shook his head as if the truffle sauce had spoilt. "But as admirable as the lad's intentions are, what would a competition be without a little . . . competition, eh?"

I shot Chigi a look—*what are you doing?* He grinned and bounced on his toes.

The pope raised his eyebrow at the mysterious, tarped platform. "Did you bring another stack of dishes to toss into the Tiber, Agostino?"

"Not today, Holiness, but like that Carnevale night, I'm

very much looking forward to seeing which of these two artists you—once again—judge to be the best."

As Chigi raised his hands over his head, I dropped my eyes. Yes, one night long ago, then-Cardinal de' Medici had judged that I'd made the better drawing, but that was over a private commission for a private man when the cardinal was only a cardinal, and the Sistine ceiling had yet to be painted, but now he was pope with a responsibility to raise his country—Florence—up with him and . . .

Chigi clapped with his usual flair, but the servants didn't yank down the tarp over the mystery platform as I'd expected. No. Instead, the door opened and in walked Margherita Luti, carrying my *tondo* of her on that old wine barrel. When the pope exhaled, "Beautiful," Margherita claims he was referring to the painting, while I contend he was referring to *her*.

But Chigi wasn't finished. He clapped again and the doors opened again and in walked Leonardo—*Leonardo da Vinci!*—carrying my portrait of Cardinal Alidosi. Another clap, and in came Sodoma with drawings for my *Philosophy*, and Cardinal Riario fanning out a stack of drawings for my *Heliodorus* fresco. Chigi said, "How many figures does Michelangelo have on his ceiling in the Sistine, Holiness? Two dozen? Three? A hundred? More?" As Michelangelo shoved his hands into his pockets, the people and pictures kept coming: Felice wheeled in the official portrait of her father, and Guillaume brought my *Madonna of the Veil*. Lorenzo Lotto carried in one of my favorite large *tondos*, a *Madonna of Humility*, painted in my private rooms during quiet moments, and the Roman banker Bindo Altoviti entered with my new portrait of him. Then, even Sarto— whom I hadn't seen since Florence—came in with my *Three*

Graces panel, and Andrea della Robbia with *St. Catherine of Alexandria*, and Ghirlandaio with my *Madonna with the Goldfinch*. When Evangelista walked in carrying a self-portrait I'd drawn when I wasn't yet twenty, I laughed out loud.

I shook my head at Chigi. It still amazes me what a man can accomplish with a hefty money bag. "And if this doesn't convince you, Holiness," said Chigi with an impish smirk, "Surely this shall." He clapped again, and his servants yanked the tarp off that mysterious platform he'd rolled into the room when he first entered.

Unveiled was my *Sistine Madonna*, the last altarpiece commissioned by Pope Julius II.

At the sight of it, Pope Leo's lips parted.

I could see why: my altarpiece shone.

A painted plush green curtain hanging on a sagging rod pulls back to reveal a holy scene: the Madonna, headdress billowing, standing atop fluffy white clouds holding baby Jesus, while St. Sixtus and St. Barbara kneel on either side of her. All of the faces are familiar to me: the Madonna is Margherita Luti; St. Barbara is my mother; and St. Sixtus my father, if he had been lucky enough to advance to such an age. Baby Jesus has the round cheeks of my little sister long before she fell ill.

Chigi—in a tone unexpectedly serious for him—said, "Look at the faces of this Madonna and Child. Yes, they're beautiful, but their eyes widen, and there's a tenseness to their mouths and jaws . . . What is it? Determination? Desperation? Fear? Unlike other scenes, this Madonna and Child aren't removed from the inevitable tragedy lurking in their futures, are they? No. This pair can see their future— the betrayal, torture, crucifixion . . . They know, like the rest of us know, that the only end to their story is the end of life

here on Earth. But this Madonna and Child don't run from their fate, do they? No. They willingly walk into that fire. And by doing so, they give us the strength to face our own tragedies. And that's a miracle, if I've ever seen one."

Pope Leo took a step forward. His eyes scanned my painting. "So, Raphael," he said. "Is that what you see when you look at this altarpiece? Is it a miracle?"

I heard my mother's voice—*"chin up, eyes meet the patron"*—but for once I couldn't heed her advice. "No, Your Holiness. I can't claim anything so bold." I bent down so that I was eye to eye with the two winged angels, leaning along the bottom of my *Sistine Madonna*. "Do you know what inspired those two messy-haired little *putti*? They're based on two boys I once saw, leaning in the window of a baker's shop, watching bread rise. They weren't the ones baking the bread, and they weren't even eating it. They were just watching, in awe of its creation. Artists are like those boys in that baker's shop window—aren't we?—like the two *putti* at the bottom of this painting. It's not our job to make miracles, and we don't always get to taste them for ourselves. But as artists, it *is* our job to *witness* miracles and capture them in paint, so that others can believe. My painting is not a miracle, Your Holiness, but I'll count myself lucky if you think I've captured even the reflection of one."

Chigi clasped his hands. Leonardo winked. Evangelista was teary-eyed; he looked everywhere except at me. "That was a moving presentation," said Pope Leo. "And we do always appreciate *signor* Chigi's shows. But,"—he shook his head sadly—"we have no intention of making the decision about which artwork survives. Although we do promise to honor Raphael's request to keep the paintings on *these* walls"—he spread his arms wide—"as for the rest, we're

going to allow our new papal architect to decide what stays and what goes."

The room felt as if it lost its air. Chigi's shoulders dropped. Margherita lowered her *tondo*. Leonardo shook his head. Michelangelo, on the other hand, seemed to inhale all of that energy. His jaw clenched as his eyes darted from piece to piece—which would he keep? Any of them? I had started to formulate a speech—trying to come up with something to win him over—when his gaze landed on my portrait of his murdered friend, Cardinal Alidosi, and his features darkened. Chigi had miscalculated. Before this show, some of this work might've been saved, but now, it was all in the Vatican, open to judgment and destruction. Soon, it would all be gone. I bowed my head and reminded myself to breathe. It didn't matter, I told myself. I would paint and paint and paint, and no matter how many pieces the world destroyed, I would paint more. Michelangelo couldn't stop that.

His Holiness said, "All we want to know from our new papal architect is should we keep or cut down . . ."

My throat tightened as I wondered which of my paintings he would name first. The *Sistine Madonna*? My miracles? My perfect *Philosophy*?

But pope said, "The Sistine ceiling."

I looked up.

"So, Raphael?" the pope asked

I didn't know what else to say so I replied, "Yes, Your Holiness?"

"What do you say?"

"About what, Your Holiness?"

"Should we keep the Sistine?"

"*Che?*"

"We said that we wanted our new papal architect to make all of these decisions so . . ." His Holiness gestured to me.

I'm embarrassed to say that I repeated, "*Che?*"

And that's when the pope said, "*Il Magnifico*—God rest his soul—made all of his sons and daughters, this pontiff included"—he tapped his chest—"promise to always spread beauty across this ugly world. So, if we're to keep our promise to our father, isn't it incumbent upon our reign to promote harmony over dissonance, wholeness over brokenness, goodness over . . . something else? And today we've seen no person better capable of promoting *those* qualities, Raphael, than you." I have no idea how Michelangelo absorbed this news, because I was focused only on His Holiness. "Therefore," Pope Leo X said with a smile crinkling his eyes, "we hereby appoint as the official Papal Architect of St. Peter's: Raphael Santi of Urbino." He held out his ringed hand. When I didn't immediately kneel and kiss it, the pope added, "What do you say, Raphael? Will you accept the position as head of my papal program?"

I stood there. Staring.

"That would be a 'yes,' Your Holiness," called out Evangelista. A chorus of *sì* rang out—from Margherita and Chigi, Sarto and Sodoma.

When I continued standing there, staring like a fool, Leonardo scooted over and whispered, "Now might be a good time to bow, Sparrow." He popped his knee into the back of mine, and I dropped into a kneel.

"Yes, Your Holiness. Yes," I sputtered, kissed the holy ring, and managed, "Thank you for the honor."

I don't remember what happened next. There was

cheering and congratulations and hugs. I remember lean-
ing in to kiss Margherita, and her pushing me away. "Oh
no," she whispered. "Not yet, *signor papal architect*," but
although this new position meant that we must keep our
secret a while longer, I've never seen a look of such pride on
her face before or since.

At some point, His Holiness put his arm around my
shoulders and said, "So, Raphael, you still haven't answered
our question. Shall we keep the Sistine ceiling or cut it down
and slather it with perfection?"

That's the first time I remember looking at Michelangelo
again. His head was ducked, shoulders rounded, like
Atlas carrying the weight of the world on his shoulders.
"Michelangelo's figures always struggle and push and strain,
as if his cursing is captured in his paint," I started in a timid
voice. "He makes everything look so difficult, Your Holiness,
while I make it look easy. So . . ."—I didn't look at the pope.
I kept talking to the top of Michelangelo's bowed head—". . .
since I think the world *should* know just how difficult it is to
paint a painting or sculpt a statue or create anything, I say
we keep the Sistine. All of it."

Michelangelo's eyes lifted. My cheek burned under his
gaze.

"*Bene*. And, what shall we do with our countryman?" the
pope asked. "Shall we keep his talents for papal use or send
him on his way?"

It was too much, too fast. I was in no condition to make
good decisions, so you can't blame me for what I did next. "I
think we should send him on his way."

"Do you?" said the pope, sounding surprised.

Michelangelo's face flamed.

"I do." I tried my best to keep my courtly composure,

but I don't trust that my voice was smooth. "Everything in the Vatican can be executed by me and my men: St. Peter's, paintings, tapestries, whatever Your Holiness pleases."

"We see."

"So, I request that Michelangelo's talents be released . . ."

Michelangelo shoved his hands deeper into his pockets.

". . . to his marble."

Michelangelo's head snapped up. He searched my face.

I said, "I believe the previous pope is in need of a tomb?"

"He is," replied Pope Leo.

"Then that would be a priority. And although I know it will be difficult for us to lose the sculptor's talents here in Rome," I went on, "didn't I hear a rumor, Your Holiness, about a certain chapel up in Florence that could also use a marble tomb or two?"

"In San Lorenzo. Our family chapel. We did say that," said the pope.

"I apologize, *maestro* Buonarroti, for making you leave Rome and return to Florence and put up with your family"— my eyes darted to his brothers, who were grinning—"but we all must sacrifice for our art. I will promise to argue for increased compensation, if that helps ease the pain." I turned to the pope. "Your Holiness, you don't mind spreading the wealth, do you?"

Pope Leo clapped. "God has given us the papacy. Let us enjoy it."

As the crowd cheered and cardinals patted a flushing Michelangelo on the back, His Holiness leaned over to me and asked, "So, after all of those fine words praising the agony on the Sistine ceiling, does this mean that the great Raphael is going to stop painting perfection?"

I laughed—a stupid, big guffaw that made me feel foolish and alive—and said, "*Mother of Eve*, forbid it. For even when it all seems futile—especially when it all seems futile—some of us, at least, must never stop trying to bend the world, even if only a little, toward beauty."

Chapter LXIV

By the time I extricated myself from my admirers, I feared that Michelangelo had left—packed up his things, already racing back to Florence—and I'd missed my chance, but then, I spotted him. He'd pulled up a chair and was sitting, by himself, in front of my *Sistine Madonna.*

I grabbed a chair and joined him.

We sat silently for a long while, legs crossed, heads tilted, staring at my painting, so much to say, and yet . . .

He spoke first. "Witnesses to miracles, eh?"

I shrugged without looking at him. I was afraid of the disapproving look I might find on his face. "The idea is too sentimental for your tastes, I know. You hate it."

"You won't hear me using it for my own promotional campaign, but . . . it's not bad . . . For you." And then, "I'm the one on the left, aren't I?"

Off that unexpected question, I turned to look at him and followed his gaze, directed at the two *putti* at the bottom of the altarpiece, those plump, winged-angels staring up at the Madonna above. Those two boys *were* us, just two

witnesses to miracles. The one on the left is raised up on his elbows, chin resting in his hand, fingers half-covering his mouth. That *putto* only has one wing showing, the second wing hidden by the angel's turn, making it appear as though one were broken off. Michelangelo had identified himself as a broken-winged angel? I bit my cheek and said, "How'd you figure it out?"

He turned to me with that look, you know the one—that *"you-godforsaken-fool"* look—and said, "Because, Rafa, I've always been the cuter one."

I smiled as he stood up and strode toward the exit. On his way out, he turned back and said, loudly enough for everyone to hear, in his angry bellowing voice that we all know too well, "Raphael Santi, everything you've achieve in art, you learned from me!" He knocked a stack of sketches out of Chigi's hands and marched toward the exit. I pulled out my sketchbook and . . .

In order to capture that moment perfectly, I didn't need to change a thing, did I? No. Because Michelangelo storming out of those rooms, all eyes on him, all gossip on him, all hearts on him, while I sat ignored in the background, was the world not only as it is, but exactly as it *should be.*

Epilogue
Rome, March 1520

I've changed my mind. Please don't tell Michelangelo—or anyone—my story. He prefers his version, and it's more important to him than it is to me. But as long as we did spend this time together, I hope that you learned something from the telling, even if only to never use a Florentine plaster mix when frescoing in Rome. I learned a few things, myself. Mainly, that I'm going to stop taking offense when people assume I'm as perfect as my paintings. It means that I made it all look so easy that I bent the world's image of *me*. Besides, my father didn't ask me to be the most popular, most talked about, most feared painter in the world. Did he?

I could keep talking all night, as you now well know, but my wife will be home soon, and she deserves a hero's welcome, don't you think? She'd scold me if word of our union were confirmed—she's very protective of my career—so I hope you'll keep that part to yourself.

But please don't let all of my requests for secrecy stop you from telling Michelangelo about my *Transfiguration* here. It is, after all, the altarpiece he's trying to best these days. So, go ahead, tell him about Jesus rising off the mountaintop,

the apostles falling down in wonder, the gesticulating crowd, the boy cured of demons, the colors, foreshortening, shadows, drama . . . I'll even give you a few sketches of my own to take to him. I dare him to try and best it. I haven't seen him since that day in the old Borgia apartments. He left Rome soon after, and I've stayed here, managing the papal program and St. Peter's. (No wonder Bramante was always so irritable; St. Peter's is a *weight*.) So, if you do see him, please tell him that I hope he can tear himself away from his marble long enough to come back to Rome for the unveiling of our new altarpieces, side by side, as the pope has requested. I'd dearly hate to miss the opportunity to go head-to-head with him once again in the halls of the Vatican.

Coda

Afew weeks later, before his final altarpiece, *The Transfiguration*, could be unveiled, Raphael Santi of Urbino died on April 6, 1520, at the age of thirty-seven. Giorgio Vasari, the father of art history, tells us that Raphael fell ill after a particularly exhausting bout of lovemaking. He died on the same day as he was born — Good Friday—and was buried in the Pantheon. Raphael's death rocked Rome. The outpouring of grief for the young, handsome painter of perfection rivaled the passing of popes.

Raphael's *Transfiguration* had been commissioned alongside a companion altarpiece, *The Raising of Lazarus*, designed by Michelangelo (and executed by Michelangelo's devotee, Sebastiano del Piombo). These two altarpieces were seen as a head-to-head competition between the two greatest living painters: Raphael and Michelangelo. Today, as when the paintings were unveiled side by side shortly after Raphael's death, Raphael's *Transfiguration* is considered the far superior painting and the pinnacle of the High Renaissance.

Margherita Luti—subject of some of Raphael's most

famous paintings including his *Sistine Madonna*—went into a convent shortly after the painter's death; she was never publicly acknowledged as his wife, but an armband engraved with the painter's name and an erased ruby ring in his famous nude portrait of her—called *La Fornarina*, "The Baker's Daughter"—have long fanned rumors that their union was sealed.

Raphael served as Official Papal Architect from his appointment in 1514 until his death in 1520. Michelangelo did not receive an appointment to that position for another twenty-five years, in 1546, under Pope Paul III, when the sculptor was seventy-one years old.

Today, Pope Alexander VI's old rooms—with Pinturicchio's frescoes—are open to anyone visiting the Vatican. So are Pope Julius's private apartments, now affectionately called "The Raphael Rooms." Raphael's apartments and Chigi Palace (now known as the Villa Farnesina) are two of the most visited artistic sites in all of Rome—behind, of course, Michelangelo's Sistine Ceiling.

For over three hundred years, up until the mid-nineteenth century with the rise of the Pre-Raphaelites (who opposed the establishment's glorification of Raphael's idealistic style) and the Impressionists (who turned away from the classical paintings of the academy), Raphael was the artist to whom all other painters aspired, the definition of *sprezzatura* in art and life: the appearance of ease in achieving harmony, balance, and grace, even in the face of adversity.

Author's Note

Raphael, Painter in Rome is a work of historical fiction. All fictions in this novel are based on a knowledge of and respect for the history, but I did take artistic liberties to serve the story, illuminate human truths about Raphael's character and his art, and explore the cultural and political dynamics of the Italian Renaissance. And, yes, sometimes to entertain. If I have inspired even one reader to learn more about Raphael or the Renaissance or to visit a museum, then I've done my job.

That being said, this story and these characters are based on over twenty-five years of research in Italian Renaissance art (including an undergraduate degree in fine arts/art history from Vanderbilt University, a semester at the University of Pisa, and studying briefly in an Italian Renaissance PhD program); multiple trips to Rome and the Vatican (in addition to the rest of Italy); and an intensive study of Raphael's biography, drawings, and paintings.

A note on the language: Even though this is an historical novel set in the sixteenth century, I use modern sentence structure, phrases, and words. This choice is purposeful.

Raphael was one of the most innovative, modern artists of his day; to his own ears, he sounded modern. If I used more traditional, stilted language it would have robbed Raphael of some of his contemporary flair. The casualness of his tone is meant to reflect that he is comfortable telling his story and not in a situation where he must put on social airs.

My passion for Italian Renaissance art began with Michelangelo, but while the sculptor has been my longtime obsession, Raphael has been my constant companion and friend. As a child, even though I knew little about him, I used to lie in bed and dream about the painter of the famous pair of winged *putti* from the *Sistine Madonna*. Putting Raphael on the page—as I have heard him in my head for so long—has been a terrifying process, but necessary to achieve my goal: inspiring readers to learn more about this brilliant artist who has arguably influenced our shared visual language more than any other in history. Today, Raphael's work seems too perfect or too expected to be adored. But that's only because he was the first to achieve our ideals; like Shakespeare in literature, Raphael created many of our clichés in art. If you want to understand your own visual language, you must study Raphael.

Historically, Raphael is difficult to grasp. He was not a prolific poet or letter writer like Michelangelo (we have a few letters, but no great trove). Raphael also did not live long enough to dictate his own biography like Michelangelo nor did he keep extensive notebooks like Leonardo da Vinci. The major historical source for his biography is Vasari's *Lives of the Artists*, but Vasari was nine years old when Raphael died, so the biographer never met the artist. Other than bawdy stories of Raphael's sexual appetites, Vasari describes a man too perfect to be human, in my opinion.

Baldassare Castiglione likely based his ideal courtier in part on Raphael, so I used his *Book of the Courtier* as a basis for the artist's public personality. I've read as many biographies, historical documents, and academic articles on the artist as I could find. Even though many details of Raphael's life have been lost to time, I've spent countless hours studying his paintings and drawings. If you want to get to know Raphael, wade into the flood of his drawings; that's where you'll find the spirit of this novel.

All of the paintings mentioned in the novel are real. Even if you didn't read this book with your tablet open to look at the pictures along the way, I hope you'll track down the works in books, on your computer, or in museums. Many of our modern titles for these paintings were not used during Raphael's lifetime. The most obvious example is the painting we now call *The School of Athens*; that name did not develop until much later, so I refer to it as *Philosophy*. Details about each painting are historically accurate, with one notable exception: I have no reason to believe that Raphael used the faces of his parents as St. Sixtus and St. Barbara or his sister as baby Jesus in the *Sistine Madonna*.

Raphael really did grow up the son of a court painter and poet in Urbino. His mother, Magia di Battista Ciarla, died when he was about eight; his father, Giovanni Santi, when he was eleven. Vasari tells us that he apprenticed under Perugino, although the details of how he came to the master's studio and how long he remained are disputed. I don't know whether he was in Florence for Savonarola's Bonfire of the Vanities, but the historical moment is real. (Botticelli famously burned some of his own work in that bonfire.) Raphael based one of his earliest masterpieces, *The Marriage of the Virgin*, on a Perugino altarpiece; if you need

proof, look at both paintings—the similarities are undeniable, even if you don't consider yourself an expert in art. Perugino may have taken the copy as a compliment or as an affront, but I erred on the side of humanity, depicting the teacher as jealous of his student for surpassing him with his own designs.

In about 1504, Raphael moved to Florence, where he copied—and likely met—Michelangelo, Leonardo, and other contemporary artists (including Davide Ghirlandaio and Andrea del Sarto). Some details—like Raphael trying to take over the City Hall fresco project after Michelangelo left Florence—come to us from history, while others—like the scene of him trying to spy on Michelangelo's cartoon and getting caught—come from my imagination (although Michelangelo publicly accused Raphael of spying on him many times, so this seems more than plausible). How, exactly, Raphael made the move to Rome to work under Pope Julius is much debated. I believe he caught the attention of the pope based on his talents (so I used his superb *Lamentation* as the catapult), but I also wanted to use the duke's threats of poisoning to illuminate a central truth of the times: this period of Italian history is rife with poisonings, and fears of such plots were common. Michelangelo often claimed that he was the target of murderous schemes—especially by Bramante—so I took him at his word.

Raphael did paint alongside Sodoma in the papal library as described, and Pope Julius II did fire the other more established painters to hand the project solely to Raphael after a short time. Which portion of the ceiling in the papal apartments Raphael painted first is unknown; I chose *Justice* because I believe it could've convinced Pope Julius of Raphael's spectacular talents. A few fired painters joined

Raphael's workshop—which eventually became the greatest workshop in Renaissance Rome—but there is debate about who stayed. Sodoma likely left, but he's such a wonderful character, I couldn't bear to watch him go so quickly (plus, Raphael includes a portrait of him in *The School of Athens*, so his inclusion has basis). Although Pope Julius did move out of Pope Alexander's apartments, leaving Pinturicchio's frescoes behind, I have no reason to believe that Raphael ever lived in them (although his first payment from the Vatican treasury isn't recorded until months after his arrival, so that's where I got the idea that he might have faced financial struggles early on).

We have loads of historical information about Michelangelo's work on the Sistine, so all of that is true: descriptions of figures, his inventive scaffolding design, finishing the *Separation of Light from Darkness* in a single day—to name only a few details. Look at the fresco of Zechariah and see if you can find that young man perhaps "flipping the fig" at what could be a portrait of Pope Julius. Michelangelo really did curse painting and resented having to interrupt his work on Julius's marble tomb (which he never finished to his satisfaction; he called it the greatest tragedy of his life). A portion of Michelangelo's work in the Sistine really did mold after three months of work—he had to start over—and yes, Michelangelo accused Raphael of trying to steal the Sistine from him on many occasions. While painting the Sistine, Michelangelo really did sign his letters "Michelangelo, sculptor in Rome" (which, of course, inspired the title of this novel).

Every named character that appears in these pages is based on a real person (except for Jester Dominic, who is named after my nephew, a request that I could not deny).

Felice della Rovere was the illegitimate daughter of Pope Julius II and one of the most remarkable women of the Italian Renaissance. The legend of her throwing herself off a ship in the middle of the Mediterranean to protect her father comes to us from history. She was widowed when she was young (although there's no evidence that she murdered her first husband; I made that up based on what I know of her character, circumstances, and times) and later married into the infamous Orsini family. Felice is a fascinating woman, I couldn't include every fabulous detail about her life in this novel, and I highly recommend checking out the bibliography below to read more about her.

Margherita Luti, "the baker's daughter," is famously the love of Raphael's life and subject of many of his most beloved paintings, including the *Sistine Madonna*. There's debate over whether Raphael married Margherita in secret (there's too much evidence to recount here). In 1514, Raphael got engaged to Maria Bibbiena—niece of Cardinal Bibbiena—but he kept postponing the marriage (some researchers see this as evidence that he was not in a position to follow through because he was already married). As basis for Margherita saving Raphael from a pack of wolves, I used a legend that surrounds his *Madonna della Seggiola tondo*: the woman in the painting supposedly saved a monk from a pack of wolves; in return for her help, the monk blessed her—and the tree he'd hidden in—promising that they would both be famous; according to the legend, Raphael's *tondo* (made out of wood from that tree) is the fruition of that blessing.

Agostino Chigi, one of the wealthiest bankers in Rome, commissioned some of Raphael's greatest works in his villa—including his *Triumph of Galatea*. (There is also a

legend that Michelangelo, too, left a painting on the walls of Chigi villa, while waiting around for a meeting with Raphael; I badly wanted to include this legend, but it never fit in the story. If you visit the villa, see if you can pick out the painting supposedly by Michelangelo: it's the black-and-white fresco of a man's head in the *Galatea* loggia.) Chigi also really did host a large Carnevale party in 1510, was the lover of Imperia (a famous Roman prostitute; we *do* know her last name—Cognati), and once famously threw his dishes into the Tiber only to have his servants later fish them back out with nets.

After the papal loss at Bologna, the Duke of Urbino (who later returned to power after Raphael's death) really did murder Cardinal Alidosi (there are historical rumors that the cardinal was a cross-dresser and that he and the pope had an intimate relationship). One of Raphael's portraits is likely of Cardinal Alidosi; I've always wondered how he felt about painting a portrait of a man whom his duke murdered; my answer to that connection is pure conjecture.

Michelangelo really did live in the Medici palace and studied in the Medici sculpture gardens when he was young. At a time when loyalty to city was paramount, I've always found it strange that Cardinal de' Medici—as Pope Leo X—promoted Raphael to be his papal architect instead of Michelangelo. The final scene in Pope Alexander's apartments is imagined; I wanted a grand scene that felt true to the time, was worthy of Raphael's art, and helped me answer the question of why Pope Leo might've hired his "brother's" rival. Also, Raphael really did save parts of the ceilings in the papal apartments painted by his rivals, and in 1515, the pope appointed Raphael as "commissioner of antiquities," charging him with cataloguing Rome's treasures and

deciding which pieces should be saved for posterity; this all showed me that Raphael was—in spirit and in his career—a great protector of art. I wanted to bring that spirit to life in the final pages.

I have no way of knowing how Raphael reacted to the unveiling of the Sistine ceiling (the pope first saw the finished ceiling at vespers on the Eve of All Saints Day, October 31, 1512; it was not officially consecrated until mass on All Saints Day on November 1, but I chose to have Raphael see the Sistine alongside the pope that first evening). For Michelangelo, the pope, and all of history, that unveiling was an undisputed victory, but for Raphael such an overwhelming triumph by his rival must have been devastating. His determination to push forward and forge a brilliant career after such a setback convinces me of his extraordinary talent, optimism, and courage.

I can't recount the truth or fiction of every detail here, so for more information about the history behind the novel and sample questions for book clubs, please visit my website at StephanieStorey.com, where you can also find a full bibliography. In the meantime, here are a few of my favorite nonfiction selections (used for my research and recommended here if you want additional reading):

For an unbeatable account of the rivalry between Raphael and Michelangelo during the Sistine years: *Michelangelo and the Pope's Ceiling* by Ross King (2003, Penguin).

My favorite modern-day biography of Raphael: *Raphael: A Passionate Life* by Antonio Forcellino, translated by Lucinda Byatt (2015; Polity).

My favorite big book of reprints of Raphael paintings (and scholarly analysis): *The Complete Works of Raphael* compiled by eight Raphael scholars (1985, Harrison House).

My favorite big book of reprints focused on the apartments and the Sistine: *Michelangelo and Raphael in the Vatican* (1992, Papal Galleries).

My favorite book of Raphael drawings: *Raphael: the Drawings* by Catherine Whistler (2017, Ashmolean Museum).

A wonderful biography of Felice della Rovere: *The Pope's Daughter: The Extraordinary Life of Felice della Rovere* by Caroline P. Murphy (2005, Oxford University Press).

A not-so-expected reading of Sistine iconography: *The Sistine Secrets: Michelangelo's Forbidden Messages in the Heart of the Vatican* by Benjamin Blech and Roy Doliner (2008, HarperOne).

One of my favorite Michelangelo biographies by my former teacher: *Michelangelo* by William E. Wallace (2011, Cambridge University Press).

My favorite condensed history of Rome: *Rome: The Biography of a City* by Christopher Hibbert (1985, W.W. Norton).

A fascinating history of the building of "new" St. Peter's: *Basilica: The Splendor and the Scandal: Building St. Peter's* by R. A. Scotti (2006, Viking Adult).

To read the original biography of Raphael: *Lives of the Artists* by Giorgio Vasari first published in 1550 (various classic translations/editions).

Raphael was arguably the model for the ideal courtier for *The Book of the Courtier* by Baldassare Castiglione originally published in 1528 (various classic translations/editions).

About the Author

Photograph by Paul Swepston

Stephanie Storey is the author of the stunning debut *Oil and Marble: A Novel of Leonardo and Michelangelo*. It has been translated into six languages and is in development as a feature film by Pioneer Pictures. Storey is also a TV producer of *The Alec Baldwin Show* on ABC, *The Arsenio Hall Show* for CBS, and the Emmy-nominated *The Writers' Room* on Sundance. When not writing fiction or producing television, she can usually be found traveling the world with her husband—an actor and Emmy-winning comedy writer—in search of her next story.

Also by Stephanie Storey

Oil and Marble
A Novel of Leonardo and Michelangelo
Trade paperback / $16.99 US / $22.99 CAN (available now)
978-1-62872-906-1

"Tremendously entertaining and unapologetic in its artistic license."—Maxwell Carter, *The New York Times*

From 1501 to 1505, Leonardo da Vinci and Michelangelo Buonarroti both lived and worked in Florence. Michelangelo was a temperamental sculptor in his mid-twenties, desperate to make a name for himself. A virtual unknown, he wins the commission to carve what will become one of the most famous sculptures of all time: *David*. Impoverished, shunned by his family, and working against an impossible deadline, he begins his feverish carving.

Leonardo was a charming, handsome fifty-year-old whose career has peaked. His commissions are late; he's losing patrons; he's obsessed with his flying machine; his engineering designs disastrously fail; and he's haunted by a woman he has seen in the market—a merchant's wife, whom he is finally commissioned to paint. Her name is Lisa.

Oil and Marble

A Novel of Leonardo and Michelangelo

Stephanie Storey

1499
Milan

Leonardo
December. Milan

From up close, he could see that the mural was already beginning to flake off the wall. The paint was not smooth, as it should be, but grainy, as though applied over a fine layer of sand. Soon the pigment would break away from the plaster and crumble into specks that would blow away, bit by bit. The earthy tones, made from dirt and clay, would be the first to go. The vermilion, the rusty red color of blood and pomegranate, would most likely stick the longest; it had the most permanent qualities. But the ultramarine worried him most. Ground from precious lapis stones, the brilliant blue was shipped in from a faraway land in the East and was the most expensive hue on the market. By using a hint of ultramarine, a painter could elevate a picture from mediocre to masterpiece, but its use on fresco was rare. Without ultramarine, his work could be dismissed as insignificant or, worse yet, conventional. And it was already starting to crack.

"*Porca vacca*," he swore under his breath. The deterioration was his own fault. He had pushed his experiments too far. He always pushed things too far. The left side of his face twitched. He took a deep breath, and his expression softened back into serenity. No need to feel ruffled. For now, he

reassured himself, this was still a masterpiece, and he was still the master. He turned to entertain his audience with secrets and stories. It was, after all, what they had come for: to hear the great Leonardo from Vinci explain his latest painting, *The Last Supper*.

"One of you will betray me!" Leonardo boomed, his voice echoing down the vaulted stone dining hall in the church of Santa Maria delle Grazie, where his fresco spanned the north wall.

The crowd of French tourists was delighted by his dramatic outburst. He knew that for many of them, he was a great curiosity. At forty-eight years old, the Master from Vinci was one of the most famous men on the Italian peninsula; his name had spread to France, Spain, England, and the far-flung land of Turkey. He was known for his ingenious designs of war machines and groundbreaking innovations in paint. Tourists traveled from all over the world to see him stand in front of his famous fresco, which was known for its luscious colors, still clinging to the plaster for now—for its thirteen realistic portraits of Jesus and his disciples, and its undulating composition, balanced around a central, stable Christ.

"This is the moment immediately following Christ's accusation," he said, stepping away from the fresco in hopes of diverting the crowd's attention away from the decaying paint. "At this point in the story, no one yet knows it is Judas who will betray Jesus. The revelation that there is an impostor among them is shocking. The disciples jump up, flail their arms, and cry out in alarm. One of them is a traitor. But who?" He scanned the tourists, as though hunting for a snake among them. In truth, he was studying their faces, looking for unique features and expressions that he might scribble into his notebook after they were gone.

"I hear you use your own face for Doubting Thomas," a voluptuous French girl remarked in heavily accented Italian. "But I do not see *ressemblance*." Her lips puckered over the French pronunciation, as though ready to plant a kiss.

Leonardo knew that both women and men appreciated his good looks. Although he often wore spectacles to aid his aging sight, when he looked into a mirror he saw that his golden eyes still sparked with youthful vigor. He was lithe and muscular, with a full head of wavy dark brown hair just starting to gray. If the masses were going to gawk at him as though he were some sort of mythical creature, he had a responsibility to look good, he reasoned, so he bathed every day and wore fashionable clothing that heralded his success: knee-length tunics, pastel-colored tights, and a gold ring with multicolored gemstones in the shape of a bird, worth more than most artists made in a lifetime.

He slid his eyes to the French girl's bosom, flushed pink and corseted upward in the latest fashion. Sometimes when a tourist caught his eye, he took the boy or girl back to his studio to sketch them, and sometimes they were so excited to meet the maestro that they happily slipped into bed with him, too. "That's because there is no *ressemblance*," he replied, copying her French accent. "If I relied on my own image as a model, I would draw variations of myself over and over again and never generate a unique face. And that would make for boring pictures."

His audience laughed, including the fleshy French girl.

Patrons often told Leonardo that when he spoke, it was difficult to tell if he were serious or joking, so he injected extra gravitas into his voice. "I'm telling the truth."

Except for one detail.

He looked down at the bejeweled bird glinting on the ring finger of his left hand, his dominant hand. God-fearing Italians considered left-handedness an aberration. The right side was the divine side. The left, driven toward sin. Most left-handed children were forced to use their right hands, to keep them on the righteous path. Leonardo's father had produced twelve legitimate children with a legitimate wife and all were right-handed. But for Leonardo, his bastard son, the result of a youthful affair with a lowly house slave from Constantinople, the sinister side had been acceptable.

In *The Last Supper*, two seats to the right of Jesus, a shadowy man in a green tunic reached for a roll of bread with his left hand. Judas was left-handed, too. "Imagine you're part of a large family." Leonardo stared past the French girl and into his painting. "One of twelve siblings gathered around a holiday dinner table. Your parent is in the middle, trying to keep order and balance. Imagine . . ." The sounds and smells of the room seemed to fall away as he meditated on Judas's left hand. "But as with any family, beneath the surface, there are secrets. In the middle of our boisterous family, one man doesn't belong. He is still among us, but hard to find."

In other depictions of the Last Supper, Judas was easy to spot, often sitting on the opposite side of the table from the others. In Leonardo's version, however, the traitor was in the middle of the group, just one of the disciples, hidden through his very inclusion, only identifiable by the small moneybag he clasped.

"In the moment immediately following Jesus's accusation, everyone is in shock, asking who is the betrayer. Is it him? Or him? Or that one over there? Or, the most frightening question of all, could it be me? When none of us have

yet been identified as the betrayer, we all are. We could all be the illegitimate other. We could all be the Judas."

As the spectators leaned in to examine each face, Leonardo groaned inwardly. He had intended to divert their attention from the deteriorating picture, not direct them to scrutinize it more carefully.

Suddenly, the refectory door banged open and an attractive twenty-year-old dandy burst into the chamber. Gian Giacomo Caprotti da Oreno had a panicked look on his smooth-skinned face, and his coiffed hair was mussed. "Il Moro is coming!"

The crowd fell silent and exchanged looks, as though trying to discern if this were a genuine warning or a ruse designed to entertain them. They glanced at Leonardo for a sign. "If you're teasing, Salaì, it's very cruel to these poor people." He called his assistant Salaì, which meant Little Devil, because of his propensity for playing practical jokes during the past—how long had it been now? Ten years already?

"This is no trick, Master. I swear. Il Moro is returning. With an army." Although prone to mischief, the young man wasn't a good actor. He was telling the truth.

Two ladies screamed. The voluptuous French girl pressed her hand against her corseted stomach. Husbands ordered families to flee. If Il Moro was returning to Milan, all of their lives were at risk.

Especially Leonardo da Vinci's.

The Sforza family had ruled Lombardy for fifty years, until two months ago, when the French military invaded the capital and drove the family from town. Duke Ludovico Sforza—called the Moor because of his dark complexion— had escaped unharmed, but it was a humiliating defeat. If Salaì were right about the ousted leader's return, Sforza

would mount a vicious assault. Every Frenchman still in Milan would be in danger.

Including Leonardo. For the last eighteen years he had been living and working in Milan, serving the Milanese court, but when the duke fled, Leonardo had not followed like a loyal patriot. Instead, he'd remained in his comfortable rooms in Sforza Castle and offered his services to the French king. If the duke returned to power, Leonardo would probably be arrested for treason. And everyone knew what the Sforzas did to traitors.

"We must go to the king. He'll take us with him to France or Naples or wherever he is headed." Leonardo twirled the bird ring on his left hand.

Salaì's expression darkened. "The king is already gone. He took his court with him. He left us behind."

Leonardo's left eye twitched. He needed time to think, so he pulled out the little notebook that dangled from his belt, sat down on the floor in front of the fresco, and began to sketch the panicked French tourists. With quick strokes, he captured rough impressions: their wide eyes, flared noses, thrashing arms, anything to give the suggestion of fear. The only way to truly understand human emotion was to study its physical effects, and having the chance to witness this kind of raw reaction was rare. He wished he could capture the sound of rustling fabric, gulped cries, and panting. If he could have drawn the taste of terror, he would have.

"Master, please, not now . . ." Salaì gently tried to take the notebook from his hands, but Leonardo would not let go. "We are abandoned. We must leave Milan."

"We should think before we do anything hasty." He must sketch that plucky French girl the way he saw her now: head thrown back, mouth open in a wail, chest heaving and

flushed. Fear looked a lot like ecstasy, and he scribbled a reminder to study the implications of such an incongruous similarity. As she hustled out of the room, he lamented that he wouldn't have the chance to indulge his desires with her.

The last Frenchman left the hall. The heavy door closed, muffling the cacophony of panic in the streets.

Salaì grabbed Leonardo's elbow. "We don't have time to think."

"There's always time to think, my young apprentice." Leonardo calmly put away his notebook.

Having time to think was why he had tried this now-spoiling experimental fresco technique in the first place. In true fresco, an artist slathered a coat of lime onto the wall and then painted directly into wet plaster, so the picture became a permanent part of the building. However, durability had its price. One had to finish painting an area of fresh plaster before it dried. It required fast, continuous work—but fast and continuous wasn't Leonardo's style. He liked to take his time, to contemplate every detail. He might start a project, stop, and then start again. Moreover, many of his favorite colors, like ultramarine, were made from minerals that counteracted with lime. It was why he'd developed a technique befitting his style, applying an egg-based tempera directly onto a dry wall sealed with primer. Using that method, he could employ his favorite mineral pigments— ultramarine, vermilion, even the sparkling green-blue of azurite. But more importantly, by avoiding wet plaster, he could take his time, making changes whenever a better idea occurred to him days, weeks, months, even years later. Once, while painting this very fresco, he had thought about a single brushstroke for three days before applying a touch of umber to Jesus's right hand.

Salaì pulled Leonardo to his feet. "I already have your notebooks and loose drawings packed." He patted a heavy satchel slung across his torso. "We'll have to leave everything else behind."

Leonardo looked back at *The Last Supper*. The paint was deteriorating, of that there was no doubt. He would not be able to save the crumbling picture. "That's all right, Salaì," he said, as much to himself as to his assistant. "Those who long to hold onto their belongings forever are misguided. We artists know how to let go of our possessions. Our work, after all, doesn't belong to us, but to the patron. Besides, paintings are never finished, only abandoned."

As they made their way out, cannon fire echoed in the distance. Outside was chaos. Galloping horses carried soldiers out of town. French courtiers and citizens frantically packed up carriages. A stormy winter wind kicked up clouds of dirt, veiling the city in a brown haze. The fashionable northern capital of Milan had descended into anarchy. In the midst of the pandemonium, a solitary French soldier stood peacefully in the piazza and gazed up into the eyes of a massive clay statue, a horse that towered taller than five men standing on each other's shoulders.

That clay horse, a monument to Il Moro's dead father, had been designed by Leonardo as a test model for what would have been the largest bronze equestrian statue in history. Poets composed verses about the glorious beast, and tourists traveled from far and wide to visit the model, planning to return to see the bronze statue once it was finished. But Leonardo had never even completed the mold for the sculpture, and eventually Il Moro had melted down the statue's bronze to make cannonballs for war. When the French invaded Milan, they had used the clay horse for

target practice, shooting it with burning arrows and beating it with clubs. The soldiers took off its ear, part of its nose, and a chunk of its hindquarters. If it had been a living horse, it would have died within the first few moments. But even though the clay model was full of holes, it was still standing.

"Master, come. We have to go!" Across the street, Salaì was saddling two horses.

Leonardo didn't move. He couldn't take his eyes off the French soldier silently communing with the great horse. Leonardo hoped the monument was giving the young man a sense of peace and purpose during this time of turmoil. The soldier reached into his belt and slowly pulled out a long sword. Leonardo imagined the young warrior placing his weapon at the foot of the statue, as though surrendering before the beauty of his art. Instead, the soldier swung his sword and yelled, "Death to Sforza!" The blade hit the horse's front right leg with a reverberating clang. The leg shattered. The horse held strong for a moment, and then teetered forward and crashed to the ground.

"No!" Leonardo shouted. He had spent four long years designing that horse. Many nights he had fantasized about finally casting the statue in gleaming bronze.

At this point in his career he was an uncontested success, but many of his contemporaries were already dead. What would he leave behind once he, too, was gone? He had no children to carry his name into the future. Half of his paintings were unfinished. The other half, including his portraits of Il Moro's mistresses, hung in private rooms and might never be on regular display to the public. He had a slew of unrealized inventions and a stack of notebooks full of useless ramblings. Now his *Last Supper* was crumbling off the wall and the model for his equestrian masterpiece

was destroyed. Years from now, would anyone remember Leonardo, the painter, inventor, and engineer from the inconsequential town of Vinci?

"Leonardo!" Salaì called, already astride his horse.

He turned away from his clay horse and crossed the chaotic street. When he'd moved to Milan, he had been thirty years old, just beginning to make a name for himself as an engineer, scientist, inventor, director of spectacular social events and, of course, painter. In Milan, he had grown into an elder master. He'd thought he would die in that great city. He mounted his horse and nodded to Salaì. Side by side, they galloped out of Milan's protective walls and into the surrounding wilderness. No one knew what the future held for the city, or for the war-torn peninsula, as kings and dukes and popes battled over territory. No one knew what the future held for Leonardo. Only one thing was certain: the Master from Vinci needed to find a new home, a new patron, a new life, and a new legacy.